Modoc

Also by Ralph Helfer
THE BEAUTY OF THE BEASTS

Modoc

RALPH HELFER

The True Story of
the Greatest Elephant
That Ever Lived

HarperCollins*Publishers*

Credits for photo insert:
Courtesy of Library of Congress: page 1, p. 2 (top and bottom),
p. 3 (top), p. 4 (top and bottom), p. 5 (top)
Courtesy of Corbis-Bettmann: p. 3 (bottom)
Courtesy of Richard Hewett: p. 7 (top, middle, bottom)
Courtesy of Ralph Helfer: p. 5 (bottom), p. 6, p. 7 (left), p. 8

HarperCollins books may be purchased for educational, business, or sales promotional use.
For information please write: Special Markets Department, HarperCollins Publishers, Inc.,
10 East 53rd Street, New York, NY 10022.

FIRST EDITION

Designed by Gloria Adelson/LuLu Graphics

Library of Congress Cataloging-in-Publication Data

Helfer, Ralph
 Modoc : the true story of the greatest elephant that ever lived / by
Ralph Helfer. — 1st ed.
 p. cm.
 ISBN 0-06-018257-1
 1. Modoc (Elephant) 2. Circus animals. I. Title.
GV1831.E4H45 1997
791.3'2'0929—dc21 97-20905

97 98 99 00 01 ❖/RRD 10 9 8 7 6 5 4

To My Daughter
Tana

≡ Acknowledgments ≡

I have had the good fortune to be allowed to enter into the mysterious world of an exotic animal from the inside out, to live there and learn the wonders it has to offer.

The trail that leads into this sphere forms the epicenter, where the essences of animal thoughts, feelings, and being live. Sometimes it can be difficult to fathom, and one needs a special family of talented friends to see one through. I have been so very fortunate to have had them when I have lost my way. Together we have held hands to build an energy that has made this book possible. My love, thanks, and appreciation go out to:

Tana—her father's mind reader. Our energy so much alike. We're always in tune with each other. She always knew what was to be. Miku Musoke—my lady, who "lived" the day-by-day adventure. She held me together during the trying times. Toni Law—the Faithful Keeper who always saw *Modoc* completed and waited patiently for it to happen. Donna Zerner—wise with the ways of words. Brought to *Modoc* her

marvelous spiritual energy believing in it from the start. Laurie Rose—from the beginning, her belief inspired me to heights not known before. Cathi—a sister who's always been there, far beyond the simple family duties. Stevie—whose inspiration will always be in my heart, even from so far a distance. Richard Curtis, my agent, who launched my career by believing in me and encouraging me to write from my heart. HarperCollins's wonderful team of talented people from Lawrence P. Ashmead and Jason S. Kaufman for giving both support and sound advice, to the copy editor, typesetter, and designer. All animal lovers.

And finally, Rebecca St. George—metaphysical, of the Earth. A writer in her own right whose detailed contributions and wisdom helped inspire and challenge me to make *Modoc* a true and loving tribute.

≡ Author's Note ≡

The story of Modoc is true. When writers attempt to write a story based on the truth, they must first take all that they themselves have seen and know it to be a fact. Next comes research and documented proof which may—or may not—be true. And, finally, there is "hearsay"—that which people tell you is factual. All this is put in a bowl, mashed and ground, and spread onto the pages in as close a semblance as possible. Then a little (poetic) political license is taken.

Therefore, the story of Modoc is true—at least as far as I know. It's the best I could do.

≡ 1 ≡

ON A GRAY, FOGGY MORNING THEY CAME, rising on the cold north winds from the icy peaks, sweeping across the timberland into the gray, misty valleys of the Black Forest . . . *baby sounds!* Somewhere below the fog layer, the insistent wails of a baby could be heard, their temerity as if from Mother Earth herself.

And then another voice arose. Deeper, brassy, trumpety, but still a . . . baby sound. It, too, was whisked away through the thermals, swirling and dashing about until it met its kin. A quiet moment hung over all. Then, together, they joined—the wailing and trumpeting became one. They drifted over the countryside, beyond the river, across the corn rows and the desolate fields of last summer's picking.

The first sunlight of the morning bathed the chilly Hagendorf Valley with its burnt ochre sphere. It seemed to rest, but for a moment, at the foot of Olymstroem Mountain upon a rather small

but quaint old German farm. It was from there both baby sounds emanated.

A rutted dirt road snaked up the center of the farm, separating the pale yellow German-Swiss style two-story house from the large, old, rock and timber barn. The barn's rock supports had tumbled down at every corner, resembling small volcanoes with boulders spewed in all directions. The rotting wood structure seemed to be part of the earth itself, and spoke bluntly of the many years of winter storms it had survived.

Circus paraphernalia lay everywhere. A huge old wooden circus wagon, its hitch buried deep, wheels dug into the mud from years before, showed chips of red and gold paint still visible on its frame. Pieces of candy-striped tent hung over the barn's windows. A broken ticket booth lay in shambles, its GENERAL ADMISSION sign still hanging from the roof. Chickens, geese, a few pigs ran free around the dwellings. This was the Gunterstein farm.

The baby sounds had separated. From the second-story window of the house only the soft crying of an infant could be heard. Hannah, the midwife, an exceedingly large and buxom woman, finished powdering the infant's behind. After bundling him in a soft, warm blue blanket, she handed the baby boy to his mother. Katrina Gunterstein gently took her firstborn. A pretty woman in her early forties, the daughter of a dirt farmer, Katrina had a wide strong jaw and a high forehead that spoke well of her inherited German peasant stock. Kissing his bright pink cheeks, she opened her nightgown and offered the baby her full breast. The touch of the infant's tiny mouth on her nipple sent a ripple of pure ecstasy through her body.

"Oh, Josef! This is a boy to be proud of. Is he not wonderful?" She looked through tears of joy at her husband, who stood at her bedside.

Josef was the epitome of a proud father gazing down at his infant son. His slender body and chiseled high cheekbones made him appear much taller than his six-foot frame. Katrina had found the man of her dreams in Josef, a quiet, gentle man of the Jewish faith. After many failed attempts during their ten years of marriage, they

were now blessed with a marvelous boy child. Although his blond hair and features came from the strong Nordic side of Katrina's family, he had the sweet and gentle warmth that radiated so strongly from Josef's heritage. They named him Bram, after Josef's father.

"The boy's going to make a fine elephant trainer," said Josef, his eyes full of anticipation.

Josef, as his father years before him, worked for a small village circus in the nearby town of Hasengrossck. He was a trainer, a trainer of animals. More precisely, Josef was a trainer of elephants. At times Katrina thought he loved the elephants more than he loved her, but better it be animals, she thought with a smile, than another woman. Besides, this love for animals was what made him the wonderful, caring man he was.

An ear-splitting trumpet shocked them out of their bliss. Realizing there was another baby to celebrate, Josef kissed his wife, the infant, and, in his excitement, even Hannah, and dashed downstairs, embarrassed at the mistake he had just made.

He felt a chill in the air as he stepped out on the porch. As morning broke, the earth's shadows eased their way down the mountains. Winter had worn out its welcome and spring was pushing the flowers up in the meadows. By the look of things it was going to be a wonderful day. Josef hugged himself briskly to keep out the cold and headed for the barn. Swinging open the large, creaky barn door, he stepped inside.

The scent of alfalfa, oat hay, and saddle soap, and the pungent odor of elephant stool in the damp musty air greeted Josef's nostrils. Bale upon bale of hay was neatly stacked against one side of the wall and formed large rectangular steps leading to the very top of the barn. From there one could touch the huge rafters that held the old structure together. On the opposite side of the barn were animal stalls, tack, and feed rooms. Inside the spacious tack room, the leather horse saddles, bridles, and halters had been buffed and polished to a high sheen. The brass buckles, D-rings, and cinches all sparkled, each piece having its appropriate place.

Hanging in an area of their own were huge elephant cinches

and girth straps. A large elephant headpiece straddled a wire-and-cloth dummy elephant head. Heavy chains, clevises, a large coil of rope, and various elephant hooks and shackles were neatly laid out on rough-cut wooden shelves. Adjoining stalls housed the farm horses, goats, pigs, and milk cows.

Silhouetted in the rays of the early morning sunlight filtering through the large open doors at the rear of the barn was a giant living form. Vapors rose from the monolithic body, spiraling up to the single hooded lamp hanging from a rafter high above in a feeble attempt to light the area below. The form had a strange resemblance to the locomotives hissing and steaming in the darkened train barn at Frankfurt station, waiting to be hitched to a long line of boxcars.

"Curpo, are you there?" Josef's voice echoed in the cavernous barn.

Out of the shadows emerged a small hunchbacked man, barely four feet high, with a chin as prominent as the hump on his back. He wore a pair of leather shorts, high-top shoes, and a gold chain around his neck, from which hung the small tip of an elephant tusk. He was bare to the waist. His strong body, covered with the sweat and blood from his latest chore, accentuated his powerful arms and torso. Wiping his bloody hands on the towel draped over his shoulder, he swaggered out from between the elephant's legs.

"I'm under 'ere, boss, with the punk," he replied in a high-pitched, raspy Cockney accent.

As Josef approached he heard a couple of short chirps and a raspberry. A grin crossed his face as he circled around, patting the mother elephant's huge wrinkled rump. Emma responded with a low rumble.

"My, my, would you look at this?"

The same expression he had had for his son now crossed his face as he beamed at the tottering baby elephant. Still wet from her mother's womb, the fragile infant stood on her tiptoes, reaching up to the huge teats full of milk. Curpo handed Josef a towel. Squatting down at the side of the little punk, they gently proceeded to dry her soft gray body.

"She's a real beauty, she is," said Curpo.

The little elephant was so small that even Curpo could look over her back. The baby nursed on her mother, slopping and guzzling as milk oozed down the side of her mouth. Her tiny trunk, some ten inches long, curled up in the air, staying out of the way for this most important activity of her first day.

Josef settled back, leaning against one of Emma's massive legs. He felt at peace with the world. Curpo had toweled off his own sweaty body and was putting on his undershirt.

"I 'eard about the baby, boss—I mean, t'other one. Congratulations to you and the missus."

"It must be one of those special happenings that has a mystical meaning, Curpo, to have my son born on the same day, let alone the same hour, as the baby elephant."

"Amuugghh," Curpo mumbled, having gotten his hump stuck while trying to put on his shirt. Josef smiled as he reached over and pulled it down.

"I always wanted a boy and a girl, Curpo, and now I have them both."

The baby elephant had stopped nursing on Emma and was now trying to nurse on Curpo's pointed chin.

"Let's not get started on the wrong foot 'ere, youngster," said Curpo, gently guiding the baby back to her mother's teat.

Josef grinned, "She's going to be the best, Curpo—the very best."

2

"MORNING, HERR GOBEL."

Josef always made it a point to stand in front of the elephant tent each morning as the owner passed by making his rounds. Herr Gobel's short, fat frame and waddling walk always reminded Josef of a penguin.

"Good morning to you, Josef, and how is our little one doing this morning? Growing nicely, is she?"

Josef feared Herr Gobel. He was an old man set in his ways, and though Josef, like his father, had worked many years for the circus, he knew anything that happened out of the ordinary could change Gobel into a most intolerable person.

"The baby's doing quite well, sir, as is Emma." Then, as an afterthought, "I told the keepers to have the first fresh cutting of hay delivered to my farm directly from the fields. It will keep Emma in good rich milk."

"That's good thinking, Josef. It's why I chose for you to care for my Emma during her pregnancy and rearing of the baby, huh!" Gobel put his arm around Josef. "There'll be a few extra shekels in your pay envelope each week, unless of course a problem develops, yah, Josef?"

Josef flushed at Gobel's condescending attitude. Afraid his anger might show, he lowered his head and turned toward the elephants.

"Now then, I'm off," said Herr Gobel, patting his round belly. "The best to your wife and baby Bram." Gobel turned and headed toward the big top, using his cane to strike at any papers or trash in his way.

Josef had plans to make Emma's baby the best trained elephant the world had ever seen. If anyone could do it, he could. His whole family was circus, and the last three generations were all elephant trainers. They had handed down all their secrets and methods, and Josef, as inheritor of that knowledge, felt he had the capability to make her the greatest. Someday, when Bram was older and had learned all that Josef had to teach, she would be turned over to him, and he'd follow in his father's footsteps.

Rarely has war, weather, or the economy prevented the circus from performing. "The Show Must Go On" became the word, better yet, the unwritten law, and rare was the day it wasn't adhered to. The circus has been part of the human tradition for thousands of years.

When one is at the circus, the blazing colors of red and gold; the oom-pah-pah of the calliope; the pungent odor of the animals, cotton candy, hot buttered popcorn; the sideshow barker with his "Step right up, ladies and gentlemen," all create a fantasy that can become real if one lets the youth within come out to play. The impossible becomes reality. Beyond the wonderment, the surprises and excitement cause a release of pent-up emotions. Time seems to stop. Troubles leave the mind. This is where romance begins. Young and old, in their own way, are swept up in this panacea of delight. The young sit amazed at the "torso" woman and marvel at the

arena acts, while the elderly wonder how she goes to the toilet and wait to see if the lions or tigers will attack their trainer.

The Wunderzircus was of average size, consisting of a performance tent, also known as the big top; a menagerie tent; six sideshow tents; half a dozen food stands; trucks and various trailers; and all the paraphernalia that encompass the making of a circus. Everything was painted in the customary striped bright gold and red with a touch of black and white for accent. The big top held three or four hundred people, including standing room, and was the largest tent in the circus. Four huge support poles ran in a row lengthwise down the middle of the tent. A circle of railroad ties formed the center ring. Within the circle, a thick layer of sawdust had been spread. Nearby lay sections of neatly stacked steel bars that later formed the big cat arena. One could see for miles the huge red letters printed across the top of the tent: WUNDERZIRCUS, and below in smaller print, THE GREATEST SHOW IN THE WORLD.

The menagerie tent housed the animals, and though some had a natural hostility toward one another, they all seemed to share a mutual respect and compatibility.

The relationship between the trainers and animals was, to say the least, different from that in any other circus. The credit was Josef's. Following in his father's footsteps, he schooled each trainer in a unique style of training his family had developed many years ago.

Respected and admired by all, his way with animals was seen in the gentleness and love the animals and the trainers had for one another. He based his teaching on love, not fear. In fact, an enormous amount of love and patience, interlaced with eating, cleaning, and sometimes even sleeping together, bound them together affectionately. The animals were constantly being bathed, touched, and preened. There seemed to be no separation between the two-legged and the four-legged—but common sense was always practiced and never forgotten. The trainers knew that the animals, because of their wild heritage, had a potential for becoming dangerous.

Three elephants, two camels, three llamas, six goats, one bear, two tigers, one lion, three chimpanzees, and one very large python

were the extent of Wunderzircus collection. Other than the snake, all were trained to do their own routines, like jumping on, over, or under various pedestals and hoops, or riding on each other's backs.

Karno had been a gift from a visiting Russian official. The hefty six-hundred-pound Russian brown bear was to have been used only for exhibition, as he had attacked his previous trainer and was not to be trusted. However, when Josef saw Karno, his experience told him that his aggression had been caused by fear training, a form of brutality. He put his old friend and seasoned trainer Himmel Theiss in charge, knowing Himmel had the love and patience to win Karno over from his days of torment. Once the major breakthrough of trust between the two was established, Karno's desire to please, coupled with his high intelligence, had him performing many difficult acts, including, for the finale, a spirited dance step with Himmel. It was not unusual to find the two of them huddled together on the cold winter nights.

Luki, Helyn, and Baby Oscar, three chimps who were an actual family (Baby Oscar had been born last year), performed an old-fashioned slapstick routine, and their gaiety was the fun spot of the circus.

Equally loved was their trainer, Appelle, better known as Appelle the Clown. The chimps considered him a member of their family. Many times when Helyn didn't get enough sleep because of little Oscar's restlessness, she would pass the baby chimpanzee to him to care for while she caught a few winks.

Appelle was never seen out of his costume. Those around him never seemed to notice. The heavy creases in his hangdog face were filled with the colored greasepaint that accentuated the deep crevices in his face, but his face, always sad, deep-lined, and soulful, needed little makeup. He never smiled. The funniest situation left him with a steady glare as though he was considering it, and then he would simply turn away and busy himself with some duty or other. It was this unique way of looking at the world that caused the roar of laughter from the crowd. Those who knew him were never sure whether he felt he was funny or not. It was as though he

sensed the sadness in all things, and people, feeling self-conscious, laughed. A strange man to be associated with the most humorous animals of all.

Sultan and Patrina, two Bengal tigers, along with Leo the African lion, thrilled their audience, chilling them as they roared and snarled during their performance. Heinz Shmitz, the big cat trainer, never used a whip, gun, or chair in his act. The animals performed for him because they wanted to, not because they were forced to. Their rewards were a favorite tidbit, pats, hugs, and kisses.

Heinz also appeared as Hercules, the World's Strongest Man, in the sideshow, lifting enormous weights and posing his glistening, rippling muscles for photos.

Josef and his elephants were the most beloved act of all. Emma, because of her size and intelligence, took the center position. To her left was Krono, a younger male bull elephant. To Emma's right was Tina, a timid, smallish elephant who, try as she may, was always a step off or a beat ahead of the music. Their act consisted of sit-ups, graceful waltzes, hopping, skipping, and headstands. With the roll of the drums came the finale. Emma reared up, her trunk held in a triumphant arch. Tina and Krono would rear up on either side, placing their front feet on Emma's shoulders. Finally Josef carefully climbed from his position on Emma's neck to the top of her head, where he would stand, precariously balanced, hands held high. The applause was always thunderous.

Because of the recent delivery of Emma's baby, the act had gone on without her until the day she could join the routine again.

A few small kiosks sold wiener schnitzels, popcorn, candy, and sodas. About twenty roustabouts tended to cleanup duties, moving animal wagons, feeding the animals, making repairs, and doing whatever miscellaneous work was necessary.

All members of the Wunderzircus family loved the circus; they looked out for one another and took pride in giving the public a great show. Four times a year the entire circus moved to a new location so people in other areas could enjoy their performances. During these times the hustle and bustle, although tough work, was

pure joy for them. The true sense of the circus could be felt every-
where, and throughout the countryside people were humming the
oom-pah-pah of the calliope.

Winters were the most difficult. Cold and wet weather kept
everybody indoors, and those were the days when word spread of
impending disaster.

"Did you hear about old man Gobel? He's dying, you know
. . . yeah, selling the circus to some rich European."

Sometimes the rumor was that the old man didn't have any
money and was selling the animals to pay his debts. None of the
trainers owned his own animals, as the cost to buy and maintain
them was beyond his means.

"What will become of us and the animals?"

These were the scariest of thoughts and affected all the train-
ers, but none so badly as Josef. The thought of Emma and her baby
being sold, or, for that matter, any of his elephants being sold, was
enough to set off his ulcers, but with the coming of each new spring,
something would happen to right the situation.

Josef always knew what he would call the new baby elephant. As a
small boy he remembered sitting on his own father's lap by the fire-
place, watching the smoke from Bram's pipe swirl in the air, creat-
ing grotesque shapes and images. He listened to his father tell him a
story he'd never forgotten, the story of a great elephant.

"This Indian elephant," his father began, "was the biggest ever
seen! Why, she must have weighed five tons, and stood twelve feet
tall, yet she was gentle as a mouse. But," his father said, "even
though she had been known to pull, push, and carry more than any
other elephant, the only thing that made her so famous was that she
could perform her entire, intricate act without a trainer."

"Without a trainer?" questioned young wide-eyed Josef.
"That's impossible! How did she know what to do? How could she
remember in what order to put everything?"

"Well, son, this was no ordinary elephant. It is said that one in
every ten thousand elephants is special . . . very special. They have

something happening in their heads. Something we humans wouldn't understand, but they know the ways of Man."

"What was her name, Father?" asked Josef.

Josef's father put down the pipe and gazed into the crackling fire before them. "Modoc, son. Modoc—the greatest elephant that ever lived."

Josef never forgot what his father had told him. He knew in his heart that his father had trained Modoc, and he felt his great sadness in the pain of remembering. Josef's father never told him what happened to Modoc, but he believed that Emma's baby was one of those special elephants. Down deep, Josef believed Modoc's spirit still lived and was waiting to be reborn—to live again through Emma's baby.

≡ **3** ≡

DURING THE SLOW SEASON CURPO was allowed to take care of things at the farm while Josef worked at the circus. A most unusual choice, the world's largest land animal working with one of the smallest humans. The slightest wrong move of Emma's leg, a misjudgment of space to lie down . . . but the elephants loved Curpo and judged their movements with great care. They seemed to treat him as their young. Josef had always liked Curpo. He knew the possible danger that Curpo's smallness could bring, but he also knew that he could trust him, that he was a dependable man and above all someone who loved pachyderms.

Emma responded well and completely trusted him with her baby. She became accustomed to Curpo's size, and if he got under foot, she would gently nudge him to one side. On one occasion, in a moment of impatience, Emma picked Curpo up, depositing him in a pile of loose hay.

"Such disrespect!" he yelled, brushing the hay from his clothes. Emma never hurt Curpo; it was as if she treated him as an equal, rather than a superior, and didn't mind showing it.

Each morning after the sun sufficiently warmed up the valley, Curpo untied Emma's leg chain, which bound her during the nighttime hours.

"Guten Morgen to both of you now. 'Tis a fine day, and perfect for our walk in the forest."

Baby Modoc had taken a special liking to Curpo from the start. Shaking the straw from her bed, she squealed with delight, running around her mother's legs, hooting with all her might. Picking up his bull hook, a device used to control and train elephants, Curpo led them out of the barn.

"Come down!" Curpo commanded in his best authoritative voice. Emma, always well disciplined, bent her hind feet into a crouch. Then, taking small steps until she was sphinxlike, she curled her trunk high in the air and allowed her tonnage gently to roll to the side. The punk stood obediently close to Emma's head, occasionally touching the tip of her trunk to her mother's tongue for security. While Emma's eye watched from its unique position, Curpo, rolling up his sleeves, placed a push broom against her neck, threw a putty scraper, a large heavy sponge, and a penknife on her back. Emptying a bottle of hydrogen peroxide into the bucket, he attached a rope to it and threw the other end up on her back. Turning on the water from a nearby faucet, and armed with the hose, he climbed on Emma's huge barrel foot. Straddling it, he issued a command of "Foot!" Emma quickly raised her foot, allowing Curpo to slide down her leg and belly.

Pulling up the broom and bucket of peroxide, he went to work with the hose, spraying and brushing the huge field of wrinkled skin. No crevice was overlooked. Her giant ear waved back and forth, almost knocking Curpo off her neck, but he hung on, cleaning and scrubbing.

Next came the scraper. Curpo dug and poked at each little cut, slit, abrasion, and insect bite. Pus, where present, was extracted. He

poured a small amount of peroxide into each wound, causing a thin vapor of heat to rise. Not an untreated spot existed when he was done. Curpo closely examined each toenail for any sign of breakage, tearing, or ingrown problems that he could report to Josef.

During these times Emma was in ecstasy. She loved the care and fussing and was anxious to have the program repeated on the other side. She was given hay, along with her morning treats of bread, apples, oranges, potatoes, and any other available fruit or vegetables. Topping it off was a five-gallon can of grain consisting of oats, barley, and molasses. Morning ended with her being led to an open vat of fresh water for her trunk to suck up or splash about, according to her wishes.

During Emma's breakfast, Katrina would bring little Bram down so he could see and get used to elephants. From the beginning, Bram never had any fear of the giants. He looked forward each morning to the visit with great expressions of glee, exploding in giggles and laughter.

By noon, as the sun rose high overhead, Curpo would lower Emma into her sphinx position again. Leaning a tall thin ladder against her side, he'd climb up astride her neck, from where all elephants are controlled by their mahouts or trainers, and pull the ladder up after him. He sat on a woven rattan mat that was tied to her neck by a single strand of heavy rope. Since his legs were too short to straddle the neck, the mat helped stabilize him, as he could put his feet into the weave. From there, with the help of the bull hook, he could control her every move.

They moved out, one huge pachyderm, one very small person, and one very, very small elephant who ran to keep up with her mother. About a quarter of a mile up the dirt road, past the cattle-grazing gate, and through the lower meadow, was a strange forest. From early spring to late fall, a phenomenon took place that made this forest like no other in Germany. The ground covering was deep and pungent with the odor of many layers of thick hot swamp grass. Pockets of steam rose from beneath the surface from an underground hot spring that sent its bubbling fingers throughout

the forest. Much of the foliage was subtropical, lush and abundant. The junglelike trees were tall and massive, with ridges of roots above the ground. Thick vines with giant leaves encircled the trees, stretching their way to the top. This canopy of green covered a vast amount of the forest. Some vines found branches of nearby trees to arch across, knotting and hugging the small forest together with protective arms. This natural "tent" caused the humidity to rise, giving warmth. It was a place where all things could feel safe and secure.

Little trails led through the thickets and crossed small meadows and glades full of ferns and brilliant green grass. These were Emma's and Modoc's favorite places. Curpo would turn them loose, Modoc to romp and play and explore the woods and Emma to eat the delicate greens at the forest edge.

It wasn't long before, under Katrina's watchful eye, Bram joined them. It was a beautiful morning; the warm breeze carried the scent of the forest and the caw of the mountain ravens. It was time. Katrina held Bram in her arms, speaking softly, reassuringly, as they approached baby Modoc.

This was an important moment, a beginning, for she knew the boy would spend his life with animals, especially elephants, and the meeting was of utmost importance. Neither the elephant nor the baby said a word. All was quiet as they looked at each other. Mo's small trunk wormed its way up, reaching to the baby. As Bram leaned over, his little hand pulled loose from Katrina's grasp, found its way down toward the trunk. A finger extended to meet the tip of the trunk. Bram's expression was one of curiosity; he felt the wet tip, Modoc moved her "finger" all around Bram's hand, sliding it across each finger and the palm. A big tickle grin spread across Bram's face, Modoc did her elephant "chirp," a tear glistened as it ran down Katrina's face. All was well. The future had been written.

From then on, Bram regularly joined them in the forest, with his toddling little feet tripping and falling along with Modoc's. They were each learning control of their bodies and minds. How to get

body and mind to work together at the same time, on the same problem, was a constant challenge.

In the middle of the forest was a glade unique among all others. Large in size, it sat in an area the canopy of the forest didn't cover. Here the sun shone brightly and warmed thousands of flower blossoms. They were called God's Blanket, and came in every color: vivid crimson, burnt orange, sky blue, milky white, dark purple, with additional hues found only in magic places.

Bram and Modoc loved the glade. Bram would stand in the middle of the field, arms outstretched, eyes closed, inhaling the wonderful fragrance. Modoc, in her own way, would mimic him, her ears out, eyes only partly shut so she could watch Bram, trunk in the air, sucking in the sweet smell. They romped through the field, hand in trunk, both stumbling, rolling, giggling, and squeaking in their own way. Mo would drop to her chest and, pushing with her hind feet, plow up a row of the field flowers, then toss the loose ones over her head, sending a shower of brilliant colors through the air.

The two babies loved to feed each other. Standing on a log, Bram would hold the jug of milk as Modoc slurped away. Modoc's job was much easier; she could hold the baby bottle by wrapping her trunk around it and lowering it to Bram. Sometimes she would hold it out of reach and take a quick suck on it herself, until he started to cry or yelled for his mother. Then Modoc would hurriedly push it into Bram's mouth, in fear of being found out. Occasionally, in her haste, she would stick it in his ear or nose, which caused a bit of upset.

As the years passed, the babies grew quickly, with Modoc maturing more rapidly than Bram. At five years of age, Bram was only four feet tall and weighed forty-five pounds. Modoc was five feet tall and weighed a thousand pounds. At ten, Bram was five feet tall and weighed seventy pounds, Mo was eight feet tall and weighed thirty-five hundred pounds, yet she was still as much a youngster as Bram.

Early mornings found Modoc rocking back and forth waiting for Bram to appear so they could have breakfast together before he left for school. The first thing Bram did upon his return was run to Mo, giving her hugs and kisses. Early on, Modoc developed a special way of showing Bram her affection. She would put her trunk over Bram's shoulder and, snaking it around his waist, hold him tight, all the while making rumbling noises. It looked quite protective.

Modoc possessed a mischievous sense of humor. Sometimes while playing she would pick Bram up and walk off with him . . . all Bram's yelling wouldn't get her to release him. She usually found a soft spot to drop him, like a nearby grass field. After, she would cock her head, lock her ears forward, lower the tip of her trunk to the ground, and emit a low guttural sound that was her way of saying, "Just kidding." Once, in an outrageously silly mood, she dumped him in a small stream, then ran as fast as she could, kicking up her heels and trumpeting all the way back to the barn.

Josef awoke one night to hear a loud cracking and breaking noise. He ran downstairs to find Modoc racing back and forth at the front door, trumpeting, and carrying on as though possessed. She had snapped her leg chain and crashed through one of the barn doors. He had never seen her act this way before. Why? Why at the front door to the house? His mind was racing. Bram! Josef flew upstairs to Bram's bedroom. Bram was lying stretched out diagonally on the bed, delirious, bathed in a pool of sweat.

Gathering the boy up, Josef raced downstairs, yelling for Katrina to get the truck key and a blanket. Curpo had arrived and was running toward the truck as fast as his small legs could take him. The tip of Mo's trunk traveled up and down Bram's prostate body as she ran alongside Josef. Curpo had the truck door open as Josef laid Bram in Katrina's lap, and she bundled blankets around him. Mo stuck her trunk through the open window trying to touch Bram, rumbling all the while.

"He'll be okay, Mo. Now you just get back to the barn."

Josef, trying to believe his own words, jumped into the driv-

er's seat and started the truck. It sped out of the driveway with Mo trumpeting and squealing, running after it. Curpo was waiting for Mo as she dragged herself up the driveway, exhausted and depressed. Mo didn't understand what was happening; she sensed that something was wrong and that her best friend was gone. Head low, her body trembling, she followed Curpo back to the barn.

Bram remained in the hospital for two weeks recovering from his illness. A deadly virus had chosen him for its victim, and had it not been for his quick arrival at the hospital, he might not have recovered at all. Josef didn't bother to tell the doctor about the strange occurrence of the psychic elephant alerting the family to Bram's illness.

The day Bram left the hospital, Josef stopped at a local farm to let him pick out Mo's choice of fruits and vegetables. Arriving home, Josef let Bram off at the barn, knowing he'd want to be alone with Modoc. Bram quietly opened the barn door and, walking on his toes, sneaked in, hoping to surprise her. As his eyes became accustomed to the half-darkness, he saw her standing with Emma. They were munching on a bale of hay.

"Mosie!" he yelled.

Modoc stopped mid-crunch. Throwing her ears forward, she blasted a trumpet that echoed throughout the barn. Bram ran to her, spilling half the food. She caught him with her trunk and held him in her special way. From her chest came her rumble of contentment. Bram wrapped his arms around her trunk and laid his head back against her chest. He knew that she had saved his life, and he loved her deeply for it. In the back of his mind, Bram wondered how she had known he was ill.

It was Sunday. This was the day Emma was going home to the circus. Although she'd been returning most weekends to perform, it was time she went back to stay.

"But this is her home," Bram protested, "and what about Modoc? She's never been away from her mother for any great length of time."

Bram, Curpo, and Josef were busy preparing the truck and trailer to transport Emma.

"Mo will be fine, and besides," said Curpo, "she's got you. Why, I've never seen an elephant love anyone the way she loves you."

"Okay, old girl, it's time to go," Josef said.

Emma caught him with a flap of an ear as he guided her into the trailer. A huge pile of bananas, apples, and bread awaited her enjoyment during the trip. Bram hugged his mother and Curpo goodbye, and away they went down the dirt road, onto the main highway headed toward Hasengrossck.

Bram loved riding in the big trucks, sitting up so high he could see for miles, the sound of the big engine roaring. His father sat in complete control, his strong hands holding the wheel firmly and keeping the truck steady. Each sharp turn in the road needed his experienced touch to counterbalance Emma's rocking motion. Her three-ton body swaying to and fro rocked the trailer. If she swayed in the same direction while going around a sharp curve, well . . . Josef had to be careful.

"Someday you will take my place in the circus, as my father did before me!" yelled Josef, putting an affectionate arm around Bram.

Josef had been teaching his son to be an elephant trainer since the day he was born. Bram had always wanted to follow in his footsteps, but he saw how his father suffered. The thought of working for Wunderzircus sent a shiver racing across his shoulders. Old man Gobel was a very selfish and greedy man. Though his father was one of the most important people in the circus, the uncertainty of employment, low salary, trying to make ends meet, and the possible sale of his animals kept Josef in a state of depression. There was an underlying problem that Bram could not grasp. He just knew it had something to do with them being part Jewish. Bram secretly hoped that by the time he was old enough, the circus would have another owner. He feared old man Gobel as his father did, and blamed him for his father's occasional illness that seemed to pop up whenever Gobel would threaten to close the circus. Bram wondered

if the old man would still be alive when he worked there. He quickly apologized to God for thinking such a bad thought.

Bram's concern for his father's ill health was not unfounded. There wasn't a day that his ulcers weren't hurting him, but it was the coughing that worried Bram's mother even more. It had started about two years ago, when the circus had gone through the worst winter of its existence. Josef never left the elephants' side, night or day, and slept on the cold dirt floor to be there if they needed him.

It was then the cough began, and it had never left him. The doctor told Josef not to smoke, but Josef continued to do so. Every night Josef was at home, Bram noticed his father meticulously peeling off the thin silver strips from the waxed paper that sealed the cigarette packets for freshness. Two packets a day, every day. For years Josef had been making a ball of the silver linings.

"Some day this will help pay for your schooling," he explained to Bram, and well it might, for it had grown to an impressive size.

But the silver ball only reminded Bram of how much his father smoked. He wished Josef would use the silver as payment for a doctor to treat his illness.

The blast of the horn made Bram jump in his seat. He realized he'd been toying with a twig in his mouth, as though it were a cigarette, puffing and blowing out the cold winter vapors. He quickly threw it out the window.

The fall season was upon them and the countryside began to show its first sign of frost. The leaf-barren trees slept in anticipation of the winter months to come.

Josef brought the rig to a stop in the outside parking area. They lowered the ramp and slowly backed Emma down to the ground. It was wonderful to hear the sound of the calliope as it played loud and clear across the circus grounds. A good crowd was coming through the stalls, and everyone seemed in good spirits. High in the air, Charlie, the man on stilts, met the people as they thronged through the gate.

"Step right up, ladies and gentlemen, boys and girls! Come

and see the tallest, strongest, and heaviest persons on earth!" called the barker. "Hello, Bram! You're sure growing into a fine young man."

Bram nodded with a smile and followed his father and Emma down the fairway. He felt so proud. Everybody moved aside as her three-ton body ambled past the penny arcade, across the back of the sideshow, and on to the menagerie tent. Josef gave her the order to "get in line." Emma swung her derriere around and backed in alongside the other elephants. Then Bram fastened a leg chain on her left hind foot as Josef fastened one to her right front.

"Now, you don't have to worry about Modoc," said Bram. "We'll take good care of her." Josef said a few words to the keeper and a quick goodbye, patting Emma on the rump, and they headed back to the truck.

That evening Bram wanted to sleep in the barn with Modoc. With her mother gone, he figured she'd be lonely, if not afraid.

"How can I sleep with her in the hay?" he asked his father. "What if she forgot I was there and rolled over on me?"

"Well, if I wanted to sleep with an elephant," he said, reminiscing about the days when he was a boy, "I should sleep head to head. Then I wouldn't have to worry about her rolling on me."

"But why does Emma sleep standing up, and Mo lying down?" asked Bram, loving any moments when his father might take on his role as teacher. This was his schooling, and Bram listened carefully.

"When elephants grow old they rarely lie down because of their tremendous size and weight. The circulation in their legs is restricted and could cause numbness, and if they can't feel their legs, they are unable to stand. Fluid collects in their stomach, and eventually can cause their death. In the wild, adult elephants doze for only a few minutes at a time. Captivity changes their habits, and therefore their sleep patterns."

Later, in the barn, Bram lay awake in the dark. The oat hay mixed with the alfalfa gave off an intoxicating aroma.

As his father suggested, he lay head to head with Mo. He had

barely closed his eyes when a loud *bang* yanked him from sleep. Bram felt Mo's trunk reaching in the dark, frantically trying to find him. He touched her trunk. She grabbed his hand, hard, across the wrist, and held tight.

"It's all right, girl, just a window blown open by the wind." He felt her nervous twitching and stroked her skin, soothing her as best he could. It was amazing to him that such a large animal could be so scared of small things, until he remembered that she was still young.

As Modoc moved a leg to scratch an itch, her leg chain clanked against the steel plates in the cement. It reminded Bram of prison: chains, steel, and concrete. He recalled when he was five, wondering how his father could be so cruel as to put a chain on an elephant, the one animal he loved more than any other. It seemed so mean! Later he was to learn that because of elephants' incredible size and strength, they have to be controlled as best they can without putting any undue stress on them.

"No, no, the leg chains work quite well. They hang loose, don't get in the way, and are easy to slip on and off," his father had explained. "As for the chain, it's like the one Curpo wears around his neck. Elephants could care less whether it is on them or not."

Bram learned some elephants could break their leg chains if they so desired. It was only the perception of humans that made the chains appear so wrong.

By midnight the weather had turned unusually cold. Bram had a blanket to sleep in and was quite warm, but he felt Mo shivering. He knew it wasn't just the cold, but a sense of loss for her mother. Once his own mother had traveled far away, and while she was gone young Bram had shivered every night. He figured Emma's huge body gave off a lot of body heat that helped Modoc stay warm. He got up and, not wanting to start the electric generator that ran the heater for fear of waking the family, lit a candle. He set the candle far from the hay and pondered the situation. How does one warm a two-ton elephant? Hay! He decided to cover her with hay. Bram opened bale after bale; pitchfork after pitchfork of

hay was thrown on her. He had no idea it would take so much hay. When he was done, there stood before him a mountain eight feet high. He couldn't see Mo, but he knew that somewhere in that enormous pile was a young elephant.

"You all right, Mo?" asked Bram.

A snakelike trunk slithered out from under the edge of the hay. A stifled sneeze and a puff of dust and hay blasted out of her trunk. This time he slept with his arm wrapped around Mo's trunk.

During the night Bram awoke again. It was unusually quiet. It was too quiet. Something was wrong. Mo wasn't breathing. He listened again. Nothing. Was she just sleeping soundly or . . . or . . . ? He sat up in a panic. Maybe something horrible had happened, like suffocating under all that hay? Bram reached down and gently pinched the tip of her trunk closed to see if she was breathing. He waited, figuring that if she was all right this would force her to breathe through her trunk. Like a bursting boiler, a great rush of air blasted out of her trunk, blowing it free of his grip and throwing Bram, startled, onto his back. Then, like a mystical apparition, she rose from the earth. The hay fell away, some still remaining on top of her head. Towering eight feet in the air, she raised her trunk to resume the loud gusts of wind in Bram's direction, showing her definite displeasure at being awakened in the middle of the night by having her nose squeezed.

"Well, you should breathe more often!"

"Erruuuuu!"

"All elephants breathe often."

"Wwwuuuuugruuuuu!"

"I breathe often."

"Braa hecuuuu!"

"So I didn't get any rest either. You shouldn't sleep so deeply."

= 4 =

SATURDAY MORNING. There was no great fanfare about it. Modoc's left front foot was resting on a large oak stump while Bram put the finishing touches to the trimming and rasping of her nails. His father had used great patience in teaching him exactly how it should be done, and Bram, perfectionist that he was, had each nail cut and groomed perfectly. There were no splits and all were nicely convex in shape. Bram smiled when he remembered how his father had made a comparison between his mother's nail kit and Mo's. Everything was the same except for size. Katrina's dainty little file, clippers, and trimmers were small compared to the giant ones used for elephants, but the method was similar.

It had been a sweaty, tough job, and he was in the process of putting some softening salve on the cuticles when an arm appeared over his shoulder and set a package on the stump. Bram looked up to see his father standing behind him.

"What is it?" he asked, stretching his back muscles that were sore from bending for the past two hours.

"Sit down, son," said Josef, asking as an afterthought, "How's the trimming coming along?"

Bram had Mo lower her foot to the ground so he and his father could both sit on the log. She stood close to Bram, her trunk playing with the twigs on the ground.

"Just fine, Papa," Bram replied, with a sideways glance at the package.

Bram had become a big help to his father, always taking his responsibilities seriously, never shirking his duties. He'd been given jobs of the utmost importance; he drove the tractor and could make the furrows almost as straight as Josef's. Bram and Curpo watered, fed, and cleaned all the livestock on the farm. Although his duties were many, his first thought upon awakening, and the last when going to sleep, was when he could spend time with Modoc.

"There is something I want to give you," Josef began, "something that has been in our family for many generations. My father gave it to me when I was thirteen. I stopped using it the day you were born. All things have a life expectancy, you see, even material things, and I wanted to be sure that it had many years of wear ahead so you would be able to enjoy using it as I did."

Bram looked into his father's face, watching its serious lines convey the message. For a moment his father appeared very old and tired, and he had to blink his eyes to return to the present. Josef laid a chamois-wrapped article in Bram's lap. The skin was old and worn but its dark mahogany color still looked rich, and it was as soft as velvet to touch. As Bram began opening the package, he noticed his father looking at his face, rather than at what he was doing. He felt embarrassed, hoping his first impression of the gift was what his father expected it to be.

He unfolded the chamois to find the most beautiful hand-carved bull hook. It was about a foot and a half long and two inches thick. The handle was made of rare teak root from India.

The end piece of tempered steel formed two points, one straight, the other curved back toward the handle, and both points were rounded off at the tips. It was entirely inlaid with sculpted silver elephants, edged in the same exotic wood as the handle. Along the handle were various carved figures of men and elephants, interacting with each other. Running down the inner side of the shaft were a series of engraved initials, of the mahouts who had once owned it. Bram noticed that the last ones were "B.G."—newly carved.

"Remember, son, this is a guide, a liaison between you and your charge, to express your desires to the elephant. It is not meant to be used as a weapon. Guide her well. Never push beyond her endurance. She will always tell you what her limits are."

Bram ran his hand over the smooth wood and metal. It seemed to speak to him, and he felt in the right time and place he could relive the great experiences the hook had known.

"You can now feel free to take Modoc out for walks into the forest. I am sure you both will enjoy them." Josef put his hand on Bram's shoulder. "This is a big responsibility I am giving you, son. You must never allow your mind to wander for a moment. Elephants are large and strong, but they need your protection from that which they do not know or understand." Josef's finger under Bram's chin raised the boy's eyes from the bull hook to look directly into his eyes. "This is also a good time to find the spiritual way of the world. A place few people ever find. When you learn to hear the voice of nature instead of your own, you will be allowed to enter through the door of the metaphysical world. Bram, listen to Modoc; she will teach you how to cross over into her world."

Bram had never heard his father talk of these things and yet he, on his own, had often thought of a spiritual existence between men and elephants.

"There are times, Papa, I feel I know what Mo is thinking, and she as well knows my thoughts. It's as though I live in her world, sharing the same thoughts and feelings, as though my blood flows with hers." Bram considered this for a moment. "If our blood min-

gles," he continued, "doesn't that mean we are kin, brethren, and are one . . . together?" he finished hesitantly.

Josef's heart swelled. His eyes misted over. He knew those metaphysical feelings from long ago, and was proud that now his son shared them. He answered by drawing Bram to him. Their embrace was one of men who share secrets few others know, of kings passing down thrones to sons, of the camaraderie that goes with living the adventure of life's new experiences.

The next morning Bram, new bull hook in hand, and Modoc headed into the forest. Cutting down through the valley and across old man Geckkor's property, they went to the secluded far end of Cryer Lake. Here the cool blue-green waters were calm and shallow. Friendly indigenous wildlife dotted the shoreline, drinking the melted snow from the Alps.

Flocks of rooks swept over the trees, cawing at Mo as she ventured, with Bram atop her broad back, out into the lake. It reminded Bram of what his father had just said. Soon the tapering land disappeared beneath her feet and she floated free. Her huge legs hung loose, letting the current move her at its will. While the water gently lapped at her sides, she drifted quietly through the sunlit rays into the cool shadows of overhanging trees.

"Well, Mosie," said Bram, who had removed his shirt to enjoy the sun, "you're getting pretty big now. Papa says you're already a third bigger than most elephants your age. He says you're very special and that you learn awfully quick. I guess we're both in school 'cause Papa's teaching me how to train and tells me the same, that I'm a fast learner." Bram let his hand drop, his fingers cutting ripples in the cool water. "Wouldn't it be great if someday you and I could have our own act! Just you and me! We'd have the best performance in the whole world!"

Mo wasn't listening. She was in a state of bliss, slowly turning in small circles as she floated along the edge of the lake. Occasionally her feet would touch bottom and she would kick off, giving her pivotal motion a boost.

"Then we would travel, maybe even to America!"

Mo still wasn't listening to a word Bram said. Self-entranced, she was gently playing with a large leaf that floated nearby. Bram's loud voice broke the rapture of the moment.

"Mo! Are you listening to me?"

Shocked out of her dream world, Mo accidentally let her trunk slip beneath the surface as she took a deep breath . . . of water. Gasping for air, she sprayed water all over Bram, who promptly lost his balance and slipped off her back into the lake.

Embarrassed by her behavior, Modoc tried to help him with her trunk. Bram was irate.

"Keep that garden hose away from me!" he spouted as he swam for shore, followed by Mo.

Once out of the water, they complained to each other that they were right.

"You didn't hear a word I said!"

"Duuuuutuuuuu."

"We could have drowned."

"Rauuu Duuutuuuu."

"I know you can swim!"

"Cauuuu tuuuuu."

The pair didn't stop jabbering to each other until they arrived home.

═ 5 ═

"HI, I'M GERTIE," said a voice.

Bram was lying flat on his back atop of Modoc and didn't hear a thing. It was a blistering hot day, and after finishing the chores he had decided to take a rest. He liked to lie on his back, his feet hooked under Modoc's ears, and catch a few winks. Mo's gentle swaying reminded him of when his mother used to rock him to sleep. Of course, for a man of thirteen years come April next month, he didn't really admit to anyone that he felt that way.

"Hello up there," said the voice again.

Bram bolted from his placid position, nearly falling, and looked to the left, back, front, right: no one. Again the voice.

"Are you always this rude?" it asked.

"Where are you?" Bram replied.

"Here, just here, under the elephant's chin."

Leaning way out from Modoc's back, clinging to the rope

around her neck, he could see from this angle a pink dress and a pair of legs.

"Who are you, and will you please come out from underneath so I can see you?"

Bram saw some kernels of popcorn fall to the ground. Apparently this person, whoever she was, was feeding Modoc popcorn. As he watched, the face of a beautiful tawny-haired little girl with hazel eyes appeared from under the elephant's chin. The face smiled. It was a gentle, self-assured smile, the kind only a little girl can have.

"I'm Gertie," said the smiling face.

"I'm Bram."

"Is this your elephant?"

"No, she belongs to the circus in town, but my father's the elephant trainer and he and . . . uh . . . I have been training her for the circus."

"What's her name?"

"Modoc, but sometimes I call her Mo. Where do you live?" asked Bram. "I've never seen you around here before."

"Up the road about two miles. I've seen you many times. Even been here before. I walk across Kunz farm and follow the rail tracks. Then I jump into the old culvert under the trestles at Weessenchter Road and, well, here I am."

Gertie gestured with her arms outstretched, head tilted, a look of confidence on her face. Bram was impressed. He'd been down in that old culvert himself and it was a bit scary even in the daytime.

"Want a ride?" he asked.

"Sure," replied Gertie, looking up and down the elephant as if looking for a ladder.

"Just stand in front of her. Mo'll do the rest."

Gertie looked up hesitantly.

"Not afraid, are ya?"

"No, just wondering how I'm going to get down after I'm up."

Bram chuckled as Gertie stood in front of Mo. "Modoc, up!"

Mo wrapped her trunk around Gertie and gently lifted her up

to Bram, who grabbed her arm and sat her down in front of him.

"Wow! It's really high up here!" exclaimed Gertie.

Bram, seeing that she was a little frightened, slid an arm around her waist, while nudging Mo with the bull hook he held in his free hand.

"Move up, Mosie. Sometimes I call her Mosie, too."

Modoc moved out in long, gentle, quiet strides that rocked them with each step. Gertie snuggled back into Bram, feeling secure and protected in his arms. When Bram caught her looking at him, he didn't turn away. He felt a strange, warm sensation creep through his body that caused him to shiver even though the sun was hot.

They arrived back at the barn just as Josef was bringing in the stock for the night, so Bram introduced Gertie to his father. The kids pitched in to help with the feeding and cleaning chores, until Josef wondered if Gertie's parents might be getting worried about her. He offered to drive her home, and when she and Bram promised to see each other the following Sunday for a picnic, Josef saw a look in Bram's eyes that he sensed would be there for a long, long time to come.

= 6 =

"NOW YOU KIDS BE CAREFUL and I don't want you back too late," Katrina said as she handed the picnic basket filled with cheeses, fresh bread, and sausages to Modoc, who raised it up to Bram.

"Bye, Mama. Bye Papa."

"If you go by the flower field," Josef added, "give Mo about an hour and she can eat enough to have a good lunch, too." He gave Mo's rump an affectionate whack as Bram, with Gertie hanging on behind him, headed out the back way of the farm toward Cryer Lake.

It was a lovely day. Summer was stealing some extra time while fall slept. White puffs of clouds hung in the sky with seemingly no interest in moving on. The rains had turned the country-side into a sea of green covering the hilltops. The slopes, spotted with groves of sycamore and spruce trees, caught the runoff and were a deeper green, with splashes of purple sage, the essence of

the lush valley. The rain waters slowed and settled into the rich loam, and from it grew the emerald grass that carpeted God's house, grass where the regal stag grazed.

Modoc walked proudly. She carried herself with a conservative grace that comes from the heritage of one's birthright. A thick woven mat of rope lay across her back, its outer edges strengthened by a bamboo frame that held it flat rather than letting it conform to her curves. Several nooses of rope were attached to the bottom edge so the picnic basket, water jug, camera, utensils, and other paraphernalia could be carried. A large handmade comforter padded most of the mat, making Modoc's broad back comfortable and roomy enough for both youngsters to stretch out.

Bram wore a pair of corduroy shorts his mother had trimmed down from his old school pants. A bright red piece of twine held them up. He was barefoot, having tied his shoes to the mat. A baggy collared shirt hung loosely from his shoulders. Gertie's plain white cotton dress flared at the bottom and was bordered with a frail lace trim. Small embroidered flowers graced the neckline. Her silken hair was long and fine, and the slightest breeze caused it to swirl up as though caught in a miniature storm. As soon as it passed, each obedient golden strand floated back down to exactly where it had been.

Bram followed Heinker Ridge until it started to slope up into the peaks, then headed down into a valley lined with giant mimosa pines. A small stream ran directly through the middle of the glen. Mo followed it, occasionally dipping her trunk in the cool water for a quick gulp, then misting the residue over Bram and Gertie, who giggled with delight. As the stream widened, it got deeper. When the dark waterline reached Mo's dry, tan belly, Bram moved her out and up onto the bank. Gertie had scooted back and was kneeling on the mat.

"Look, Bram, I'm a circus girl."

Rocking back and forth, she threw her hands up in the air, imitating the girl performers wearing their glittering costumes in the grand finale. Bram, rolling up one end of the comforter for a pillow,

lay back as he watched Gertie's mimicry. Her eyes half-closed, she lost herself in imaginary circus music. Her young flexible body swayed and moved, her hips undulated to silent rhythm; slowly she rose, never hesitating for a second. Modoc seemed to sense the moment and slowed her movement to smooth the bounce in her gait. Gertie began to hum one of the calliope tunes.

Bram was so fascinated by her apparent abandonment of their reality that he forgot to breathe until his body reminded him, and he gasped to take a deep, fulfilling breath. God, she's beautiful, he thought. He'd never seen Gertie like this. Modoc's showers had wet her hair and dress so that it clung to her, innocently accentuating her small firm breasts. Dancing on Modoc's huge wide back, she appeared to be floating in space as the beautiful scenery passed around her. Bram felt hypnotized in timeless quietude, with only the sounds of Gertie's soft humming and Mo's legs rustling through the underbrush.

Gertie placed one foot on Mo's backbone and started to turn, slowly at first, then gradually faster as she gained confidence. One arm rose like a crescent moon above her head. The lace of her dress billowed around her, with the speed of her twirling, ascending. Arms outstretched for balance, she let her head roll back; the centrifugal force flung her hair into one horizontal line as she spun like a ballerina in a music box. Gertie's momentum, from the height of bliss, became awkward. Suddenly she was dizzy, trying to grab for something solid in the world now rushing by her. She became a marionette whose puppeteer had been suddenly distracted. Bram easily caught her fall into his strong arms. When she saw the concern in his face, her panic and disorientation subsided. Touching the sweat on his brow she put her finger to her lips. Bram had been enthralled, and he held her close, her body heat from the dance causing the now-familiar warmth in his loins. Gertie put her warm sensual lips on his; Bram closed his eyes. This was love of the deepest kind. She was his first love.

The water looked so inviting. Cryer Lake curved through miles of the great Black Forest. Bram unloaded Mo, lowering every-

thing to Gertie on the ground. Together they carried it to a great old pine tree, where roots ran above ground for a hundred yards in all directions.

"It's all yours, Mosie!" Bram cried.

Modoc bellowed, swatted her trunk on the ground, then headed for the lake. The placid water, whose surface was as smooth as glass, exploded as Modoc blasted her bulk against its calmness, throwing a cascade of gushing water everywhere at once. Bram stripped to his shorts. Gertie, in childlike innocence, pulled her dress off, leaving her panties on. Shoes flew in all directions. Hand in hand, screaming and yelling, they dove into the azure water. For an hour the three played. Mo thrashed the water with her head, whipping it back and forth, causing waves to sweep over the children. She danced and bellowed, completely immersed in her pleasure.

Bram took Modoc into the deep part of the lake where he and Gertie could climb up on her back and use her as a diving platform. Sometimes Mo would gently pick them up in her trunk, depositing them on top of her head so they could dive from a higher place.

The old pine tree's needles provided a perfect carpet of shining green for their picnic blanket, and the simple fare seemed like a sumptuous feast. Looking straight up the massive trunk into a multitude of boughs, as Gertie curled up kittenlike against him, he imagined the branches were people as he stroked her hair. He remembered what his father had once told him, "Trees are like people and give the answers to the way of Man. They grow from the top down. Children, like treetops, have flexibility of youth, and sway more than larger adults at the bottom. They are more vulnerable to the elements, and are put to the test of survival by life's strong winds, rain, freezing cold, and hot sun. Constantly challenged. As they mature, they journey down the tree, strengthening the family unit until one day they have become big hefty branches. In the stillness below, having weathered the seasons, they now relax in their old age, no longer subject to the stress from above. It's always warmer and more enclosed at the base of a tree. The members

remain protected and strong as they bear the weight and give support to the entire tree. They have the endurance."

Bram liked his father's teachings and he realized that in humans the strength is also in the collective family support. He knew he would grow and become stronger until he, too, could shoulder responsibility with dignity and respect.

Bram loved all forms of nature, worshipping it as others did religion. He believed the whole of God was in every atom as well as in the totality of nature. In the eagle as in the feather, God was all Creation. His father had once told him, "Only things that have no power of choice are perfect. Nature is, man isn't."

Gertie had fallen asleep under Bram's gentle stroking. A wave of fulfillment swept through him as he realized his happiness. While Gertie slept, Modoc found a sandbar just beneath the surface of the water where she could lie and scratch her sides, rubbing all the ecstasy off. Then she, too, took a nap, the muddy upper half of her body quickly drying in the hot sun. Birds landed on her, picking and searching for any tidbit to be found, not knowing they were walking on a living matriarch.

A cool breeze alerted Bram to the lateness of the day. He kissed Gertie awake and yelled to Mo, "Move up, Mo! They began packing as Modoc rose from the sandbar.

Bram tied a rope around Gertie's waist and his own, then looped it into the rope weave mat. A quick pull brought them both together. It also prevented them from falling off were they to doze. As the sun began to descend slowly behind the horizon, Bram and Gertie slept soundly, rocked by the gentle motion of Modoc as she rounded Cryer Lake and headed up the ridge toward home.

= 7 =

THE SIDESHOW, which many patrons considered a "freak show," featured a group of people who were born with, or had suffered, a mishap in their lives. This made them different from others, shunned by not-so-polite society. These people had joined together as a family unit for their own security and because of a love of the circus.

Curpo was billed as the Littlest Man in Germany. He hated being referred to as a "freak" and was overjoyed when Herr Gobel allowed him, at Josef's insistence, to help with Emma and her baby.

Lilith, the Fat Lady, weighed over six hundred pounds. She was helped from place to place by whichever four or five people were at hand. Her house trailer had a special door cut into it to allow for her girth and heavy-duty springs to support her weight. Occasionally Lilith even needed some assistance with her toilette, but the circus was her "family" and they managed to get through most things together.

String, the Thin Man, was also billed as the Tallest Man Alive, hovering almost eight feet in the air, resembling a human daddy longlegs spider. When he bent over to speak to you, he lowered himself slowly, deliberately, as the change of height would oftimes make him dizzy. Canvas billboards were best hung by him. He had no meat on his bones to speak of, had very little strength, and wobbled as if on weak springs whenever he walked. Doctors claimed he probably would have died years ago without the circus. His performance gave him a purpose. He was needed.

Schulz was called the Seal Man because his hands grew out of his shoulders, resembling flippers. Normal in all other ways, Schulz had never learned to accept his defects. He hated people helping him and yet needed their assistance.

Sweet Little Marigold, a woman twenty-three inches long, had been born with only a head and upper torso above the waist, and no limbs whatsoever. Blessed in other ways, however, she was a finely educated and intelligent lady, with a fluent mastery of five languages. Her skin had the fine sheen of delicate porcelain, her eyes were almond-shaped and pale hazel. Her head, crowned by a thick mass of long, flowing golden blond hair, completely encircled her torso. Lovingly cared for, Marigold was carefully carried on a velvet pillow by a large mulatto woman who answered to the unusual name of Moonspirit. French was the only language spoken between them. Moonspirit was always ready to help, and their smiles to each other could send messages no outsider could know. Sometimes, to add softness to the pillow, Marigold would be placed on the thickness of her own hair, the waves and curls billowing around her. She had the look of a flower emerging from the comfortable bed of its golden petals. Circus audiences often left her presence feeling transfixed, as if having succumbed to an ethereal vision of spiritual enlightenment.

Mesmera, the snake dancer, featured Slip, a fifteen-foot Indian python. A sinuous lady, she was the epitome of controlled body movement. Her slender and graceful physique, undulating muscles, and stretching tendons all moved in juxtaposition. Her eyes

were as awesome as her body. Once transfixed on another pair, they overwhelmed, forcing the other to look away as one does from looking into the sun. Her head seemed to be the only part of her body that held her steady and balanced. Voluptuous breasts heaved.

While all this mastery of extremities continued, Slip slid his bulk around her throat, down the earthquake-ravaged stomach, settling in the violent sea of her hips, content to let his muscles grasp her torso with such strength that he followed her exact movement without being bumped or jostled. She ended her act by kissing him on his hard, shiny, scaled mouth as his quick thrusting tongue slipped from a small orifice between those nontelling jaws.

Sweet Little Marigold, the Torso Lady, and Karl Schulz, the Seal Man, were getting married! Whether it was a marriage for love or companionship, no one could say. Little Marigold had been born of normal parents, who had sent her to a home for invalids in Dusseldorf. The home was called Baselfeld, an establishment funded by the wealthy, where parents of deformed children could hide their offspring.

"Mother told me that she loved me," Marigold reflected in a conversation to Bram, "but because I was different, I couldn't live a normal life. She felt that being with others of a similar kind would be better for me. I cried and told her I was afraid, that other people scared me. I was so lonely. Down deep I knew that she abhorred me. She never helped me with my personal needs, you know—like bodily functions. Why, she never even held me in her arms. But then, you see, back home we had maids at my beck and call. Not that I was spoiled, or anything like that, *pas de tout*," Marigold hastened to add, "I just never quite realized how helpless I was until I went to that horrible place."

Bram looked at the little woman, whose kind eyes were glistening at the memory. Curpo had told him places like that existed, but he had never known anyone who had actually lived at one. "It must have been awful, Marigold. But they did take care of you, didn't they?"

"They took care of us, all right," she said. "There was never enough staff, or decent food, and the place was always drafty. Sometimes, when I was sitting in the dark, all the spooky demons in my mind would come out. If I sneezed, or my nose dripped and grew cold and chapped, I couldn't wipe it. If I was chilled and needed my shawl, I stayed chilled. That's when I let my hair grow so long; it helped keep me warm. The worst was if I had to go to the toilet. I had to sit in my wet urine all night. You see, I have these tubes under here"—she glanced down—"and, well, I was petrified thinking of what could happen, like if I started to fall—or fell face down! Why, I couldn't breathe if I did that!" Marigold's face was flushed now, her eyes wide at remembering.

"A bee might crawl on my face, or they would leave me in the sun too long. Once I saw a large rat enter my room and I couldn't see where it went! I knew it could do anything it wanted to me, crawl on my face or bite me—and there was nothing I could do! I thought I felt something on my back. I gasped, and when I did, I swallowed some of my hair. Every time I tried to breathe, I swallowed more. I was choking and there was no way to let anybody know. I was truly lucky, though. A paraplegic saw me and ran his wheelchair into an attendant to get her attention." Marigold continued, "I guess I felt very sorry for myself until Moonspirit came along. She and I are the same intellectually, and our friendship and trust has grown." She paused thoughtfully.

"You're probably wondering why I'm getting married. Well," she said, without waiting for an answer, "nobody has ever needed me. I've always needed help, but when I met Karl at Baselfeld, he was so sad and lonely, it brought back memories of my past. We used to talk for hours. We have the same interests, the same philosophy about life. We get along well, and are good companions for each other. We'd never find normal people wanting us, and besides, we understand each other's needs."

"What about Moonspirit?" Bram asked.

"She'll stay with us. The three of us will get along just fine." At this, Little Marigold smiled a mischievous smile. Bram sensed

something in her voice that was a bit odd, something beyond the understanding of his age. He let it go. Wishing Little Marigold well, Bram headed for the barn, proud that she had chosen him to confide in.

The wedding was a simple affair. It was held in the sideshow tent. Everyone from the circus attended, plus a few friends from town. Flowers were arranged on either side of the main stage. The calliope man played the wedding march from clear across the circus grounds (old man Gobel wouldn't let them move it). Little Marigold looked beautiful in her wedding gown, with its lace-covered bodice and yards of white satin that draped from her "waist" to the floor. A tiara of red roses crowned her golden hair that swept down the full length of the dress.

Josef and Katrina were there to share in the joy of the wedding, each knowing how happy wedded life could be.

Appelle, dressed in his clown outfit (that's the way they wanted it) was the best man. String and Himmel the bear trainer were ushers. Lilith, the Fat Lady, was the maid of honor.

As unusual as it may have seemed, when Moonspirit carried little Marigold down the sawdust aisle, on a gold and satin pillow, with Karl walking beside them, love and caring were on every face. Tears flowed and sobbing was heard when Mesmera, the Snake Lady, fastened a gold chain around each of their necks, from which hung their gold wedding rings. They said their "I do's" and Karl kissed Little Marigold. Everyone applauded as they came down the aisle and got into a waiting car to begin their weekend honeymoon.

"Well, Curpo," said Bram, "that was some wedding. I'm really happy for them."

Bram and Curpo got into the back of the truck, Josef and Katrina into the front, and headed back to the farm.

The years fell like dominoes, each no different from the last. Modoc grew at an astonishing rate, her heart keeping pace with her body. She had an enormous capacity for loving all things—and they in turn loved her. Birds landed on her back, picking and scratching,

cats rubbed against her legs without fear of being stepped on. The mice in the hay ran only if they were in the hay on the way to her mouth.

Fall came quickly that year, and Christmas was just around the corner. Big butane heaters were wheeled into the barn to keep Mo and the livestock warm, for the cold months now descended upon them.

The circus closed its doors for the season. Many employees went their own way, waiting for spring so they could rejoin one another again. The equipment was battened down. The canvas tents, except the menagerie, were folded and stored. Strong, hardy animals like the camels, llamas, and goats stayed to last out the winter. A few dedicated keepers remained to feed, water, and care for the livestock.

Bitter German blizzards descended, one after the other, and the sun was not to shine for months to come. The countryside was blanketed by a deep, snowy white. The skeletal trees stood starkly against the cold gray sky. Carrying the same morbidity, all things looked the same. Water stopped running, lakes and streams turned to ice.

For some perhaps, winter brings joy and cheer—a time to play, to ski the mountain slopes, to sled, to skate, and to throw snowballs. For those who care for livestock, who worry about lasting the winter, as Josef did, to see if they still had jobs in the spring, who strove to provide enough heat and food for their families and the animals just to stay alive, these were times of depression. Times of survival.

The Gunterstein barn had always been used for the circus's winter quarters. Josef, good soul that he was, offered it, and Herr Gobel, greedy man that he was, accepted. He never offered Josef an extra pittance for allowing the animals and some equipment to stay there. Gobel supplied the animals with food, but even that came scarce.

Traditionally some performers set up sleeping arrangements within the barn and helped to care for the livestock. Bram felt it was really to shelter those who didn't have a place of their own during the winter months. In truth, it did more. There was an undercurrent

of fear running through all of them, fear of the loss of the circus. It was more than their jobs, it was their lives. The circus kept the "family" together.

The roustabouts securely tied down everything at the circus grounds so the blustery driving wind and rain wouldn't carry it away. A few were left there to guard the heavy equipment. Gray, dismal skies never altered the pale look of everything. The hay bales in the barn were slowly being depleted, being used for both feed and bedding. As the season took its course, the domestic stock—cows, horses, pigs, goats, and the barnyard birds—had taken a liking to the exotic animals, especially Modoc, and on particularly cold nights they would huddle up to her for the warmth her large body could offer.

"That old man, Herr Gobel, hasn't even been by to see us this winter," Katrina observed. Josef was gripping his stomach as his ulcers again declared their painful existence. This was not lost on his wife. "It's because he knows you'll take care of everything for him," she continued. "You've spoiled him rotten, you know."

Josef hadn't eaten a full meal in the last week. His skin had no color to it, and the gaunt look in his face bespoke the worry in his heart.

Weeks turned into months, and as the snow piled deeper against the old barn, the road leading to the farm became completely impassable. Anyone entering had to brave a small path that paralleled the road. It zigzagged through the bleak grove of sycamores and over the small bridge that straddled the slopes where the runoff of melted snow from the mountain poured down in the summertime.

Over the past year Bram had tried to see Gertie as often as possible, but the constant storms and bad weather conditions kept them apart. Even schools had been closed, and telephone lines had been down for some time. All Bram could think of were the wonderful moments they'd spent together, especially at Cryer Lake. These tender thoughts were always in his mind and helped carry him through some of the cold winter nights.

Late on a Friday evening, when the storm clouds had disappeared for the first time in many weeks, a bright cold sky asserted itself. A third-quarter moon lit up the countryside. One light burned in the farmhouse that sat still and alone in the snow-covered valley. Smoke drifted up from the chimney as Katrina finished making a kettle of potato-corn soup and six or seven dozen raisin-nut cookies. The cookies had been Bram's favorites since boyhood. She smiled at the thought. He was, of course, still a boy, but he had gotten so big and was handling so many chores that sometimes she saw more of the man in him than the boy.

"Maybe it is the weather," Himmel suggested.

A small group gathered around the fire that Josef had built in the early weeks of winter. It had been kept burning to take away the chill that each and every day brought. There had been no mail for weeks, and the discussion centered around whether the rumors about the circus closing down were true.

"No, they could have gotten through to wish us well, see how the animals are, or if we need anything," another objected.

"If it 'ad just been a story, we would 'ave 'eard by now," added Curpo. "Not a word 'as come down."

"Maybe the post couldn't get through," suggested Heinz, but Josef knew that last month's mail had just been picked up.

"No news is . . . well . . . no news," added Karl. He laughed at his own mockery of the seriousness of the situation, while the others looked on with less levity.

Katrina arrived at the barn, the roustabouts close behind, helping her with the hot, heavy kettle. Hissing steam escaped the pot's lid into the air. The delicious aroma filled the barn and everybody grabbed whatever was handy to dip into the pot of savory soup. Other foods that had been prepared were passed around. Appelle lit a small fire in the middle of the dirt floor and together with his chimpanzees, roasted chestnuts. These were passed around with Lilith's fraupotatoes, beefsteak, some sweet corn. Hot coffee rounded out the meal. Katrina's rich cookies were dessert.

This particular evening Modoc decided to retire early, lying right in the middle of the barn's activity. As her tonnage slowly settled to the ground, everybody moved quickly, pulling chairs, sleeping bags, and cots out of the way. Bram found an old pillow and nestled against her head. The livestock scattered throughout the barn, some resting against Heinz's bear Karno, and others with Tina and Emma. One of Appelle's chimps fell in love with a rooster who loved to pick at the chimp's back. It must have felt good, as the chimp would lie there for hours while the bird walked up and down its back, picking and scratching.

The recesses of the barn echoed with the old-timers' tales of the circus as it used to be, of the thrills and excitement when the people crowded into the big top to see the Mighty Samson defeat Ackavar, the Fighting Bull, or watch Persaavich, the greatest aerialist who ever lived, perform his dangerous routine without a net. In the middle of Josef's story of how, ten years back, the circus had survived a fire, a fight broke out between String's pet performing goat and a farmyard pig. Nothing serious. Both wanted to lie by Modoc. Both wanted exactly the same spot. They had plenty of space, but they wanted that same spot. The cooking fire burned low as, one by one, people and animals alike drifted off to sleep.

"Slip is gone."

"What—Slip? I don't know any Slip," muttered Lilith, trying to roll her bulk over, half asleep.

"Slip, my python. He's missing," said Mesmera.

"Mm, well, tomorrow—we'll—WHAATT!" Six hundred pounds of anything never moved as quickly as did Lilith. "Where! Where is she?" she cried.

"It's a he, and if I knew I wouldn't have asked you. God, you don't have to wake up the whole place, you know."

By now everybody in the barn was alerted to the fact that Mesmera's fifteen-foot python was missing. Half the people retreated outside into the freezing snow rather than confront the serpent. The other half tore up the barn, searching every nook and

cranny. Slip was finally found wrapped comfortably among Moonspirit's multitude of satin and velvet pillows. Once Slip was safely put away under Mesmera's care, the frozen little group came back inside the barn. They huddled around the cook stove, shivering, shaking, and saying bad things.

"Stupid snake," grumbled String.

"Slimy worm," added Lilith.

"Freak," said Little Marigold.

That did it. Hysterical laughter broke out from everywhere.

"Good night, everybody!"

Bram couldn't sleep. He nudged Curpo to keep a sleepy eye on Mo and buttoning up his jacket, stepped out into the clear white night. He was worried. His father didn't look well at all. The somber mood of the circus family, all concerned whether there would be a circus to return to, depressed him. And above all, what about Modoc? What would he do without her? Cold mist of the night air escaped his mouth as he sighed deeply.

Bram's belief in nature being the Supreme Entity gave him a feeling of inner strength as he looked up. He felt a kinship with the stars, and even with the desolate countryside around him. He closed his eyes, took a moment to think only good thoughts, then turned to rejoin his friends. As he opened the barn door, a flash of light caught his eye. A car was braving the cold winter elements, slipping and sliding up the road. As it came to a stop down below, at his driveway, Bram saw a figure emerge and wave goodbye to the driver. The car managed a U-turn and headed back in the other direction. A moment of terror overcame Bram. Was this the messenger on his way to tell them about the circus? Had it been sold? The person, too far away to identify, was in a hurry, occasionally tumbling in the deep snow as it headed toward the barn. The figure wore a large winter overcoat and was bundled up to keep out the chill. Bram waited at the top of the road, and as the figure drew closer, he felt he knew this person. Could it be? Nein, but . . . it looked . . . Bram was muttering to himself.

"Gertie . . ." Bram half-whispered. "Gertie! Is that you?"

"Bram! Bram!" Her voice rang out as clearly as a crystal bell.

Cold happy tears ran down his cheeks as he raced down the hill, slipping and sliding until they collided, tumbling over into the snow several times, each holding the other until they wound up in a soft embankment of snow. For this brief moment, life was perfection. Hidden beneath layers of their parkas' high collars and their scarves, their faces merged. It was warm inside as they explored each other with steamy kisses and touches. Cold noses, warm cheeks, and eager mouths found kin. Bram had never been so happy to see anyone as he was to see Gertie. Arm in arm they joined the others, but for some reason, it just didn't seem as cold as it had been before.

Josef was sick. The doctor's car was parked by the farmhouse. Bram had seen it before, whenever his father's ulcers and coughing spells acted up—these days it was every few months. In the beginning the medicine had taken care of the problem and his father would be up and about within a couple of days. Since summer, however, his condition had worsened, and the prescriptions seemed to have little or no effect. Doctors had been baffled by his illness. They understood his ulcers and felt the reason he had them was his concern for the elephants and the circus. The cough, however, was a mystery. Tuberculosis was ruled out. Some thought it was consumption. The doctors couldn't understand why the ulcers were affected by his deep coughing. Bram was worried about his father, knowing Josef was not a complainer. If the doctors were there, it must be bad.

Bram put Modoc up in the barn and entered the house as Dr. Kreiss and his mother came downstairs. The doctor told Katrina to keep Josef in bed and to make certain he took his medicine.

"Is Papa going to be all right?" asked Bram, seeing the moisture glistening in the corners of his mother's bright eyes.

"For now, son, for now," she said, and went back upstairs.

"Move up, Mo!"

Bram took Mo out for a walk. She'd been in the barn for over

ten days, waiting for a big storm to pass. The last couple of days had been warmer and today the sun shone brightly and the day was clear, as if it were summer. The snow was melted around the barn, except for the shaded areas to the north. Bram rode atop Modoc.

"No use both of us getting our feet wet," he rationalized to Mo. He was careful not to walk her in the slippery patches and stuck to the walkways everybody had been using. There the grass grew through patches of snow and allowed Mo's big feet some traction.

It was early Saturday morning and all were still sleeping. Mo found some frozen grass peeking from under a little snow, and she ripped it up, smacking it against her leg to remove the ice. The rattle of tire chains broke the stillness as a small truck traveled down the roadway, heading straight for them. Bram's heart skipped a beat. It was the mail truck. Why now? This wasn't mail time. It usually wasn't delivered until after two.

Bram saw a sign on the truck that read SPECIAL DELIVERY. The postman carefully slowed the vehicle to a stop on the icy road so the wheels wouldn't skid. He stuck his head out the window.

"I have a letter for Herr Gunterstein."

"Right here," Bram said. "I'll take it."

To the postman's surprise, the letter was handed up by Modoc's trunk, signed for by Bram, and the receipt was returned to the postman.

Bram put the letter down between Mo's shoulder bones, studying it for some time, wondering at its contents. It's during these times, he mused, we try to change what we believe is about to happen. Bram used his imagination to alter what he thought was in the letter. It was to no avail. Down deep, he knew what it said. A tearing feeling cut through his stomach: Modoc. Slowly turning the envelope around, he sought the name of the writer. It was from Herr Gobel to Herr Josef Gunterstein. A cool breeze from the north made Modoc shiver. Bram felt the vibrations coursing through her body, causing a shiver in him as though they were one. He slid the letter inside his shirt.

"Let's go home, Mo."

Josef sat in the living room, in his favorite chair. The room was dark except for the single light shining from within a worn brown paper lampshade. Katrina sat on the floor at his side. Curpo and Bram sat cross-legged on the floor across the room, backs against the wall. Slipping on his reading glasses, Josef read the letter aloud. His voice resounded, echoing monotonously.

Dear Herr Gunterstein:

Due to my poor health, the strain of operating the circus has become too much. My doctor has advised me to leave for a warmer climate. Therefore, I wish to inform you that I will be selling the circus.

Thank you for your years of faithfulness and dedication. Please see that all your personal belongings are removed from the circus location by this same day, next month, as all animals, equipment and vehicles are being offered for sale immediately.

Sincerely,

Franz Gobel

Josef settled deeply back into the shaded recesses of his chair. The letter dropped from his hand to the floor as Katrina pressed the back of his hand against her wet cheek. Bram nodded to Curpo and they left quietly.

It seemed an aura of death was present. A man's hopes had just died.

= 8 =

TRUCKS, SKIPLOADERS, AND ROUSTABOUTS were busy moving circus equipment and paraphernalia off the Gunterstein farm. When the big elephant truck drove up to load Modoc, Bram was there. No one knew he had cried most of the night. His father, sensing Bram's grief, had come and sat on the bed beside Bram.

"Son, I know you are feeling many things because Modoc is leaving. It is difficult to let go of something that you love so much."

Bram looked at his father. He seemed old, but there was a wisdom in his voice that Bram had not heard before.

"Papa, I will miss her so much. I don't know what I will do without her. We've always been together—always, and now . . ." His voice trailed off. His eyes began to fill.

"Bram," his father said, placing a hand on his shoulder, "You and I know there is a connection to all living things. It is the connection of life that holds us together. That living bond is so

strong it can never be broken." Josef smiled at his son. "Modoc does not have to be next to you to feel close. When you are asleep in this room, she is elsewhere, yet your closeness has not dimmed. It is not distance that separates, Bram, it is the mind and heart. Let her go, son. Only then will peace come to you," Josef sagely advised.

Let Mosie go? How does one do that? thought Bram. Try to think of other things? Impossible!

Josef, Bram, and Curpo drove Modoc to the circus grounds. It was a quiet drive, and except for Josef's occasional cough or grimace, no one spoke. The spring flowers popping all over and green leaves sprouting on the trees went unnoticed. The skies were overcast when they arrived. Modoc was unloaded and placed alongside Emma and the other elephants.

The spirit of the circus had been broken. By early evening everything was tagged with a serial number. Vehicles were lined up in a row, animals housed in the menagerie tent, and costumes hung in the laundry tent. Buyers were to arrive the next morning to start bidding for whatever interested them. Everybody noticed old man Gobel was not there.

That night Bram and Curpo planned to sleep in the menagerie tent. Josef wanted to stay as well, but his cough was so bad that his friends convinced him to return home.

Evening found the animal trainers and sideshow performers gathered in the menagerie tent. They came together for comfort and hope. Throughout the night they talked. Some cried at the injustice of it. Appelle sat with his chimps cuddled up against him. They, too, sensed the problem. Karl, the Seal Man, sat holding Little Marigold on his lap.

"Maybe whoever buys the circus will take us all, and we can stay together like we've always been," Little Marigold offered hopefully.

"How can this happen? Why? It's been my whole life." Lilith sat on one of the hay bales, her enormous body completely covering the hundred-and-fifty-pound bale.

"I don't know where to go, how to earn money," said another. "Anyway, who would have me?"

"I heard the government has an invalid program that would—"

"A what! An *invalid* program? *I'm* not an invalid; I'm not like Marigold or Karl." Lilith shot a look at them. "Sorry kids, but it's true. I've got all my equipment."

"But nobody can find it," came a voice from the dark.

"All right, wise ass, who said that?"

"Look," Curpo interjected, "this is no time for us to fight among ourselves."

Bram stood. "There's nothing we can do until we know what will happen tomorrow. Then decisions will have to be made."

"But Bram, what about Modoc? What are you going to do?" String's voice was soft and sympathetic. In the soft glow of the circus tent's lighting, Bram's face took on the appearance of that of a much older person, perhaps even the face of his father.

"Nobody can separate something that's inseparable," Bram replied. Everyone was momentarily quiet. "Nobody."

In the morning the buyers began to arrive. Each drove a shiny black sedan that was parked in a designated row. German, Japanese, and American buyers with all-knowing and condescending attitudes presented themselves at the sale. Bram and Curpo had put the elephants out on their tethers as instructed by Herman, a little man in a wrinkled brown suit who claimed to represent the Gobel family. As the potential owners inspected the circus's assets, a whirl of dust caught their eyes. A screeching of brakes was heard at the far end of the circus as a huge Duesenberg limousine pulled onto the grounds. Instead of parking with the others, it drove directly to the entrance of the big top.

The limousine door opened, and before the chauffeur could get around to tend to it, out stepped a well-dressed man, his dark hair slicked back, a bit silver at the temples. He wore a pinstriped suit, red tie, and white and black buck shoes, and carried with him an attitude of conceit. He and three assistants walked directly into Gobel's office. Soon Herman, the gentleman, and his entourage

returned. They strolled around the grounds, discussing various items for sale, assessing others. Many buyers came by to greet the gentleman and kibitz about the auction. Bram saw that they were coming his way. Curpo nudged him, giving him a "you can do it" look, and promptly disappeared.

"This is the son of the elephant trainer. Ah . . . what is your name, boy?" snapped Herman.

"Bram, sir, Bram Gunterstein."

"Yes, well, you can show Mr. North what the beasts can do."

Bram looked past Herman to Mr. North. "My father usually works them, sir, but he's sick, you see . . . "

"Get on with it, boy. Mr. North doesn't have a lot of time."

Bram noticed that Mr. North would barely look at him. "My father . . ." Bram began.

"Enough of your father!" Herman interrupted impatiently. His voice had risen a full octave. "Now you will please show Mr. North what they do."

Bram continued to look at Mr. North, trying to establish some communication, but to no avail. He couldn't understand why the man wouldn't at least acknowledge him.

Resigned, he put Modoc and the other elephants through the act his father had taught him. Bram wondered for a moment whether he should have tried to make them perform badly. Perhaps if this man didn't like what he saw, he wouldn't take Modoc. But even if he wanted to, it would have been difficult, as Modoc knew her routine too well, and she executed it perfectly. After the performance, Mr. North managed a curt thank you over his shoulder.

Bram saw the men exchange handshakes. Mr. North, waving to all the other bidders, returned to his limousine and drove away. In short order the other bidders followed suit, and when they had all left, Herman called the circus family together.

"Now then," Herman began, almost smugly, "it gives me much pleasure to announce that the world-famous circus entrepreneur Jack C. North will be acquiring the circus. I am sure you all

agree that Herr Gobel will be very happy to know that it will not be broken up."

"But what about us?" asked Stretch. "Will he take us with him?"

"Hmmm, well, will he take you with him?" repeated Herman, as if it were no secret. "No, no, no! He is taking the circus to the United States of America and has plenty of frea— . . . ah . . . performers . . . of his own. He just needs the animals and the equipment."

A voice in the crowd spoke up. "How can you say that he bought the whole circus? We *are* the circus—we and the animals. How can you give our animals to other people to train? They've been with us since their birth, and we love them as our own."

"What will become of us?" another voice said. "There's no work for our kind of people!"

The tone of the group now became almost threatening. Herman was clearly becoming nervous. "Yes, well now, all of you must go home. In the morning other trainers will arrive to learn the animals' routines."

The crowd broke up, each going his own way. Bram was dumbstruck. "How can this be, Curpo? They can't just take it all away! There must be something that can be done for us to stay together—and how about Modoc!" His mind reached out for an answer. He would stay the night with Mo, sending Curpo back to the farm to tell his parents what had taken place. "You'd better tell Mutte first, she may want to tell Papa herself."

Bram wanted to be there in the morning to meet the new trainer and see if there was any way he could convince him to let Bram accompany Modoc to America.

Bram felt someone waking him from a deep sleep.

"Hey! You! Wake up!"

He opened his eyes to see a burly middle-aged man bending over him. The man nudged Bram with a bull hook.

"Who are you?" asked Bram sleepily.

"Jake." A note of pride in the man's voice: "Mr. North's head elephant trainer. Now you'd better move on. I've got a lot of work to do."

Bram stood up. "Uh, you don't understand. You see, my father is the elephant trainer for the circus."

"You mean, he *was* the trainer. Now it's *my* job."

"But . . . I'm his son . . . and I also work the elephants. Especially Modoc."

"Mo who?"

"Modoc, this one here."

"Hmmm, well, we can change that name real quick. Look, kid, I know you like elephants, but I've got to get going."

"But I can show you her cues," Bram protested. "Wouldn't it be a lot better for you and easier on her?"

"If you want to hang around a bit, I guess it's okay. Maybe I'll ask you some questions—maybe I won't. Just stay out of my way."

Bram agreed. He figured it would give him some time to come up with something so he could stay with Mo.

One day Bram overheard the new circus crew saying they'd be leaving at the first sign of spring. The new owner had hired a large Indian vessel, *The Ghanjee*, to take the animals and equipment to New York via India.

Bram hadn't been home since the sale. He was worried about his father and planned on having Curpo take care of the elephants in the morning so he could see his parents. Josef lay quietly in his upstairs bedroom. The doctor had given him a sedative to ease the cough. Bram sat on the edge of the bed. His father appeared to be asleep. Beads of sweat blanketed his forehead, and he looked drawn and exhausted. Bram examined the room in which he had been conceived, noticing as if for the first time the dark, drab colors. The walls were dark yellow, which somehow blended with the old gray lace lampshades and beet red upholstery, now well worn. The only light came from the two small reading lamps on either side of the bed. Their pale light merely added to the dreariness of the room,

giving it no cheer at all, and giving the shadows more authority. This was not a room for living in, but rather a place to unload sorrow and depression that had formed throughout the day. Sleep was important here, but only from need, not desire.

Josef was one who always took his worries away with him. He carried them along, hidden inside with his hopes and despairs every day of his life, locking them away. He told his problems only to his elephants. They did not judge him and he loved them dearly for that. They were large enough to hide his fears and pain, and there the feelings had stayed until now. Old man Gobel had taken away his blanket of security. He was now exposed. His worries had become his Grim Reaper, ready to take him away when the burden became too great.

Josef raised Bram as he had the elephants, with love and respect. Although their life had been a poor one financially, the love for the animals and each other sustained them through the years. What would they do without the animals? His father's eyes blinked open. A smile crossed his face.

"Hey, how is my Bramie?"

Whenever his father felt very loving, he called him his Bramie. Bram took his hand. It was warm and gentle, and yet the strength of years and struggle could be felt.

"I'm good. How are you feeling, Papa?"

Josef closed his eyes and rolled his head on the pillow. "Ah, probably not so good. The doctor says if I'd stop worrying I'd get better, but how do I do that? I have bills, I have the farm, clothes to buy, food to purchase, trucks to maintain. I sometimes feel each part of my body needs my personal attention to run and function. I'm tired of being the leader, Bram." He held his son's hand firmly and looked deeply into Bram's face. "It's you who must now be the man." He continued, "I know you're young, but you're not alone, and you have the blood of your father and your wonderful mother. And you have Modoc." His lips cracked into a smile. "My father said, 'Let your problems be your teachers'—you are a far better stu-

dent than I have been." He hesitated for a moment, as though afraid to ask the next question. "Is . . . Mo . . . okay?"

"Yes, Papa, she's fine."

"Is there someone else handling her?"

"No, Papa," Bram lied, "they're letting me. Only me."

Josef smiled. "You never lied very good."

His chuckle turned into a slight cough that quickly built into an explosive, throat-wrenching attack. Finally the cough subsided. Father and son talked of many things, all mundane, avoiding the more important issues. When they finished, Bram leaned over to kiss his father good night. Josef wrapped his arms around Bram and held him close. He was trembling, and his tears wet Bram's cheek. Josef's voice was that of an older man than was lying in the bed.

"You are special, Bram. You and Modoc. You were both born on the same day, at the same hour—for a reason; you and she are connected for that. You must take care of Mo, Bramie," he whispered. "Promise me, you will. She loves you and you her. Together you will find a way."

"I will, Papa, I will."

Bram left the room. He didn't . . . he couldn't look at his mother. He ran to the barn, closed the door, and cried. He cried for his father, cried for Mo, and cried for his own unhappiness

꞊ 9 ꞊

WHEN BRAM ARRIVED at the circus grounds it looked as though a tornado had come during the middle of the night and taken it away. All the circus equipment had been packed in big cargo crates, stamped across the front in ten-inch red letters: DESTINATION U.S.A. The big top had been taken down and packed, most of the vehicles had been sold, and the calliope was being readied for shipment. The fairways had been dismantled and lay on the ground, ready for packing. Only the menagerie tent still stood. Jake was repairing an elephant harness when Bram walked up.

"Morning, Jake, how's Mo this morning?"

"Hi, kid. Jumbo is fine. Look for yourself."

"Jumbo?"

"Yeah. That's her new name. Better for advertising."

"But won't it confuse her, having two names?"

"She doesn't have two names," Jake answered irritably, "and

don't let me catch you using Mo or any other name anymore. You hear me, kid?"

"Sure, Jake, I hear you."

Mo was nibbling her hay when Bram entered the tent. She gave him a low rumble of affection and a hug with her trunk. Bram grabbed an ear and, pulling it down, whispered, "Hi, Mosie."

Spring was fast approaching. The melting snow had filled the rivers, days were becoming warmer, and beautiful flowers filled the hills and valleys. It was on such a day that a car, horn honking, sped into the circus grounds and headed straight to the menagerie tent. Curpo sat next to the driver. Both jumped out of the car and approached Bram. After talking a minute, the three quickly got in the car. With a cloud of dust kicking up behind it, the car raced out of town to the Gunterstein farm. Josef had taken a turn for the worse.

The spring sun cleared the ridge as the procession slowly wound its way up the dirt road to Grenchin Hill Cemetery. It was named after Mr. Meister's daughter, who had lost her life falling from her horse on the very spot where the cemetery was located. She was the only one buried there until Meister died. Since then, a few had chosen this lovely spot to sleep their longest sleep. It overlooked miles of rolling green hills that eventually melted into the great mountains to the north. Grenchin Hill itself was quite steep, and the graveyard had room for only a few dozen. Josef had known the family since childhood, and when Meister died, he left two sites for Josef.

On a nearby hill, silhouetted against the sky, Bram and Gertie sat atop Modoc. They looked unrelated to what was happening down below, as if they were from another time. The trio watched the serpentine line of cars make its way up the hill. Some of Josef's friends came in trucks, others arrived in family cars. A nearby neighbor drove his tractor directly from the plowing field. Bram pointed out the Tall Man, the Seal Man, Little Marigold, the Fat Lady, and the rest. They'd all arrived by one means or another. Curpo and some of the roustabouts—unbeknownst to the new cir-

cus owner—had loaded the calliope on a flatbed truck and drove it to the cemetery, parking it near the gravesite. It was the best way they knew how to say their goodbyes. When the last car neared the crest, Bram nudged Mo and headed for the cemetery.

Bram had asked if Modoc could be there. Katrina had called the new owner, but could not get permission from him for Mo's attendance until Herr Gobel intervened and persuaded the American buyer. Katrina figured it was Gobel's guilt at abandoning his circus family so abruptly that made him do it.

Bram and Gertie both dressed in black. Together they'd made a huge black ribbon for Modoc's neck. A spray of wildflowers from the field was fixed to a twig of tamarind and hung down her forehead. Bram slid off and then helped Gertie down. Brushing off her dress, Gertie took her place by her father; Bram stood with his mother.

The calliope began to play its oom-pah-pah as the rabbi gave the sermon. Bram had never been to a funeral before, and found it hard to believe his father was lying in that long, shiny box. Bram knew that wherever his father was, he would look out for his family.

As Bram helped his mother place some flowers on the coffin, Mo, on a signal from Bram, reached up and took the flora off her forehead, stepped forward, and placed it on the coffin with the others.

The sun fell behind a cloud and did not reappear for the rest of the day. The weather turned cold, and shivering against a gray sky, they lowered Josef into the ground. Katrina's soft sobs were joined by many others who mourned Josef's passing. Bram could not cry. Instead a hard, tight ball of hurt filled his stomach, and his teeth and jaw hurt from clenching them unknowingly.

As the music of the calliope drifted over the hills, there came the lone trumpeting of an elephant who, in her own way, was saying goodbye to her friend in his final resting place, the little cemetery in the hills of Germany.

= 10 =

NEWS ARRIVED FROM THE PORT that *The Ghanjee* from India had docked and was being readied to receive its circus cargo. The day for boarding was getting closer. Bram heard that Mr. North was coming to the circus grounds before leaving on a boat that would precede the Indian ship to America. This would be his last chance to speak to the new circus owner.

It wasn't long before the big black limo appeared. As he walked around, the owner seemed to be in a pleasant mood, greeting his employees, shaking hands with most of the people.

"Afternoon, Mr. North," said Bram, determined to put his best foot forward.

"Good morning, young man. Aren't you the son of the old elephant trainer who just passed away? Pity, but we all have to pay our dues someday." Mr. North started to move on.

"Excuse me, sir, if I may." Bram extended his hand as though

to stop Mr. North, but a quick look from North dropped that hand immediately.

"Yes? What is it?" North replied in a somewhat bothered tone.

"I would . . . like to go with you . . . I mean, Modoc . . . that is, the animals. To the United States."

"How old are you, boy?" asked North.

"I'm just turning sixteen, sir, and am a bit mature for my age. My father showed me everything to do with Modoc . . . I mean, Jumbo, and, well . . . I could do it if you would give me a chance."

Mr. North gave Bram a long, steady look. "No," he replied, and started to walk away.

"But, sir, I . . . "

"No was my answer. Now excuse me."

"But why?" Bram shouted after him, but Mr. North never turned his head around as he replied, "Let's just say because you're not one of us."

Bram stood there, rooted to the spot. "What? What kind of reason is that?" he shouted after Mr. North.

"He's prejudiced, son," said a voice from behind. Bram turned to find a man standing behind him.

"What does that mean?" asked Bram.

"Prejudice means one kind of person doesn't like another kind of person."

"Even if they don't know each other?" asked Bram.

"That's right. They can dislike them for their color or religion or just for being from a different country."

"You sound American," Bram said.

"Yeah. I'm a transportation chief. In charge of hauling and loading the circus on and off the ship."

"How come you're telling me this?"

"Because only a few people are like that North fella, and I didn't want you to think all American people feel the way he does."

"That's good. People shouldn't be preju— prejudiced for no reason," said Bram.

"My name's Kelly, Kelly Hanson. What's yours?"

"Bram Gunterstein," the boy replied, shaking Kelly's extended hand. "I'm Modoc's trainer; she's an elephant that performs here."

"Well, I'd better be on my way," said Kelly. "If there's anything I can do for you, just let me know."

"I was just thinking about Mr. North," Bram continued. "You know, he's in for a big surprise.

"Why's that?" asked Kelly.

"Modoc's Jewish."

Bram turned around and headed down the green fairway just as the sun was beginning to set.

"Bram, you 'ere?" Curpo's voice echoed in the near-empty barn. A few chickens and goats scattered as the door banged closed.

"Over here." Bram sat where they used to chain Modoc. "Sure glad you came."

"Ooh, this ol' barn's so cold and depressing," said Curpo, looking around, rubbing his two small hands together to gather warmth. "Ya know, all the folks 'ave banded together, tryin' to put up their own circus. I thought it was just wishful thinkin' until a group of do-gooders, some wealthy people, chipped in some money. Now I 'ear they 'ave some kinda trust fund set up to 'elp support them."

"That's great news. I don't know what would have happened, otherwise." Bram paused, glancing down. "You know, Mama and I really appreciate your staying on at the farm, helping out."

"I'll stay as long as needed."

"You've been a good friend, and the only person I can trust . . . so there's something I have to tell you, and you'll probably think I'm crazy, but I've given it a lot of thought. It's the only answer."

Curpo had no difficulty reading Bram's thoughts. "You want to sneak on board the ship when it leaves," said Curpo. "You must be round the bend!"

Bram's face became red and teary-eyed. He looked desperately into Curpo's face, and the young man's desperation spoke louder than words for Curpo's approval.

"Papa asked me to take care of Mo. It was his last wish . . . and I love her. She could die without me."

Curpo felt the boy's pain and knew this was something he would do, regardless of Curpo's approval. What Bram needed was the strength his support would give.

"Well, maybe it just might work," Curpo replied, appeasing the boy. "Crazier things 'ave 'appened and worked out just fine. You just keep thinking it will, that's the important thing." Bram's smile cheered Curpo; he cared for Bram very much and hated to see him upset. He spoke gently. "But . . . what about your mum? And, well, everybody? You can't just leave. You 'ave responsibilities."

"Curpo," said Bram, getting more comfortable as he talked, "I heard Mama talking. Papa left an insurance policy that will more than take care of her."

Curpo tugged on Bram's shirt, bringing him down to his level, and looked Bram straight in the eye. "Then I'll be wishing you a bon voyage the day you sail away from the dock." He smiled. "And if the truth be told, I'd probably do the same, so let's get on with it. We've got a lot of preparing to do."

They embraced each other, savoring the emotion of the moment, each praying in his own way that things would turn out all right.

Bram didn't sleep much that night. His thoughts drifted to what his mother would think of him for taking this bizarre step. How would his friends feel? Would they think he had run away from his responsibilities? Bram knew he had to leave a note, but would that be enough? It had to explain how he wanted to honor his father's last wish.

"Take care of Modoc," Josef's words echoed; Bram felt his father's presence. He felt the moisture on his cheeks and the power of his father's last trembling hug. This was the only way.

As Bram stared out the window at the moon, it became clear to him. He was making a spiritual decision and would do as the animals do. They had no power of choice. They were guided by their instincts. He would do the same and not use his power of choice, but rather trust his instincts to guide him into the next phase of his

life. It was about a kind of knowing . . . feeling . . . listening to one's inner self. Besides, how can honoring your dead father's wishes, and being with one you care for be wrong? He would leave when the truck caravan pulled out of town.

"Did you hear the trucks are leaving tonight?" mentioned one of the roustabouts who had been particularly kind to Bram.

"What? I thought later in the week! What happened?"

"I don't know, something about the tides."

"What time tonight?"

"Three o'clock they're pulling out."

Bram went home that night so as not to raise any suspicion. He'd made an arrangement with Curpo to pick him up later in the night. Katrina had prepared Bram's favorite supper, and it was the first evening since Josef's death that they had eaten together in the family dining room.

"How are you feeling these days, Mama?"

"Fine, Bram, just fine." Katrina paused. "Why do you ask?"

"Oh, no reason. I just felt with Papa gone and all . . . I just wanted to be sure . . . you know what I mean."

"I know, honey; your father was a very special man. I don't feel you ever get over the death of someone you love, but he's in a good place, and will be watching over us if we ever need him."

"I really miss him, Mama. Every time I look at Modoc and know she's going, I feel I'm letting him down. I feel so helpless, like there's something I should be doing."

Bram spoke over a forkful of apple pie. Katrina put down her coffee and looked intently into his eyes.

"You do what you have to."

"But, Mama, I . . . "

Katrina got hastily to her feet, smoothing her apron. "Now, help me clear these dishes."

He wrapped his arms around her, whispering, "I love you Mama, and I'll never forget Papa."

"I love you too, Bramie." A glint of light reflected her tears.

* * *

It was the stroke of midnight, still three hours before the circus trucks were to depart. For the tenth time he read the note he was leaving.

> *My dear Mutte,*
>
> > *Please do not worry about me. I have gone to be with Modoc. Papa's right—we have to be together, and I want to honor Papa's wish to take care of her. I know you will be fine; you have Curpo to take care of you, and the others from the circus are always ready to help. I will get a job assisting the new elephant trainer and be with Modoc. When I get settled, I'll contact you. I'll save enough money for you and Gertie to join me, and maybe even Curpo, too. Thank you, Mama, for being the best mother a son could have. I'll miss you.*
> >
> > > *Love, your son,*
> > >
> > > *Bram*

He slipped the letter into an envelope and laid it carefully on the kitchen table where she would be sure to see it in the morning. One last quick glance around his room, a click of the door latch, and he was gone.

Curpo was waiting at the prearranged place. Sitting behind the wheel of the car was String. The front seat had been removed so that String could fold his eight-foot frame into the special home-made seat that would fit him. To anyone driving by, it would appear that String was driving from the backseat.

"Hi, guys. String, thanks for coming. I really appreciate it."

"No problem," replied String. "When Curpo told me what you were doing I wanted you to know I was behind you all the way."

The ride to Gertie's was made in silence. Bram thought of all he was leaving behind, and what the future might hold. About a

quarter of a mile before Gertie's house, String stopped the car and turned off the headlights.

"Remember Bram, the caravan leaves at three A.M."

"I know, Curpo. I'll be back in time."

The two men settled in to wait as Bram cut across the corn rows Gertie's father had worked so hard to plant that season. He disappeared into the dark.

Gertie's house sat in a small ravine, making her second-story window accessible from the ground below. By placing a small log, previously positioned against the wall, Bram climbed up and softly rapped on the window.

"Gertie, Gertie, it's me—Bram," he hissed against the glass windowpane. He waited, then knocked again. "Gertie?"

The window was misted from the heat inside her room; it was still cold outside at night. Through a myriad of colorful crystalline patterns on the frosted glass, Gertie appeared as a kaleidoscope of mystical shapes, gliding, wavering, approaching the window. Then she came into focus. She unlocked the catch, and with Bram lifting from the outside and she from within, the window rose.

Bram hurriedly climbed over the sill and closed the window quietly behind him. Gertie was sleepy-eyed, shivering in her thin nightgown from the night air, a look of concern on her face. This was his warm and tender Gertie.

"Bram, what are you doing here? Is something wrong?"

Quickly unbuttoning his heavy coat, he embraced her shivering body, folding her in, wrapping the coat around the two of them. Pressing against him, she gathered his warmth, melting it with her own heat. Soon they were alive with each other. Their young, cautious desire ignited into romantic intimacy.

They lay for what seemed like a long time in each other's arms. During this time, he told her of his plan, as gently as he could.

". . . and I'd never be happy with myself, not for the rest of my life, if I didn't try to honor my father's wish . . . and you know how much I love Mo. I don't know what I'd do if anything happened to her."

"I know." Gertie smiled tearfully. "Your mother told me I'd always have to share you with Modoc, the way she shared Josef with his elephants." Quickly Gertie tried to wipe the tears from her pale eyes. "It's not that I don't understand. It's just that it's happening so quickly."

"But it's the best way, Gertie," he insisted. Bram had his father's watch, and he checked the time. Standing, he grasped Gertie's hands and pulled her up to him. She was sobbing quietly. "I love you, Gertie," he said, "and I know that it'll be a long time before we see each other again, but I'll write often, and . . . "

"Oh, Bram! I love you so much." Gertie threw her arms around him. "I'll wait. I'll wait forever, knowing that someday we'll be together." A torrent of sorrow flooded Gertie's heart as she resigned herself to his leaving.

They stood by the misted window. Gertie pulled his jacket collar up around his neck, tucking his wool scarf in a crisscross across his chest. Bram stood there like a boy being readied for school. He loved how she cared for him, and tried not to think of leaving her. He raised the window. Swirls of light snow began to blow through. They said goodbye with their arms, their eyes, their hearts. Then a kiss, and he was gone.

Closing the window, Gertie wiped a circle of visibility on the pane with her hand. She saw him sprinting down the valley as she pressed her weeping eyes against the frosted crochet. The freezing window glass cooled the tears on her cheeks.

String returned them to the circus grounds just in time to see the caravan of trucks slowly pulling out. Bram directed him to park in the shadows behind some broken kiosks. Huge floodlights washed over the hustle and bustle of the last-minute operation. People scurried everywhere, loading equipment, pushing heavy crates up the slide ramps into the trucks, while others scrambled onto the running boards or inside vehicles so as not to be left behind. Bram recognized his friend, the transportation chief, shouting orders through a hand-held bullhorn. He waved and was acknowledged with a nod.

"That's Kelly Hanson, the American I told you about. He's helping me get on a truck, and eventually the ship, I hope. I had to promise that if I got caught, I wouldn't reveal his name." They sat in the car, observing the evacuation.

"'ow do you know which truck to get into?" wondered Curpo.

"Kelly told me it will probably be the last one, and to look for an American flag on its antenna."

Curpo pulled out a little pouch. "We want you to have this. It's a small reminder of all of us, trinkets really, but, well, we wanted you to have them."

Bram's throat tightened. "I don't . . . know what to say. How could I ever forget any of you? You're the best friends in the world. I'm going to miss all of you." He began to place the pouch among his things when he felt String's large hand on his shoulder. He looked up.

"Look here, Bram," said String, "If . . . I mean, if things don't work out, well, it's okay. Don't be embarrassed to come back. Nobody can fault you for trying."

"Yeah, sure." Bram struggled to put the thought of failure out of his mind.

"I think your truck just pulled into line!" said Curpo.

Bram straightened up. "Then I guess this is it." He grinned. "I'm scared. I've never been so nervous. The farthest I've ever been is Frankfurt and now I'm going to try to get to America, huh! Take care of Mama and Gertie. Ah, I know you will. There's no one in the world I trust more."

Bram and Curpo embraced, both feeling the impact of the moment. Then Bram reached an arm forward, around String's shoulder.

"Thanks for the lift . . . and tell the group . . . well, you know, just tell them."

"Sure. You go on now."

Bram got out of the car, looking around furtively. Kelly had told him not to be seen.

He turned to wave goodbye when he saw tears flowing down Curpo's face.

"Curpo! You've got tears in your eyes."

"Where'd ya expect them to be? Besides, they're small ones, don't you think?" Curpo smiled faintly.

"Curpo, I'll never forget all you've done, for me and for my family. I just wanted to say . . ." He couldn't finish, all he could say was "Bye, Curpo!"

"Bye, Bram—you take care, you 'ear?"

He dropped low, ducking into the shadows as he left the car. The thought of Modoc strengthened his determination to succeed as the truck with the flag suddenly appeared in front of him.

The coast was clear. Bram made a dash for it. A quick toss of his gear and a jump, and he was riding on the tailgate. Then up and over, and he found himself lying on some sacks of equipment and supplies. Collecting his bag, he scuttled to the back of the truck and nestled down behind some crates.

It was pitch dark inside the truck. Through a crack in the wooden side panels, he saw car headlights flick on and off a few times—signaling everything was okay . . . and goodbye. As the car pulled away, a sick knot formed immediately in his stomach. He'd made it . . . so far. Bram heard the sound of a match being struck. The darkness was set ablaze with the flickering match. Bram was shocked to see a grizzled old vagabond sitting just a few feet from him. The bum smiled a toothless grin, puffed on his cigarette butt, and the match light went out.

= 11 =

THE JOURNEY FOR BRAM was one of wonderment and danger.
The caravan moved slowly over the roads, keeping pace with the
rough depressions of the highways. He slept cautiously, always
aware of the movement of the trucks. At night when they pulled
over to rest, fuel up, or grab a bite to eat, Bram would venture from
the truck to go to the toilet. After that he would sneak back inside
and snuggle down, always aware that one false move, one mis-
placed noise could be his undoing, and all that he had planned
would be for nothing. He wondered what the ship *The Ghanjee*
would be like. From the conversations he overheard with the men,
it would be huge. It would have to be, thought Bram, to carry all
this cargo and more.

He crossed the borders from one country to another, hearing
different languages and seeing the differences in the environment.
Green rolling hills, forests, lakes, beautiful crystal lakes, some as

beautiful as Cryer Lake. Bram ate by rationing the food he had brought. Occasionally the bum would sneak out of the truck and head for a local store. Bram figured if someone saw him they would think he was just one of the roustabouts. Then he would bring back sandwiches, pickles, chips, and drinks that he would share with Bram. Every time Bram looked at him he would crack his toothless grin. He never talked, just smiled.

Bram opened the pouch his friends had given him, smiling as he looked through the mementos. It made him think about what his father had said about not having to have your friends close, and that distance does not separate—only the mind and heart.

One evening, as the trucks pulled over so the drivers could rest, Bram heard one driver say that by this time tomorrow night, they would finally reach the port. He could hardly sleep that night, watching out the slats of the truck for signs they were approaching the ship dock. The air felt crisper, the sky seemed brighter, the stars more plentiful. There was something new in the air, he thought. A strange odor—an excitement came over him. The ocean! He could smell it!

The moon was low and battling for position in the sky as the caravan of trucks pulled up to the shipping dock. Longshoremen and circus employees prepared to unload their cargo. Huge beacons of light illuminated the area with the brightness of day. High overhead, the engine of a giant crane roared to life.

Bram slipped out the back of the truck before it stopped, and hid behind a stack of large cargo crates. Across the side of the crate was stamped in large bold letters: CIRCUS CARGO-NEW YORK. A dense fog had moved in, making visibility difficult. The smell of the dock reminded him of the fish market back home. It had a salty air to it; in fact, Bram felt the taste of salt in his mouth. He heard the sounds of the harbor thunder. Chains for hoisting cargo rattled, men called out orders in many different languages, small trucks hauling everything from vegetables to fine fabrics shifted their gears to low as they cautiously moved to the edge of the docks. He noticed a few men dressed in uniforms walking around in pairs. Perhaps they

were the police or guards for the ships. Whatever they were, Bram decided to stay hidden for as long as he could and as far away from them as possible.

Bram wasn't more than twenty-five feet from the edge of the dock. The blast of a horn caused him to jump and as he turned toward the sea, he saw something coming through the fog with giant floodlights sweeping into the darkness, illuminating a huge dark form that slowly drifted toward the dock. Creaking restlessly was the immense twin-stack Indian freighter, *The Ghanjee,* the able-bodied vessel that had traveled the high seas for the past twenty-five years.

Bram could never have imagined so magnificent a ship. Six rows of lights lined the side from bow to stern, while way up on the deck, people looked over the guard rail. Ropes were thrown down from the vessel and lashed around large wooden stumps protruding from the dock. Overhead, a large crane swung an immense hook and net to the dockhands below, where they loaded circus equipment and paraphernalia. Upon a signal from one of the long-shoremen, the crane lifted its heavy load higher and higher until the cargo swung over the railing and disappeared into the hold of the ship. This was repeated for the next two hours until every truck was emptied of equipment and animals in cages, except the one carrying the elephants and their equipment. Bram started to worry. The sun had been up for hours now, and with most of the circus trucks having been unloaded, he felt that if something didn't happen soon, he'd be discovered.

A loud trumpet from an elephant had Bram scanning the docks to locate its source. His head shot up and down like a periscope. Another trumpet made it clear. Shielding his eyes from the sun's direct glare, Bram saw Modoc high above his head, swinging from the crane. The heavy chain suspended from above divided into four strands that extended down to the corners of a thick flooring. All four of Mo's feet were chained to a pallet, and a heavy rope was attached to a wide sling that was in turn strapped around her belly. This helped support Modoc and kept her from falling. Yet

another line was wrenched taut to prevent the platform from turn-ing. Although it appeared quite precarious, Mo seemed to be doing just fine, and in fact looked as if she was enjoying the ride. Those men know their business all right, Bram thought. He was shocked from his reverie by a hand grabbing his shoulder. He spun around and was face to face with Kelly.

"Glad to see you made it," Kelly hissed. "We don't have time to talk. You gotta move now, son, while everybody's watching the elephants. Get in this box and keep low." Kelly pointed to a large wooden container.

"But Kelly—" Bram tried to ask a few questions.

"*Later*, just GET IN! There's other stuff going in the box with you. It's a lot of miscellaneous smaller stuff, and don't worry if they nail the box closed. I'll find you after a while and let you out, okay?"

"Okay . . . I guess," Bram mumbled.

As Kelly marked a large "X" on the wood, Bram threw his leg over the edge and dropped inside. Fortunately a bunch of card-board boxes and canvas broke his fall. Using them as a hiding place, he built a cavelike structure in the corner and crawled inside it.

Bram didn't have long to wait before various "items" began sailing through the air, pieces of the kiosks, wagon wheels, training equipment, harnesses, and tools. The heavy cardboard over his head deflected most everything, and he survived the onslaught. Darkness replaced sunlight as the men succeeded in sliding the cover over the wooden crate. He heard the big nails hammer the lid securely into place. Thin shafts of light found their way through the wooden slats. A sharp lurch sent him reeling across the box. Chains rattled while the men hurriedly fastened them under the crate. It shifted and was soon airborne, swaying as it attained a height far above the ship's railing. Peeking through the slats, for the first time he could see the whole deck. People looked liked insects. Massive plumes of smoke billowed from the ship's two great stacks; she was preparing to get under way.

The crate swung over the vessel and stopped, then Bram felt

he was falling! His heart skipped a beat, his breath came faster, then a large hole opened up underneath him. He plunged into the darkness of the hold. Bram heard chains being detached and slid out from underneath the crate.

He had just settled down for a rest when he heard something hard hit the top of his crate. They had stacked another one directly above him. He felt panic. What would happen to him if something horrible befell Kelly, or maybe he even died! No one knew where he was. He would suffocate to death. Bram huddled in the corner, listening. Only the sound of his own breathing could be heard. He hadn't slept in the last twenty-four hours and, finally, the darkness brought on drowsiness.

"Bram! Are you okay? Bram! Bram? Do you hear me?"

Bram awoke, perspiration dripping from his forehead, to find that the crate above him was being lowered to the floor by a tractor. Voices sounded muffled. It took a while for him to realize where he was.

"Yeah," Bram called, "I'm okay. Just fine."

With an abrasive, wrenching sound of a crowbar pulling the nails out, and a hefting of the top, the crate lid fell away. Bram leaped up to the open edge, and with Kelly's help, jumped to the floor below.

"Boy, am I glad to see you, Kelly. I was worried that you might have missed the boat or something, and nobody would've known I was there, and—"

"I wouldn't have forgotten you, boy, but listen, your problems are just beginning. If they find out about you there'll be the wrath of the captain to answer to. Come on, I'll show you where they're keeping the elephants. I put some food down there for you, too."

Bram smelled the animal hold long before they arrived. The hay and animal droppings were something he'd spent a lot of time shoveling. The animals were housed in a rather large section of the hold, twenty-five by fifty meters, on the starboard side of the ship. It ran along the bulkhead that separated the seas from the elephants. Each elephant was chained to a large eye bolt welded into the superstructure of the ship.

Across from the elephants was an army cannon. Painted a dark gray and tied down by several steel cables, it appeared in the dimness like a demented aberration of an elephant. Like its counterparts, it was large, gray, and chained, settling back into the shadows with its long, thick muzzle protruding. A protective shield bridged the wheels, and in the eerie darkness it appeared like a tortured mouth twisted at the corners, giving it Lucifer's grin.

Kelly told Bram that the lions, tigers, and other animals were housed in another section of the ship. "Look, kid, I've got to go. There's food hidden in an old blanket next to the stall. Stay out of sight and I'll pop down every so often to see how you're doing and bring you more."

"Thanks, Kelly, you're a good friend. I really appreciate all that you've done for me. Maybe someday I can—"

But Kelly was gone. He didn't understand why Kelly had decided to help him; someday he would ask. Interrupting the darkness came the thunderous blast of an elephant.

"Mo! It's me!"

He ran to her, embracing her trunk. She was so excited she picked him up, swaying with delight. Emma was there, and Tina and Karno. For the next few hours, Bram told them all that had happened to him, how he missed home and his friends. He checked them over, looking for any punctures from the bull hook. He found some on all of them and many on Modoc, four in the base of her trunk, several in both front knees, and three on her head. He was furious. He hated trainers who believed they had to be tough, show authority, be strict. They used the bull hook as a weapon, stabbing, jabbing, causing unnecessary pain when only a bit of patience and understanding were needed. Some trainers had been caught sharpening their bull hooks so as to inflict pain. Bram knew that the true test was to rest the point of the bull hook on the tip of the index finger to see if it drew blood. If it did, it would prove that the trainer's methods were brutal. It's a sign that the hook was being used with too heavy a hand.

Suddenly he heard the echoed talking of men coming from

somewhere in the hold. They were getting closer. He grabbed his meager belongings and disappeared under the straw behind Mo as two keepers appeared from around the corner.

"I tell ya, I heard Jumbo bellow," he heard a voice explain.

The voice was familiar to him. He snuck a peek and saw it was Jake, the trainer. With him was an Indian carrying a bull hook, which he referred to as a "choon." Bram couldn't be discovered now. Not after all he had gone through. He took a deep breath as he recognized Jake, and crawled back further into the straw. He tried not to breathe at all lest he be heard and discovered.

"They do not look upset to me," said the Indian as he came close to where Bram was hiding.

Jake shook his head, "I heard this one trumpet—something must have bothered her."

He heard Jake pat Modoc and walk around the animal. The Indian stood almost directly in front of where Bram was. He closed his eyes and prayed.

"I do not see anything," said the Indian. "The others are quiet enough."

"Well, I ain't one that likes surprises," replied Jake. "No sense in Mr. North gettin' damaged goods, ya know."

Bram's heart moved from his throat back to his chest as they headed out into the passageway.

As the days passed, Bram settled into organizing his existence. He found a metal cabinet of fair size located behind the elephants where the trainers kept their equipment. Underneath the drawers was a broken bin built into the frame of the legs. Its door was jammed, and only by pulling hard could he open it. Brushing out the cobwebs, he put his stuff inside, jammed the door back into its original position, and sprinkled some dust over it. He felt sure no one would attempt to use it.

Bram had worried about obtaining food, but was pleased to settle for sharing Modoc's. Every morning and evening the elephants were fed a diet of alfalfa and oat hay mix; five pounds of grain; a treat of bananas, apples, oranges, and bread; plus whatever

else the kitchen had as leftovers. Bram picked through it before Mo and her friends could devour it all. There was a hose for fresh water handy at all times.

The scary moments came when the keepers arrived to clean up. They would wheel a large bin ahead of them, shoveling the dung and hay into it. Once they finished, they spread fresh straw for bedding. Bram had to keep ahead of the keepers at all times. When they were working at one end he would stay low at the other. As they progressed down the line, he kept moving ahead of them. At the end of the row when they weren't watching, he made a quick jump behind the bin. As they pushed it out, he would slip away into the dark, taking advantage of the shadows, and later work his way back.

When Kelly brought food or clothing to make his stay more comfortable, they would sit and talk of many things. Kelly told him that the ship they were on was an East Indian vessel, owned by British authorities, and was commissioned to travel the route between Europe and the eastern coast of the United States. He verified most of the things that Bram had been told about their route.

"This is by no means the shortest way," Kelly continued, "but it was all Mr. North could find that would get us home before the seasonal storms hit and make the oceans too dangerous."

They talked of the United States and how, if Bram made it, he could survive. Bram was surprised to find out that things were not as easy as he had thought, but there was no turning back. He'd take it a day at a time and keep a positive, optimistic outlook.

Bram introduced Kelly to Modoc and the other elephants. Kelly was a little unsure of being next to animals that big, but once he got to know them, he liked their gentleness and kindness.

"I can see you and Modoc are best of friends," he said to Bram one day as he watched the care Bram took in cleaning Mo.

"We were born at the same time, at the same place. We've always been with each other. I couldn't imagine not being able to be with her. We're connected, my father always told me, and we are."

"Well, I'd hate to see anything happen to separate you two. Be

careful, Bram. I'll come back when I can. See ya. Bye, Modoc."

The dark quarters and gentle rolling of the ship had a soothing effect. It gave Bram an opportunity to hear sounds and see things about the elephants that he was never fully aware of before, the grinding of food between those massive molars, the gurgling noises in their stomachs, the swishing of tails against their buttocks, the rasping of their legs rubbing together, the squeaking and rumbling sounds when they spoke to one another. Amid the intimacy of their elephant lifestyle, Bram felt that somewhere in the course of time he had been an elephant. His instincts and thoughts were the same as Mo's; their fears, needs, and concerns were all shared.

Modoc treated Bram as her son. She was always hugging, kissing, and sharing her food with him. Sometimes when he fell asleep in the hay she would stand over him, quietly rocking her body and rumbling softly.

A week had passed, and Bram figured it was time to make his move. Kelly has insisted that he remain hidden but he felt the captain might have compassion for him, and if not, there was no way the ship would return him to Germany. He gathered his things from the cabinet, raked the straw out of his hair with his fingers, and was saying goodbye to Mo when he felt a strong hand grip the back of his neck.

≡ 12 ≡

"WHAT IN THE HELL do you think you're doing!" The voice was loud and angry.

"I . . . was just going to see the captain," Bram stammered under the powerful grip.

"Oh, were you now? Well, maybe we'd better go and see him together."

Bram was held from behind so powerfully that he couldn't even turn to see his captor. Modoc's ears shot forward. A low vibrating moan could be heard.

"It's okay, Mo," said Bram. "Not to worry, girl," he coughed back as he was being guided out of the menagerie area and up to the top deck.

Bram's life in the dark hold hadn't prepared him for the sudden blast of bright afternoon sunlight. His eyes burned in the dazzling glow, and he was forced to shut them, letting the hand shove

him stumbling in the right direction. He heard voices around him.

"Who's the kid?"

"Where'd they find that?"

"Peeuuwww! Hey, how about taking a bath?"

The "hand" spearheaded Bram rudely upstairs, across planks, through narrow passageways, and up more stairs until he was finally pushed through an oval-shaped door. As his eyes became accustomed to the light, he found himself in what he later learned was the wheelhouse. Its handsome walls, ceiling, and floors were of hard oak and polished to a sheen that could only be outdone by the beauty of the shiny brass handrail, window frames, piles, and couplings. Most impressive of all was the great steering wheel. A sailor stood with his hands on the wheel, steadily watching the horizon.

"What is your name?" came the authoritative voice of Captain Patel from the front of the cabin.

Bram turned to see a man in a uniform whose jacket was adorned with bars of color. His dark skin accented his white turban. He had thick eyebrows and very intense brown eyes. He stood by the round porthole and had been peering out at the ocean through a pair of binoculars.

"Bram, sir. Bram Gunterstein."

"What are you doing on my ship?"

"You have my elephant, sir—that is, the circus does."

As he approached Bram, the binoculars dangled around the captain's neck. "What do you mean, *your* elephant? Mr. North purchased all the animals in this circus."

"Yes, sir, that's true but, well, you see my father died, and he told me to take care of Mo—that's my elephant, only the circus people call her Jumbo . . . and they don't like me calling her Modoc, but we can't be separated . . . "

"Wait a minute!" ordered the captain. "Now let's get something straight here, young one. The animals, *all* the animals, belong to Mr. North. *You* are a stowaway, and I have the power to throw you overboard!"

The captain had stepped within halitosis range and was

becoming more enraged as he continued. "Now," he bellowed, "I have no idea what you're talking about, nor do I care. I will instruct the purser to hand you over to the local authorities at our first port of call. Until then, you will work in the galley for your room and board. Is that understood?"

"But, sir, Mo . . ." Bram stammered.

"Not another word out of you, boy!" snapped the captain. He turned to the man who was still holding Bram by the neck. "Get this person out of here and show him what life can be like for a stowaway!"

"Aye-aye, sir. Come on, punk, move it."

For a moment the sailor released his hand. The blood rushing back into his neck made Bram feel faint, but immediately pressure was reapplied. Bram let out a yelp and was led away.

Pushed through a series of corridors and a pair of swinging doors, he found himself in the ship's huge galley. A number of crewmen scurried around, cooking, washing dishes, peeling vegetables. The atmosphere was chaotic. Pots and pans banged against one another. People were shouting. Crates of food slid across the floor. A man in a chef's hat and a dirty apron barked orders at everyone. It seemed no one could do anything to please him. The cook looked down at the prisoner and his warden.

"What is it?" he shouted.

"Stowaway. Captain's orders that he work a full schedule in the galley till we get to port." With this, the viselike grip released Bram.

This was the first time Bram had a chance to see the face of the man with the bulldog clutch. His burly features were as large as his body, his hands twice the size of a normal man's. Bram silently nicknamed the man Hands. Later he found that others did the same.

Each day for a span of twelve hours, Bram cleaned, washed, and dried the dishes for every person on the ship. The detergents and soaps were so hard on his hands that by the end of the day they were sore, cracked, and bleeding.

Sometimes Bram slipped out for a bit of fresh air. It was great

to be out on deck. Warm, salty Indian breezes from the east blew gently. The calm sea swept as far as he could see. Dolphins escorted the ship on its journey, their glistening, arched bodies diving in unison as though protecting the ship. Sometimes, when enormous waves broke over the bow, gushing water onto the deck, he marveled how the great ship plowed through like a knife through butter. It felt good to be alive.

"Do you think, sir, if I finished my chores early, there's a chance I could go below and see Modoc?"

"What do you think this is, boy, a pleasure trip? Have you forgotten who you are? What you've done? And if you finish early, I've got a few other things you could be doing." The cook stormed off, banging the pots with his meat cleaver.

Every so often a loud siren would stun the crew and passengers into silence, as the captain's voice barked out an announcement or important instruction. Today he declared that it had been three weeks since they had left port, and that *The Ghanjee* was ahead of schedule by two days. The captain said he was pleased with the ship's condition, and all hands could expect a bit more money for their efforts when they reached their destination.

This brought a rousing cheer from the crew on all decks. He went on to say that the weather predictions were "balmy winds and calm seas." The captain also announced that the next day at 0800 hours there would be an inspection of the entire ship in preparation for landing on Asian shores.

The cook called his galley crew together and spewed a list of instructions to ensure that everything would be shipshape. Bram's workload nearly doubled and kept him working late into the night. He fell into his cot exhausted and didn't stir until five o'clock the next morning when ship's bell rang the hour.

Arriving at the galley, he noticed everyone was wearing his topside uniform, and the general atmosphere was as polished as the brass on the steering wheel. One of the sailors handed him a package.

"Here, put this on."

Bram's eyes lit up when he pulled out the uniform of a midshipman. Hastily scrambling into it, he found the uniform a bit large, but was rewarded by his reflection in the stainless steel sheeting of the galley. Then a hat was passed to him. The brim had been stuffed with paper, allowing for a good fit.

For the first time since coming aboard, Bram felt like one of the crew. He had a sense of belonging. He had found friends. He had seen to it that his area had been polished to a "spit shine" like never before. Not a crumb could be found. Everything was in place. This would be the first time he would see the captain since the fateful day of his "capture." A boatswain's whistle sounded. The galley crew formed a line from the doorway to the back of the galley. Cook had been careful to point Bram's way to his place in line.

Captain Patel appeared at the doorway, followed closely by Hands. Cook called for attention, and there was a salute. Bram didn't know if he should salute or not, and after a fumbled gesture, wished that he hadn't. The captain walked through the galley, occasionally wiping his gloved hand over a piece of kitchenware. Seeming pleased, the captain started back down the line when he came to an abrupt halt in front of Bram.

"How's your elephant, son?" asked the captain.

Bram felt this an odd question under the circumstances. He knew the captain was trying to trick him into a revelation; Bram had been forbidden to see Modoc, and the captain knew it.

"I haven't seen her, as you asked, sir."

"I hear from the cook you're doing a fair job."

"Yes, sir."

"Hmmm. Each day, after you've done your chores, you may see him."

Bram could hardly contain his reaction. He felt as if the chains of the captain's order that had been around him suddenly had been broken. He felt lighter.

"Her, sir. She's a she."

"Don't contradict the captain, boy!" Hands snapped.

"Well," the captain continued, "whatever, you may see her for

a bit, but only her. You are not to visit the other animals. Understood, boy?"

"Yes, sir! Thank you, sir!" Bram's eyes shifted up and down, afraid to stay locked too long with the captain's. Out of the corner of his eye he could see the ever-stern Hands smiling just slightly.

"Hmmm," nodded the Captain. The great man saluted the crew, the crew saluted back, and then he was gone from the galley.

That evening Bram retraced his steps into the hold. Corridor after corridor angled down into the belly of the ship. Lighting was sparse and the superstructure of the ship looked alike everywhere. Reaching an intersection of three tunnellike passageways, he stood bewildered, wondering which to take. Raising cupped hands to his lips he took a deep breath and shouted "*Mooodooooc* . . . " The echoes reverberated throughout the curved ceilings and walls. He called again. "*Mooodoooc* . . . "

Sounding not unlike the awakening of a brontosaurus from a million-year sleep, the powerful reply came. Mighty and strong, it exploded down the middle corridor—so powerful one might expect to see that prehistoric monster following its voice up the passageway.

A smile covered Bram's face as he raced down the corridor. "Mosie! Mosie!" he yelled.

Bursting into the open area where the animals were housed, Bram caught Modoc mid-trunk, hanging on as she swung him high in the air, trumpeting all the while. Emma, Tina, and Krono all stood by and Bram gave each a tremendous hug, returning to Modoc once again. Bram and Modoc talked for hours, each in his own way— Bram gabbing on and on about all that had happened to him, Modoc mumbling and squeaking while touching him all over with the tip of her trunk. Bram examined each part of the big elephant, head, face, legs, trunk, for cuts and bruises . . .

Bram never returned to his bunk that night.

13

THE WEATHER HAD TAKEN a turn for the worse. Winds swept across the freighter with increasing intensity, rain began to fall, lightly at first and then harder, and the mighty vessel plowed slowly through the ever-roughening seas. The waves broke higher and tempers were shorter. A freak storm for this time of the year had whipped the ocean into giant waves that crashed down on *The Ghanjee* from bow to stern. Suddenly there came the boatswain's whistle.

"This is the captain speaking," boomed the big man's voice throughout the ship. "As you can see, we have encountered a determined tempest. All personnel, except those previously instructed, are ordered below decks, and are to stay there until the storm has abated. At present we are some fourteen nautical miles from the coastline of India. A broadcast has been sent to the port authority in Calcutta to advise them of our position."

While the crew hastened to secure galley equipment, Bram dashed to look out the porthole. Never in his wildest thoughts would he have imagined the sight that greeted his eyes. There was no sun, no warm breeze or seagulls wafting nearby. Their dolphin escort was nowhere to be seen. Satan's own demon was rising from the dark waters to howl and blow wet rain and gloom on those sailing helplessly below. *The Ghanjee* rested in the palm of his reptilian hand, and he tossed and jerked the great ship like a toy. Huge waves crashed against the porthole, as if a door was slamming to avoid human eyes not meant to see more. Bram had to hurry and help batten the hatches closed. The crew settled in to wait out the violent storm.

It roared all day and night, whipping mercilessly at the vessel, plunging it into deep watery valleys, then lifting it as if it were a feather up to the lofty white-capped peaks, then crashing it back down to the valley again. The water raged and roiled, always turbulent. The crew spoke openly about the seriousness of the matter, but Bram could think only of Mo and the other animals in the hold below deck. He slipped away at every opportunity to comfort the elephants. The upheaval of the ship made it impossible to prepare the regular hot-cooked meals for the crew, so small solid foods were passed out to them—apples, bread, oranges, cheese sandwiches, and fresh water. Many of the crew and passengers alike were unable to keep their food down, and some were toughing out the storm in sickbay.

Kelly appeared in the galley. "Bram, how are you holding up?"

Bram turned, surprised to find his friend there. "Not so good, I guess. Everybody's worried about the storm." He suddenly noticed some kitchenware sliding by them as the pitch of the ship turned drastically starboard. He caught it before it could fall. "You don't think anything bad could happen . . . do you?"

"Naw, it'll blow over soon. This old ship is unsinkable."

"I heard the boatswain talking to Cook. He said the captain sent out a distress call to the mainland, so maybe something is happening we don't know about."

"It's just a precaution, nothing more." A strange pallor swept

over Kelly's face, and suddenly he didn't sound very convincing. "You take care now. I'll see you later." Kelly hurried away.

Bram spent that night with the elephants. No one could have slept, even if he'd wanted to. The storm had whipped itself into hurricane proportions and the great ocean ruled the ship now. Bram, knowing nothing about the sea and the ships that sail upon it, believed the captain had everything under control.

The elephants were restless and moody, rocking back and forth, and had a difficult time keeping their balance. The ship pitched and rolled like a rubber ball tossed about on the waves. The elephants trumpeted, ears thrust forward in a frozen position, eyes opened wide, bodies shivering in fear. Bram stayed by them, comforting them, talking about nothing special, just a nonstop line of gentle chatter while he ran his hands over their heads and trunks. He could almost hear his father's voice:

"Touching is one of the most important things a trainer can do for his elephant, Bram. Remember, it's the best form of communication, better than any known verbal language."

Bram remembered his father's lesson, and knew this was a time when it was needed most. The rocking of the vessel was becoming more violent. The wind forced its way down into the hold, howling and whistling its high-pitched screech. When Emma started to lose her footing, he swiftly put his shoulder to her leg and pushed with all his might to stop her slide, but to no avail. Bram looked up just in time to avoid Emma's crash to the floor. He was thrown across the room, sliding in the wetness until his fall was abruptly halted by his crashing into an iron support column.

Roaring in panic, Emma righted herself, only to collide with Tina. Then a loud *snap!* Emma, in her fall, pulled one of her back leg chains out of the steel ring bolted to the floor. Bram knew if the elephants got loose he wouldn't be able to control them. Water was seeping in from somewhere and spreading throughout the hold.

In the midst of the elephant melee, movement caught Bram's eye. Across from the elephants, back in the shadows of the cabin, something moved. As the ship plunged into yet another watery

abyss, it moved again. Straining to see in the near-darkness, he finally saw it. One of the chains holding the huge army cannon had broken loose and was slapping at its side with each roll of the ship. The cannon was moving!

Bram could scarcely bear to think of the consequences if it broke loose. It had moved only a few inches, but it was straining against its remaining safety chains. He bolted into the corridor, yelling for help, slipping several times in the water. On the wall was a large box marked EMERGENCY. Bram threw open the door and pressed the button. A loud horn began to sound, hooting in three intervals each. Within seconds, half a dozen men came running up the corridor. Kelly was one of them.

"Bram! What's wrong!" he yelled, dashing after the boy.

"Where's Jake? I need him!" Bram screamed, not even turning his head.

"In sickbay! Fell against a railing and hurt his shoulder! He can't help anyone. What's happened?"

"The cannon!" Bram shouted back. "It's broken some of its moorings, and it's moving! If it starts to roll around in there with the elephants . . . it must weigh tons!"

Kelly understood at once. Water had risen in the hold and was sloshing around the elephants' knees. It was difficult for the men to get a stable foothold and some leverage to tie ropes on the cannon; they were slipping and falling from the pitching and rolling of the ship.

Snap!

The cannon broke another chain. This time the monster slid forward three or four feet. It would take only one good pitch for the other chains to break. Bram began to panic. Water was causing other cargo to shift and break loose. Pallets were being washed out from underneath, and the boxes and equipment were floating in the water. Some thrashed about.

The realization of the ship actually sinking hit Bram. Everybody would drown! Every*thing* would drown. Bram fingered the pliers in his pocket, trying to decide whether to unscrew the swivel link and set the elephants free. He forced the thought from

his head. Modoc was holding strong. The others had found a way to stand by bracing against one another, with Mo in the center. The weight was on her, but she held firm and steady. Bram left the elephants to go help the men secure the cannon.

The oak beams were creaking and groaning like a human in agony. Two men had started a bilge pump but were having little success in lowering the water. *The Ghanjee* dove stern-first into yet another deep valley. The cannon lurched forward, snapping the remaining chains and dragging all the men with it. The great iron weapon of war rolled out into the middle of the floor and stopped—a mere six feet from the elephants. The next plunge from the bow rolled the monster back into its "cave," as if it were an animal preparing to launch a new attack.

The cannon was huge, much more formidable up close than it had been under its canopy. Kelly shouted, breaking Bram's frozen stance.

"Bram! Loosen the elephants! We won't be able to hold it again!"

Bram awoke from his fearful stupor, aware that he was already moving. He slipped his head through the cord that hung from the bull hook around his neck, freeing his hands. Racing from one elephant to another, he unscrewed the swivel. First Tina, who was now screaming in fear, then Krono, Emma, and finally Modoc. She was standing in two feet of water. Bram had to grope under water for the swivel when he felt the next deep roll of the ship. It threw him against Mo's legs, knocking the pliers from his hand. Swearing in exasperation, Bram saw the cannon shift direction and start its journey toward Modoc.

"Move up, Modoc! MOVE UP! MOVE!! MOVE!! MOVE!!" he screamed.

Modoc strained every muscle in her body.

Pop! Pop!

The right front and back links broke as the cannon roared down on her. Mo had just enough room to step aside. The cannon went by with the thunderous sound of grating metal and collided with the bulkhead, its muzzle bending the steel superstructure severely.

Bram was still groping wildly under water for the pliers. With luck he grasped them, and gripping with both hands, released Mo's other foot before the cannon rolled backward. Emma, Krono, and Tina took refuge as far away from the cannon as they could. Modoc stayed close to Bram, shivering and rumbling. Then Bram realized more trouble was at hand.

Bram saw that Kelly had grabbed two sailors who were trying to flee the hold. The sailors argued the ship was going to sink, that it was no use, they'd have a better chance up top. Kelly let them go.

"It's no use," he fumed, "the goddamn cowards—they'll pay for this when we reach port!" Bram was relieved to hear Kelly even *talk* about reaching port. "We've got to stop that monster before it rams a hole right through the side of the ship!" Kelly continued.

Kelly, soaking wet from head to foot, stood defiantly against the odds. Wading to the spot where the cannon had rammed the wall, he was able to finish tearing off a dangling piece of metal, ripped loose by the impact of the cannon. The cannon started to make its run. As it gained speed, though, everybody jumped clear—slipping and sloshing in the rising water—except Kelly. He thrust the metal strut into the spoke of the wheel, causing it to lock up. The cannon spun around pivotally, but now it shifted to a new position. The strut spit out the twisted trunk and it lay dangerously jutting out of the water.

Beginning a fresh attack, the huge cannon headed for Emma and Tina. The elephants waited until the last second before moving away. Bram saw that the elephants were so petrified, they could have run right into the cannon as easily as running away from it. He called to them, but the animals were terrified, and had transfixed their concentration on the cannon, which was now rolling through the hold with a vengeance. Time after time the hulk careened across the hold, narrowly missing elephants and people, smashing up cargo crates, equipment, decimating anything that couldn't move out of its way.

Bram knew it was only a matter of time before one of the elephants would be hurt. The constant battering against the bulkhead

was starting to show. A huge area was badly gouged and weakened by the giant cannon's muzzle, which remained almost completely unscathed, even after the pounding it had taken.

A horrible scream pierced the air. Bram whirled to see a sailor caught by the wheel of the cannon and dragged under water until the cannon careened into the ship's hull. The sailor only reappeared when the cannon rolled back in the direction it had come. Then he floated lifeless to the surface, mangled, crushed under tons of unforgiving iron. Bram had never seen a dead person before, seen this type of carnage. He had known that man; he knew he should be feeling something, but shock prevented it. He went to Mo, hugging a leg, wanting to protect her from the cannon, from the water, wanting to make it all go away. In the midst of this din, Mo reached down with her trunk and affectionately gave him a hug; she even rumbled to him. Bram knew there was nothing she or anyone could do.

For the last few moments, the cannon had stopped its onslaught. It seemed to be resting . . . no . . . waiting there in the dark recess of the ship's hold. The elephants had calmed a little in this moment of quiet. Bram stood, disbelieving. Could it be over at last? He joined Kelly and the few others who had remained.

"Is it over, Kelly?" Bram feared the answer.

"It's either over or we're in the eye," Kelly replied, wiping salty water from his soaking face.

"Whose eye?"

"This is no average storm. I've been in a lot of them, I'll tell you, but never one like this."

"I knew it was a hurricane," piped up one of the Indian sailors.

"It's not gonna stop!" cried another.

"Whadya mean?" asked Bram, turning to Kelly

Kelly turned to Bram. "Listen, Bram. If it's a hurricane, then we're only in the center part, the eye."

"The center? You mean, there's more?"

"Could be," Kelly said, running his hand through his hair. "The center's where everything is calm and quiet. It can trick you. You think you're past the storm, and then it rises up and . . . "

"How do you know if this is the . . . eye?" asked Bram.

"We wait. If we're in it, we'll feel the full fury of the other half."

"Well, if it is, we'll be a hell of a lot safer on deck," said one of the sailors. The others mumbled in agreement. They began to head up top.

"He's right, son." Kelly turned back to Bram. "We'd all better get up top."

"What about the cannon?"

"If it's a hurricane it won't matter. This ship won't stand another—"

"But what about the animals?" Bram's voice cracked as he tried to hold back the tears. Kelly's strong arm weighted Bram's shoulders.

"Look son, we've got to look out for each other now. We'll do what we can to help them, but if it means . . . Now, why don't you just come on deck with me. We'll wait there and see what happens."

"No, you don't understand, I can't leave Mosie and the others." Bram's tears were flowing freely now. Kelly grasped both his shoulders and looked him in the eye.

"Bram, listen to me. I know you and the elephant are close. I've seen you two together. But we've got a chance only if we're on deck—and if we make it, then perhaps we can help her and the others. But right now we've done everything humanly possible. There's nothing more that can be done." Kelly continued to look Bram in the eye until Bram lowered his head. "Now come up with me."

Bram sniffled and wiped his nose with the back of his hand. Looking over his shoulder at Mo, he nodded. "Yeah, sure. I'll be right up."

Kelly eyed Bram closely. He understood what he wanted to do. "You don't have much time. You promise?"

"I promise."

Sloshing through the water Kelly glanced back to say, "You're a helluva kid," before he vanished into the darkness.

14

BRAM TOOK A MOMENT to gaze around the hold. Litter floated in the water, some of it bobbing against the dead sailor's mutilated body. Tina, Emma, and Krono were now calm and quiet, standing in the water, shivers running from one to the other as through one body. The ominous cannon, still alive, waited, its barrel sticking defiantly out of the shadows. Then there was Mo. She stood by, at his shoulder, ready to do whatever he asked. She was there for him, big and strong, and yet so very helpless. How grand, he thought, that the way of nature is not to let animals know their death is imminent. Yet he knew that Mo sensed the situation.

Anticipation hung heavy on the silence in the hold. The wood creaked with each rising swell like a solemn refrain of a lonely sea chantey, softly lulling the storm. In limbo they waited attentively, breath held, in stasis, awaiting the outcome. Only the dripping sea

water and the breathing of the elephants accompanied the eerie stillness.

Bram went to Modoc. She wrapped her trunk around him and belly-rumbled. The other elephants came over and completed a circle with their heads touching, trunks entwined in the center. Bram had no desire to leave, never had had any intention of doing so. He regretted breaking his promise to Kelly, a lie was wrong, but it had been right for the moment. Drawing his legs to his chest, crossing his arms, he rested his head. To sleep from exhaustion would have been a welcome escape.

It began as a whisper, as if the slight bump of an oar hit the side of a rowboat. Ripples of water that had been calm began to escalate into miniature waves, which began washing against the elephants' legs. These little waves grew with the speed of an angry genie loosed from his bottle. Everything came to life suddenly, the water, the cargo, the debris in the hold. The dead sailor's body began its macabre watery dance. The waiting was over. The eye had closed; the storm returned.

The monster lurched to life, its grin more hideous than before. It moved out from its den, creeping slowly as if to survey the situation. Bram moved the elephants as far away from the cannon as possible. They were calmer now, as if sensing the end. He wondered pensively if he'd been wrong about nature's mercy to her animals. Outside the ocean roared to life. He heard thunder's voice collide outside the ship with lightning, a deafening cacophony that commanded action. Yet, somehow, the cannon stood still. It waited, as though saving its energy for one final onslaught.

So it was. A giant chasm opened under the ship's bow, and she started down, plunging abruptly into the canyon of water. The ship raced the waves. The cannon moved, rumbling out of its sanctuary, picking up speed, heading directly for the worn bulkhead, its muzzle poised for the blow. The ship plunged deep as the cannon left the floor and sank its muzzle into the steel bulkhead. The metal sheared off, ripping open the whole side of the hold as the massive monster vanished into the waiting sea, sinking to its watery grave.

For a split second the ocean seemed to freeze in time. Then the deluge hit. A wall of water exploded into the hold in one mighty gusher. Anything not bolted down was caught up in a tremendous volatile explosion.

The storm was in the hold whipping, beating, lashing every-thing that was within, then expelling it in all its hysteria into the open sea.

The impact tore Bram away from Modoc, wrenching free his grip from her legs. He felt his body turning over and over, pounded, beaten, pushed by a force of enormous power. His eyes were sightless. A spiritual calm overtook him. He had lost all sense of direction. He felt the heaviness of the icy ocean water. A burning sensation in his lungs commanded him to breathe, to take a breath, just one, but his sense of survival made him hold his breath just a little longer . . . just another moment.

He burst to the surface like a buoy that had been forced under water, coughing, sputtering, wheezing, gasping for precious air. Water ran from his nose and mouth. The overwhelming taste of salt made him retch until his stomach ached. Bram fought to stay on the surface of a world gone mad. He was being swept along by huge mountainous waves. Up and down like a roller coaster, he was taken to the top only to be dashed down into the chasm below. Bolts of lightning arched across the darkened sky. Rain beat incessantly against the surface. A sharp object, flotsam from the ship, hit him sharply in the back. More dangerous debris floated by, pieces of smooth oak, still shiny, combining with chunks of the masts, unopened bottles, books, clothing. A piece of wood came by, big enough to cling to, with its brass fittings attached. He tried to reach it, but to no avail—the ocean was too violent for him to direct him-self.

His conscious mind was keeping something from him. Each time his thoughts wandered, there was something out there that wasn't allowing it to come through. Something he didn't want to know. His mind battled with his thoughts—the debris, the ship, Kelly, the hold. Mo . . . Mo! Modoc!

"Modoc! Modoc!" he cried.

The aching sobs for dead loved ones are the worst pain to bear. The breaking, shattering of all that once was between two living beings, gone, never to return, causes a weeping only the gods who created it should experience, the acceptance of nonentity.

Bram rolled onto his back, letting his body hang limp, floating as he watched the lightning perform for him. The rain beat down on his face, flushing the burning tears into atonement with the sea.

"Mosie," he whispered, half-lucid, "Breathe the water in. Suck hard, inhale deeply. It will pass . . . Die without pain. Be at peace."

15

"*Help! . . . Help!*"

Bram jerked his head above the surface, clearing his eyes and ears, and began to tread water. "Where are you?" he screamed.

"Here!"

"Over here!"

The voices were near, but the impenetrable darkness and the huge swells shielded Bram's view.

Lightning struck low and lit the sky for a moment. There, not fifty yards away, was a group of people holding on to one another, trying to stay afloat. Bram tried to swim toward them, but after ten minutes was exhausted and still not within reach, until a wave swept him by and a hand reached out, grabbing him by the neck. Only one person had a grip like that!

"Hands! You made it! Am I glad to see you!" cried Bram. Then, looking around, "All of you!"

There were five—Hands, two Indian sailors, and two Americans. Hands offered his big grin.

"Looks like you picked the wrong ship to stow away on, boy."

Bram could only smile his reply, as the swim had taken away his breath. Bram took his place in the group alongside Hands.

"If we made it, maybe others did, too," said one of the sailors.

"What happened to the lifeboats?" asked one of the Americans.

"Conditions on the deck were so bad we couldn't get any launched. They were banging against the side of the ship so hard, it was more dangerous to jump into one than risk staying on the ship. A few tried, like that poor fellow over there."

He pointed a bent finger in the direction of one of the sailors. The man's leg, supported by a floating piece of wood, hung crushed in his ripped pants. His face was as blue as the face of the dead sailor in the hold. The group fell silent.

Another voice pierced the dark, and then another. The wailing of lost, scared people carried on the wind. Everyone started yelling and screaming.

"Over here! We're over this way!"

Within what seemed an hour, at least twenty people came together, some sick, some dying, most exhausted, in shock, or both. The strong were helping the injured, trying to hold them up.

"It doesn't matter how many of us are out here together, you know," said one dazed sailor, "it won't help us stay afloat. We'll just pull each other down."

"Shut up, mister, or you'll get my fist in your mouth," snarled Hands, his face screwed up into an angry knot.

"Ha! Doesn't matter which way I go. In fact, yours sounds like a pretty good deal."

Hands realized the man was irrational and began helping the injured man be more comfortable. The hours dragged by; the storm seemed to lose its hurricane intensity.

"Thank God, the water's warm," said an American.

"It's because we're in the Bay of Bengal. If this had happened

in the Atlantic Ocean, we'd all be dead by now. The water is much colder there," replied Hands.

In the hours to follow, many took turns being supported by friends who held them up. One man slipped quietly into the water; he was not seen again, or discussed.

Bram's little group now totaled thirty-four, a large number to survive such a devastating sinking. If help didn't arrive soon, their survival would all be for naught. They would drown from exhaustion and exposure. Hands said that an SOS had been sent over the wireless continuously from *The Ghanjee* for six hours before she sank. He told the rest he felt their SOS had been heard, but no ship could come to their rescue until the storm subsided.

Bram was trying to float and sleep at the same time. Hands took an "Indian grip" with a person on the other side of Bram, which supported the boy while he rested. Bram tied himself to Hands, turned on his back, and closed his eyes.

What a whole different sensation he experienced. The body without its eyes was never prepared for the onrush of waves, and therefore didn't resist, just allowed itself to be pushed and shoved at the ocean's will. Bram's body for the first time felt itself sore and tender of muscle and bone. Had he not been tied, he surely would have been carried away. His thoughts wandered aimlessly from home and loved ones, to the sinking, and Mo. God! How will I ever live without her? he thought. As he sunk deeper into an exhausted sleep, the dream, the nightmare, became more real.

"Bram! Wake up, son! Listen!"

Bram came out of his sleep. Turning over, he saw everybody alert, listening. "What's wrong, wha—"

"Shush!"

Bram listened to the waves and wind and, oh my God, a trumpet! A trumpet! Was he still dreaming? Bram looked around; everybody heard it.

"Did you hear it?"

"Yes."

"Impossible. Listen, listen . . . "

Again the trumpet.

"Mo . . . Mosie. God, please let it be. Please Mo . . . Mo."

The sound was coming closer. Then, over a passing swell, a large gray mass was seen coming, washing down the current, closer, much closer. For a moment the mist cleared and they saw her.

"Yeah, yeah—it's her, it's Mo! It's MOODOOC!" Bram screamed and screamed, over and over. Again and again, Mo answered back, trumpeting, calling her young to her. Bram was close enough to see her thrash her trunk in the water, bellowing her frustration. He leaped through the water, forgetting he was tied. Hands quickly undid the knot. Bram swam harder than he ever had. Mo, too, was coming fast, caught in a current that was about to bypass and pull her away from him. Mo lunged like a horse, putting everything into her powerful body, and swam forward, stretching her trunk toward him. He reached out his hand, the tip of her trunk came closer and closer, until they touched! Bram grabbed it and Mo pulled him to her and screamed a voice never heard by humans. He hugged and kissed her neck and trunk and eyes and he wept. He couldn't talk, the emotion choked him up. He tried, but he couldn't speak.

Mo swam ahead to the people. They were hollering and cheering. Some old rope was thrown over her back, clothes tied to it, and all could relax. They didn't have to swim or stay afloat. Bram had climbed up on Mo's back, wrapping his arms around her neck. The others formed a circle around her, tying themselves to the rope. The hurt and wounded were put up top with Bram, and for the first time since the sinking, all slept while Mo, like an island, floated in the churning sea.

Early morning broke with the storm having subsided. The waves, although large, had lost their force. Their valleys were not as deep, nor the crests as high. The whitecaps had gone, and visibility was ten to fifteen feet, with fog so thick it looked as if a cloud had settled on the water. It was another time, another place, where things were wet and silent, where corners did not exist, and all light had gone but for a candle's worth, aglow against the pale dawn sky.

As the survivors awakened, they looked upon one another with despair and pain. They had not realized what ravages the storm and the ship's sinking had wrought until they saw one another's faces. Before, they'd only imagined; now they saw horror written in agony and pain. Bram had slept the night atop Mo, and awoke when he felt the tip of her trunk on his face.

"Is it over?" he asked of anyone who knew the answer.

"It's over," said a voice from below. Others nodded and mumbled their agreement that the hurricane, at least, had passed.

"What now? How do we get help?" Bram asked innocently.

Hands was stretching his huge, long arms, relieving the soreness. "We wait, lad. There's nothing else we can do but wait for them to find us."

"Yes, but they probably think we all drowned."

"Enough of this pessimism now," spoke Hands firmly. "I think you'd all better thank your lucky stars that this elephant showed up. If she hadn't, many of us wouldn't even be here right now. And the only reason she's here is because of the kid."

"You're right, sir, but this is all so damn peculiar. I mean, whoever heard of an elephant swimming in the ocean?"

"Elephants are great swimmers," defended Bram. "Why, back home, we used to swim all day and she never got tired. That's because she can just float, naturally. Unless, I guess, she gets waterlogged or can't hold her trunk up anymore."

"Is this your elephant, son?"

"Well . . . "

"Yes," Hands interrupted. "You're goddamn right it's his elephant."

Bram looked at Hands in surprise, saw his grin, and added "Damn right!"

Everyone was starting to feel hunger pangs, but above all, the worst agonizing pain, the pain of thirst.

"With all this water around us, you'd think a little bit wouldn't hurt," one of the circus roustabouts mused.

"Just try it, you'll see," responded an elderly midshipman.

A system was established whereby people would take turns resting up top on Mo. She seemed not to mind and was content as long as she was within view of Bram. Every couple of hours, four or five people would tread water in front of Mo, allowing her to stretch her trunk out across their shoulders so she could relax it and rest a bit. At first she thought it good fun and would wiggle and tickle their faces, so Bram told her no, and because of the seriousness of his voice, she soon stopped.

The day passed without their encountering more people or debris. Bram, to while away the boredom, loved to curl up underneath Mo's chin. He'd nestle in between all that muscle and skin and movement. It was like being in a room all to himself—the chin and jaw above, the neck and chest behind, two huge legs on the side, and sometimes the trunk would come down for a visit from above. It was when he was "in his room" that he noticed Mo kicking her feet and swimming. Realizing the importance of conserving her energy, he taught her to stop kicking and let them hang.

"We aren't going anywhere," he told her.

The glow of day disappeared. Night had fallen, and still no sign of help. Men were openly crying, worried about their families, their chances of rescue. One man put his hand on Bram's head, praying and thanking the Lord for him. Bram lifted it off and put it on Mo's head. Light rain fell most of the night, and by morning everyone was chilled and preferred to stay low in the water.

The second day was no different from the first. The fog got so heavy that it was as if they were in a small mystical room, with vaporous walls, a watery floor, and an eerie light glowing from above. Even their voices took on a hollow effect. By nightfall many cases of delirium were evident. Outbreaks of screaming, crying, fighting, and thrashing in the water became more frequent. Those who felt that there was no hope in sight seemed to work their way around the rope to the back of the elephant. There, in a private moment, they could just drift away.

Idling their way into the third day, most were resigned to their

fate. Few talked, too weak to care about anything. Bram felt his body weakening. He slept more and even caught himself talking aloud. Mo, too, suffered from exposure to the elements. Her body quivered from the constant lapping of water at her sides. She was losing her body heat because of no circulation, and strength was leaving her muscles. The men were so weak they could no longer help support her trunk, so sometimes, in sleep, her trunk dipped below the water, causing her to awake sneezing and sputtering, choking on the salt water. In her own way, she seemed to understand what was happening.

What seemed to be more important to her than anything, including the dangers of the sea, was being with Bram. At times he would nestle up to her ear and tell her stories about the barn, the circus, Gertie, Mutte, and Curpo. It was as comforting to Bram as it was to Mo.

That night Bram counted twenty-seven people still clinging to life. The ocean was calm, the water warm, all was quiet except for an occasional moan. Bram had fastened a piece of rope into a support sling to help Mo rest her trunk. It would last awhile, then break, and he'd have to start over again. Many times he and Hands joined together, acting as human rope, lifting just the top portion of her trunk above water so she could breathe. They knew that without Mo, nobody would last more than a few hours.

By Bram's mental watch, it was about ten o'clock in the evening when they heard it. At first it sounded like a motorboat. It was the only mechanical sound they'd heard since being in the water, and everybody—everybody who was conscious—rose up to listen. The little band of survivors started to scream, yell, many were crawling, scrambling for a foothold to climb on Mo's back, sinking her down. Bram and Hands had to fight, kicking and shoving, to get them off, but the people had gone mad, desperately close to death, with only one hope: the sound of an engine.

Then they saw it! The sight brought tears of joy to waiting survivors. Crazy patterns of colored, flashing searchlights were waving up and down, ruffling the darkness, weaving trails of red, blue,

and orange against the fog bank. Then the bow of the ship broke into view.

"Helloooooo . . ." came a voice.

"We're here! Over here!" yelled Hands instantly.

Through the billowing vapors knifed an antiquated Indian dhow—small but powerful. It featured one mast with its sail tightly furled from top to bottom, and a small wheelhouse located in the forward center of the boat. Huge amounts of rope were coiled throughout the deck. The low throbbing of the powerful engine made Modoc a bit nervous. Across the bow was carved the name *Sahib*. On board were two Indian men, each wearing a turban—one white, the other red—and both sported the traditional beard. Their white teeth flashed smiles as they moved in closer to Mo.

"They told us on the radio what to expect, but one must see it to believe."

"Go easy now, man, we don't want to frighten her," said one.

"Aye-aye, sir," the other answered.

They cut the engine and let the boat drift until Hands could grab hold of the side. The wind had picked up and the swells had increased, so it was difficult for him to climb aboard. Once on deck, Hands could see the tug wasn't much bigger than Modoc.

"Aren't there any larger boats that could be sent?"

"We heard the SOS and have come to help, as I am sure other boats are doing. Please accept my apology for not having a larger vessel," replied the man humbly.

"Sorry, I didn't mean to be rude, but you see we have a problem here."

"If you mean the elephant, oh, that's no problem! Just leave it and I can arrange for you to acquire another when we reach shore."

Hands glanced toward Bram, but he'd gone to "his room" out of sight under Mo's chin.

"I am most sorry to have to tell you, sir, that we must load quickly, as a very unhappy storm is approaching and we must go back immediately." The swells had become full-sized waves, their whitecaps riding the crests . . . reminders of the past.

"Okay," signaled Hands, "one at a time. Get aboard."

A sigh of relief swept through the men as Hands allowed them to board the vessel. Many collapsed on the deck, trying to find their sea legs, or too weak to stand. Hands was beside himself. What was he to do? Never in his career had there been a problem that he couldn't resolve. He'd grown fond of the boy, and Modoc, too, and had promised that everything would be all right.

"Bram!" Bram reappeared into view at Hands's shout. "Look, son, the only way to do this is to go back with the boat and bring out a vessel big enough to handle the job."

Hands knew what he was saying was ridiculous, since Mo's trunk was already hanging completely below the waterline except for the tip. With the storm approaching, there wouldn't be enough time. From under Mo's chin came Bram's resigned voice.

"It's okay, Hands, you go on. I'll be fine."

"What the hell are you talking about, huh? Now don't be stupid, boy. A ship will find her and . . . Bram, you hear me?" Hands was starting to lose it. His voice broke from the strain. Bram had turned Mo away from the boat.

"Move up, girl, that's it, move up." He was moving her slowly away from the boat. Her energy was at a low ebb, and had it not been for Bram, she wouldn't have budged.

"Bram! Get the hell back here! You're crazy! You can't do this!"

"Don't worry. Mo and I will be okay." As the fog swallowed him into the invisible, his voice trailed away saying, "Eye Hands, thanks for everything."

"No, wait! Don't go. I've got an idea." Hands was berserk with what was happening. "We can tow her in! That's it! We'll put these ropes around her and tow her. Bring her back here now, Bram!" Hands immediately set to work. "You men grab those ropes!"

Nobody moved.

"Bram, bring her around!"

Hands was tripping and falling as he tried to handle the ropes by himself. The men weren't moving. With the storm coming they'd have to get back to port at full speed, and tugging Mo would only

slow them down. More important, they saw she was failing fast and was too weak to endure the trip.

"You men hear me!" Hands raged, tears welling up in his eyes, his throat in a knot. "Now give me a hand!"

He reached down to gather another coil when one of the sailors picked up a huge chunk of wood off the deck and coming up behind him, cracked him hard over the head. Hands fell, blood oozing from his temple. Everyone sat still, looking at his body, except the man who had hit him. He rolled the lifeless body over, sopped up the blood with the bottom of his shirt.

The sailor turned to the captain of the tug. "We can go now."

The storm had gathered strength and the tug was being tossed around like a cork. The big engine revved up, the boat leaned back and roared ahead, powering its way through the waves, back from where it had come. As it disappeared into the fog, voices could be heard crying out.

"Bye, Bram, thank you . . . "

"See ya, Mo."

"Sorry . . . "

= 16 =

HOURS HAD PASSED. The fog thinned, and in places had torn open to reveal the white brightness of a three-quarter moon outlining the massive thunderheads that dominated the heavens. Whitecaps had transformed into large, smooth swells that rolled in wide sheets of bottomless liquid, while a light warm rain sprinkled the surface with silvery dimples. Mo's huge, flaccid body floated low in the water, as though dead, her energy long gone. Mini-whirlpools slowly swirled around Mo in big circles, as if she were a leaf being washed downstream. Bram was nowhere in sight. A clot of floating debris got hung up briefly against Mo's side. A hand slowly reached out from under Mo's head and grabbed the largest piece of wood."

"This'll help some, Mosie."

Bram's voice was barely audible and he was shaking, weak from exposure and exhaustion. Struggling to lift her trunk off his

shoulder, he set it on the floating piece of wood, which sank a bit from the weight but kept the tip out of the water for the moment. Bram knew she was dying. Mo's body was cold to the touch, and unmoving; her trunk lay listless, no sign of life anywhere in her entire being, except her eyes . . . living eyes in a dead body, as though someone inside was looking out. It was from these half-closed eyes that she watched his every move. Cuddling down under her chin, he supported her huge head as best he could on his shoulder.

"Now, girl, we have to think about all the good things that have happened to us. Papa told me that whenever things go bad, look to—" Bram felt a slight shudder in her body. "Mo, are you listening?" Tears spilled over the rims of his eyes as he set her head down and moved to her side so she could see him better. Her lids were closed. *"Mo! . . . Mo! . . . "*

She opened them slowly, searching languidly until one looked directly at him. This was the boy she loved, the one person in the world for whom she would do anything. The glazed eye saw his lips move, his mouth speak. Her whole existence of trust and love was in her gaze. Bram's voice was choked with tears.

"It's time, Mosie . . . now don't you be afraid. We'll be together, and as long as we are, nothing can hurt us." He wiped his face of the flood of tears, they tasted so sweet; then put his cheek against hers. He smoothed the soft skin around her eye with his finger. "Goodbye, Mosie. I'll see you on the other side."

Modoc's eye gradually closed, squeezing a bead of wet out of the corner.

"Now I'm going to slip this board out from under your trunk," Bram said, kissing the wet spot, "and when I do, you just keep thinking of the circus, and Emma, and the clover fields, and all your friends who love you."

Bram realized that these were his own final moments, and for the first time he felt scared. "Papa . . . sorry, Papa, I tried." A warm sensation came over him as he thought of seeing Josef. He knew his father would be waiting. "Maybe we'll even meet your namesake, huh, Mo?"

Bram didn't want to be out there alone without her, and he knew once the board was pulled, she wouldn't be able to keep her head above water. He gently pushed his arm up into Mo's mouth, resting his hand on her tongue. He asked her to "hold," knowing this way he'd be pulled down with her. Then, looking around to see if there was anything he might have forgotten, white with terror, he said, "Goodbye, Mama . . . Gertie . . . Curpo." He pulled the board; it drifted away.

Modoc didn't fight it; she instinctively knew they were at the end of their adventure. In a few minutes her huge head slowly sank into the water with Bram's arm locked in her mouth. His head disappeared beneath the surface also.

For a moment all he felt were the bubbles; the agonizing wash of the sea was gone, and a peace and quiet descended upon him. By reflex, he held his breath. He was slowly letting it escape when he heard a noise. A curious noise. It was a distinct sound, the vibration of a *motor* and it was . . . yes! Getting louder!

He wrenched and twisted, trying to swim up, but his arm was firmly locked in a death grip. Fighting for his life, he pounded on Mo's cheek. It was futile; they sank deeper. Bram was about to black out, everything was fading into one . . . the water, the bubbles, Modoc, the noise . . . Everything was melting together and spinning, spinning into oblivion.

Suddenly he felt the impact from a gigantic splash only a few feet above him. It was so enormous, so startling that Modoc, in her resigned death throes, reacted. Shocked, she moved up, breaking through the surface of the water, carrying Bram high into the air with her! They were blinded by the brilliance of floodlights. Men in special suits were all around them in the water, some holding up Mo's head and trunk, others swimming under her, fastening a thick canvas sling beneath her. Bram felt a powerful arm scoop him up. Airborne for a moment, he was placed upon a hard surface. People were attending to him, but through the crowd his bleary eyes searched for Modoc. He could see her being hauled out of the water by an enormous crane. A large man wearing a turban was shouting

orders. They were on board a ship, the whole back of which lay in the water like a great hinged gate. In a state of shock, Bram wondered why the ship didn't sink.

Mo was carefully swung over the deck and gently lowered. As her feet touched the deck, her legs buckled and she collapsed, so she was laid on her side. Bram, exhausted, passed into unconsciousness.

"Engines . . . full throttle . . . radio Calcutta for arrival at 0400!" and the local city ferryboat got under way.

≡ 17 ≡

"I'M SORRY, but the doctor left strict orders that the patient is not to be disturbed!"

"But I understand he's starting to wake up, the doctor told me so himself!"

Bram was gradually coming around, first in his mind, trying to contemplate who he was and what was happening to him, then in his body, pushing away the excruciating pain. His eyes opened to a blur of pastels, white, light brown, pale yellow, a tinge of blue. Nothing was moving in the blur except a brown flat thing that kept cadence with a creaking sound.

"Please, I have to be there when he wakes up." The man pushed his way past the nurse and headed into the room. Leaning over the bed, he tried to look through the mosquito netting that tented over it. "Bram, you in there, old man? It's Kelly . . . from the ship."

Bram fought with his senses to clear his mind as well as his vision, which was slowly coming into focus. He saw he was lying in a bed encapsulated in gauze. The man outside the netting was talking to him. Kelly . . . *Kelly!* It all came back fast and hit him hard. He bolted into a sitting position. Searing pain cut him to the quick; every muscle, joint, bone, and tendon was sore and painful. He howled in agony, clutching his body for comfort. Kelly pulled back the netting as the nurse, giving him a dirty look, settled Bram back down into the pillows and blankets.

"I . . . don't understand . . . you were on the ship when it . . . "

"Yeah, me'n a couple other guys were the first to be picked up. We lucked out and floated on a large piece of the captain's wheelhouse." Kelly's face changed quickly as he recollected. "It was real bad, son, but"—he cracked a smile—"some of us made it. I couldn't believe it when they told me you were here. I mean, after all, you were down in the hold."

Bram raised up on one elbow. "Kelly, Mo! Is she . . . ?"

"She's still down, but look, she's still alive. That's why I had to come here. I knew when you woke up you'd want to know."

"Where is she, Kelly?"

"They've got her at a place, a special place for elephants, outside town a ways. Everyone's talking about her. That's how I heard. I ain't been there, but I don't think it's too far."

"I've got to go to her, Kelly." Bram started to get out of bed.

"Hey, wait a minute . . . now look, you've been in here seven days—a whole week! Let the doctor do his stuff. You know, give you a few needles, some X-rays, then get a good night's sleep and if things look good in the morning, well . . . maybe they'll let you see her for a little while. I'll personally take you to her."

Bram lay under the covers thinking about what had happened and what he must do. He slept well into the night. When he awoke the room was dark. Switching on a small table lamp, he took a look around the room for the first time. At the far corner of the room, a very old man wearing a turban and sarong sat on a carpet on the

floor. In his hand was a thin rope that led to a large flat rattan fan attached to the ceiling. When pulled, the fan waved to and fro, cooling the air in the hot, humid room. Unfortunately, he'd fallen asleep, and the fan hung motionless.

Bram had to find Mo. Fighting off the excruciating pains in his body, he lifted himself to an upright position. He fumbled with the netting, tried to find the opening, but his patience wore thin and he ended up ripping a large hole in the transparent material. Sliding through the gap, he searched the room for his clothes, which were nowhere to be found. Bram took one of the large pillowcases, tore an opening in the closed end, and slipped it over his head down to his waist. By standing on the bed, he managed to untie the cord holding the netting together and used it as a belt, fastening it around his waist to hold up his skirtlike apparel. A second pillow was ripped into strips, from which he fashioned a simple but effective turban. Once done, he examined himself in the reflection of the medicine cabinet.

"Not bad," he whispered to himself, "not bad at all."

Moving to what appeared to be the nearest exit, he pulled back the red and white striped curtain and cautiously looked out. There was no one to be seen. Bram took a few steps to a nearby railing and peered over the edge.

The hospital, originally a Hindu palace, was structurally sound and sumptuously designed. Converted at the turn of the century, it had high arched ceilings and giant, intricately carved columns that seemed opulent for its current use. The building featured a second floor that opened to a view of the massive central lobby and its entrance hall. Its balconies circled the inside of the entire building, and numerous walkways that led to rooms had been converted into operating rooms, an X-ray department, and pathology laboratories. Each open area employed one or more "fan men."

From the balcony Bram watched with fascination as fifty or more fans swayed rhythmically in their endless task to keep the hospital as cool as possible. However, the mesmerizing motion of

the fans often put some of the operators to sleep. To save the generator, candles lit most of the rooms.

Sticking close to the shadowed corridors, he found his way downstairs and through the front arches leading to the street.

Bram stood at the hospital entrance, looking out with confusion into the dimly lit street. Although it was quite dark, he could see the road was a badly damaged tarmac—mostly dirt with a patchwork of deep holes, boulders, ruts, algae-covered mud pockets, and potholes full of black water. The street was bordered by ancient clay buildings, some two stories high. Small windows had been cut into the walls at the discretion of the builder. Stupas crowned the rooftops of the few that could afford more stylish construction. Kiosks lined the street in front of most of the buildings; their colorful awnings lay still in the night without the faintest breeze. A few bone-thin stray dogs meandered across the road, followed by an assortment of multicolored goats.

Beggars filled every nook and cranny. Some huddled over a cooking fire, waiting for a small piece of sustenance to have the bacteria cooked out of it. Bram could hear their low mumbles, noting these people moved quietly, watching for the unknown with fearful eyes. This was a city in waiting.

In his weakened condition, Bram's nausea and pain were almost overwhelming. Half a dozen Brahma cattle nibbled at the grass along the edge of the road. He looked at the various signs protruding from the buildings, trees and poles—all in a strange language he could not read. However, one in particular caught his eye.

KISMET ROYAL ELEPHANTARIUM
10 KM

An arrow pointed the way. Bram followed the arrow's direction. An elderly Indian rode by slowly on a dilapidated old bicycle. He passed Bram in the road and noticed the young boy wince. He reduced his speed and said something to Bram. Bram didn't understand what the old man was saying until he gestured for him to sit

on the handlebars. Bram smiled in appreciation and nodded. He climbed on board.

For miles he sat on the handlebars, his body tortured by every pothole and rut they hit. The man driving never said a word, but occasionally rang a small bell attached to one handle. He seemed obsessed with ringing it. He rang it at every rut he hit, every water hole, every bog. He rang it often, even when they stopped and had to walk the bike.

At a crossroads, the driver stopped. Bram thanked the man as best he could. The man looked at Bram and began ringing the bell as he rode off into the sweltering Indian night.

Bram walked on until he noticed ahead shafts of light coming across the road and disintegrating into the forest beyond. From where he stood, he couldn't see where the light originated. Hastening, he rounded the corner and was met by one of the most beautiful sights he'd ever seen.

A gleaming white palace of unbelievable grandeur stood on a bluff. A multitude of brilliantly colored lights lit the alcazar and the surrounding fields of rich green grass. Made of the finest alabaster, its top was studded with stupas, domes, spirals—all rising in the sky. Pathways ambled in every direction on the palace grounds, lined with vivid blooms of chrysanthemums, bougainvillea, and roses. Waterfalls of all sizes cascaded cool, fresh water into streams and brooks brimming with exotic and colorful koi. Gracing the entrance, centered on the front lawn, and resting high upon a platform, was a full-sized teakwood replica of an Indian elephant, its head held high in all its majesty, its trunk raised in a sign of triumph.

Bram had never seen such beauty and elegance. He followed the stone walkway that led up to the marble staircase. He counted forty stairs as he climbed to the great doors of the palace, but saw two guards standing at either side, each holding a lance. Bram didn't want to risk being discovered, especially when he felt he was so close to finding Modoc.

To the right he spotted a narrow path. Bram followed it but

soon was lost in a maze of roses, lilacs, and daffodils. The aroma was breathtaking, and mingled with it was an all too familiar odor: *elephants!* He followed the scent; the pain seemed to leave his body as he hurried through the garden, sniffing the air. He came out on an open lawn. Some twenty yards in front was a knoll. Running to the top of it, overlooking the valley below, Bram was greeted with a spectacular sight.

It was the elephant compound, better known as the Elephantarium. All the structures were of Hindu design, bleached white stone walls, tapered roofs, gold-leafed spirals, with Hindu statues and artifacts delicately placed throughout the facilities. Directly in front appeared to be the main office building. The building with the hospital flag flying from the roof spoke for itself. Circling around, he approached the hospital from the side, hoping no one would be there this early in the morning.

The door creaked as it opened; its echo let Bram know he was in a very big building. It was pitch dark inside except for a row of small candles set on the ground and running down the middle. Bram's eyes hadn't adjusted to the darkness yet, but he knew elephants were here. Their heavy breathing, blowing air through their trunks, and rattling of chains told him there were more than a few. As his eyes adjusted, he started to walk down the center, alongside the silently flickering candles. Bram gasped as he saw elephants lying or standing on either side of him. Big ones, a few medium-sized, a couple of punks. Some had bandages, a few wore splints. This was indeed the hospital . . . a hospital for elephants. Many wore heavy metal identification plates linked to their leg chains.

Bram carefully checked each one, hoping to find Modoc. There must have been twenty, but by the time he got to the end, there was no sign of her. Bram felt his body quiver. Was it a reminder of the ocean, or Mo? Had she died; had Kelly not wanted to tell him before he had recovered?

"Mo?" he whispered, "Mosie, are you here?"

All the elephants became quiet, listening to the stranger's voice in the dark. Then, one by one, they answered Bram with

grunts, trumpets, and squeaks. The vocal assembly was deafening. As they settled down, Bram heard a low guttural sound.

"Mo . . . is it you?" His heart raced. Again he heard the sound come from another section of the building. It was barely audible, back in the dark away from the others. He heard it again, the same noise, a weak animal trying to speak. Reaching down, Bram picked up one of the candles and walked into the darkness.

"Mosie, where are you? Mo . . . ?" Away from the other candles, the darkness was total. Time and time again he tripped over something or other, lying on the ground.

"Mosie, say something, baby, so I can find you." He stopped for a moment.

Up from the floor rose a moan from the edge of death. Bram fell to his knees. There was Mo, right in front of him!

"Mo! Mo! You're alive!"

He put the candle down nearby and ran his hands all over her. Pressing his face to her cheek, he cried tears of joy, of deep and utter gratitude. Mo's trunk managed to maneuver itself to his face, the tip exploring all over, checking as best she could if he was all right. Bram laid up under her chin, their favorite place, even though he remembered his father's comment about sleeping head to head. She laid her trunk over his shoulder as a mother would with her child, and listened as he began to tell her, in a hushed voice, all that had happened since he last saw her. Thus, Bram found Mo, and by the light of a single candle, the two talked in their way, of ships and oceans, love and death, pain and survival. Had an outsider listened in, he would surely have thought these stories must have been a child's delusions—until the candle burned low, and sleep became the victor.

= 18 =

"WAKE UP! WAKE UP, SIR!"

Bram awoke from a deep sleep to find a group of people standing over him and Modoc. They all wore garb similar to what he remembered seeing on the staff at the hospital. On their turbans and kurtas was an insignia with an elephant similar to the statute in front of the palace. The name ELEPHANTARIUM was arched over it.

"Please, sir, are you not aware of the danger you are in by being where you are at this precise moment? Sir?"

The young man who spoke was tall and slender, with black, shining hair, and was dressed in a kurta. Bram realized he was still lying under Mo's chin and promptly stood up.

"English? You speak English?" he asked, happy at last to speak with someone who could understand him.

"Yes, as do you, I see. Most of us here have learned many languages, English is one. This is good. My name is Sabu," said the

stranger, "and I am in direct charge under Dr. Scharren, our in-house veterinarian."

"Mine is Bram, and Modoc and I were rescued at sea."

"Oh, so you are the one that I have heard about. I wish you welcome to our establishment, but it is most unusual for our guests to come to us in this way," said Sabu, smiling.

"I'm sorry, but I haven't seen her since the emergency, and was worried, so I . . . "

"I understand, but now, please to let me show you a place of privacy where you may change your clothes and eat nourishing food and rest from your trip."

"Thank you, I appreciate your help, but Modoc needs me. I think it's better if I stay here."

Sabu looked at Bram with a serious face. "You are one of us, I see." Then changing the thought, "She has done nothing more than turn over now and then since she came here, and we are afraid that the disease of peritonitis will commence, as her circulation is poor."

At once Bram went to Mo. "Good morning, Mosie, how're ya doin'?" He put his face down close to hers and gave her a small quiet kiss on the cheek. Suddenly Bram became self-conscious and embarrassed in front of Sabu and the others. But Sabu smiled his understanding. "All right, Mosie, it's time to get up now. We've got the world to see and I don't want to see it alone, so move up, Mo! Move up!"

Mo's eyes opened wide. She looked around, taking it all in, and seemed to gather energy. "Please, everybody, help support her as she stands. Okay, Mosie, now girl, up! Up, Mo!"

Mo started to rock, each time raising her two free legs higher in the air. On the third try, she threw her head into it, and with the help of six people, all pushing, managed to right herself into a sphinx position.

"Good girl, Mo. Now rest a minute while all that good blood races around and fills in those dry spots that haven't had any for a long time."

Sabu was awestruck. "Why, this is very wonderful!" he exclaimed. "You speak the tongue of the pachyderm."

"If you could bring a few more people to help when she stands, it will make her feel more secure," requested Bram.

Sabu spoke to one of his assistants, who raced away. "Meanwhile, we can rub her down with a mild astringent to assist the movement of the blood, yes?" asked Sabu.

"Yes," affirmed Bram.

Sabu's assistant came back with twenty men, all eager to help. The liniment had been applied and Bram was ready to stand Mo. He addressed the group.

"As she stands, think of yourselves as her muscles. Apply your strength to those areas that need it." Modoc was surrounded by people, all awaiting Bram's signal to help her. "Okay, Mosie, come up! Come up! Now, Mo! *Now!*"

She began by stepping two front feet backward, raising her front section. Bram had all the men launch themselves against her chest and her front legs, and push as hard as possible. Slowly, her front feet stepped backward until they were in place. Her head was now quite high in the air. Everyone ran around to her hind section, forming a semicircle.

"Mo, this is it, girl. This is all the way. Come up, Mo, come up!" She strained for all she was worth, and so did they, with some even getting underneath—a dangerous place to be if their effort failed. With great shoving and lifting of tonnage . . . slowly . . . Modoc stood! A cry of victory went out, triggering every elephant in the ward to answer back with full-blown trumpets. Special supports were brought in and a sling was lowered under Mo so she could relax her bulk at will and take the weight off her legs.

Bram stayed twenty-four hours a day, feeding, watering, cleaning, and helping Dr. Scharren with shots, pills, and any other medication that was necessary. He set up a place to sleep, and the staff saw to it that Bram had everything he needed to be comfortable. He could eat all his meals with them or have them brought to him if he felt Mo was having a bad time.

Dr. Scharren, a rather obese man, was always having trouble picking things up, climbing stairs, or, for that matter, doing anything that required physical exertion. He was quite jovial about it, however, and his good nature carried through to the care he gave the animals.

"You should go to school and become a veterinarian," he suggested to Bram. It was during a time when one of the not-so-nice elephants had rammed its tusk into another who was standing too close. Sabu was away, so the doctor asked Bram to assist him. The wound was quite deep and needed a number of stitches.

"I used to help my father with things like this," Bram said, holding the hemostat as Dr. Scharren sutured the jagged wound. "Blood never bothers me, but I'd still rather be a trainer than a vet, if you'll pardon me, sir. Elephants are much more fun when they feel good." The doctor laughed and continued suturing.

Sabu informed Bram that the owner of the Elephantarium, the maharajah, had heard of the Modoc incident and, upon inquiring, was very pleased with Mo's progress.

"He said he was proud to have such heroes here as his guests and looks forward to meeting you soon. Until then, he offered a place to live and the continued best care available for Mo. I told him of your desire to sleep alongside Modoc, but he wanted me to speak with you anyway."

"Please tell him I think it would be better for me to stay with Mo until she is completely over her illness, but then I'd be happy to accept his kind offer. Deep down, Sabu," Bram added, his voice taking on a serious note, "I feel Mo's problem isn't just physical. With what she's been through, well, I think it will take some time before she feels safe and secure again."

"Master Bram, you are a rare person not to choose the comforts for yourself. I will inform His Majesty of your decision."

When news was brought to the maharajah that Bram preferred to sleep by Mo until she was better, he ordered a bed to be made for him. Constructed from valuable teakwood, it was ornate and hand-carved, with a canopy, and fitted together without the use of a sin-

gle nail. Wherever a joint was needed, a peg of a particular wood was inserted, and within a day's time, the peg exuded a strange sap, causing it to swell and thus seal the joint firmly. After the carvers had finished, an artist was called to paint the designated areas. The painter loved bright vivid colors, and created many elephants in various scenes of performance, combat, and work. He chose to paint each a different color. There were green and blue and red elephants and every other shade one could imagine. While gaudy, it was truly a work of art . . . and Bram loved it. The day it arrived, all the mahouts and their assistants turned out to see it. It was carried by six fan men, followed by a procession of the carvers, and their apprentices, the kitchen staff, and a small entourage of the maharajah's delegates, all anxious to see if Bram was pleased. Carved and painted at the top of the headboard were the words HATHI-KA-SAHAB which meant "Master of the Elephants." A week hadn't passed before a matching table was added, and a week after that, a chair.

Kelly became a frequent visitor, bringing fruit, nuts, and gifts from the city. They were walking through the Elephantarium's facilities when Kelly pointed to a gold-domed structure standing high above the trees in a nearby section of the forest.

"What's that?" he asked.

"Sabu told me it's where they keep the Royal White Hathi; that means 'elephant' in Hindu. Nobody is allowed to see him unless granted permission by the maharajah himself."

"Maybe someday he'll let you see it," said Kelly.

"That would be a fantasy come true, 'cause I don't believe it really exists. If it does, I can understand why it's so very sacred and respected by the Hindu people. Maybe it's just for their eyes." Bram thought about it for a moment and then changed the subject. "I still don't understand how we ended up in Calcutta. This is way off the course the ship normally takes. At least that's what I was told."

"Well," said Kelly, "that storm was powerful! Once we rounded the tip of India, the hurricane blew us off course, and the current from the bay pulled us in."

"Good thing it did or we might never have made it."

"When you think of all those people lost . . . "

". . . and the animals," Bram added.

"I know. It seems impossible."

"We're very lucky, Kelly. The Indian people here call it good karma. They say we were saved to do something special here on earth."

"Well, whatever it is I'm supposed to do will happen in the good old U.S.A."

"What? When?"

"Probably next week. I received a telegram from the circus saying how badly they and all the people back there feel, and the sooner I return, the better."

"Did it mention anything about the animals?"

"No, an earlier wire said they were sorry that most of the people and animals were lost."

Bram stopped for a moment. He placed his hand on Kelly's arm. "Kelly, this is very hard for me to say and I never wanted anybody to lie for me in my life, but if they should ask about Mo or read something . . . "

"What's a Mo? I don't know anything about a Mo." Bram looked at Kelly. He didn't know what to say. "Hey," said Kelly, "no big deal, okay?"

"Okay."

Kelly threw his arm around Bram's shoulder, and together they finished their tour of the compound.

Bram asked everyone he met if he'd heard about any survivors, hoping to hear some news of Hands. There was only one small newspaper in town that appeared once a week. By the second week, the sinking was old news, and just a small article appeared on the back page, retelling the same facts.

Everybody knew that the ship had gone down in the worst typhoon to hit the area in the last decade, and that there had been only a few survivors. Wreckage was found up and down the coastline; the bodies washed up on shore included that of a male ele-

phant, but no news about any living person or animal had been reported.

Sabu noticed that Bram was quiet most of the afternoon, staying away from the others, staying close to Modoc. He approached respectfully and placed his hand on Bram's shoulder. Bram looked up.

"You seem most sad today, Bram. What has happened?"

"It's . . . the elephant they found on the shoreline was Krono. Another friend lost. It makes me sad when I remember all my friends who . . . died."

"They say that no one ever dies. We simply move into another form to live again. In our country there is no death, only the changing from one into another, much like the caterpillar into the butterfly. I'm sure your friends have all come back in their new and brilliant forms."

"Thank you, Sabu. I would love to see Krono and the others again, no matter what form they are in."

Later that day Bram checked with the hospital to see if there was any news of Hands. No one could understand what might have happened to him. Bram spent the night with Modoc and held tightly to her, so that he could feel her form close.

The next day a courier brought a message written in gold ink, saying that the maharajah would be pleased if Bram would accept an invitation for lunch at the palace. Folded over the messenger's arm was a smart-looking red and brown kurta, insignia and all—a gift for Bram to wear at the luncheon. It was exciting for Bram to even think of seeing and speaking with such a powerful man—a man who apparently loved elephants the way Bram did.

Bram was escorted to the palace by Sabu, who told him all the things he should and should not do in the ways of diplomacy and etiquette at the palace.

"Never sit higher than he sits. Never interrupt his speaking. Remember to thank him for his courtesy. Always answer his question before asking your own . . . "

By the time they arrived, Bram was a nervous wreck. "I'll never remember all that!"

Sabu smiled. "I'm sure it will be there when you need it."

They entered the palace through the purple and white marble great hall. Its length was equal to the distance from the barn all the way down to the mailbox back home, thought Bram. They were met by one of the maharajah's assistants, who escorted them to a large, airy, open room adjoining what appeared to be a veranda.

The setting had captured nature's beauty, with clear blue pools, rock crystal waterfalls, tropical plants from the jungle. Pink flamingoes, kiwi birds, and atlas deer were free to roam the grounds.

A table at the edge of the pond had been set for four. Long-stemmed Italian red crystal goblets, hand-painted china dishes, intricately folded napkins appealingly graced the table. The assistant who had vanished for a moment returned carrying a gold tray with two clear crystal glasses filled with an iridescent purple drink. Bram followed Sabu's gesture by taking a glass. Cautiously sipping, he found it so delicious that he had to fight the temptation to gulp it all at once.

The echoes of two men talking could be heard as they entered the room. Both appeared to be in their forties, both slightly gray at the temple. The first wore a turban encrusted with jewels and was dressed in a white velvet coat, adorned with pearls; the larger pearls dripped off the collar and cascaded down the front of the fitted jacket. Smaller pearls outlined the pockets and seams. Matching velvet pants ended at a pair of velvety smooth suede shoes.

The second man was British and wore an expensive bush jacket adorned with epaulets. English riding jodhpurs and highly polished oxblood riding boots completed his wardrobe.

Sabu turned and lowered his head slightly as the two men approached, and Bram followed his friend's actions.

"Ah! Welcome, my boy. Sabu, good to see you." The man in the velvet jacket stepped forward to shake both their hands. This was undoubtedly the maharajah. He continued, "I would like you both to meet Mr. John Rudyard, my good friend from the teak forest of Burma."

All parties shook hands. The maharajah turned to Bram. "I want you to know that I have had a detailed account of your actions at sea, and I commend you for your bravery and loyalty to your dear friend, Modoc."

Bram, a bit embarrassed by the compliment, lowered his head and whispered, "Thank you."

The maharajah continued, "Mr. Rudyard will be staying with us for a short time, using our facilities to train some of his elephants for his forest operation."

As the men returned to the patio, four waiters appeared to draw back their chairs for seating.

"If I can be of any service during your stay, Mr. Rudyard, please don't hesitate to inform me of your needs," offered Sabu.

"That's very kind of you, I must say," answered Rudyard. He turned to Bram. "You, young man, have done an extraordinary thing, keeping your . . . what's her name? Modoc? Yes, Modoc, afloat for such a desperately long period of time."

"She has a strong heart, sir," Bram replied.

"More like a loving one, I'd say, hmm?" interjected the maharajah.

Bram fiddled with his napkin. Sabu, seeing his predicament, came to his rescue. "Young Bram has done a remarkable job with Modoc, Your Highness. He seems to have that special ability with elephants to control them through their emotions, rather than forcibly."

"Yes, I have heard of what has happened since your arrival, and find it most interesting." Then, turning to Rudyard, the maharajah added, "John, perhaps Bram would like to see how you prepare elephants for work in the teak forest."

"Of course, it would be my pleasure."

The sumptuous feast in no way resembled a simple lunch. Bram and Sabu left the palace with Bram talking a mile a minute. The palace, the food, meeting the maharajah and Mr. Rudyard, and soon going to see elephant training for something he never knew existed was more than he could have imagined. All his young life

Bram had been told how to train elephants to perform. Certainly there were times when they were needed to help with heavy work around the circus, but this was different. These elephants spent their lives working, as circus elephants did performing. Bram talked all the way back to Modoc's quarters, and then he had to repeat it for her!

= 19 =

A FEW DAYS HAD PASSED when a small Indian man wearing a sailor's uniform came to see Bram. As the man approached, Bram recognized him as one of the sailors who had been in the water with them. The sailor walked slowly toward him, then, taking his hat off, looked down and greeted Bram in a heavy Indian accent.

"My name is Vinod Shah. I am a seaman in the British navy. I was on the ship and later in the ocean with you. I have come to beg your forgiveness for the horrible thing that I have done." Bram had no idea what the man was talking about. The man continued, "When we were rescued on the first ship, Hands wanted to try to bring Modoc on board, maybe drag her in the water, but it would have been unrealistic! It was wrong of me to hit him, but I was thinking of myself . . . and the others!"

The man was overwrought, completely shaken by his confession.

"Sit down, Mr. Shah." Bram offered him a chair. "Explain, what do you mean by 'hit him'?"

"I picked up a piece of wood and hit him over the head, hard. He . . . he fell. I killed him." The man's weeping became uncontrollable. "He was an inspiration to us all. I tried to find out what happened to his body but no one could help me. We never knew that you and Modoc were saved." Vinod's face flushed at the remembrance.

"Did you check the newspapers?" questioned Bram. "There might have been something."

"It is quite possible," Vinod said. "But in this country the news on one side of the street may not be that which is talked about on the other." Mr. Shah got up from his seat. "I wanted to thank you and Modoc for saving me . . . all of us. I will leave you now."

The next week brought news that many bodies had washed up a hundred miles to the east. The current had been strong and swept them out to sea, only to be carried back to shore by yet another current. It sent shivers up Bram's spine to think it could have been him and Mo. Listed among the dead were Captain Patel, Cook, and some of his crew. Also six Americans including Jake, the elephant trainer.

Bram knew he would never hear about the big cats, the bears, or the chimps. They had been kept in heavy cages, which would have sunk immediately. Poor little Oscar, how he must have panicked; Emma, Krono . . . and Tina, never getting anything right . . . Maybe it was just as well, he thought, as they didn't suffer a slow death like so many of the humans in the water. His heart went out to Appelle, the clown, and Himmel, the bear trainer, and the rest. He hoped they never found out. Losing loved ones was one death, drowning at sea was another . . . one too many.

As the months passed, Dr. Scharren and Bram worked diligently to bring Modoc back to health. Even the depression that had so worried Bram now seemed to be gone.

He decided he was ready to move into his new quarters overlooking the elephant training area. For Bram it was like going to

heaven. No other place like this existed in all the world.

A spiral staircase led up to his apartment. His quarters featured a wonderful view of the training arena. The entire residence was made of carved teak, sanded and polished to perfection.

Bram's gifts from the maharajah, the carved bed, table, and chair, fit perfectly into his new lodging. A beautiful hand-woven machar dani—mosquito netting—hung in a large knot from the ceiling above the bed. Even the floor was made out of teak limbs and leaves, treated and woven into a pattern trampled by elephant feet until firm and flat. The big, gracious double window overlooking the ring opened to a small balcony where one could sit and relax with a cool drink while watching the elephants down below.

The arena itself was made out of huge teak logs. The tongue and groove construction formed an indestructible fence for even the might of an elephant, were it to choose such an exit.

A nearby storage facility held various-sized pedestals, solid drums, pull harnesses, drag chains, headpieces, and equipment of different shapes and materials neatly arranged according to the trainers' needs.

Modoc was kept underneath the apartment in a specially constructed area so she and Bram could be within voice and touch of each other. She learned quickly that she had only to rub against the staircase to alert Bram, as he could feel the vibrations throughout the house.

He looked forward to working with Mo in the arena, and to trying out the different equipment. Just as exciting was the prospect of watching Mr. Rudyard train his hathis.

Bram heard that this maharajah owned more elephants than any before him. He had a genuine love for them and used any excuse to have a parade to show them off.

The maharajah's favorite elephant was Atoul, the sacred white one. Bram had heard of such an animal, but still believed it to be just a story.

"Ah, but it is true, Master Bram," Sabu told him, "and I feel that someday the maharajah will allow you to see him. He is kept

away from the others in a golden temple located in the forest, on the grounds of the palace. No one is allowed to go there. Atoul is the largest of all elephants, with tusks that weigh seventy-five kilograms each. Their base are gray as the mourning dove, the tips milky white. His color is the white of snow, and he has deep-set black eyes. His nails are painted bloodred, and the hair of his tail is braided into the pattern used by the ancient mystics to bring togetherness to the people. Only one man, Jagrat, a mystic holy man, has been trained to handle him. It is said that he has learned the way into the elephant's heart and found peace and contentment there."

"Maybe someday Modoc could meet him," said Bram, aglow with the wonder of it all.

"Maybe," said Sabu.

Bram's quarters were a delight, and he would sit many hours at the window watching the mahouts bring their animals in for training. One day he saw the arena being cleared for the next session. Twenty-five huge, heavy timbers were rolled in by many assistants and laid in a row along with some heavy-duty harnesses and chains. Into the arena strode a man leading two fairly large elephants. It was Mr. Rudyard. He waved to Bram. Bram returned the gesture and moved to the balcony to get a better view. Each elephant sported a fine pair of ivory tusks. Bram watched as Mr. Rudyard put the elephants through a procedure of pushing, pulling, lifting, carrying, and dragging the logs from one pile to create another.

Sabu arrived and watched with Bram for a while. "Their names are Dindhi and Kali," he told Bram. "He trains elephants to work the teak up in the forest region of Burma. He's quite good, and the forest villagers respect and trust him."

"Isn't it hard work for the elephants?" asked Bram.

"Yes, but it also builds them into strong and healthy animals. They work only four hours a day and receive superb care. It is a privilege to be a teak elephant, as he can master the needs of the mahout. And it is just as difficult to become a mahout, as everything you see being done here must eventually be controlled from the top."

That night Bram lay in bed thinking of what it must be like to live in the forest, working with the other trainers, having the elephants hauling and pushing those great logs. In many ways he felt better about it than training elephants to perform for the public, which sometimes seemed disrespectful to the elephants, having them sit up and roll over like a well-trained pet. Yet he knew that kind of thinking came from people who were judgmental of others. If the animal doesn't *know* what it is doing is foolish, then only the person who thinks it is suffers those feelings. As long as the animal enjoys what it's doing, and is not forced into something it doesn't want to do, then it's okay.

The early morning sun found Bram lying with his head at the foot of the bed, looking up at the carved headboard. In the center was the finest carving of them all. It was of Atoul. One front foot held high, trunk lifted, ears alert, tusks speared forward—he appeared as a spiritual elephant god. Bram's gaze was so intense, his eyes burned. He squeezed them shut for a fraction of a second, then opened them, readjusting the focus. His skin became cold and clammy. Atoul was staring at him!

The dark eyes were set into a brow of white, and the moon gave them the appearance of moving. They became disjointed and left Atoul's body, coming toward Bram! Bram rolled away, landing on the floor. He peered back over the bed at the headboard and found everything in order, as it had been.

He sat on the bed trembling. He didn't feel fear. Strange, yes, but he felt his reactions were due to the shock of what had happened, but not the happening itself.

He fell back asleep, feeling Atoul was there to protect him, and would someday let him in the mystical door his father had spoken of. Perhaps Atoul might even speak with him, as Modoc did now.

For the next few months, when the arena was available, Bram would work Modoc, teaching her the ways of the teak elephants. He noticed her body changing, new muscles developing, and her outward physical appearance seemed to improve.

Early on a Sunday morning when Bram was taking Mo for a

walk, Kelly came to say goodbye. He walked alongside the two and they finally rested at one of the pools. Kelly looked up at the blue sky and sighed deeply.

"I'm going to miss this place, you, Modoc—all of it. It's been quite an experience."

Bram felt uncomfortable. It seemed to him he was always saying goodbye to friends.

"Kelly, I don't know how I can ever repay you for all you've done. I don't think anyone has had such a good friend. But I always wondered why you did all those things."

Kelly cleared his throat and ran his hands through his hair. He laughed. "When I first saw you, I remember how hurt you were by Mr. North's comments. I felt kinda sorry for you. Your father had just . . . passed on, and then you were about to lose Modoc, and, well, if it had been me, I would've done the same thing." He picked some grass and played with the blades in his hand. "Of course, no one needs to know all this, huh, Bram—I mean, I don't want the world to know ol' Kelly has such a soft heart. I got a reputation, okay?"

Bram smiled. "It's all right, Kelly, I won't tell a soul. And neither will Mo. But I think a lot of people already know."

Kelly finally drove off with a wave and good wishes for the future. The last thing Bram remembered him doing was a simpleton's gesture, saying "What's a Mo?" Bram knew his secret would be kept.

Weeks passed into months. Bram was becoming a member of the family, at least as far as the staff was concerned. He drank of the knowledge they could give, and he in turn shared the many secrets his father had taught him, plus things he'd learned along the way. Modoc became an inspiration to all who had the good fortune to live within the sphere of her life.

Bram lived as a Hindu, wore the clothes, ate the vegetarian diet, and was slowly learning their language.

All the letters he had written to his mom, Gertie, and Curpo had washed away in the mighty storm. Since his rescue he had not

written . . . not even once. He was afraid to. A letter to Gertie or the others would reveal his location—and that Mo was alive. One slip and the whole town would know. God forbid, Herr Gobel or any of his friends might learn, too. When he was first caught, Bram was sure that the ship's captain had radioed ahead to the police so they would pick him up when the ship docked. He probably had sent a message to Mr. North as well, telling him about Bram's stowing away on the ship. If North heard any report about Mo's survival, he would link it to Bram, and what better source to find Mo than through his family?

In the middle of the palace's private forest flowed the beautiful Agra, a mystical river of dark blue water. It writhed through the forest like a giant serpent, angling through the trees, changing in width, in girth, never ending, sometimes multichanneled, splitting into many tributaries.

Each morning found Bram astride Mo, ambling through the forest on the way to the river. Others would join them, and sometimes as many as thirty elephants could be seen at one time. As they passed close to the edge of its azure crystallike surface, their images would reflect as clearly as if they were looking in a mirror. Only the leaping of a occasional trout broke the still waters, shattering the reflection into a thousand pieces. On both sides of its shore rose gigantic vine-covered trees and tropical plants with leaves the size of Mo's ear. The blooming flowers were on loan from God's Blanket.

Soft red clay trails meandered throughout the forest, occasionally coming to visit the pleasant coves along the water's edge. Hundreds of huge circular footprints were embossed into the clay path where the elephants had trod for many years.

Each mahout was free to take his hathi on the trails. As they arrived at the lake, bellowing and trumpeting could be heard for miles.

There they took their hathis to a special cleaning area at the edge of the water where they had to "come down" to be scrubbed

clean. Once finished, one by one, each rose and headed for the open water. It was playtime! Tails up, trunks held high, they launched into the lake. Modoc joined the others in part of the daily ritual, but when the others ventured into the water, she stood at the edge, ears at rest, her trunk hanging loosely, the tip nosing the mud gently as small waves lapped at her feet. Bram stood by her side, gently running his hands up and down her legs.

"It's okay, Mosie, sometimes I feel the same way." She ran her trunk up his arm. "Those were horrible days, and we'll never forget them. But someday you'll know what was then is not now and, well . . . you'll see."

He washed her down with some water from a tightly woven basket dipped in the lake. It was tedious work, but eventually she was fresh and clean, and together they headed up the trail. Mo's ears followed the sounds as she listened to her new friends play in the water.

Bram saw him from afar . . . rushing across the grassy slope at the edge of the forest. He and Mosie had been relaxing there in the warm sun, enjoying the soft breezes, feeling the happiness of being there.

"Bram! Bram!" yelled Sabu. "I have news for you that is great!" He flopped down, exhausted from his run.

"What is it?"

Sabu tried to catch his breath while telling Bram the news. "The maharajah . . . has given you permission . . . to meet Atoul!"

Bram sprung to his feet and paced a circle around Sabu. "What? Where? When? That's wonderful—that's incredible!"

Breathlessly Sabu revealed, "Tonight . . . at sundown . . . you are to meet Jagrat at the edge of the lake, by the great mimosa tree. He will take you to Atoul!"

Bram bathed, slipped on his best jacket, and was at the foot of the mimosa tree long before sundown. What would it be like to see a white elephant? Why was he white? What was his sacred origin?

These questions and more raced through his mind, whirling in anticipation.

When the sun set on the horizon, a man dressed in a white turban, white kurta, and white sandals appeared on a slope just near the tree. He stood quietly enough to make one think him a statue. The imminent darkness seemed to do little to affect the stark whiteness of his attire. He was looking off into the forest, and only when Bram's nervous foot crunched a pebble did he turn. With the slightest rise of his chin, he beckoned. Bram reacted with a start and headed up the small grassy hill. As he approached, he noticed the man was thick of stature, had a mustache, and carried a golden choon. On the left side of his jacket was the Elephantarium insignia, and on the front of his turban was a spherical gold brooch. A leather pouch hung from his neck. Placing the palms of his hands together, he slowly bowed.

"I am called Jagrat. I have been instructed to take you to meet Atoul."

Bram greeted Jagrat in the same way, just as Sabu had taught him. "My name is Bram, and I wish to thank you for allowing me this pleasure."

They walked deeper into the forest where it was unkempt, left to its natural growth. As they walked, Bram saw the golden-domed roof of the Temple of the White Elephant. Instead of walking to it, they were walking parallel with it. The forest became thicker and harder to move through. The moon in all its fullness appeared low on the horizon, backlighting the surrounding forest into dark silhouettes.

Out of the darkness came a sound, the sound of a chime. A piercing single note of high resonance reverberated through the forest, through Bram's being, and through the dark itself.

Then, standing on a ledge some twenty meters above them, silhouetted against the moon, the elephant appeared huge and jet black as the forest around him. The monarch stood still, listening. As they approached from below, Bram looked straight up at the gargantuan figure. A beam of moonlight hit the tips of his tusk and

blasted back a whiteness that held its own against the white Patriarch.

Jagrat circled the ledge abutment, walking up a small, narrow spiral path cut into the hill. When they rounded the hill, the moon was at their backs, illuminating everything, and the dark shadows were left behind. Atoul slowly turned his magnificence toward them, emerging into the lunar glow.

Bram looked up at this colossus of nature. Atoul's body was thirteen feet tall—a height hitherto unknown to Indian elephants. His body was the purest white, his great tusks like daggers, thrust out, the tips with a glistening sheen, honed sharply. His trunk was twice the thickness of any other. Bram could have walked under him without his head touching the broad girth of the belly. The majestic elephant stood before them as if from a fable, frozen in time and space.

"Approach him from the front . . . slowly, then stand close."

Bram was as if possessed. Standing in the light of God would have meant no more to him than this moment. He took a deep breath, squared his shoulders, and advanced. In five steps he found himself within a few feet of the great elephant. Then he noticed the chimes hanging from his neck, one silver, the other gold. Each had the same sphere engraved on it as was on Jagrat's turban. Bram peered up into the face of the old monarch. He was immediately pierced by the black orbs that gazed down upon him.

As he stared, Bram recalled the experience he had had while lying on his bed. It was the same, happening over again, only this time he stayed and looked back. Atoul seemed to be moving toward him. Bram allowed himself to be swallowed up into the bottomless black eyes.

His mind reeled, all his senses were filled. Time and space did not exist. He felt himself being lifted, his hands held firm on hard smooth cylinders . . . then a bright whiteness filled his vision. He had the sensation of being in a great sphere, floating among the atoms of all living things—the forest, the animals, the earth itself. All things knew one another, and were in harmony. As he was

transported through this snowfall of life and vitality, there was a wonderment of sharing . . .

. . . and there was music. It came from the multitude of atoms, each expressing its individual song of Creation, blending into a natural symphony of the most exquisite kind . . . and then, silence . . . except for the melodic, breathy sound of a flute.

═ 20 ═

BRAM AWAKENED IN A BASKET CHAIR, hung from the high arched ceiling of a temple. Jagrat appeared carrying two glasses filled with a golden bubbly liquid and offered one to Bram.

"Here, drink this," he said.

Bram drank it down, enjoying the smooth sweet taste. "Where are we?" he asked.

"We are in the Temple of Atoul. This is . . . the room of metaphysics and meditation," began Jagrat. "Only things that come from the mind and heart are talked of here."

The room resembled a miniature temple. Above, a high domed ceiling; below, walls covered with inlaid tiles; the floor, marble; and in its center a copper and teak table surrounded with cushions.

"How did I get here?" Bram asked.

"It is not important. How do you feel?"

"I feel . . . wonderful."

"And your memory, what do you recall?"

Bram thought for a moment. "I remember being so close to Atoul. I could smell incense, and then his eyes . . . and a feeling of . . . of . . . floating, I guess, but it was wonderful. And then I was in a kind of bubble of living energy that began to whirl and"—Bram broke into a sweat—"and I remember music . . . beautiful music, music that my mind has heard before but none that I have ever seen played."

"Is that all?"

"Yes, I think so. What does it mean?"

Jagrat took a final sip from his glass. He paused, as if weighing his thoughts. "They say each man has a path. A path to God. It is inside here," he said, pointing to his forehead, "and here," he said, pointing to his heart. "There are those among us who search for truth and learn these great ways by hard study and teachings; there are but a few who have it in them as you do . . . naturally.

"The maharajah has chosen wisely. I am to share with you some of our most sacred beliefs. He feels these things will be of help to you in your quest for fulfillment in this life, and the next."

Bram listened intently, knowing that he was privileged to be the one so chosen.

"Many Hindi believe in the Cosmic Law of the Universe, that to seek truth and God in silent meditation for many years will bring enlightenment, the Nirvana they seek, and many do indeed encounter heavenly bliss in this solitude. But just as there are many rivers that lead to the same ocean, so are there many paths that lead to God.

"But here we know the law of nature," Jagrat said. "God created it. God *is* nature and as He is perfect, so is nature perfect.

"Those of us who are in tune with nature and animals know it is our way of life, Bram. There is a connection to all living things, a vibration of Life. Animals were not given a power of choice. A lion does not try to eat legumes nor an elephant meat. We believe the best way to communicate with nature, God, is through a liaison: the animals." Jagrat reached over and touched Bram's shoulder. Bram

saw the same intensity in his eyes that he had seen in Atoul's.

"Nature hears one voice and obeys it," Jagrat continued. "That is why ten or ten thousand birds may rise from the surface of a lake at the same time and yet never touch one another. Man hears only his own voice. He constantly bumps into another. Even his voice mirrors his erratic walk, jealousy, hate, ego, pride, lying, cheating. He makes his own judgments and falls prey to his greed." Jagrat smiled, a twinkle gleaming in his eyes. "Remember, the moon is reflected in one drop of water as is the entire ocean—so it is with God. He is reflected in each living thing—in a grain of sand as the entire shore, one star as the whole universe. Each animal as in all creatures."

Jagrat moved slowly around the room. Bram's eyes were riveted as he watched and felt a power within him listening, understanding—and knowing. He heard Jagrat's words: "Man's power of choice to rely on himself rather than being one with nature has been disturbing. If something is not used properly, such as the ability to tap into the vibration, it becomes weak and loses power, it atrophies. Man is losing his ability to hear the voice."

He stopped and gazed at the light from the distant moon as it streamed into the room, revealing exquisite patterns on the marble floor.

Bram spoke for the first time. "But, Jagrat, is it not as natural for man to have the power of choice as it for the animals not to have it?"

Jagrat nodded. "We all were given a set of rules to live by," he explained. "The only difference is that man must use his intelligence to organize and control his directives, and learn to use his power of choice correctly. Man is like a child with a new toy; he hasn't yet figured out how it works. He understands the principle, now he must learn the controls.

"When man chooses to develop his innate power of communication with nature and therefore hear the voice, all will be right with the world—we will be as one. What you have been able to do with your Modoc is what man has been seeking for a long time. To communicate with nature through the animals. Treasure it.

"I end by telling you to listen and hear the vibration, the song of nature. The sounds of nature are its music, its lyrics, and it comes from all living things. The subtle violin whispers of the wind in the pine forest, the howling bassoon of the violent monsoon, the clarinet of the birds, the drums of the earthquakes and volcanoes, the cymbals of lightning and thunder, the harp of the oceans, together they play God's song—early morning dripping of water from a night storm, the songbirds in the meadow during the sunny afternoon, the owl, the roar of a lion, the evening breezes blowing through the trees. It is a true song. Not a story. Not a fable with a point made at its end. But a song that sings within and without all living things.

"I hear the music; I learned it through Atoul. I know it is always in sync—the harmony, the melody are perfect and are always there to hear. That is the way it is. Perfect. It is everywhere at all times.

"It can never be stopped or disrupted. It is in our sleep, yet does not awaken us. We are all musical instruments in God's orchestra. The music is never the same, it changes from minute to minute.

"Man must learn to tune in. It will be his nature to try to change it, but he can not create something better than the Creator. Teach your fellow man to listen, especially your enemy. Hear nature's symphony. The blind can see it, the deaf can hear it. To listen to the sounds of nature is to hear Creation at its beginning, middle, and end at the same time, together and apart. For man, nature and God are one.

"Your experience with Atoul was to see if you had the power to reach into him; as he and you together merged into one natural thought, Atoul created the passage to learning and you were able to go there, see, experience, and return. You have the power of communicating with animals. Use them as a conduit, listen to the voice of nature."

= 21 =

THE SUN BROKE INTO DAYLIGHT like an egg being cracked against a window frame. A strip of bright yellow-red rays lay firebranded across the bed. The bed moved! Bram rolled over, covering his eyes from the brightness.

"Okay! Okay! I'm up!"

It was six o'clock. Modoc always thumped his ceiling at that time—a sure way to get him up. Bram spent a good hour cleaning Modoc's area, telling her everything that had happened last night. The more he thought about it, the more it seemed unreal. He rolled the philosophy over and over in his mind, comparing it to his own thinking, and was pleased that it was so similar.

The previous night had changed Bram. It seemed he had grown from a boy to a man overnight. His attitude, speaking manner, the way he carried himself, all said: *"I have matured!"* Knowledge and experience do that.

He found himself wondering about his future. How long would he stay here? Surely there was no place better in the whole world for his kind of lifestyle than the Elephantarium. He knew now, more than ever, he could never give up Mo. What they had endured together bonded them for life. His father was right—they were connected. The months he'd spent at the Elephantarium had taught him a great deal.

Bram received a message from the maharajah, asking to see him immediately. Although they had been having frequent lunches, it was most unusual for them to meet on a Friday, as this was the maharajah's time to meet with all his ministers and ambassadors.

"Bram, I'm afraid I have bad news for you . . ." The maharajah picked up a yellow piece of paper. "This morning I received a lengthy letter from your Mr. North. He stated that an article in the New York newspaper spoke of an amazing rescue at sea involving a young man and an elephant. He further stated that seeing as the ship carrying his animals was lost in the vicinity of the rescue, he assumed the rescued elephant was his."

Bram's stomach felt as if it were spinning and tying itself into knots. His heart raced.

The maharajah continued, "He goes on to say that since the animals are of the utmost importance to the circus, and feeling that perhaps more have been found than have been reported, he is arranging for passage on the first ship leaving New York for India."

"But . . ." Bram began.

"Wait, there's more. He says, '. . . and regarding the boy, he is a thief, do not be fooled by him. He has stolen property that belongs to me and I will never stop in my endeavor to regain it and see to it that this boy is punished to the full extent of the law.' He ends by requesting my full support in this matter."

The maharajah set the letter on a garden bench. "Bram, we have become good friends, and I want you to know that I will do whatever I can to help you in this situation."

Bram was shocked. He sat, scanning the letter, but reading

nothing. "I have to go . . . take Modoc with me," he said flatly, staring into space.

"Wait, Bram, listen to me. There are alternatives. I could possibly convince Mr. North to allow you to return with them, and stay with Modoc."

"No," Bram said dejectedly, "he wouldn't. He doesn't like *our kind of people* . . . Jews, and even if he agreed to it now, I don't trust him to live up to it once we leave. Besides, others would work Mo, I'd probably go to prison, and that would be more than I could bear."

"What if . . ." the maharajah continued thoughtfully. "Bram, if they do find her, I want to say always there will be another elephant waiting for you here. I promise it will never be taken away. I would offer to buy Modoc or even offer Mr. North a trade but under the circumstances, I do not think he would let her go."

"Please, sir," Bram said, "your kindness and hospitality have been most gracious, but I cannot stay. I have to make arrangements to leave, quickly."

Before Bram could stand up, the maharajah rested his hand on Bram's shoulder. "Please, another moment." Clearing his throat, he went on, "I am the sovereign leader of a very large principality. Many of my people know what has transpired here. In my position I cannot do anything illegal. I cannot let Modoc go! To do so would be against my principles, and my people would lose faith in me."

Bram jumped to his feet. "What? You mean . . . but it can't be. You are my friend. You said you would help me!"

"Bram . . . you must understand. It is a matter of proprieties and protocol."

"All I know is that unless we leave here immediately, North will come and take Modoc!"

The maharajah was quiet for some time. Finally he spoke. "Very well then, I must say the following—Modoc is as of this moment under my care and authority, and any attempt to take her will be met with resistance. However," he added, standing up, "if by some means she was to be smuggled out without my knowl-

edge, I would be most upset, and have to look far and wide for her. But India is a very big country, and there are many places to hide such an elephant. I would, of course, have to tell Mr. North of the predicament, and assist him in every way that I can."

The maharajah stroked his beard. Then, looking at Bram with a knowing smile, he said, "But then, I don't think anybody would be so foolish as to do such a thing. Do you?"

Bram busied himself preparing to leave. He was grateful for the maharajah's "understanding" and wanted to leave quickly. He needed the time to get away, far away. He put everything he owned in a circle on the floor, separating the articles into piles. Each pile was put into an individual burlap bag and stored in a closet. There was a soft knocking at his door. He quickly pushed away any remaining evidence of his departure.

"Come in."

Sabu entered, carrying with him a number of items necessary for Bram's trip. Many of these Bram hadn't thought about. Sabu settled on the floor and began laying them out.

Bram dropped down beside him and spoke softly. "I didn't know that you knew I was . . . "

"You have many friends here, sahib. Here, I have brought you maps of the areas you might be crossing."

"I think I'll head—"

"Please! Do not tell me. It is best that I do not know. Then no one can see a lie on my face if there is none there. You must be careful, sahib. India is a poor country, and there are people who would do bad things in an effort to better their own lives."

"I was only going to say that I plan on sticking to the forest during the night, and the cities by the day, as I am told there are more thieves in the city at night."

"It is true, but sometimes things can reverse themselves. Such is the way of God. However, the forest is a good source of food for Modoc. It will also serve as a great hiding place if the need arises. When do you plan on leaving?"

"Tomorrow night. It will be the first night of a full moon, and we will be able to make it to the outskirts of the city by early morning."

Bram stood up and walked around his room slowly. "In all the places I have ever seen or read about, this is by far the most beautiful, not just in the material things, but in the hearts of all I have met. I will miss you as a brother, Sabu, and maybe someday we'll see each other again."

A howdah had suddenly appeared at Bram's door.

"It is obviously a gift from God," Sabu stated simply. "You must take it graciously and use it well."

The time of his leaving had come quickly. He wanted to tell everybody goodbye and thank them for their friendship, but that was impossible. Sabu would have to explain to a trusted few after he left.

A messenger from Atoul's temple brought a note—Bram recognized the handwriting immediately. The note said:

> On your journey there will be many waters to cross. Agra—tonight, 10:00, with Modoc.

> *Jagrat*

Bram was excited to have received the note from Jagrat, and though he had no idea what it meant, he knew it must be important. This was the night of his leaving, and he figured he would leave a bit early so as to visit the lake on his departure. He couldn't say goodbye to the maharajah, but made up an excuse to see him once more.

The maharajah sat in his royal chair, two feet high upon a dais. A fancy, colorful carpet lay at his feet. A pair of beautiful white and peach-colored cockatoos raised their crests as Bram entered. Two court attendants stood at the far end of the large room. Bram stood at the door waiting expectantly.

"Come, come, my friend," the maharajah beckoned. "I understand you wish to see me. Here, sit by me."

"I was so distraught with the news of Mr. North that I forgot to

tell you how awe-inspiring the meeting with Atoul was. It will be in my mind and soul forever. What he and Jagrat share only deepens the knowledge my father taught me. Since meeting them, something has happened. Modoc and I don't need to speak to each other as much. We just . . . know! And I feel . . . older, more in tune with life. What I have to do now I will do with a new energy."

An understanding smile crossed the maharajah's face. He noticed a concern on Bram's face. "There is something else you wish to discuss?"

"Yes, one that needs your wisdom."

The maharajah looked questioningly at him. "Hmmm, yes, of course, if I can be of help."

"My question is, how faithful must one be to one who has died? Does a promise carry on after one has departed to his afterlife?"

The maharajah stepped down from his heights and approached Bram, knowing he was speaking of his commitment to his father.

"The commitment is to yourself, young man. It is you and you alone who will feel if your decision is right or wrong. Some things are promised in haste, others to appease and satisfy a sick one, some for love . . . or hate. As for your atonement in the afterlife, any decision made in this life will follow you forever." He put his arm around Bram's shoulder. "I do not feel you have any need for concern. You are a person who carries a good heart, and I feel your soul will be richly rewarded in the afterlife."

Bram was deeply moved. "I thank you deeply for your wisdom and kindness. It will never be forgotten." Bram stood motionless, hoping that he'd spoken in a way that wouldn't embarrass the maharajah.

The maharajah beckoned to his valet. The man approached carrying a red velvet pillow. Placed on top was a golden chain, and hanging from it was a medallion similar to the one Jagrat wore. Etched on the back below the royal family crest was Bram's name. As the maharajah slipped it over Bram's head he said, "This is known throughout India and will be respected by all who encounter it." His voice lowered to a whisper. "You are as a son to me."

Bram could not move; the glint of moisture filling his eyes was seen by the maharajah, who knew this man-child had suffered much since leaving his home and loved ones. Now, again, he must continue, all for the love of an elephant. The maharajah opened his arms. They moved together and embraced, as father and son. Both felt it was the last time they would see each other.

Bram left the palace, never to forget the most wonderful place he had ever seen.

= 22 =

THE LIGHT OF THE FULL MOON moved through the trees as they approached the lake. The forest was silent and smelled of ginger as Mo walked the earthen trail. In the back of Bram's mind he was trying to decipher Jagrat's note when he spotted him standing under the mimosa tree, waving a silent greeting.

"Salaams, Bram."

"Salaams, Jagrat."

"Before you leave there is something that needs to be done for Modoc. But first we must remove the howdah from her back."

Within minutes the deed was accomplished. Bram said nothing, knowing that whatever was being done would be of great significance.

"Take Modoc to the lake."

"But she's afraid of—"

"Just have her stand at the edge," Jagrat said patiently.

Bram walked her to the shoreline. Patting her leg, he asked her to stay and walked back to Jagrat.

"Come with me," he said, and Bram followed him up the slope where they had first met.

They sat quietly, joining the forest and lake in solitude. Nothing stirred on the Agra's mirrored surface. Modoc stood calmly, dabbling the tip of her trunk in the mud. Bram kept mulling over in his mind the words of Jagrat, "On your journey there will be many waters to cross." What did it mean?

Something moved in the middle of the lake. A circle of ripples formed as though surrounding a large object. Modoc stopped playing and stood still. The ripples formed a large "V" and slowly headed in her direction. Her ears shot forward, trunk raised as she stared across the lake. There was something there, but nothing to see. Bram looked at Jagrat. He, too, was staring at the water.

The arrow of ripples continued toward Modoc. As it approached the shore, it stopped. Mo made a rumbling sound in her body and carefully stretched out her trunk. She was seeing something others were not allowed to see. Something was holding the tip of her trunk, and leading her out into the water! Mo didn't resist. Slowly, she carefully eased her way out, stopping occasionally to rumble a bit, then moving on deeper and deeper. By the time she reached the center of the lake, she was floating with another . . . elephant!

"Atoul?" guessed Bram.

Jagrat looked at him; his dark eyes seemed to see far beyond Bram. He smiled. "Yes."

Now Bram understood. Jagrat knew of Modoc's problem with the water, and in his mystical way had enlisted Atoul to help her.

"She will be all right now," said Jagrat, walking off into the forest. "I wish you both a safe and enlightening journey," he said into the darkness.

"We will always remember you, Jagrat," called Bram. "Thank you."

* * *

It was daybreak, as expected, when Bram entered the forest that lay south of the city. He had traveled all night, sticking to the back roads as much as possible. Most of the dirt and brick streets were deserted because of the early hour, and just the occasional cripple or homeless person could be seen sleeping in the doorways. The only tarmac roadway ran through the center of town, and Bram felt it would be best to stay clear of areas where people might later recall having seen him. Nobody paid much attention to an elephant walking on the old streets at night, or, for that matter, to any of the cattle, goats, donkeys, or Brahmas eating grass along the embankments.

Once in the forest, Bram found a well-traveled trail and directed Modoc onto it. It was headed away from the city and toward the sea, exactly where he wanted to go. The clear skies and early morning humidity told of a very hot day in the offing. He checked the rigging, seeing that the eight-inch-wide woven hemp cinch was not too binding on Mo. The howdah sat comfortably on a foot-thick mat filled with camel hair and lined with sisal cord. It was made of strong giant bamboo laced with bindings of reed, sisal, and jungle root. No bolts or screws of any kind were used as the howdah had to move with the animal, not be too rigid, lest it caused pinching and cutting. There were six holes in the top of the frame into which poles were inserted to support a small canopy. This would ward off the sun or rain. Bram had tied the assorted bundles to the outer edge of the howdah to form a circle, putting everything within close reach for his needs. The flooring of the howdah was similar to the one he had used back home. Made of thick woven rattan, and with the help of an overlying blanket, it made a comfortable area in which to function.

Lying on his back, Bram watched as the sun filtered through the trees, a sparkle here, a glitter there. He heard the music Jagrat had spoken of, gentle, whispering, tinkling cymbals of the living forest. Modoc lumbered on; she knew her responsibility and never strayed off the trail or stopped to bother a bush or flower, which allowed Bram to take naps. She, too, enjoyed the music.

Bram awoke with a start. Modoc had stopped! Above him was

a trunk giving little warning signals of squeaks and chirps. He jumped up to have a look. Crossing the trail was a huge python. Bram guessed its length to be twenty feet or more. The head had already passed into the grass on one side of the road, while the tail was still to come out of the weeds on the other! Mo stood quietly, ears alert, trunk balled up, waiting patiently.

"It's okay, girl. Nothing to worry about. Just let him go his way, and we'll go ours."

Once the snake had disappeared, Mo kept a wary eye as she passed the place it was last seen. The trail ended after about an hour or so, coming out on another narrow dirt road.

Bram saw another elephant coming down the road. The mahouts waved at each other, then continued on their way.

The days turned into weeks as they headed in a southeasterly direction. It was Bram's plan to follow the coastline until he passed the headwaters of the Ganges River, then continue south into Burma and onward to the teak forests. This was the one place he felt he could support himself and still hide from Mr. North.

They were heading up a narrow winding street in the city of Cushda. As the morning lights appeared, hordes of people began their day's work, buzzing from one place to another, selling their wares, trading, buying, bargaining. In a matter of moments, thousands overflowed the sidewalks, filling the streets, jamming the crossroads, pushing and shoving. The din was one of tempered chaos. Each acted as though only he were on the street. The odd vehicle, with all its power, stood idle, motor racing, horn tooting, but all in vain. It, too, had to flow with the tide of humanity.

Mo's smooth, flat, round feet cushioned Bram's ride as they ambled from the town up the dirt road, and on into the quiet of the nearby forest. Bram knew they had a long way to go.

23

As the weeks went by Bram and Mo lived wherever the trail took them, finding odd jobs along the way. A man offered them work to look after his goats. Mo pulled cars stuck in the mud. Another time she stood for four hours while three men stood on her back erecting a sign high up on the top of a roof. For three weeks she carried water from a well located high on a ridge down to the village below. She was asked to work as a plow horse, and another time helped to push a car to get it started.

Cool breezes signaled their approach to the higher ridge areas, where great stretches of bamboo forest appeared. The bamboo, sometimes as high as fifteen and twenty feet, dwarfed even Mo. This was a great delicacy for her, as she loved the tender roots that lay so close to the surface of the ground.

The twosome was invisible to the outside world as they made their way through the forest thickness of lush groves. Even from

above, all that could be seen was the parting and waving of the tops of the bamboo as though a giant snake were weaving itself through the jungle below.

Locals cautioned Bram about Bengal tigers that frequented the bamboo, waiting for a victim to come their way.

"Stay up on your elephant, don't come down for anything. Tigers respect elephants and generally do not bother them, but you . . . well, they would not hesitate to attack one who would make such a good meal, that is for sure!"

For the days they were in the forest, Bram rarely slept, afraid he and Mo would fall victim at any minute. Night was the scariest time. Twice they heard the snarl of a tiger. Though Bram built a fire that would have rivaled any, he still remained atop the howdah at night as Modoc slept standing up.

After three weeks in the bamboo they emerged onto a vast plain. It stretched as far as the great mountains to the south. To the east and west the country merely sloped away and disappeared into nothingness.

Its vastness seemed ominous, giving Bram a crawling feeling down his back caused by fear of the unknown. He knew the teak forest lay far away on the other side of the mountains, so after filling his camel-skin water bags and checking to see he had enough food supplies, he took a deep breath and said, "Move up, Mo!"

And off they went, into an arid region known as the Klippzanii. Few trees grew in the vastness, most of them barren and wind-torn. The grass was sparse but enough for Mo if they stopped occasionally.

Two hours out found them traversing a small stream of water that flowed off the mountains. Modoc took long sucking gulps of the cool mountain water.

The second day was the same as the first. Thank God for the stream, thought Bram. Though it was small, it was constant.

The days grew hotter, and Mo walked in the streambed, whisking the water against her sides, under her legs, showering her back along with Bram, who appreciated every drop. He soon rigged

a linen sheet over the top of the howdah, forming a small enclosure, letting the sides of the sheet hang down over Mo's sides, the top of her head, and her back, to protect her as well. He couldn't see out but no matter, Mo would never leave the water and it was heading in the right direction. The constant showers wet the sheets and kept them both fairly cool. The heat rose from the barren floor, causing mirages to form against the horizon. It was like Dante's Inferno with the images dancing in the sweltering void. The huge pachyderm silhouette against the evening sky appeared as a tribute to ancient times.

Bram lay out on his mat. A slight breeze blew through the wet linen, cooling the space within. Mo's monotonous swaying cast a drowsiness over him and he lapsed into a tranquil sleep. She seemed to know when he slept, as her motion never faltered but kept even, steady and free of disturbances.

Bram's dreams were of all rhythmic things, the tossing of the ship in the ocean, his mother rocking him as a child, the circus trucks lumbering across the countryside, sitting with his father in the big elephant truck, rolling with Gertie in the summer grass.

One afternoon as Bram dozed on his mat atop Modoc's back she stopped . . . abruptly! He woke to the sound of voices.

"Oh! mighty sahib," said a thick, deep, uncultured voice, trying to act theatrical. A variety of rough voices began to address the covered howdah.

"Do you travel alone in this aberration?"

"Are there two?"

"Three?"

"Maybe a woman?"

"Pretty?"

"Huh?" A titter of laughter could be heard from around Mo.

"You must be very wise to travel and not see where you are going." More laughter.

"You must now come out of your apartment, m'lady . . . or ma'am."

Uproarious laughter.

"Now, if you are alone and have no master, then we, with your permission, of course, will oblige you."

Bram heard a rustle of bodies running around. He heard four, maybe five, voices talking in a language he did not understand. Some whispered, others chuckled. Bram felt Modoc's body tense. Reaching into one of the bags he pulled out his small knife and slipped it into his waistband. Cautiously he lifted an edge of the sheet. The tip of a long snake-curved steel blade pointed inches from his face. Three dirty, unshaven, jagged-toothed, grinning faces looked up the blade at Bram.

They were dressed in bits and pieces of ragged cloth, each a different color, with long black dreadlocks that were in total disarray. A sloppy stained rag resembling a turban bedecked the tobacco-chewing leader called Hamid. He stood on a piece of broken tree log so he could reach the howdah with his sword. There were two other men, one leaning against a skeleton tree, the other standing at Modoc's head, resting the tip of his saber on her toe. Five in all.

"What have we here?" smirked Hamid, running the tip of the blade against Bram's cheek. "Why, you are just a young cock. Where did you get this beast, huh? Did you steal it? Ha! Yes, of course you did, no boy would have such a fine beast as this." He spat, some of it landing on one of his men.

"Hey, what you do, that's not nice, I—"

Hamid whipped the blade from Bram to the man's side, knocking him flat. The man grabbed his side but found no blood.

"Next time I'll use the edge, you idiot." The sword sliced the distance back to Bram's cheek.

Bram decided that he was the boss not because of his brains, but because the men feared him.

"What do you want?" asked Bram in as adult a voice as he could muster.

The quiet of the void was rocked by their outburst of laughter.

"We want him . . . or," looking under Mo, "is it a her?"

"She is mine and not for sale, so get out of the way. We're in a hurry."

"Ah, but a little cub like you wouldn't leave us poor starving men out here without any food or transportation." The whinny of a horse was heard nearby. Gently pushing the sword aside, Bram leaned out and saw three horses tied to some shrubbery.

"You come down now, boy."

"No, you let us be." He started to give the signal to Mo to move on.

"No! No! That would not be wise. 'Cause then my good friend Ranji would have to do a bad thing."

Bram saw one of the men had worked his way around to Mo's hind foot and laid his small dagger against her back tendon. "You have heard of the Achilles' heel, haven't you, boy? One slice in the right place and the foot becomes useless ... for life. Even the biggest animal can fall from one quick cut, never to rise again."

"If you want her, why would you hurt her so badly that she can't walk? What good would she be to you then?"

The bandit, embarrassed by the boy's logic, waved his saber in frustration. "Look, boy, I have no patience, especially with one so young as you. Now are you coming down?"

"No!"

Hamid raised his sword as though to strike Mo but instead slid the blade under the howdah cinch strap and with one slice, cut it in two. Then with the help of the other men he pulled on it until it, along with Bram, came crashing down. Modoc whipped around, not knowing what had happened. Bram's supplies were strewn everywhere.

The bandits rushed in, pushing, searching, pocketing, fighting among themselves over the items. Bram tried to stop them but was thrown aside. Hamid grabbed him by the arm and put his dagger to Bram's throat.

"Look here, sahib!" The big man's voice was now firm and resonant. "You go to that tree, sit down, and leave us be."

Bram, weighing the situation, realized there was nothing he could do. He wrenched his arm free and headed for the tree. Modoc, seeing him go, emitted a low rumble and started to follow him.

"It's okay, Mo." She stood where she was, not quite certain what was happening.

"You are a very smart boy to do that. I am impressed, veeerrry impressed," said the man who had been hit by the sword.

The ransacking was over quickly. Everything lay askew on the ground.

"There is nothing of value here," yelled one of the men, "but the elephant."

Bram looked up. "What do you mean? What . . . what are you saying?"

Two of the men mounted their horses. The others pulled ropes from their belongings.

Hamid walked over to Bram. "I do not like whites. Especially young males—and especially you in particular. Do you understand?"

"Yes."

"We are going to leave and we are going to take your elephant with us. Do you understand?"

"Yes."

"Now if you or your elephant do anything to provoke us, I will shoot your elephant first so you can see her die, and then I will shoot you. Do you understand that?"

Bram stood in shock. Hamid picked him up by his shirt, holding him close. Bram smelled the stench of his body.

"Do you?" he yelled.

Before Bram could speak, a mighty rumble was heard. Modoc, head low, her trunk balled up, came full tilt at Hamid. Dropping Bram, he screamed.

"Stop her! Stop her—or I will shoot!"

From out of the rags on his body he hastily pulled a gun, aiming it at Modoc.

"No! No! Stop!" Bram screamed at her. Just as she was about to lift Hamid, Mo stopped and stood shuddering, a low deep guttural sound coming from deep inside her.

Hamid, badly shaken, brushed himself off and spoke with a quiver in his throat he could not hide.

"You stupid imbecile, you made her do that! We are taking your elephant! Now either you help us or I'll kill her where she stands."

"If you kill her, what have you gained?"

"It is our code, jackass! That which we cannot have, neither will our enemies, and you, sahib, are now our enemy. Now do with your beast what you will and let's get on with it."

Bram went to Modoc, smoothing her anger. "Easy Mo, it's okay, easy girl." She answered him in squeaky baby talk, her trunk wrapped around him.

Bram knew he had no choice. He figured they wouldn't hurt Modoc unless she did something to put their lives in danger. It was obvious they knew nothing about elephants, and for that reason alone, the situation could become very dangerous. He figured he would follow them, maybe get some help or even steal her back. But first he had to get her to go with them.

"Mo, I want you to go with these men. They won't hurt you." He knew she didn't understand him literally but could feel his intention. It was also important that the men *thought* she understood him. Mo listened not to the words but instead to Bram's intentions, which to her spoke louder.

Hamid and his men circled Modoc. Two horsemen threw ropes over her head. The others stood ready to leave.

"Let's hope you have taught her well," Hamid said as he mounted his horse.

He took his position in front. Two on horseback rode on either side of Mo, each with ropes stretched out around her neck. The other two brought up the rear. Hamid looked back, saying to Bram, "You are one smart fellow, and for that I give you your life and your belongings. Do not be stupid and try to follow, sahib."

Then he gave a signal to his men. They moved out. As Mo felt the ropes pull on her neck, she stood her ground until Bram told her, "Move up, Mo, it's okay, girl. Move up!"

She moved ahead slowly, looking back, not understanding why Bram was not coming. "Bye, Mosie . . . bye."

She answered back with a squeak. They rode off over the vast flat land.

Bram stood and watched, hoping Modoc didn't try to escape. His only hope was to think of something quickly.

A warm wind had blown in from the north, whipping the dust into the air. The simmering heat from the desert floor rose and appeared to create grotesque images on the horizon. Lakes without water, trees without roots, forms of fantasy concocted by one's imagination. Bram watched as the men, Mo, and the horses became one long thin silhouette, dissolving, separating, connecting in a string of occurrences. All unreal surrealistic changes, things that were once living forms were now but thoughts of a heat wave.

From the waning images there appeared a hovering dot. It grew as its form changed and separated. Pieces came together, then parted, until finally a steady picture of something coming was formed. Bram wiped his eyes, the dust having blurred his vision.

Something was coming! Mo? Did she escape? Or was it a rider coming back? For what? Were they coming back to kill him? Of course, that's it! They couldn't do it with Mo there, and he had seen their faces and could identify them to the authorities!

The rider was coming fast now, his rags of clothing blowing in the wind.

Bram's heart raced, gulping his breath. He could see the man now. Sword drawn, he leaned forward in the saddle, intent on his mission.

Cupping his hands to his lips and with all the vocal power he could possibly summon, Bram screamed, "MMMOOO-DDDOOOCCC!!!"

His voice broke the stillness like a crystal falling, shattering into a thousand pieces. The scream carried on the hot wind, blowing against the dark rider, past the mirages to the giant ears of Modoc. Ears that could hear what no mortal can. She stopped, stood stock-still. Her head was held up high, the tip of her trunk stretched into the wind, then it dropped. The tip started a rhythmic thumping in the dirt.

Thump . . . thump . . . thump. And from the innermost recess of her being came an ancient primitive sound, a whine of anguish seldom heard by any living thing . . . uttered only at the time before a kill. The two horses, one on each side of Modoc, sensed death. They were privy to the voice that only animals hear. They carried their riders who still held the ropes looped around Mo's head. In front, Hamid forced his steed to strut a proud and indignant step. The other was behind Modoc. In one great terrifying explosion of energy, she spun her huge body, the ropes pulling the horses off their feet, spilling the men. One man was picked up and whipped to the ground. Stepping on his head, she encircled her trunk around his body, and with a quick snap dismembered him. She stepped on the other's head, squashing it instantly.

Modoc had never killed before, but the voice the wind carried gave her the right.

Hamid, in sheer panic, threw his knife with abandonment. It struck Modoc with a thud, blood gushing down her chest. He reached for his gun but with one mighty thrust, Modoc picked him up, threw him under her knee, and knelt on him! His body popped open, its innards exploded. The last man ran away screaming for Allah. Modoc didn't pursue him; it was not revenge she sought. She was on her way, racing for Bram, trumpeting as she ran.

The rider, unaware of the fate of his comrades, raced his steed to a skidding stop. He was off his horse before the dust settled. Bram recognized him as the "spat on" bandit. He slowly slid a long saber from its sheath and moved toward Bram.

"How can you kill when it's against your religion?" asked Bram, trying to avoid the inevitable.

"What do you know about us? I kill for survival and with you alive, my survival cannot be assured."

The man took a swipe at Bram, who, being quick and young, sidestepped the thrust. He thrust again. Bram ducked and ran for the tree. The bandit moved in and with a mighty swipe barely missed Bram, but took off a three-inch limb with one blow! Bram raced to the scattered items from the howdah and as the man

dashed in, he threw them at him: clothes, rope, foodstuffs, anything he could reach. The bandit, furious, came at Bram with a vengeance. Bram slipped and fell, trying his best to stay out of the reach of the saber.

Then he saw . . . Modoc! Dust flying, ears flapping, coming fast. He had to keep out of reach for just a while longer. He picked up a long piece of bamboo and with all his strength hurled it at the horse. It hit him on the rump and he took off, racing across the plains. The bandit was seething! He approached Bram with his saber, held with two hands. Bram screamed. Modoc's trumpeting answer was heard by the bandit. Looking over his shoulder, the bandit saw the rage of an entity of nature, a blur of dust and legs, running full out, ears forward, sweat flying, trunk loose, whipping in every direction. She was a wild thing, a killer about to kill, a god of nature. Bram rolled away. The bandit stood facing Modoc in total disbelief, his weapon hanging loose in his hand.

Mo never stopped. She ran directly into and over the man; the body burst, his blood squirting . . . body parts were thrown in all directions. Bram had never seen Mo kill anything before. Her vengeance scared him. He had never realized her strength and stood in awe. Mo stomped and slid her feet across the body until it was a thin hide of an unidentifiable thing. Then with the blood still running down her chest, she came to Bram, encircling him with her bloody trunk, holding him tight. Her body trembled from the heat and exhaustion of the battle. Bram reached up and quickly and smoothly pulled the knife from her chest, her blood oozing down his hand. He laid his head against her quivering leg muscles. His body and heart flooded with the impact of it all. He broke into an uncontrollable sobbing . . . a mixture of love and grief.

24

A HUNDRED YARDS DOWNSTREAM Bram found a place where the water widened. With Bram scooping the dirt with his hands and Modoc repeatedly dragging a front foot, they succeeded in creating a fair-sized shallow pool. He had Mo lie down in the middle so he could pour cool water over her injury.

Sucking in the water, she blasted it deep into the six-inch wound. She sometimes winced from the pain. Using a scrap of cloth, he cleaned and dried the hole as best he could. He knew he had to get her to a doctor to prevent infection from setting in. Cutting off a piece of the damaged cinch, he fashioned a huge bandage, which he put around her chest, supported by another rope over her shoulder.

Due to Modoc's weakened condition, he decided to leave the howdah behind. Putting anything worth salvaging into two bags, he tied a rope between them and hung them around his neck. Bram

walked by Mo's side, leaving a pool of crimson red as they followed the stream, heading toward the mountains in the near distance.

It had been two days since the abduction and Modoc had slowed down considerably, occasionally dragging her feet in the dirt. Her ears hung forward, head low, eyes droopy. Her bleeding had subsided but there was considerable swelling and pus oozing from the wound.

On the morning of the third day they arrived at the edge of the mountains, where a quaint village nestled near a small sheltered valley. The community, poor as it was, existed on the side of a hill that had not been graded. No one bothered to cut horizontal floors in the houses to walk on, but rather built them on the natural slant of the hill. Although not too severe a slope, it nevertheless caused a ball to roll from one end of a room to the other with ease. The slant was everywhere, and the local citizens didn't seem to mind walking, sleeping, sitting, or eating in this strange position. Bram was to discover the reason for this unusual phenomenon was the yearly floods that came with the monsoon season. The downpours were so heavy, the floods would roar down the mountainside, literally lifting some of the old structures off the ground. Trenches were built to avert the onslaught but it proved too powerful, and hence holes were cut into the backs of the buildings to allow the water to run its course through the houses without washing away the floors, or the houses themselves. Seeing it happen every year, they had decided long ago not to bother with repairs.

Although there were many goats, Brahmas, and pigs running loose, Bram saw no elephants. As they approached, several people came out to see the two. Apparently not many passed this way. Surrounding Bram and Modoc, they spoke among themselves in a dialect Bram had not heard before.

He pointed to Modoc's wound and gestured for need of medical treatment. Within moments, ointments, bandages, and antiseptic were brought and applied by one man who seemed to know what he was doing.

In the days and weeks that followed, Bram and Modoc came to know and befriend the people of the village called Mayaua. Most

had lived in the village their entire lives, as had their parents and theirs before them.

As Modoc's health improved and her strength increased, Bram put her to work hauling water from the wells high up on the ridge. Where they had previously carried the water in goatskin bags, one upon the back of each man, now dozens at a time were loaded on a slide board the townspeople fashioned. Modoc would pull it to the water storage area.

As the monsoon season approached, the city began to prepare for it, boarding the windows, reinforcing the doors and framework of the buildings. But everyone worked on the most important build-ing in the village—the storage building. All the food supplies har-vested from the year before were kept there, along with bags of rice, grains, seeds, and oils. At the far end the equipment ropes, wood, wire, fencing, and farming tools were stored. With Modoc's help they finished a month ahead of schedule.

The village was proud to have an elephant. Though it wasn't theirs, they had all learned to love Mo and thought of her as their own. The children painted designs of bright colors all over her. A woven tapestry, depicting the past wars the country had fought, was taken from the wall and draped over Modoc's back. The village artist painted detailed figures of Indian deities on Mo's tusks. Flowers were picked and woven into a garland that lay over her forehead.

Although poor, the village had not lost its ability to enjoy. Dances, featuring strange musical instruments and foodstuffs, were held in the dirt streets of the village's marketplace. Bright-colored ribbons were wound around the fronts of the shops.

Bram and Mo earned their upkeep by doing any job that needed Mo's size and strength. Bram's ability to teach and show her what had to be done and how to do it made them an unbeatable team. Together they hung signs, hauled water, dragged lumber, and even performed for the children every Saturday afternoon.

Bram knew he would have to spend the winter in the village and although anxious to move on to warmer climates and, hope-fully, a job in the teak forest, he also realized how very fortunate

they were to have found such a warm and caring village.

The winter hit with a mighty wall of water. Sheets of rain poured down in an incessant torrent, never letting up for a moment. The village became a slippery slide of mud that started high above them in the nearby hills. By the time it arrived at the village, it had gathered force and was rushing through the town at great speed—carrying with it anything it touched. The rain gutters did their job carrying the mud to the bottom of the hill. It flowed into the valley below. Now Bram understood why the townspeople left the town in its slanted condition. Had they rebuilt, it would only have been washed away.

Bram wondered what had become of Mr. North. Was he still looking for them, or had the rain stopped him for now?

One morning Bram awoke to the voices of children. Their giggling and laughter reminded him of his school chums at play during the recess hour. It seemed like a lifetime ago. It was the first morning in a long time that he hadn't awakened to the pattering of rain on the tin roof. The monsoon season had passed. The rains left the surrounding hillsides with brilliant hues of color, each vying for the attention of one's eye. Small flowers popped up everywhere, reminding him of the field flowers at home. Lately it seemed as if he compared everything he saw to his home and friends.

He knew it was time to move on. New places and people would occupy his mind and ease the pain of remembering. He also didn't want to lose sight of his goal—to find and work in the teak forest.

The whole village turned out for their leaving, and with Modoc packed with all the food and equipment she could carry, they started up the sloping hills, zigzagging their way to the top. They looked back and saw many of the people still watching. A wave of his hand sent many into motion waving colored streamers and blowing horns and whistles that could be heard all the way up the mountain. Modoc's trumpet answered their enthusiasm, and then they were gone—heading into the high country from where the rains had emanated.

25

FOR A MONTH HE PRESSED ON, rarely stopping except to ask directions, sleep on the ground, or bathe in a nearby stream. The earlier spring rain had drenched the earth and changed the forest drastically. A strong sweet-smelling scent of musk hung in the silent humid air like moss from the mandarin tree. The forest and vegetation grew thicker, more exotic, more junglelike.

A burning crimson sun appeared and disappeared among the tall vine-covered treetops as they moved up the trail. Bram shed most of his clothing so the sweat could run freely down his back. He tore a piece of orange fabric from material he found in the sack the villagers had given him. This he twisted into a band and tied around his head to keep the salty sweat from running into his eyes. Cool sun-sparkling streams of mountain-fresh water meandered through the forest.

A smattering of people walked the trail. They traversed small tributary paths leading in and out of the forest. One old man, bent

low from carrying a heavy wooden yoke, winced at the pain of its pinching into his shoulder. Clay pots hung from each end spilling water as he attempted to balance his rather obstinate load.

An occasional elephant passed, blowing a snort to Modoc, she offering a chirp in return. Topless women carried a multitude of items on their heads. All were dressed in bright-colored apparel. Others pulled rickety carts make of root and wood, covered in ornately carved bark; all waved, offered friendly smiles, and were most helpful in informing Bram as to his whereabouts and pointing out the best route to his destination. He was feeling the sweetness of a new forest and was in no hurry. The plumage of the birds was iridescent. The drone of the insect life was a steady monotone, and the chatter of the monkeys composed one cacophony of song.

The trail divided. Both paths were of the same size. "Move up, Mo!" he said, letting her be the decision maker. She chose the one on the left. After some time the trail began to narrow. He was about to tease Mo for taking the wrong trail when he heard the sound of running water. Bram dismounted. He approached an idyllic area where the ground cover was similar to the grass Bram had found at the maharajah's palace—brilliant lime green and as soft as a silk robe. A light pale mist rose from the earthen floor, swirling its way up through the sun's rays.

A cool breeze brought the sound of a waterfall. Bram followed the sound, letting it guide him through the forest. Mo followed. Coming out of the brush, he stood at the edge of a beautiful pond. Lily pads floated in bouquet, their large leaves catching the eye of the myriad fluorescent purple-backed dragon flies that swooped and hesitated over the pond. The bush came right up to the shore of the pond, giving it a look of privacy.

The heat of the day made the pool more than inviting. He slipped off his wrap and headband. He put his amulet, alongside his choon, in the bag tied across Mo's back so he wouldn't lose it in the water and, without hesitation, dove into the silent waters. He swam hard. The stronger the stroke, the more swiftly the water pulled at his body, giving him a feeling of his nakedness.

Mo stood at the shore spraying her body with the cool water with an occasional eye directed at Bram. He floated on his back, eyes closed. He floated aimlessly, his mind suspended in a surrealistic world of gentle love and tenderness.

"Hello."

The small voice came as the chirp of an insect, the movement of a leaf, the warm wind through the grass. Moments passed before Bram realized it wasn't the voice of nature—it was a girl's voice.

He exploded! Completely disoriented, he splashed his balance, then dove beneath the surface. Swimming under water, he headed for the lily pads and gently let his eyes and nose emerge. His eyes searched the shoreline, trying to pierce the underbrush. Then he saw her. She was sitting on the shore, her legs askew, head back, occasionally running her hand through her hair, long raven-colored hair drying in the sun. Her wrap of bright red and yellow material appeared wet.

"Hello," she said again, only this time with a bit of a giggle in it. "Sorry if I startled you, but I come here often to swim. I rarely see anyone else."

Bram raised his head high. Her voice was hesitant.

"I live close to here. The weather has been so hot . . ." No response from Bram. She became a bit embarrassed at the silence. "Sorry, I best go." She started to rise.

"No, it's okay. You . . . just . . . surprised me."

"I know," she said, her eyes looking at Bram's cloth lying on the ground.

"Please . . . ah . . . will you?"

Understanding his wants, she picked up his wrap and threw it to him. Bram quickly tied it on and swam to the shore. As he stepped out of the water, the girl rose in front of him. She was much smaller than he had thought. Her almond-shaped eyes looked up at him. A smile came gently and she said, "I'm Sian."

"I'm Bram."

All was quiet. Neither knew what to do next. Modoc saved the day. She moved to Bram, wrapping her trunk around him.

"This is Mo. Her real name is Modoc, but I call her Mo. Sometimes Mosie." His voice trickled on. Mo reached an inquisitive trunk over to the girl and sniffed her long hair, wrapped the trunk around her carefully, and brought her in close. Bram heard the low belly rumble of "Everything is okay." "She likes you," he said.

Hugging Mo's trunk, she said, "I like her, too. Would you like to see mine?" she asked.

"Your what?"

She laughed. "My elephant."

"You have an elephant?"

"Well, it's really my father's. We have many, not many but a few . . ." She hesitated. "Like four!"

He noticed a slight English accent mixed with her Indian tongue. "Do you want to meet her? She's just here." She pointed into the brush.

"Sure," said Bram. As they started to walk, Bram held Mo's ear to guide her through the forest. "Why? What do you do with them?"

"My father works at a teak village. You know, where they cut the wood."

"Yes, I know, I've come a long way in hopes of finding such a village that would employ me . . . and Mo."

"We could ask Father. Maybe he could help."

A rather smallish elephant stood quietly just off the main trail. Sian undid a soft hemp rope tied to a tree from around its leg. Once free, the elephant reached down, picked up the rope, and, as if it were carrying its own leash, walked to Sian.

"This is my baby, Swati," she proudly announced.

Modoc greeted Swati with a rather snobbish attitude. "She is a fine animal," said Bram, running his hand over the pale gray underbelly.

Each mounted an elephant, Sian getting a leg up from Swati. Mo lowered her head and Bram grabbed her ears. She lifted him up until he could jump to a straddle position. He followed Sian as they headed up the trail, enjoying watching her hips sway to and fro.

How close the village was! Had he continued up the trail he would have come upon it within the hour.

They had ridden to the top of a mountain overlooking the village. Sian and Bram slid off their mounts and walked to the rim. The teak village was as Bram had imagined it to be. It was nestled in a lush green valley, inundated with towering teak, with a muddy brown river that coursed its way on the far side. An occasional peaked thatched roof was visible through the forest.

She led the way down a small path that ended in the middle of the village. A man came out of one of the larger buildings. A sign overhead stated: TEAK FOREST VENTURE, LTD.—NORTHERN DISTRICT. On the door, a small sign read: OFFICE.

He was a thick person, stockily built, with dark eyes and black hair. He wore a clean white, short-sleeved shirt with epaulets and the customary shorts.

"Hi, Father!" greeted Sian. She kissed his cheek. By the look of surprise on her father's face, Bram knew that the kiss was not something she did often.

"This is Bram, Father, and . . . uh . . . Modoc."

Bram stepped forward to shake the man's hand. The handshake was brisk and heartfelt.

"I'm Ja." He walked over to Mo and said in the same breath, "This is a handsome animal you have here. From up north, I take it?"

"Bram has come looking for work, Father."

"Yes, well." With hesitation: "I must attend to my duty just now. But I am sure Sian will be most happy to show you our village." Then as an afterthought: "I'll talk to the headman this evening and inquire about a position. By tomorrow we should know. Sian, Bram can stay the night at one of the banana houses until such time as he can meet the headman," offered Ja. Then with a gracious smile and slight bow he was gone.

Up on the slope stood a row of palm-thatched huts. There were bananas everywhere. Monkeys sat in the nearby trees, too full to move.

Bram learned one had to be careful of the giant palm spiders

that frequented the plants. They were as big as a man's hand. One could be reaching for a banana and end up with a couple of large fangs sunk into a finger. A quick wipe of the hand against the stalk usually dismembered the hairy body from the head, but sometimes the fangs remained and in many cases had to be removed surgically.

Sian took Bram through most of the compound. Near the bottom of the slope were three large thatch-covered buildings, one dining area, another building for offices, and the third for repair and storage of the elephant gear. This building was the last in the row and closest to the river.

At the far end of the valley, about halfway up, stood a small Hindu temple. Hand-carved of teak, it was a reminder of how beautifully the teak could be used.

The larger structures represented the families with the most children and the better positions. The largest, most elegant private residence was the home of the headman of the village, a man Bram was yet to meet. The hospital, laundry, market, and school were the smaller buildings.

Running parallel to the river was the elephant lineup. Two three-hundred-foot-long heavy hemp and vine ropes lay parallel to each other about fifteen feet apart. Heavy root stakes held them to the ground.

Every ten feet there was a circle of rope tied across from one rope to the other. When the elephants were brought into line side by side, they were tethered by a front left and a rear right leg in the loops of the rope. Each night they were alternated.

Bram and Sian walked back to the banana huts. Food had been set out for him and there was water in a cauldron still hot from the smoldering coals.

"Have a nice sleep," Sian said. She headed down the trail to her own house. She turned her head sharply as if to swing her long hair out of her eyes, but in truth to give Bram a final smile. "Till tomorrow."

He lay in his bed a long time . . . thinking. He decided not to reveal the maharajah's amulet to anyone. He didn't want people to

do things for him because of whom he knew. He would never know if they were truly his friends or if they felt they had to help him. No, he wanted to accomplish things on his own. Bram's last thought as his eyelids fell was that North would never find them here.

The trumpeting of many elephants awoke Bram. He sprang to the open window to see a wonderful sight. Down near the river as many as thirty, maybe forty elephants and twice that many people were preparing for the day's work. He dressed hurriedly, patted Mo his intention to return, and headed for the river.

The din of the activity centered around the river area. Having just finished their early morning bath, the elephants were being prepared for their particular functions. Some were in the "come down" sphinx position resting on their knees and front feet while special howdahs were fitted on them. Others moved into their harnesses that hung in the specially constructed wooden frames.

The elephant would lower its head a bit and move into position by putting its head into the thick, heavy hemp harnesses while two assistants connected the tracer ropes. These were to be used for pulling.

When the elephant was needed to push something, the mahout commanded the elephant to drop its head, causing a thick mat loosely tied around its neck to fall forward. This was used for protection. When not in use, the elephant lifted its head and the mat fell back into place.

A number of elephants were having their tusks rubbed and polished, then a sheath of stitched leather was slipped on for protection until they were used to lift logs.

The jabber of the mahouts, the sounds of the elephants complaining or being mischievous, the hustle and bustle of the operation, all caused an excitement in Bram. In the middle of the preparation stood Ja. He was talking to another who Bram felt was the headman. The man was dressed quite different from Ja. He wore a tan shirt with a number of insignias and badges, tan shorts, high tan socks, and long-legged boots. A tan pith helmet completed his outfit. He also carried a riding crop.

Ja waved Bram over and introduced him to the boss, a man by the name of Singh. A time for them to "have tea" was arranged after lunch, and Bram walked away wondering if the conversation had happened at all.

Returning to his hut, he washed up, changed clothes, and was unshackling Mo when Sian arrived.

"Did you enjoy the morning routine?" she asked. "I watched you from above," she said, answering his unasked question.

"It was wonderful. Even though everything seemed in chaos, there wasn't a movement without purpose. Each thing was done to perfection and in the same breath. I hope I am accepted."

"It's not that easy to be a mahout, Bram. These men have dedicated their lives to their work. Their elephants have trained for years in the special tasks needed to perform the duties. You and Mo would have to pass many tests. Why, it could take years!"

"I'm ready, and so is Mo. Her body's at a hardness that is comparable to these others. She is strong and intelligent. Many things I see being done here, she has done; others I will show her and she'll learn."

Bram's tenacity for the job was so intense that she was amazed at his determination.

Bram figured there were about fifty mahouts, maybe sixty assistants and keepers, ten cooks, fifteen kitchen assistants, a smattering of camp boys, security guards, and a rather large number of wives and children who were allowed to stay with their husbands and fathers. A good-sized village, to be sure!

Many of the elephants were large bulls, carrying heavy tusks. Most females either didn't have tusks, or their tusks were much smaller. If tuskless, they were known as haulers. They did heavy duty work, like pulling and pushing timber.

The large males used their tusks to pick up the heavy teak and balance it with their trunks, either stacking it in sections or carrying it to the trough, where the teak was sent cascading to the river far below.

If a male became unmanageable, special hardwood balls were screwed onto the tips of the tusks so they couldn't inflict injury on others.

Mo's tusks were coming in at a fast rate and were quite large in comparison to those of other females. This was most unusual although Bram had seen some large tusks on the female elephants up north.

In a quiet place standing under a huge teak not far down the river stood a giant elephant. His tusks were massive. The trunk hung loose, the ears forward . . . the body lurched forward. In two strides he stood in the sunlight.

Astride the elephant was a man with long silver hair. His body was lean and muscular. He wore a loose-fitting sleeveless white cotton shirt and white wrap. Bram's eyes locked with those of the old man for a moment. Bram turned to Sian.

"Who's that?" he asked.

"Kalli Gooma, the head mahout. He's very old. No one knows exactly but it's told that the date of his birth coincided with the first revolution. That was seventy-five years ago! He stays strong, works every day, and is respected by all. His word is law to all the mahouts."

When Bram looked again, they were gone.

The meeting took place in the headman's residence. Bram thought it a bit unusual, but Singh was a man of comfort and enjoyed his afternoon Pimms cup in a proper setting. He had also asked Bram to bring Mo along. Hands were shook all around, seats offered, and Mr. Singh began the conversation.

"Well, boy, I am informed that you are interested in working for Teak, Ltd. in the position of a mahout. This is, of course, impossible as you have had no training in this most difficult field. Why, there are those who wait many years to be accepted." Singh glanced at Modoc, who was busy eating the flowers on the veranda. "And a fine specimen she is. I can offer you a job in the kitchen or maybe assisting the mahouts. In your off time you would be allowed to help the elephant staff and in so doing, learn the trade. In a few years, well, we will see, but meanwhile your elephant, what's her name, Modoc, would have to be put in the lineup and worked by

another more experienced person." He looked at his watch. "Well, what do you say?"

Bram was dumbstruck. He didn't know what direction to take. "I . . . ah . . . sir, please. Sir?"

"I'm sorry but that's the best I can offer."

Singh got up to see them out. Bram stood but rather than leaving, he hesitated.

"May I speak for a moment, sir?" he asked.

The headman was a bit taken aback by the young man's insistence. "Very well, but please, a brief moment."

"Sir," Bram started, "please don't think me rude or disrespectful . . . but I have come a long way." He saw a frown creep across Singh's face. "I have experience in the fields you speak of. I worked under my father in a circus in Germany. He taught me things that make me qualified to be a mahout. Please sir, give me some time . . . maybe two weeks. Let me study the ways of the mahout and what is required."

The headman sat down. Never had he heard such a request. "Why . . . I . . . don't believe I hear you correctly."

"Sir, I will sleep elsewhere, supply my own food, cause you no grief. Just let me observe. Then let me be judged by Kalli Gooma. And if he approves . . . would you then accept me?"

The headman looked at Ja. Ja raised his eyebrow with a noncommittal smile. "Very well, this is a bit crazy, there's not a chance. Maybe it's the Pimms but, well . . . give it a try. I will allow you this . . . ah . . . unusual request. However, if you fail, you will be assigned to the kitchen staff and your elephant given to another of our choice to work in the forest. Agreed? Huh!"

Bram was perplexed. He knew in his heart that he and Mo could do it. But what if he failed? He didn't mind the kitchen duty, but what about Mo! Working for another. He didn't know if she would. What if the man was cruel?

"Yes! Very well, thank you, sir . . . I . . . "

"Now please be good enough to leave me to my . . . ah . . . lunch," Singh cut him off.

* * *

"Sian! Sian!" He raced toward a prearranged meeting place near the river.

She was waiting to hear the news; she would be there to comfort him or share in his delight. Bram found her as planned. She was dressed in a thin white cotton wrap, her tan skin against the white, her dark hair like a soft blanket of silk. Bram burst into the clearing.

"I got the chance! He said okay."

He held her in his arms. Anxious, out of breath, she felt his excitement, his eagerness, and her eyes darted from one side to another, as she consumed every word.

Bram stopped his burst of energy; he had felt her tremble. The look on his face caused her eyelids to drop. When she did look, his lips were on hers, warm, moist. Their arms encircled each other. Bodies perfectly fitted to each other. It was a time of Nirvana.

26

THAT NIGHT BRAM LAY AWAKE; his thoughts were of Gertie. Such treasured moments! The time she danced on Modoc . . . and almost fell! Running through the field flowers, swimming in Cryer Lake, their first kiss and his promise to return. The thoughts blinked tears onto his cheeks.

The next few weeks moved quickly for Bram. He knew now that he had to let Gertie go. He had to tell her about Sian and set her free. To have her keep up her hopes, especially now, would be unfair. He loved her as he loved Sian, but Sian was here and now. He could touch and hold her, and their life in the forest was full of happiness.

How was it possible that a man could love two women equally? It shouldn't be! A man should love one more than all others. Why not him?

Bram's thoughts went to his mother. She, too, must be told he

was alive and well. And Curpo, his dear friend. He wondered if Curpo still watched over his mother.

He realized, maybe for the first time, that he had given his life to an elephant. Warm and wonderful as Mo was, she was still an elephant. He had forsaken all. His mother, the girl he loved, everything for Mo. Was she worth it? Maybe so. But wasn't it selfish to hurt his loved ones the way he had? To leave as he had? And, worst of all, not to tell them what had become of him? How horrible it must be for them not to know whether he was alive or dead. Sometimes that was more difficult to deal with than knowing the worst. If there was to be suffering, then it should be his alone. He would no longer hurt his loved ones.

That night he made the choice. He would keep in touch with his family. He would not tell where he was, and hope that North would not find the letters. He realized the postmark would reveal his whereabouts, so the letters would have to be mailed as far away from the village as possible. He remembered the letter North had sent the maharajah. This man was determined to find them! He was rich and probably had hired many people to look for them. North figured they were somewhere in India. Bram knew once the letters were mailed, he would have to live incognito. Live as secret a life as possible. If he heard that North was near, he would move on. If North found him, he would deal with it. One thing he knew for sure, North would never give up his search for Modoc. Bram would write a letter the very next day.

Now another thought sprang into his mind. Would he have done this had his father not asked him to? The shock of that thought made him sit upright in bed. Had he been using his father's dying message to cover what he would have done anyway? Was it easier to blame his father? Whatever happened, he could always say his father "asked him to do it." The truth was, he would have gone regardless. He simply couldn't allow North to take Mo, or have Jake handle her.

But there was more. There was something else Bram suffered from . . . guilt. Guilt for taking another man's property. To steal, to

Images of Modoc

Few photographs exist to document Modoc's heroic and adventure-filled lifetime. The pictures reprinted on the following pages have been collected through the years by Ralph Helfer and were taken primarily during Modoc's circus years and the later periods of her long life.

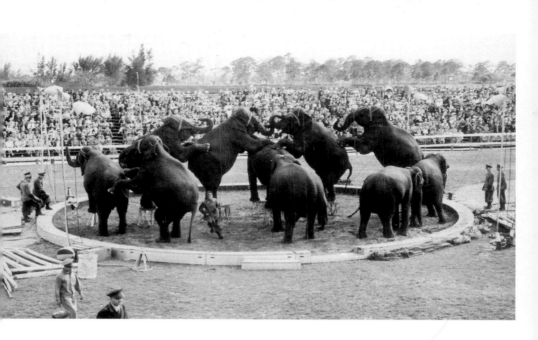

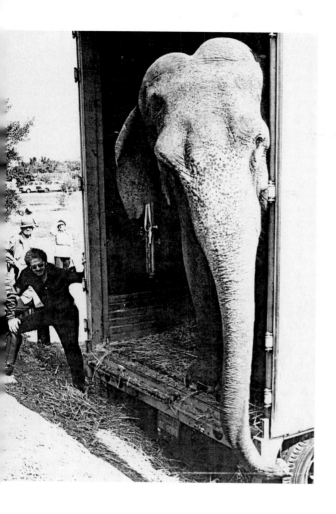
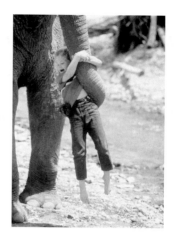

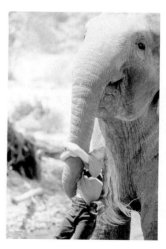

be a thief! His parents taught him never to do that! Yet, on his deathbed, his father had asked Bram to "take care of Mo." For a moment, Bram felt a hatred for his father. How could he ask two opposites of him? Two things impossible to do! How could Bram take care of Mo when she didn't belong to him? Well, he had tried. He felt he had done all that could be expected of him.

The night had been long. Maybe the longest he would ever know. Maybe the most important.

The next morning he wrote two letters. The first to his mother and Curpo. He spoke of the ship sinking at sea, of the Elephantarium, of the attempt to steal Modoc, of missing them, of his fear of North, of his decision to speak out, and . . . about Sian. That was the hardest part. He asked them both for their forgiveness and understanding.

The second letter was to Gertie. He told her most of the same things but in greater detail, more explanation, as though he were stalling, not wanting to get to the part of the letter about his relationship with Sian. But then he wrote:

> My future was in the past . . . the farm, being with you and my family and friends. But now it's too late. Where I am going is so uncertain that it is best we part. I may never be able to return. My life is so unsettled—never knowing when or where North will come.

Then he spoke of Sian. How they had met. How understanding she was. He spoke of the pain he was going through, loving them both. He had been feeling selfish until last night. Then it all came to him. He could never give Mo back to North, and therefore he would never return home. He had to keep going, and this meant that he might never see Gertie again.

> You are too beautiful a girl to stay idle waiting for something that may never be. How long this could take, where I may end up, are unknown, and therefore you must get on with your life. I will always love you, Gertie. You will be on my mind and in

my heart forever. Sian will be told this, and I know she will under-
stand, as I hope you do now. Be well, my love. If our God deems it,
we may meet again. But for now, let us both send beams of happi-
ness to each other.

<div align="center">

Love,

Bram

</div>

A runner was sent with the letter and as he vanished into the
forest, Bram felt the tension leave that had been his far too long.

Bram asked in the temple, in prayer, how one man could love
three ladies at the same time? Gertie, Sian, and of course Mosie. He
didn't count his mother. That was different. He hoped his prayer
would be answered soon.

Though he carried the pain of loving Gertie with him, the next
two weeks were the most joyous Bram could remember. He had
much to learn about emotions of the heart. For he had truly fallen in
love. He and Sian were inseparable.

There was talk in the village of Bram and Sian's closeness. To
be as intimate as they had been was not accepted. To be as close as
they were was unknown in their faith and tradition. Although
Sian's mother and father, as well as the villagers, had kind and
warm feelings for Bram, he was of another race and religion. It
could not continue. It was Ja who first spoke of it during a walk
along the shore of the river.

"Bram, I have something important to speak to you about."
Ja's voice was hesitant yet firm. "It's regarding my daughter and—
you."

The men stopped their walk, gazing gently at each other. Both
had learned to care for and appreciate the other's honesty and
truth, and they both realized that what was about to be said was of
great importance.

"You and Sian can no longer be . . . well, as intimate with each
other as you have been. There is no future in this relationship. You
are not one of us, at least in race and religion. And therefore you
could never marry her. It is not allowed."

They had stopped alongside a giant fig tree, and hearing the news, Bram stretched his hand out to support the unsteadiness that now coursed through his body.

"Ja, what are you saying? Sian and I love each other. The love is stronger than all you have said. We can overcome these things. Sian told me of her faith and said, as you did, that it was not allowed. But she is prepared to leave with me if it becomes necessary. We could never be apart!"

Ja's voice became stronger. "Did she also tell you that she would become an outcast, that she would never be allowed to see her family and friends again? And, worse, that she would be considered a whore! My little girl—a . . . "

He could not repeat the word. His voice had become shaky. "I . . . am . . . sorry, Bram, but I know of no other solution."

Ja left, brushing his hand over Bram's shoulder. Bram stayed at the tree until the sun no longer warmed the village.

Bram could think of nothing but what Ja had told him. Not to be with Sian was as bad as not being with Mo! His depression was affecting his mahout training. He found himself blaming Mo for his own mistakes. Precious time was passing, but try as he might, each day was a struggle to work without thinking of Sian and the thought of being without her.

All was being lost! He knew that the way things were going, he would lose both Sian and the opportunity to be a mahout. Bram had just finished working with Mo and had taken her down to the river to be scrubbed and bathed. He heard a voice.

"Sometimes it is better to accept help than to suffer the consequences without it. Only men suffer the pride and ego that they themselves have created. The Creator never gave animals these burdens. They are of little use, but it is my guess that He had to test us to see if we could overcome.

"All life is built upon steppingstones that reach into the Beyond. Without them we would never reach our goals. Use them, you have earned them, and they are yours."

For a moment Bram contemplated what he had just heard,

then turned to confront Kalli Gooma. He found no one there! Even though he had never spoken to Kalli Gooma, he knew it was his voice he had heard. Instinctively Bram knew that Kalli Gooma was speaking of his friendship with the maharajah.

The word spread fast. Bram was the chosen son of the maharajah! Such an honor was of the rarest form, even rarer than being his actual son. For that would have been a natural thing, but to be chosen . . . one out of multitudes of millions! This was a rare privilege indeed!

The village had gathered. Bram had shown them the amulet. Oohs and ahhs were heard outside the door for the waiting ears of those who pressed close, awaiting the outcome.

The son of a maharajah surely . . . most certainly . . . was qualified to become a member of Ja's family.

Bram wore the amulet from that day on, for all to see. He wore it proudly, with dignity, for he had earned it!

The day for the test approached. The whole village was eagerly awaiting the outcome. They offered to pitch in and help. They hauled ropes and wagons full of teak for Bram to teach Modoc with. Ramps were set up to simulate those in the compound, as he was not allowed to practice there.

Bram had become a popular figure, and now with his love for Sian so obvious, the village supported him even more, encouraging him every step of the way.

Modoc worked every day to learn the intrinsic nature of the teak. She worked the routine and repetition of the task at hand. The pushing, pulling, all were tough and complicated. The saving grace was the rapport between Bram and Modoc; they had emotional codes between them that allowed things to be done without others knowing how they were accomplished. Above all, it was quicker, and more efficient. The mahouts were amazed when they saw he rarely used the choon.

As the days passed, Bram noticed Kalli Gooma watching from

afar. When Sian asked him for a meeting with Bram his answer was "Another time."

"But he sees me making mistakes," sighed Bram.

Sian tried to assure him that Kalli Gooma would be fair and judge him only on his performance at the test.

With the test being the following morning, Ja thought it would be nice to invite Bram to dinner in an effort to encourage him. Both of Sian's brothers and an older sister were there. Her mother, as usual, was a delight, as they spoke of the pending test and what the future would hold for him and Sian.

Sunday. This was the morning of the day of the test. Bram, along with Sian, went to temple early so he had time to prepare for the day. Then, with a kiss from Sian, and good luck wishes from her family, he left.

He took Modoc to the river and bathed her. The water was quiet and low on the banks. There were no ripples. There had been no rain for a month. The odd fish would surface for a gnat, then disappear in the murk. Mo lay on her side, her trunk building sand hills, sloshing the water while Bram scrubbed and picked her skin clean. Her nails had been trimmed and rasped, her eyes and ears cleaned. She righted herself so he could give her a final brush. Then a quick dip in the cool water and Modoc was ready.

"This is an important day, Mosie." He rested his head on her leg. His fingers felt the velvet skin on the back of her ears. "But I want you to know that it's okay if we don't get the job. I mean, well, that's just how it's meant to be." He reached up with both hands and hugged her tightly around the neck. She belly-rumbled to him as though to say, "I know, Bram, I know."

He wore his best wrap—the same kind the mahouts wore, only it was of a different color so as not to offend those who had already proven themselves. Bram took the choon from around his neck.

"This is a guide—a liaison between you and your charge, to express your desires to the elephant." His father's words echoed

back to him. Then with a leg mount, and his command of "Move up, Mo!" they headed for the compound.

No one was allowed to see the test except the mahouts, Ja, Singh, and of course Kalli Gooma. Mahouts were also invited from other faraway villages. When Bram rode into the compound area a cry of encouragement rose from the crowd, and what a crowd there was. It seemed as if every village for miles around had taken up the invitation and sent its mahouts.

The weather had turned humid. Bram was pleased that the band on his head blocked the nervous sweat from his eyes. Weeks ago he had been instructed about what would be expected of him. The compound looked bigger than the one hundred by two hundred feet he had measured earlier. One side offered the pull section, the other the push. On the pull side, thick coiled ropes were set out. Six heavy teak logs, a heavy-duty work harness, accessories, clips, oils, brushes, picks, and other equipment were all laid out in their corresponding sections.

On the other side was the push area. There were a series of head mats; three wagons of different sizes, each loaded with teak; a steep ramp, perhaps one hundred feet long; and many wheel chocks to prevent the wagon from rolling backward.

In the middle was a small area consisting of a heavy tree stump, rasps, clippers, and other nail-trimming accessories. Close by was the medical supply area, where Bram would show his medical skills. A final area housed a riding howdah.

There were no clocks.

No music.

On an elevated reed platform two men sat cross-legged behind a large kettle drum. They each held two large sticks with the tips wrapped in animal skin. Bram had been told that when he began the test, one of the drummers would start to beat the drum. They had the ability to increase the rate of the beat so gradually that it would be hard to notice. At a certain time, it would stop. It was best that the test be completed before the drum stopped. When one of the drummers tired, the other would pick up the beat. Bram

recalled a game played with chairs when he was a child that seemed quite similar.

Bram stood beside Modoc. She was quiet and seemed to anticipate what would be needed of her. A head nod from Kalli Gooma and the drum started. In a single move Bram was on Modoc's back, choon in hand, and the test began.

Head down, harness fastened, kick tracer chains into position. Approach log. Gauge tracer distance to the log. Kick tracers into line. Back up. When tracers secure, firm the rope. Test weight. Start the pull slowly. As log moves, put strength into chest and front leg muscles. If logs heavy, dig toes into ground. Chest may touch the ground on some pulls.

The hours passed slowly. The drumbeat increased. The teak was incredibly heavy. It was many hours into the day. Bram and Mo had finished the pull and were just about to finish the push. She was on an incline pushing six heavy teaks loaded in a wagon up the ramp. Bram dropped wedge-shaped wood chocks to her and she carefully slid them against the wheels while she pushed against the heavy load to keep it from sliding back. She had to chock the wheels three times before reaching the top. The weight was enormous. Over eight thousand pounds. At the second chock position, a back wheel broke! The whole load slipped and was about to come tumbling down on Modoc! This teak was big enough to easily knock her over—maybe break a leg. The mahouts in the crowd stood as one. Even Kalli Gooma showed concern.

Modoc, using her great strength, leaned into the load, and with her trunk and tusks, picked up the side with the broken wheel, making the load level. Bram threw a chock down to her. She felt it with her toe, but the angle of the wagon prevented her from seeing it. Bram, lying flat on her back, spoke to her, telling her where the chock was and where to move it. Her ears perked forward, listening to every word he said. Finally she managed to slide it under the other back wheel so she could release her hold on the wagon. A sigh of astonishment and relief was heard through the compound. But Bram wasn't done yet. He moved her up close to the wagon and

told her to set her feet in a firm position. He sprang from her back to the wagon, seating himself on top of the teak. Leaning over the edge of the wagon, carefully watching that the load didn't shift, he commanded her again to pick up the load on the bad side. With a great show of strength, Modoc hooked her tusks under the bed of the wagon. She grabbed the railing and, lowering her head, pushed the wagon and its contents up the incline to the flat area above while balancing the load with her trunk. A roar of approval greeted Bram and Mo. When the cheering stopped, so had the drums. But Bram and Mo were done. They had completed the test in the time specified. Bram hoped that their work was satisfactory.

Bram took Mo down to the river. She slowly walked out into the stream where it was deep, unusual for her, and there slowly lay in the cool fast water. The sweat from her body, the deep marks left by the pull harness, obstinate at first, finally gave way to the soothing nature balm. Bram sat on the shore watching. He was so very proud.

27

A NOTICE IN THE VILLAGE said that Kalli Gooma would give his judgment the following day.

Bram and Sian sat silently at dinner. Her family tried to cheer up Bram by telling him how everybody had spoken of his handling of the broken wagon emergency. But he sat quiet, holding Sian's hand. After dinner they walked on the veranda; Mo browsed nearby. Bram wanted to tell Sian about Gertie but felt it was better to wait. They kissed good night and he went to bed with heavy thoughts.

The word spread quickly throughout the village. Modoc had passed the test, but Bram was to work as an assistant for one month with Kalli Gooma, at which time he would be given his final approval.

The village was amazed at the decision—what is an elephant without his mahout? All that an elephant does is through the

mahout. But they respected Kalli Gooma and knew he had his reasons.

Bram saw deeper. He knew that Kalli Gooma saw beneath the thoughts of others. Bram knew that Mo was different, that she could reason alone, that she had crossed over the line. Her visit with the white elephant had opened wide a door that before had let in only a small amount of light. Kalli Gooma had passed Modoc because she was centered in a world where she could hear both nature's voice and man's.

Bram was anxious to share his excitement over the test results with Sian. They met at the bend of the river, at their place under an ancient fig tree. The sun had set. The moon, full, had lifted itself onto the edge of the mountain rim.

Their moments alone were cherished. The touch of each other's bodies. He, exploring the curves, the way her softness melted away at his touch, tracing his fingers around her eyes, touching the blink, watching the tears of joy wash down her face. She, feeling his chest, the corners of his mouth, never venturing beneath his waist. Her shyness made her catch her breath when her fingers got too close. Once, during play, she rolled over him, feeling his hardness. It shocked her. She started to roll away but Bram held her tight, closely, breathing hard. She was to understand later of his needs and the way to satisfy them.

The next morning Bram met Kalli Gooma at the river. He watched as Kalli Gooma wove some heavy rope used to support the teak. Nearby the rush of the water and the bumping of the logs could be heard as they descended the winding slosh at high speed, splashing their way to the river below. Bram set to work, assisting Kalli Gooma. Neither spoke for some time.

"You have been allowed to see the white elephant."

Bram was amazed at the insight of this man.

He continued, "There are few who have. When I was very young, I, too, worked at the Elephantarium. I learned all there was to be offered. I achieved many steps and moved into a realm of a higher place." Bram listened intently, feeling honored to be with

this mentor. "You have come from a different land," spoke Kalli Gooma. "Yet my father, like yours, taught me from birth how to love, enjoy, and train the big ones. I have spent all these years using that knowledge, in preparation for learning new things. A good teacher teaches what he has been taught. A wise one teaches what he has learned."

For hours they spoke of many things, the village, teak, the future of the country, even Bram's love for Sian. Then Kalli Gooma stood.

"There are two areas Sian hasn't taken you to. One represents Life, the other Death. The keepers of these areas have opposite traits."

Kalli Gooma led the way up into a new part of the forest. The trail was very wide, and one could see that it had been well maintained. Bram heard the laughter of children coming from up ahead. As they topped a small rise in the jungle floor, the vegetation cleared, and there under a massive canopy stood one of the largest bull elephants Bram had ever seen.

"His name is Bandolla," offered Kalli Gooma.

Bram looked at the elephant. He seemed in good health. Why was he up here in the forest hidden from everything? Bram wondered.

"Bandolla is our breeding bull. He is the biggest and best bull in all the jungle—also the meanest. Many people are taken in by his gentle approach, only to be dashed and broken under his feet. He is used for all our cow elephants. He's very dangerous and will kill without hesitation. His meanness was not inherited. Probably came from something that occurred in his youth because his offspring have been large, beautiful animals with gentle hearts."

Bandolla was shackled in a way different from those below. Instead of two feet, all four feet had ropes on them, and the ropes were much thicker. They were tied fairly firmly to heavy stakes in the ground, not giving him too much room to move. The loops on the hind feet were tied more snugly around his legs because the back legs were like stove pipes, the circumference being much the

same at the top as at the bottom. If the rope could slip down the leg, it could come off.

The front feet were quite a bit different, heavier, stouter, the knees more pronounced. The foot spaded out into a large flat pie shape. The rope might slide down the leg but could never come off the foot itself. Kalli Gooma explained to Bram that the four ropes were used only when people had to work close to him, which they were about to do, and were loosened after the breeding. "He can seem almost gentle, sweet, rocking smoothly, swaying to and fro," Kalli Gooma went on to explain. "But it is these moments that have lain to rest some of the boys in the cemetery."

Bandolla stood in a bed of tall grass that he occasionally picked up and brushed his body with. Eight heavy teak poles supported a roof of palm fronds. The twenty-foot-high palms were lashed tightly together. The canopy was at least twenty-five feet long and possibly twenty feet wide. When Bram saw him stretch his trunk and body for a mango that had fallen from a nearby tree, he realized why the compound was so large. Bandolla's reach was enormous. If he ever succeeded in grabbing one of the main poles with his trunk, he could pull the whole structure down. An escape could prove a disaster.

His tusks were weapons of beauty, measuring eight feet in length. They had never been used for hauling the teak, therefore there was not a blemish, break, or scar—the ivory hue glistened. They were perfectly matched.

He was generally turned out into a large stockade made of heavy teak logs behind the canopy. There he could wander at his leisure. However, during breeding he was brought in and shackled under the canopy.

The children Bram had heard lived in small bamboo huts set in a semicircle twenty yards from the bull. They were of mixed age, perhaps from eight years up to twelve. Handsome boys they were, with brown skin, piercing dark eyes, alabaster teeth. All were nude save for an occasional simple bracelet or necklace. They were friendly enough when spoken to, yet never ventured an opinion or

asked a question. All were illiterate. They frolicked as youngsters do, inventing games, playing ball, wrestling. They were never allowed to play with the other children of the village.

"These children are blessed to be given the right to work with Bandolla," said Kalli Gooma. "It's a practice that's been handed down for centuries. When a breeding bull is mean and intolerable and yet of such exceptional quality that his genes are wanted, he is kept as Bandolla is . . . guarded and handled by children.

"For years many men were killed trying to work around their breeding bulls. The bulls are clever. They know if you take your eye off them for a psychic moment, get a hair too close, sneeze, cough, whatever will give them a fraction of a moment's advantage. They've got you. Once the trunk has just a single curl around any part of your anatomy, well, they'll either beat you against the ground or step on your head and pull!" He pointed to the children. "I have seen their little bodies like dolls, limbs torn, and thrown as twigs in the wind.

"Children are small, light, and, above all, very quick and agile. Their nudity, their bodies being covered with slippery oils, makes Bandolla's job of catching them most difficult.

"Beyond the stockade is a small cemetery," Kalli Gooma continued, his voice becoming deeper, sterner. "There is a row of little graves, some having been there for many years. Each Sunday these boys go there, say their prayers, leave a token of remembrance to the dead, and, in turn, they leave with a reminder of what can happen in a moment of carelessness."

Bram noticed that his voice had become firm. "Always remember, never forget. Never." Kalli Gooma's mood changed. "These boys are handpicked off the streets of Calcutta by Tabul, the headman himself. He is in charge of Bandolla. The children are small and lean. He has an eye for the quick, keen-of-eye ones. Some street boys know him. They practice things to show him, hoping they will be picked."

"But why? Why would they want to risk their lives?"

"It's safer. They have no parents or relatives, the older ones

would kill the young over a scrap of bread. The streets of Calcutta are famous for all the horrors the human mind is capable of causing. They steal, rape, sell their bodies—even kill."

Kalli Gooma greeted the boys with hand slaps, shoulder pats, handshakes. They were proud that he acknowledged them. "Here the boys have a chance at having a good life," he continued. "Plenty of good food, a place to sleep, healthy surroundings, friends who take care of them. And if they survive, and most do, they can become assistants to the mahouts, work in a dozen other capacities. It's the story of life. If you can be a survivor, you can succeed in anything."

That morning a breeding was to take place. Tabul had gone down to the river to bring up the cow. In the middle of the hut area were two large wood open-air vats that measured ten feet across. In one was a clear, thick, honey oillike substance that filled the air with an odor of spiced eucalyptus. Bram was told Bandolla hated the smell and taste.

In the other was a detergent of soapy water that had the scent of ginger. One of the boys was stirring the first vat with a three-foot-long ladle. Occasionally he would spread the substance over his body. The rest of the boys were playing, spreading the glaze, wiping and smearing the ooze on one another's bodies. Backs, buttocks, legs, everywhere, until they all looked like honey sticks at the local shop. A few of the older boys had finished and gone ahead to prepare the area. The ground had been brushed smooth, the ropes laid out; long-handled choons and even a large bag full of emergency medical supplies sat nearby. Everything seemed to be in order.

"If there comes a problem, you must not intervene," said Kalli Gooma.

Bram nodded his head in agreement. Coming up the trail was Tabul with a large cow elephant. Her name was Seria. Two mahouts accompanied him, one on either side of the elephant. They all carried long-handled choons that made it easier to reach any part of the elephant's body.

Seria seemed anxious. Tabul held the choon near her front legs. If she moved too fast she would run into it. The hook, although not sharpened, acted as a reminder to do what Tabul wanted.

As they approached the area, Bram noticed a large, heavy apron covering her entire back end.

"Sometimes Bandolla gets too rough with his tusks and jabs hard. The apron prevents any serious injury."

A couple of the boys threw buckets of water against Seria's buttocks to clean her up, then brushed her down with brushes bound together on sticks.

All was ready.

From the moment Bandolla saw her he went wild. His trumpets could be heard for miles. Each rope was pulled to the maximum. He tested them all, pulling each with his trunk, straining his utmost to break them. The earth itself shook. He threw his fodder in all directions, lashing out with his trunk at everything that moved. He was a locomotive off the track, gone berserk.

The boys, all oiled up, careful to wear the special rough leaf shoes that prevented them from slipping, swarmed into the area.

Three on each side, three on the back; Bandolla was like a boxer trying to cover all positions. His body rocked, trunk balled up ready to lash out in a fraction of a second. The boys wasted no time. Their slippery bodies moved in and out with precision. Each knew his job. Ropes were slipped off, others put on. Giant feet kicked furiously at the slimy little boys who swarmed over him. They threw hay to distract him.

His trunk lashed out clear to his back. The balled-up trunk would twitch with anticipation, aiming at one of the "bugs." Then, as a frog's tongue lashes out for an insect, the trunk sprang forth, aimed at one of the gnats. It missed, but by only a fraction of an inch.

Bandolla's erect penis was bursting for attention. It moved and swung as though it had a mind of its own. Some six feet in length, perhaps weighing twenty-five pounds, and prehensile, it moved, snakelike, as though searching for the entrance to its lair.

Tabul ordered the mahouts to turn Seria's buttocks toward Bandolla. At the same time the boys were preparing to loosen the two ropes holding the front feet.

"This is the most dangerous time," confided Kalli Gooma.

From an outsider's point of view, everything looked chaotic, disorganized. But in truth, it was a precision team working together for a single cause.

The cow was backed up to Bandolla where he could touch her with his trunk. He laid his heavy tusks on her back, strained at the front ropes, trying to raise himself. His frustration caused him to ram the cow. She roared in pain.

The boys, seeing that he was ready, prepared to loosen the restraint. Tabul gave the signal. The boys slipped into the danger zone untying the ropes, watching the trunk and the kicking feet as they became loose.

But Bandolla was more interested in Seria. With his front legs loose, he raised himself onto the back of the female. Seria spread her hind legs to support the bull's weight. As he moved up on her back his tusks reached her head.

The penis had searched and found the vulva. Insertion was imminent. He roared with energy, his eyes bloodred. Seria, with the weight of the bull, could only stand still and submit. Bandolla stretched his trunk forward to the cow's head. She responded and met him with her trunk. As the delicate tips of their trunks met, the orgasm erupted.

Once it was over, the boys quickly tethered Bandolla's legs. Bandolla took a couple of swings at them, but only halfheartedly. His energy was drained.

It had all taken a matter of moments. The boys were done, exhausted. They headed back toward the vats with the special detergent. They resembled slimy eels as their bodies slid into the tank from all sides. The tension eased as the stories and laughter began. Things were in hand. The beast was tethered and all was safe once again.

Kalli Gooma had listened and was now preparing to leave. "Bram"—this was the first time he had used his name—"when the time comes, you will make a good mahout. When the time comes." His voice drifted off as he headed down the path and he was gone.

Bram lay awake that night thinking of what Kalli Gooma had said. In the months to follow, Bram would be called upon to assist Tabul in many breedings.

28

BRAM AWOKE TO A LOUD COMMOTION. The early morning sun had not yet appeared, leaving the lush greens of the forest in shades of gray. The voices of many could be heard yelling, shouting obscenities. Quickly dressing, Bram raced down to the melee.

A group of villagers had a man from another village by the arms. They were moving him at a fast pace to the headman's house. Ja, among them, carried a bloody panga. Everybody was talking at once. Singh was standing on the veranda as they approached.

"What is the problem?" Singh said, trying to be heard over the din.

Ja spoke up. "This man was caught in the act of killing his wife, Mira."

The crowd was becoming angrier. Singh raised his hand for quiet. The crowd lowered their voices.

"Is this true?" he asked the accused.

The man smelled of liquor and had trouble keeping his balance. He lowered his head; his sobs could be heard. "She was leaving me. What had I done that she would do this? I didn't mean . . . "

"Ja, take him to the hold. Notify his village elders. Have them meet me in my office about . . . ten! We will discuss the case at that time."

As the crowd dispersed, Bram heard someone say that the man was a mahout by the name of Kim.

That night candles were lit at every house. Some villagers went to the temple and prayed to their Maker. All were talking about the horrible tragedy. As the evening wore on, visitors from other villages were given huts to sleep in so they could stay the night.

Bram and Sian huddled on the veranda late into the evening, talking of things that they had never experienced or known about.

Morning.

The elephants were not to work this day. Everybody waited anxiously around the huge teak tree in the middle of the village. It was called the Rumor Tree. Nothing was fact until it was done, it was only rumored to be so. Not only rumors were posted.

Placards were posted there. Notes were hung. It was the meeting place. All gossip, rumors, and stories either began there or ended there. All things were spoken of. This was where dirty laundry was verbally washed and held in the air for all to see. This is where the decision of the elders would be heard.

Guilty! It appeared on a large palm-paper leaflet tied to a peg that had been pounded into the bark.

Everybody had known what the results would be. Some hoped for a miracle, but most were prepared for the outcome. The execution was to be within the week.

Preparation was obvious throughout the village. Mourning clothes were made or repaired. Flowers were cut, arrangements made. Special prayers were offered in the temple.

Bram hadn't seen Kalli Gooma for most of the week. Bram was

told he was overseeing the site where the execution was to take place.

It wasn't until the end of the week that he arrived in the village. He beckoned to Bram.

"There were two places Sian did not take you. One you have already experienced, and now it is time for the other. Tomorrow the execution will take place. I would like you to accompany me to the Cross-Over." Bram assumed that meant the place where Kim would be put to death. "It had not been used for a long time, and it took time to put things right," he volunteered.

Kalli Gooma and Bram were well into the mountains before the sun had spilled its molten heat on the ridge. A small sliver of a trail wound its way up the steep valley. A river of pure icy spring water coursed its way down the middle. As they rounded a corner, Bram noticed another river had come from out of the forest and was running parallel to the first river—only flowing in the opposite direction!

They followed the path between the two streams until they came to a heavily wooded thicket. Huge boulders stood sentry as they entered what appeared to be a smallish amphitheater. Once inside, Bram saw that the two streams were, in fact, one. At the curve of the stream, where one flowed into the other, a fury of white water gamboled over round, smooth rocks. The yin and the yang. One was needed to allow the other to be.

"This is the Cross-Over," Kalli Gooma said.

Just ahead was an escarpment that projected out from the mountain. It was as if an eruption had taken place many years ago and the earth had pushed itself out and away from the mountain.

Kalli Gooma and Bram stood at its base. It appeared to be about twenty feet high but not more than fifteen feet wide at the top, maybe thirty feet long. A wood and stone staircase ran up the front. The men climbed the staircase, and upon reaching the top, Bram found it was quite flat. He could see the entire Cross-Over from there.

At the back of the "mound" grew a large teak; its branches covered a good portion of the area. There had been another tree, quite large. Its stump was at the front of the mound. Bram studied the stump. It was polished to a fault. Many hands must have worked long hours doing such a job. Bram noticed two concave shallow indentations chiseled out of the stump. From the rumors in the village, Bram knew what these were for.

He let his fingers idle over the shallows. Both were close to the front edge of the stump, easily accessible to anyone approaching by the stairs.

The first one was intricate. It was directly in front, oval in shape and perhaps four inches deep, and molded to hold a human head sideways. A larger indented circle was chiseled around the oval. The second indentation was off to the side. It was round, about six inches deep, and the same size as the indented circle. It was the footprint of the front left foot of an elephant!

There was a strong pungent odor in the air, one Bram knew well. Looking up, Bram saw a large female elephant coming out of the forest from behind a teak. A man in a black sarong carrying a gold choon walked by her side. A purple cape was draped over the back of the elephant. Across her forehead hung a black facepiece that had slits for her eyes. On her front left foot was a silver bracelet made of many symbolic amulets, which jangled when she moved. Later Bram was to find out that the left foot was the single one entrance into the new world. The right foot was the exit. The bangles on the left foot were bright and sparkling, and all the engravings were of happiness and health and prosperity.

On the right foot was a solid brass anklet ring. Black onyx swirled through it. This bracelet did not jangle or make any noise. The symbolic etchings cut into the brass were of the demons and represented all things that lived in the place before life and after death.

The elephant's name was Keesha. The mahout greeted Kalli Gooma with a respectful bow. To Bram he gave an eye acknowledgment. Then, moving to the front stump, he commanded Keesha to hold steady.

The Cross-Over was ready.

A long procession of villagers had wound its way up the trail. In front was Singh, then Ja, followed by the elders. Just behind them two men were holding on to Kim. He seemed to be in a drugged state, as the men were supporting him from falling rather than concerned he might escape. Behind followed the men of Kim's family, and the mahouts. No women were allowed to see the procession. A banging of drums had followed them up the mountain and continued their rhythmic beat. The drummers alternated, emitting a barely audible high-pitched note that didn't fluctuate. As one ended his note, the other blended in so that the effort was one long monotonous note.

"These proceedings are always held in the morning. If they were at night, he would not be able to see his way into the next world. The accused is given a mixture that relaxes the body but not the mind. This way, he is easily controlled but his mind is not altered. It is important that he knows . . . "

As they entered the Cross-Over, Kalli Gooma met and escorted them to their positions. Singh stood on the left of Kim and Kim's father stood on the right. The two men continued to assist Kim. Kim looked up to see Keesha standing above him. His knees gave way and he collapsed.

Kim's father, tears streaming down his face, helped the two men to right his son. Kalli Gooma brought out a heavy leather full-headed mask and with the help from the others, put it over Kim's head. The mask was thick and peaked at the top. It was larger than Kim's head.

The crease in the leather was brought to a fold at both the back and the front, making the head appear flat. The neck area was lastly wrapped in a thick burlap material with caution so as not to cut off his breathing. Two large buckles fastened to keep it in place. The flat look was to be of some advantage at a later time. The only openings were two large apertures at the nostrils. The single note sung by the drummers had changed to a deeper note as the two men supported Kim up the stairs. The father whispered something into the mask. If

Kim answered, no one would have heard his reply through the thick leather. Kalli Gooma followed the men up the stairs. A body motion from him, and Bram followed. Upon reaching the top, the men tied Kim's hands together at the back. His feet were also tied.

On a signal from Kalli Gooma, the mahout stepped forward with Keesha. She placed her left foot into the proper indentation. The other straddled the second shallow. Kim was gently laid down with his head resting sideways in the concave. Bram now saw why the mask was cut to allow there to be more comfort in that position. It also made it difficult for Kim to move his head.

There had been no noise from Kim since he had entered the Cross-Over. But once he felt the men's hands leave his body, a muffled cry was heard. Kalli Gooma nodded to the mahout. Keesha's right foot was raised to its highest position. And then Bram heard Kim. A loud cry of anguish. A cry from a faraway small room sounded and the foot fell! The earth shook. The head mask filled. The body quivered. The drummers' note became deep and low.

Kalli Gooma looked up to the sky. "It is a good day," he said, and they headed back down to the village.

= 29 =

BRAM AND SIAN WERE TO BE MARRIED! It said so in flower garnets strung together on a large oil-polished palm leaf and pegged to the Rumor Tree. It had been some time since Kim's execution. The village was back to working the forest. They had started cutting in a new area. The trees were much larger than before and the men had been coming home exhausted from their duties. But they had also earned extra money. Bram thought this would be the perfect time to celebrate with a marriage, and there were other things that spoke to him of the marriage.

Sian had come to see Bram after a sweaty day in the forest. He was taking his shower in a hut with no roof. A bucket of water was suspended by ropes above him. When pulled, the bucket tilted and poured its contents on him. He had just soaped and scrubbed his body thoroughly with a eucalyptus leaf brush. He learned the hard way to soap first, then flush with the water. The first time he cau-

tiously had to leave the shower to fetch more water quickly before anyone saw. Bram's eyes were closed. The water felt good and the brush made his skin tingle. While trying to get some soap out of his eyes, he felt his back being gently brushed. A smile crossed his face. *Sian!* She had always been shy but lately had been more provocative, flirting.

Still squinting from the soap, he turned. Sian stood just out of range of the water. She wore a mischievous grin as she slowly kept brushing. She kept her head up but couldn't resist an occasional look down. Bram grasped her arm, pulled her to him, and grabbing the rope, pulled it hard. A deluge of water cascaded down and drenched them. Sian, embarrassed, laughed, and they hugged each other tightly, kissing and touching. Their bodies were soaked, her sarong was tight to her skin, and she felt his sexual pulse. Bram knew then, it was time.

The wedding was to be the following Saturday. Sian's mother wove a special wedding dress for her and had a handsome white sarong with matching turquoise shirt for Bram. The whole village turned out for the event. Flowers were cut and adorned the huts, walkways, trees, even the elephant quarters. Stalks of bananas hung from the huts. Fresh mangoes, coconuts, tree tomatoes, sweet berries, pawpaw, all were nestled in nests of flowers.

Kalli Gooma had declined for "spiritual reasons" so Singh stood with Bram as Sian's father was to stand for her. On the morning of the wedding, ten of Bram's mahout friends arrived at Bram's hut to accompany him to the temple. They were dressed in their best clothes. Sian's father gave a round of his special strong, enriched coconut juice. A quick toss down and they were off, along the trail that would lead Bram to a new existence of emotions and family ties.

Sian's family walked the path together. Her father came first, walking proud, a smile of well-being fixed across his face. Her brothers followed. The females of the family came next, busily straightening her dress, combing her hair.

She was radiant. Her dress was of fine woven white and

orange Indian silk. The fit of the dress emphasized her small yet curvaceous frame. Her natural tan skin and dark eyes were framed by her long, fine, silken hair that was as light as the breezes that caressed it. A red choker made of polished traded beads hugged her neck. She was beautiful, a girl in full blossom.

Melodious music filled the air. The village was alive with the warmth and happiness that only a marriage can bring.

Every village in the region was invited, most of the citizens came. The wedding was wonderfully simple. Their vows were their own. They spoke of the forest mountains and the cool streams, of the great teak, of the elephants, and of the golden thread that holds it all together. They spoke of the yin and yang being present in all things. The ring was of gold and silver thread, one strand wound around the other.

Kalli Gooma had arranged for the couple to exit the temple by walking through a corridor of elephants lined on both sides! And they all wore flower leis! Modoc stood at the end of the line, loaded with their packed bags, ready to whisk them off to a special place by the lake where they had first met.

The trio headed across the center of the village past the Rumor Tree and into the forest. The children ran alongside, throwing flowers and green leaves. The last that was seen of them was Modoc's buttocks, her tail swishing to and fro, throwing flowers from the long garland of roses and carnations that was tied to it.

With the passing of the years, the village prospered. Bram sent many letters home, knowing that it was risky, and still never revealed his whereabouts. Bram and Sian had agreed to wait to have a child. It was important for him first to have security, a proper home, and money to last in case of emergency. He was too proud to take money from his new relatives. It was important that he do it on his own to show Sian's parents their daughter had married a man of quality.

On a day filled with sunshine, when the two young marrieds were enjoying their life together at a gathering of Sian's family, a

passing traveler brought news and rumors that a guerrilla war had broken out fifty miles north of the mountains that housed the teak. The nearest town had heard scattered news about small groups that had invaded various areas, but nothing of note ever followed. There had been fighting on the border. The country's army had fought for a number of years and finally broken through the main artery, sending the remaining rebels scattering throughout the vast region.

The village council had been meeting once a week for the last four months to discuss and keep abreast of the situation. They had set up a security program whereby men were stationed at intervals from the village down to the nearest town, a distance of ten miles. A small battery-operated telephone system set up at two-mile intervals relayed any messages . . . but there had been no occurrences.

"Captain Rajah Mohinder, commander of the Eastern Division, has arrived with his escort and is coming up to see Mr. Singh." The voice was that of Mapur Punda, stationed in the town below.

The jeep, using its four-wheel ability, arrived an hour later in the center of the village. Captain Rajah Mohinder and three army soldiers armed with rifles left the vehicle and headed briskly in the direction of the main office building.

"Captain Mohinder, good of you to come," said Singh as he stepped forward to shake hands.

The captain shook hands and introduced his comrades, who then sat in a rather unprofessional way on the couch.

The captain cleared his throat and spoke with authority. "Mr. Singh, there has been no enemy activity in some time."

"Yes, it has been very quiet," Singh agreed.

"My command will be pulling out in the morning. We have our orders. The relay system has been deemed no longer necessary."

"Well, I must say that is a bit of good news. This thing has kept us from doing a proper job on the teak for months. Those stupid rebels must have realized the futility of attempting to overthrow such a powerful and well-established army as this country has."

The captain nodded and prepared to leave, then stopped. "Would it be possible for me and my men to stay the night? That trail you call a road would be quite difficult to maneuver at this time of evening."

Singh gestured to a waiting guard. "See that these men have some food and a good place to sleep."

There were thank yous all around, a few good nights, and they were gone.

Singh took a minute to radio his security men that they could return to the village. It would no longer be necessary to secure the area. He heard a few cheers, something about "a good meal" and "a waiting wife." He smiled, turned off the radio, clicked the light to dark, and headed into the evening shadows.

Bram and Sian were asleep when Bram woke to a noise just outside the door. He sat up, listening intently. Nothing. Turning over, he felt the warm firm body of his lady. She slept deep in trust, knowing he would keep her from harm's way.

Another noise, a rustle. Bram left the bed swiftly but not to awaken Sian.

Thinking a forest animal was about, he picked up his choon and readying himself, pushed the door open. The muzzle of a gun poked his chest; he heard a click as the safety was taken off.

"Back inside," spoke a voice.

Bram backed in, followed by the man with the gun and two others. One of the men pushed Bram onto the bed, waking Sian with a start.

Neither of them wore clothes to bed as the weather had been humid. The sheets had slipped down from Sian's body, revealing her firm young breasts. She quickly grabbed the sheet and hid herself. One of the men struck a match and lit a candle on a nearby table. The glow cast a shadow across the hut, revealing Captain Mohinder and two of his men.

"What . . . ??" Bram was bewildered.

"Shut up! Not a word!"

One of the two gunmen stuck his weapon against Bram's body.

"Shhhhhhh!" The captain seemed to be listening for something. Then his attention went to Sian. He grabbed her arm, pulling her to her feet, the sheet falling away from her body.

Bram jumped up, grabbing her in his arms.

"Sit down! SIT DOWN! NOW!!" One of the guns was pushed into Bram's ear.

Slowly he sat on the bed, trying to help Sian hide her body as best he could. A gun butt cracked down on his arms. He winced from the pain. Again the rifle smacked down—hard! The pain was excruciating. His hands slipped away.

Sian stood nude and in shock as her captors pleased themselves looking at her body. She wept softly; her body trembled.

"Close your eyes," said Bram. "The pain will be less."

Sian's eyelids fell. Her body seemed to relax a bit but the sobbing continued.

"Well, well, a man of the spirit," said Mohinder. "*But it won't work!* When she opens her eyes, we will still be here! *Ha!*"

His hairy beard separated to show a row of big buck teeth. The grin was ear to ear. Mohinder stopped for a moment, again listening. Turning to Sian he said, "She is a pretty one." And then his temper flared. He grabbed her arm, pulling her to him. He wiped his wiry beard across her bare shoulder.

It was too much for Bram. He sprang for Sian to pull her away. The captain was a big brute of a man, with powerful arms. He reached around Sian, grabbed Bram with one hand, and pulled him against Sian. She was squeezed between them both.

"Be a man in bed, not here, not now," he said. It came as a warning. His attention turned to Sian. "You are truly beautiful, my love." He reached his hand to her breasts, running it over her nipples, cupping her breasts, feeling the weight of each.

The soldiers, anticipating Bram's reaction, reminded him of the gun by pressing the barrels hard into his skin.

Mohinder's hand traveled down her trembling stomach to the edge of her pubic hair.

"ENOUGH!!" yelled Bram and smacked the captain's hand away.

The captain grabbed Bram by the throat. "You are a lucky bastard, you are. If you weren't needed, I would blow your cock off and let you live to see what you could never have!" His face was beet red. Then as an afterthought: "Maybe I still will before this is over."

Bram stared into Mohinder's face. His fury was not in the least bit lessened. "Why are you here?" he challenged them.

"Ha! We want your village," charged back Mohinder.

"What do you want with us?"

"From the girl, what all men desire. From you . . ." He looked Bram up and down. "I have been told you are the best one for the job."

"What job?"

"To work the elephants."

"What for?"

"Just shut up. I have told your Mr. Singh that the war is over. Ha! Not true. The bastard army is not far from here. We got these uniforms from a few of their laggards after a brief skirmish—"

A shot rang out! Then another! The captain left Sian and moved to the door. "Ah! Good. My men have arrived."

Now Bram understood what Mohinder had been listening for. While Mohinder was busy for the moment, Bram succeeded in moving Sian away, partially covering her with the sheet.

"Both of you—let's go!" the captain ordered. He looked at Sian. "Later I will have the time." Sian looked away, her long hair shielding her eyes from her captive. "Move it!" he yelled.

Sian went first, wrapping the sheet to cover her nakedness. Bram grabbed his wrap, putting it on as they headed for the village center.

The village was in a state of panic. People were coming from every hut, some being pushed, some being knocked down. Women screamed, shots rang out. Bram saw a few people falling. He didn't know if they had been shot or just pushed. Fires had been lit everywhere. The whole population of the village crowded into the center around the Rumor Tree.

Bram saw Kalli Gooma for but a moment, caught up in the crowd. A number of military vehicles had moved into the area. Soldiers and equipment were being unloaded. Machine guns were being set at strategic positions around the village. Rajah climbed up on a large dead teak log.

"Now listen here! All of you. In the name of the Peoples Liberation Party, we have taken over your village. Now hear this! My troops have my orders to shoot you . . . any of you . . . if you decide to try to escape. We are here to move our men and equipment through the Dullirah Mountain Pass to the north."

A murmur rose from the people. Dullirah Pass was impassable.

"The army is headed this way. If we have a confrontation with them here, in your village, many will die. If, on the other hand, you assist us in getting over the mountains, no one will be hurt. We will leave you in peace. Now go to your homes, sleep well, for in the morning we will need to work hard . . . and fast . . . to accomplish our goal. And . . . I must remind you, if you leave your hut before morning . . . YOU WILL BE SHOT!!!"

Sian slept in Bram's arms the whole night. The slightest noise caused her to jump or cry in her sleep. Bram's mind raced. What could he do? There must be something. He knew that anything requiring force was hopeless. Force was all these men knew. He decided to go with them peacefully. To not cause a problem by which others could get hurt.

Morning seemed to be waiting just outside the door all night long. Bram felt that whenever he got up, the night would be over and he would have to face the day. Sian awoke with the experience fresh in her mind. She held Bram tight, her head buried in his chest. She had wanted to bathe, to get the captain's smell off her. But Bram felt it was not the thing to do. There were soldiers everywhere. He didn't want a repeat of what had occurred last night.

Before they left he spoke to Sian, quietly explaining that no matter what had happened or would happen, he would never stop

loving her. "He took nothing away from us. A bit of dignity, perhaps, maybe he caused an embarrassment, but nothing more. Do you understand?"

She looked down into her lap, nodded her head.

"No," said Bram. "Look at me. *Look* at me with your eyes so I can see that you understand."

He took her chin, raising her head. Her eyes were filled with tears. Little quakes shook her body at intervals. Her lips trembled.

"I love you, Bram," she said, and then, "He . . . took . . . nothing . . . away from us."

Bram brought her to him. They held each other for a long time. Her tears dampened his shoulder.

"Now let's go."

Outside was a different world. The quiet from within was overshadowed by the hustle and bustle of people, soldiers, trucks, smoke, yelling, fires. All the activity seemed to be directed to the river where the elephants were tied out.

"Sian, I want you to go your father's house. Stay there until I come for you."

"But I don't want to be alone. My father is working. What happens if *he* comes . . . I will die before I let him . . . "

"Don't worry, honey, he and his men are too busy, and besides, I'll be with him so I will know where he is every minute."

"He hates you, Bram. Please watch yourself. Be careful."

"He needs me. That will keep us safe."

They kissed and he was gone.

"What do you need me to do?" Bram had come up behind the captain, who was barking orders to anyone within range.

"Well, well, I see you have decided to join us in our endeavor."

"I am not joining you, I will do as you say only to keep the people safe."

"Bullshit! You are afraid I will pluck a petal from your little flower. Right? Huh? Right?"

Bram knew he was trying to break him, to get him angry. "You're right, I am," he said.

"Well, my enemy, you are wise to worry." He put both of his hands on Bram's shoulders, drawing him near. "The first chance I get I plan on having your lady, and you can watch. Now come with me so we can become better acquainted, huh?"

Captain Mohinder pivoted, putting one arm around Bram's shoulder as they headed for the elephant building.

Bram was put in charge of the operation. For the next two days the whole village helped the guerrillas prepare for the trek across the mountains. Heavy cross frames were made from the biggest bamboo, tied with reed and fitted to the elephants who would carry the load.

Machine guns were mounted on special racks and set high up on the backs of the biggest elephants. Modoc was one of them. Bram saw that thick swamp grass mats were woven and placed under the mounts to prevent them from resting on the bare skin of the elephants.

The elephants to carry the guns were taken into a small valley by the mahouts so they could practice getting them used to the gunfire. Many panicked and ran off. It took the whole of two days before they were quiet enough to allow the guns to be set on them and fired.

Bram's thoughts went to Sian. At least he felt she was safe for the moment. If the captain had touched Sian, Bram would have tried to stop him, even to the point of death. The captain needed him too much to risk that.

Singh was mostly locked up unless information that he could supply was needed.

Kalli Gooma was never asked to work. He sat under the Rumor Tree and watched. Bram spoke with him at times, asking if he was all right. All his thoughts had a special connotation.

"Tomorrow is a new day. Let's hope it doesn't rain."

Ja kept the village going. Food was prepared on schedule each day. The village had given over the main office building to the guerrillas' needs. Beds were brought in, tables and chairs were rearranged, and the communication board was manned by the soldiers.

Each day the captain pushed the men to their fullest capacity, and at night he drank his fill of liquor and slept deep. Bram knew that the next day would be the day of leaving.

He and Sian woke early. Bram spoke softly to her. He could see that she was panicked over his leaving.

"This morning, take Swati to our lake and hide until someone comes for you. Pack enough food for a couple days."

"They'll find me! I know it! I know it!" Sian was near hysterics.

"Sian, now listen to me! By time they notice you have gone, it will be too late. Mohinder has hours of work to see to, and he won't leave the elephants until he is sure that everything is done. I will be with him at all times. Now then, there have been so many elephants coming and going for reed, grass, timber, you won't even be noticed." He kissed her forehead. "Wear something to hide your beauty, dress in rags if you have to."

"But if you leave today, I won't see you." Her voice echoed the fear in her face. She was whispering and crying at the same time. "I want to go. Please, Bram, let me go!"

"Sian, baby, listen. The captain will come looking for you before we go. I know he will. He needed me for preparation only. If he finds you, I will die trying to save you and we will both be violated. Do you understand? I have to go with him but I'll be back." He cupped her head in his hands. "I must know that you are safe. Some of the other women will do the same as you. Once you return to the village, calm the others—they will need your help—and take care of your family."

He kissed her many times, her lips, her ears, her nose.

"Please take care, come back."

He was out the door and gone. "I will," she heard. "I will."

= 30 =

THIRTY-FOUR ELEPHANTS STOOD READY. Eight had been outfitted with machine guns, the others carried the equipment, food supplies, and men. Heavy, thick hemp ropes laced with fig vine were used to tie the equipment on. Some elephants seemed nervous. This was all new to the elephants but the mahouts kept them in line, talking softly to them. The villagers were quiet, except for some women who were crying, saying goodbye to their men.

Bram had been with Mohinder since early morning, carrying out his orders. Bram wanted them to be on their way as fast as possible to avoid a clash with the army. And then there was Sian. Maybe if he kept Mohinder busy the captain would not have time to think about her.

Ja was doing a final check of the food bags that hung from the howdahs. Each elephant carried six soldiers, who in turn carried rifles.

The children of the village wandered glassy-eyed, not compre-
hending what was happening. Singh was brought down to the
loading area as well.

"They're taking all the best teak elephants. Those that are left
are too small to work," said Singh.

"Do you think any will come back?" asked Ja.

Singh's look was enough for Ja not to set his hopes too high.
Mohinder started up the trail leading to the village. Bram went with
him.

"You realize that the elephants will never get over the pass.
Maybe the men but nothing more."

"Have you been there?" asked Mohinder.

"No."

"Then you don't know. So shut up."

"Where are we going?"

"To be with your wife."

"I can't let you do that."

"Then I will have to shoot you or you can watch!"

Bram prayed Sian had gotten out all right. They arrived at the
house to find it empty. Captain Mohinder yelled a few profanities,
then turned to Bram.

"Well, asshole, where is she?"

"I don't know. I have been with you the whole day. Maybe
she's just around."

"Just around, huh!" Bram felt this was the deciding moment. If
he was to be shot this would be the time. Mohinder grabbed Bram's
arm, hustling him outside. "Hey you, soldier."

"Yes, sir."

"The pretty girl, Sian's her name, find her." As an after-
thought: "Get some of the others to help."

The hours went by. The mahouts climbed down from their
mounts to rest under the nearest shade trees. The elephants stood
quiet, their trunks playing with blades of grass or one another's
tails. The village dogs slept. The heat of the day was taking its toll.

"We'll have to unload soon," said one of the mahouts.

"The sweat is building up under the howdah pads."

One by one the soldiers came back, each afraid to approach the captain with the news.

"Nowhere to be found," said the soldier.

"Nowhere to be found. Bullshit, she has to be here." Mohinder started to bark some new orders when far off in the distance, toward town, gunfire could be heard.

"Shit," was his only word. "It's time to go."

From out of nowhere Mohinder's fist collided with Bram's jaw. He went sprawling, blood gushing from his mouth.

"You bastard, you'll get yours. All right, load up!" he shouted, "we're moving out."

The village sprang to life. Elephants lowered their heads to let the mahouts board. The dogs barked. Ja did a final check of the loads on the elephants. Kalli Gooma came to say his goodbye.

"Survive, my friend. Stay alive and don't look over your shoulder." He placed his hand over Bram's heart, then mounted his elephant and left.

A special howdah had been rigged on the front elephant, a massive beast called Sinja. This was for the captain. Two soldiers rode with him. An umbrella had been rigged up to keep sun and rain off him.

Bram rode Modoc, who was packed full of equipment and a machine gun that took up most of her back. One soldier manned it, another walked alongside.

Bram, in the eyes of the captain, was just another mahout. Bram liked it that way. It kept him out of problems.

Bram saw the captain whisper something to one of his soldiers, who nodded yes. He figured it was something to make Bram pay for the captain not having Sian. Well, whatever it was, it was worth it, Bram thought.

As the convoy ambled up the trail, Bram looked back as though he would see Sian waving goodbye. But no one was there. At least he knew she would be safe.

In the beginning the trail up the mountain was gradual, but

the difficulty increased as the days wore on. The elephants, who generally worked four hours a day, were not accustomed to this kind of effort.

Their muscles had been developed to lift and pull, not for the long strides and constant uphill movement for hours on end. The weight of the howdahs was burdensome to them all.

Though Bram had carefully fitted each to carry a proper load, the soldiers were ordered to put on more, thus the weight was too heavy, not balanced, and constantly shifting because of the unevenness.

"You must tell the captain to stop more often," said one of the mahouts. "The elephants need to eat and drink or they will lose their strength."

The soldier came back with the message, "Go to hell."

It was four days into the climb when one elephant went down. Bram saw it was dehydrated from lack of water.

"They will all go down if we don't let them drink and eat more often!" he said.

Reluctantly Mohinder gave in, for without the elephants all would be lost.

The Dullirah Pass loomed ahead. Usually covered in thick fog, it sometimes revealed itself in the early mornings. Many prayers were offered that night. All knew it would take a miracle to get through it.

Mohinder's plan was to cross the pass into the valley below. At a town there he could regroup his men and become productive again. He knew from that position he would have the advantage and could advance on his enemy without their knowledge.

Bram spent a sleepless night thinking what lay ahead the following day: the entrance to Dullirah Pass. For the years he had been in the village, he had heard many speak of the lives it had taken, of its steep terrain, treacherous avalanches, and dark fog. His worry was centered on Modoc. For the first time her size would be a disadvantage.

The sun was casting its morning rays into the small glen that

housed the men and elephants for the night. Their equipment lay everywhere. The elephants were enjoying the swamp grass and low brush that grew on the floor of the hollow. Suddenly they stopped foraging and stood stock-still. Something was happening. Bram stood up to share what they were tuned in to. Then he heard it. An elephant trumpeted from the valley down below! Bram ran to a nearby hill, raced to the top, and saw below a young elephant with two riders coming fast up the trail! The elephant was blasting away, telling all that it had arrived. The herd answered back in full accompaniment. Their tails arched, their ears bent forward, waiting patiently for the arrival.

As the trio came closer, Bram's heart began to beat faster. How was it possible? Why? But as they neared he knew. It was Sian riding Swati. Seated with her was one of Captain Rajah Mohinder's men!

When they arrived, Sian jumped off Swati and ran into Bram's open arms. They smothered each other in kisses. He held her tight, so very tight. His passion was mixed with the pain of the situation. Now he understood what the captain had probably whispered to his man: "Stay behind. When she comes, bring her."

"Well, my good friends, you can never say I don't have feeling for my good comrades." The captain could hardly contain himself. His eyes found Sian's. "Enjoy yourselves for the moment until we pack up, then you ride with me."

They sat under a nearby tree. Sian explained how she had waited. But when she came out to the valley the soldier was there.

"We hardly stopped along the way so we would catch up to you. And not carrying a load made it all the easier."

Now, what to do? Riding with the captain was not a problem. The seats in the howdah were separated, and the only intimacy one could have would be to hold hands. It was the thought of the coming night that sent chills through Bram.

With the elephants loaded, the caravan headed into the pass. Sian rode with Mohinder. Bram took a position just behind. The captain seemed to like that, as he would constantly try to touch Sian and then look to see if Bram was watching.

The pass was as treacherous as Bram had dreamed it to be. Perhaps twenty miles long, it arched its serpentlike curves up the side of a thousand-foot cliff. The terrain was barren except for the odd oaken tree, leafless and skeletal against the sky.

The weather turned cold and the winds were constant. The elephants formed a single line. Their equipment was repacked so as not to jut out from their sides. The walls of the cliff housed large rocks that could hang up the equipment or, worse, bump it and send the elephant over the edge. Sometimes the walls arched over the trail, and the howdah had to be taken off and hand-carried until it could be put back on farther down the trail. Most of the elephants were shaking from the cold. Bram silently thanked Ja for remembering the quilted blankets. He saw to it that they were spread across the elephants' backs.

The fog had moved in, making any forward movement impossible. They were lucky and reached a small open spot where the elephants could crowd together for warmth. There was no food or water. They just stood absorbing their pain. The night wore on. One elephant tried to lie down and almost pushed another over the cliff.

The only sign that morning had come was that the fog had become pink rather than gray. Mohinder sent a soldier ahead to see if the trail was getting any better. When the soldier returned the news was grave.

"The trail is no more," he said. "An earth slide has covered the trail for at least two hundred feet. The earth is loose so it must have happened recently."

"Take twenty men, get the shovels out of the packs, and clear it!"

Bram and the mahouts tended their elephants as best they could, unloading a few at a time, as there was danger of slipping off the edge.

They stole some foodstuffs, bread, fruit, and vegetables, and distributed it among the weakest elephants.

When the trail was opened up they continued on their way. Both Sian and Bram were thankful that with Mohinder being so busy and uncomfortable, Sian was the last thing on his mind.

It rained that night and continued into the early morning, making the trail slippery. The mud caused small land falls on the trail. The elephants were starting to slip and slide, some falling to their knees. Many hours were spent getting them on their feet again.

Bram thought they had about two more days before they would be out of the pass.

The following morning the fog was the thickest it had been. Visibility was nil. Mohinder seemed to be a man possessed . . . he hit his men, swore, and made irrational decisions.

"Get him up and moving or I'll shoot him!"

Sinja, the lead elephant, had gone down and refused to budge. There was no room for the others to go around.

"If he dies on the trail you will never get around him," said Bram. "And there is no way of moving him once he is dead."

"Oh no? I'll move him. If I have to cut him into pieces! I'll move him!" Mohinder took out his pistol. "Tell me where to shoot, Bram. I never shot an elephant before." He pointed the pistol at Sinja's head.

"Wait a minute! Look! These elephants are on the verge of panic. There's a danger of them bolting and crashing to their death a thousand feet below and taking all of us with them! At least give us a chance to try. Okay? Okay?"

Mohinder seemed catatonic. Bram didn't wait for an answer. He brought Modoc up to the downed bull, turned her around, and positioned her facing down the trail. Getting his pull sling out of his pack, he lowered the chest plate over Mo's head, letting it settle on her chest. Then he carried the two pull ropes over to Sinja and tied them together under Sinja's chest. Taking a bunch of rattan and blankets, he stuffed them between the pull ropes and his chest.

Bram knew Sinja had the strength to stand. He had just lost his will. He needed support from his friends. Ten mahouts got in front of him. At a command from Bram for Modoc to "move up," the mahouts started to push, talking encouragement to him.

"Come on, boy, you can do it!" they yelled.

"Up you go!"

Mo pulled gently and, as the men pushed, Sinja got his front feet under himself and slowly began to rise. When he was standing on all fours, Bram released the ropes and slowly talked him into backing up. Once he reached a place he could turn around, Bram praised him, feeding him a bit of food from the soldiers' packs.

The fog had taken away the ability to see one's own feet, but the trail, small as it was, was there. Bram put Modoc in the lead position, placing her where the side of her body rubbed against the cliff wall. Then he had her slide her front foot along the trail. He figured keeping her side against the wall would prevent her from falling off the cliff on the other side, and sliding her foot would keep her on the trail.

As she moved, Bram had the other mahouts do the same with their elephants. The line moved slowly but it was enough to keep Mohinder from killing an elephant and maybe the rest of the party.

Hours went by until the fog began to clear. Bram noticed that many elephants were bleeding from sliding their feet in the dirt. An elephant with sore feet can be a serious problem, so the first chance they got, the mahouts treated their feet with a medication, then trimmed away any of the pieces of flesh that hung from their pads.

It happened so quickly that there was nothing anyone could do. Bram heard a cry for help go up somewhere back in the line. He looked back into the mist, and as if in slow motion, he saw one of the elephants going down on her knees. She bellowed her pain, her tired feet, her hunger and weakness. Then she lay over and fell . . . to her death. She never made a sound going down. All that was heard was her hitting the bottom, many light years away.

"She committed suicide," said Bram to Sian.

Bram knew that when an elephant dies, the others announce the death with a great deal of commotion. This time none said a word. They knew . . . and so did Sian. Before the day was out two more had chosen the same fate. There was no need for Mohinder to kill. They were doing it themselves. By now the soldiers themselves would have turned back, but it was too late. They had to make it or die trying.

The day broke bright and sunny. Everybody cheered and surged ahead with renewed strength. The end of the pass was in sight.

It sounded like the droning of bees. They came out of the east. Several biplanes came up out of the valley, flying low. Each had a machine gun mounted on the wing.

"Ready the guns! Move! Move!"

The captain was his old self again. His men moved like well-oiled robots. It was too late to take the machine guns off the elephants' backs, but guns were cocked and waiting until the planes were in range.

"Wait! Wait! Don't shoot!" pleaded Bram. "We're like sitting ducks out here. There is no cover! No place to go. Surrender!"

"You're such a stupid man. We are fighters. We are here to fight to win. This is what it's all about. To win."

By the altitude of the planes, they were coming in to see the situation, not to fight.

"Shoot! Shoot!"

The machine guns opened up rapid fire. The elephants that had been sleeping woke with a start. Fire bursts filled the air. One plane caught fire and was going down. The others had veered off and were coming back . . . this time to check out things.

"Oh my God! The elephants! Sian, get on Mo!" yelled Bram. The trail had opened up at that point. Modoc was in the lead. Bram jumped to her. "Leg up, girl!" She raised her foot. Bram hopped to her shoulder. The man operating the machine gun never saw what hit him. Bram's choon had found its mark. Sian hung on to Bram as he yelled, "Move up! Mo, move up!"

Mo moved with a vengeance. Her legs stretched out, trunk held high. She was running for her life!

The machine guns opened fire, as did the planes. Men fell from their positions. A few elephants were going down. The rest followed Modoc in a panic of trumpeting and screaming. They ran full out. Machine guns fell off their backs, men hung from the straps. Equipment was strewn everywhere.

The planes came back again, strafing everything that moved! The thud of bullets hitting flesh was heard . . . Modoc!

Two bullets had found their mark. They had gone straight into and through Mo's head. Blood poured from their small but lethal openings. Her body crumpled; she went down on her front knees, twisting her head back and forth in agony, roaring her fury, her trunk uncontrolled, wallowing in the dirt. Bram started to dismount but Mo regained her feet and, wobbling sideways, trumpeting, blood gushing down her trunk, she careened into the protection of the trees and collapsed. Bram and Sian were thrown into the underbrush. Mo's scream was that of a wild entity caught between two worlds. A maddened being, crying from the pain itself, the horror of seeing the yin and the yang in all its terror. Bram raced to her side baby-talking, caressing: "Mosie, Mosie girl, it's okay. Easy now, lie down. That's a girl." He ran his hands over the two bullet wounds. They were up high on the forehead. One of them had ripped through the lower part of her ear. She lay gasping, blood still pouring from the wounds. Her breath held for too long, a scary period of time, then released in an explosion of air. Bram was covered in blood. His shirt, pants, the whole front of him. He didn't give it notice until he realized that only his hands had touched Mo. He checked himself for wounds. None were of any significance. "Sian, honey, give me a hand!" yelled Bram, his voice shaking. "We have to stop the blood. Sian? SIAN . . . !"

He raced to her side. She was lying in a pool of blood, her own! Bram picked her up gently. He put her hand over his shoulder. It slid off.

"Honey, come on now, baby." He checked her mouth, eyes, pushing, squeezing. "Sian, honey, look, we made it! We made it! We . . . Honey? . . . Honey? Talk to me, baby. Say something, please . . . please! Say something!" His tears burst in a gush, drenching his face. "Papa, help me! God, please . . . someone!" He was shaking uncontrollably. "Oh my God." Bram hugged her to him. She hung limply in his arms, blood oozing from a number of bullet holes across her body. Her beautiful eyes were staring at the infinity, her hair strewn out across Bram's shoulder.

"Sian, my Sian . . . my love . . . my baby." Bram cried his anguish. Sian lay dead in Bram's arms. Soft, warm. The life spirit was still leaving. Hesitantly, not quite sure. But the cold death spirit won out. The warmth left: the life that was in her hair, the sparkle in her eyes, the softness in her skin turned bland. The Death Spirit had taken her personally, her smile, her laughter, her future. It had taken her from Bram.

By this time, most of the elephants had found cover in a grove of trees. The planes circled overhead, coming in low, spraying the area with gunfire. Elephants were still coming in, some dragging a leg, others hopping. Bodies of men, both mahouts and soldiers, hung from their backs, some dead, some injured.

Captain Rajah Mohinder's foot hung from the bottom of his howdah, bullets having ripped through him and into the elephant behind him. His body had been dragged and kicked by the elephants' feet into an unrecognizable mass of blood and body parts.

The war was over. The suffering and pain of those around him was seen, heard, and felt. Bram covered Sian with a silk cloth the people from the slanted village had given him. For the next two hours he sat with Mo. She had righted herself into a sphinx position. Her head rested on the ground. The blood had stopped, the heavy breathing had subsided. Bram saw that the bullets had left her body on the side of her skull in the large bulbous area of her cranium. He washed the wounds with cool water from a nearby stream, hoping that they would not become infected. At first he had been amazed that Mo still lived until he remembered that the brain of an elephant is down low—in fact, behind the eyes. Many a hunter has been killed shooting into the large head of a charging elephant, not knowing that the bullets were only going into a mass of spongy tissue. There are no vital organs or large blood vessels there. Bram remembered his father telling him that if the head of an elephant was made of solid bone, the elephant couldn't carry it. It would weigh too much. The spongy tissue made it lightweight.

By evening Modoc was standing. She had lost a lot of blood

and seemed to have a huge headache, but she walked. Slowly, unsteadily, but she walked.

The dead were buried. Elephants that were beyond help were put to rest. The guns and war equipment were left. The soldiers who were able, along with the remaining mahouts, followed Bram up the ravine heading for a town that he hoped was there.

And so it was, not far. Just over the ridge. He found a great old tree and it was there that he buried Sian, in the early morning, so she could see her way into the hereafter. He and Mo stayed with her until the sun went down.

He sat on the ground and wept openly. A hand clutched his shoulder. He looked but his tears blurred his vision. Slowly the figure came into focus.

"Mr. North!"

= 31 =

BRAM'S MIND AWOKE long before his body, to a slow-turning kaleidoscope of smells and noises. The smells became the scent of his surroundings, bringing a musty odor filled with old rags, dried blood, elephant stool—dead things. The noises became the sound of people yelling, commotion, screams of pain, the squeal, the trumpet of an elephant.

Modoc!

He sat up with a start, only to be racked with pain that sent him collapsing back on the bed. He was lying on what appeared to be an old ragged army cot. It was one of many, set out under a large palm-frond roof high above his head. There were no sides to the structure and he could see people bustling in and out in all directions, some carrying buckets of water, others with bandages and medical supplies.

Bodies lay everywhere. From one end to the other a maze of

arms and legs jutted out from under the covers, some bloody, some writhing in agony, others just stiff. Rigor mortis had already set in. They were mostly the members of the Peoples Liberation Army, but the mahouts had suffered as well.

He spotted some of his friends. Neither he nor they had the strength to do more than flash a faint smile of recognition. Women with Red Cross armbands scurried between the cots, helping the wounded. The day was hot, mucky, sticky. Flies availed themselves of the wounds on the bodies. Bram raised up on his elbow to see outside, around the edge of the canopy.

Old dilapidated trucks rumbled by, their tires kicking up a storm of dust that settled on everything, including the wounds of the injured. Two-wheeled carts, loaded with the wares of the day, were pushed or pulled by men and women alike. They were filled with melons, bananas, slabs of precut wood, rolls of burlap, tin pans banging together, jostled by the rutted dirt road. Unattended chickens, pigs, goats, an occasional Brahma scurried in all directions.

"How are you feeling?"

Bram turned to see Mr. North standing at his bedside. It was not difficult to notice the unconcerned way he asked. But then what could Bram expect after all that had occurred?

"Weak. Just weak and sore," he answered. Bram tried to adjust himself but the pain shot up his body, forcing him to remain still. Mr. North raised Bram's head and slipped a pillow in place. For a moment Bram thought he was going to suffocate him with it! Mr. North wore an impeccably clean pinstriped suit similar to the one he had worn the day he had bought the circus. He looked completely out of place compared to the others working in the area. He pulled up a chair next to Bram.

"You've slept a straight twenty-four hours. Those bullets just grazed you but they tore up your flesh quite a bit."

Bram was unaware of any bullet wounds, but the soreness in his body told him he had sustained some injury. He tried to remember yesterday. The horrors were not hard to find. They were waiting like the Grim Reaper, there to bring back the pain, that deadly suf-

fering of knowing that what once was, is gone, and can never be again.

"Let her go, son, and only then will peace come to you," his father had said when Modoc was taken. But Bram questioned it then as he questioned it now. He felt inadequate; that form of thinking was for older, more intelligent people. He would have to grow into it. He remembered Mr. North standing over him at Sian's burial place and then . . . waking up here. Mr. North saw the questioning look on Bram's face.

"You never said a word after we first met. You got up, grabbed hold of Modoc's tail, murmured to her to 'move up' or something like that, and she brought you here. The whole line of elephants followed. What an incredible sight that was! All those elephants, some near death, limping, bleeding, they all followed her!" Mr. North had found a rag and was cleaning his shoes. "Both you and Modoc were weak and . . . well, you almost fell a number of times, tripping and whatnot. Actually, you did one time. Fall, that is. I tried to help but Modoc wouldn't let me. She picked you up, waited for a few moments until you could stand, then moved on slowly. She was staggering all over the place, poor beast, but she got you both back."

"Is she . . . okay?" he asked hesitantly.

"Oh yes, doing fine," said Mr. North. Then continuing his thought: "Those bullet holes . . . why I've never seen or heard of such a thing. I never knew . . . "

Mr. North talked on for a brief period before realizing that once Bram heard that Mo was all right he had dropped off into a deep sleep. Maybe it was from sheer exhaustion or from a need to escape the pain of thinking . . . knowing that Sian, his beloved, was dead. That she would never lie in his arms again. That she was alone back there like his father up on Grenchin Hill. Bram, too, was now alone. What would he do without her?

He fell into a deep sleep. Sleep, like time, can be the healer of all things. Bram found himself running down alleyways and dirt roads looking for Mo. He was sweating and out of breath when he ran full tilt into a man wearing a dark shroud.

"Please, sir, I am looking for an elephant, she is big and—and—"

"The one called Modoc?" the face inside the hood asked.

"Yes, that's her! Where is she?"

He pointed a bony finger. "Some men came and hauled her away many days ago."

"What? What?"

Bram awoke in a sweat. As he lay in his cot he had visions of Mr. North lying to him about Mo, when in fact he had already taken her.

Two days had passed since Bram had been brought to the village. His strength was returning and he was anxious to see Mo. He would see her tomorrow. His thoughts again turned to Sian. Early in their relationship he had had to leave for a few days to haul teak deep into the forest.

"Let's try to meet each other in our dreams!" he had suggested.

She laughed her lighthearted giggle. "That is impossible!"

He told her that he had heard of people doing it, that it took a lot of practice but in the end . . . it worked if you believed!

"That way we will never be alone."

"Then we will try," she said.

"But first we need a meeting place," said Bram.

They chose a beautiful small rise high in the forest as the place to meet in their dreams. They had met there many times in their waking hours. A large fig tree was growing old there and cast its branches in a huge arch around its base. They always called it their tree.

"This is where we will meet in our dreams! Under our tree!" And so they did. After many months of practice one could dream of their place and most often the other would be there! There the warm breezes blew, the flowers were sweet to smell, the simple things of life were best. There he could hold her hand, comb her hair, touch her face, kiss her lips at the time of a smile . . . He would

try to meet her again, in her after-death, to share their ethereal love as they once did in their dreams.

The morning sun had not yet cleared the mountain when Bram awoke from a restless sleep. A nurse, seeing his struggle to dress, helped him in his endeavors.

"You shouldn't be leaving your bed just yet, Mr. Bram," she cautioned, tracing her fingers across the deep purple slash of bruises that swept down his chest.

"I have to meet a lady," he said. He thanked her for her concern, steadied himself, and headed out of the makeshift hospital. On his way, he stopped by a few beds, shaking hands and chatting with his mahout friends. They talked about the battle, about those who had died, both elephants and men. They were all concerned about being able to return to their homes and loved ones.

"I will speak to Mr. North. I am sure he will help. I have to see Mo now, but when the time is right . . . "

Bram had no idea how he would do this but looking into their faces he had to give them some hope. A wave goodbye, and he was out in the morning sun, heading in the direction he had been told Modoc and the other sick elephants were kept. He asked along the way. All pointed toward the end of town. As he approached the road's end, a small valley surrounded by a series of modest hills began to open up. The smell of elephant permeated the air. But there was another. Maybe only for Bram—the smell of the war. He walked to a rise at the end of the road and looked into the valley below.

The door to Bram's mind shut at what his eyes saw. It was best. Sometimes the mind does that. It hides things from its own eye. Not wanting to remember, to believe, to be hurt. To change the levels of compassion and understanding to pain and suffering. His breath was gone, his throat dry.

Scattered in the valley lay what appeared to be giant gray stones, rocks in transition; a passage of time between life and the cadaver. Elephants! Some already hard from rigor mortis, others

just barely breathing, waiting their turn to become stone. Still others wandered aimlessly, some hopping, others dragging their broken limbs, bumping into other elephants, tripping over the dead and dying. One stood on his trunk rocking back and forth, trying to figure out why he couldn't move ahead. Another lay on his side trumpeting, feet thrashing out, running in sheer panic, his brain caught in the mindless mid-world of the war. He believed he was still on the field of battle, racing away in a world gone mad. Pools of blood broke into tiny tributaries and arched their way around the bodies. The mahouts who were able scrambled around doing whatever they could to help. Bram wept, drenching his throat with inner tears for their suffering. In a barely audible sound, a primal voice from the mind in anguish was heard: *"Dear God."*

Bram looked over the field of death and pain. The carnage was awesome. Blood, flies, bees were everywhere. The bullets had done their damage. It was no different from the hospital he had just left. He walked among them, touching, speaking his concern to both the men and the elephants. He knelt down occasionally to caress the heads of those who couldn't rise to say a few words of encouragement to the mahouts.

The mahouts, along with others from the village, were treating the elephants as best they could. Bram saw that the doctor who had been attending him and the others was now helping to save the elephants. Some were in great pain as he dug and poked trying to extract the bullets. The mahouts did everything in their power to stop the bleeding. They packed large wads of cotton and gauze into the wounds. A pile of bloody bullets lay on the ground.

At the far side of the area were five or six elephants in recovery. One was Mo. She lay on her side breathing heavily. A mahout was wrapping gauze around a thin stick, dipping it into an antiseptic, then running it into the tunnel the bullets had made in her head. The pain was excruciating. But she lay there seeming to know, to understand. Some of the holes had gone completely through her head. Other bullets, lodged deep inside the spongelike cartilage, had to be dug out.

A stream of cool mountain water ran directly through the middle of the grounds. At one place the stream formed a large pool. Many of the elephants lay in the cool water, letting it soothe and clean their wounds.

Modoc tried to rise when she saw Bram but he soothed her into staying, rubbing her trunk and hugging her. He took over for the mahout, thanking him for his help. For the remainder of the day Bram treated Mo, bringing her fresh water, carrying fresh-cut grass and dried mountain clover from the slopes. He had to be careful with the mix so as not to cause stomach problems. He spoke to her of all that had happened. Of the life and death of those they both knew and of his visit with Mr. North.

In the days that followed the bleeding subsided but the swelling and infection remained. It was evening before Mr. North arrived. Bram had been told by a local that he would be coming up. He knew he would. It was just a matter of time.

"And how is my girl doing?"

"Just fine. Still weak. But she's eating better and the swelling seems to have gone down."

A series of fires had been lit sporadically throughout the valley to keep the elephants warm as well as to give light. Bram had carried all the branches he could find and lit four small fires around Modoc. Soon they were ablaze and the warmth between them was like a huge blanket.

Mr. North took a seat in front of one of the fires on a large log that would eventually be sacrificed. He was faceless with the blazing fire at his back.

"Bram, it's time we had a talk."

Bram figured this was it. He knew the time had come. Mr. North lit a cigarette from one of the flaming branches.

"I don't think in all my life I have ever disliked anyone as much as I dislike you," he said. "No, I don't mean dislike, hate is a better word!"

Two pointed spirals of fire flared behind Mr. North's head. He blew smoke from his cigarette that mingled with rising smoke from

the warming fires around him. He surely looked like his Maker.

"Wh . . . ?" Bram stuttered, not expecting this from him. He was unable to say anything, not that Mr. North allowed him to.

"You have cost me a fortune!" he continued, ignoring Bram's words. "You have caused me and my people to chase all over the world for the both of you! You have lied, and cheated, and stolen from me!" His voice became louder. "Why, you damn near got my elephant killed!"

Mr. North stood and came close to Bram, almost too close. Bram could feel his muscles, sore as they were, begin to tighten. Mr. North was so close now, Bram could smell his breath. The veins on the man's neck protruded with his growing anger.

"Modoc is mine—not yours!" He was yelling now. "I own her! I paid good money and bought her!" He calmed for a moment. "And now comes the hard part. What to do? I want to throw your ass in jail for more years than you could afford. But I understand Modoc won't listen to anyone but you. If Jake was alive, he would beat some sense into her."

North's voice softened a bit. "I realize all that you have done. Many things were perhaps things of . . . bravery." Then the pitch changed again. "But most of it is pure bullshit! Who do you think you're kidding? Why, I have never heard so much crap in all my life! That stuff in the ocean, being attacked by thieves, and all the rest. Maybe the others believe it . . . not me!"

"But Mr. North, it did happen! Ask anyone who was there! They'll tell you—it's true!" Bram stated, standing. "She *did* save lives . . . "

"Sit down, Bram! Now!"

Bram slowly sat down, his eyes on North.

North continued, "However, I'm a businessman, Bram, and not a product of sweet sentimentality, so . . . I figure a wise answer is to capitalize on it. We'll call Modoc the Sea Elephant or Neptune Hero, something . . . anything that will make the people come. Why, we will make a hero out of her and—"

"Heroine."

"Yes, heroine out of her! People will pay to come and see her now more than ever!" The heat from the fires was warm on his back. This man was ruthless. North went on, "I know if we present Modoc like that, it will increase sales—that will help pay some of the money you cost me. I know Modoc is special. I could not have gotten to where I am now if I didn't at least have the talent to see talent. And I wouldn't have bought her if I hadn't seen it in her! I'm not so stupid as to not realize that you are able to bring this ability out of her."

There was a moment of quiet tension in the air, both men staring each other down. It was Mr. North who broke the stalemate.

"And while we use the publicity to get people to come, you will work on a special act. Better than the one I saw at the circus. Are you listening to me, mister?"

Bram, eyes were on the man; his stomach tightened at the thought of having to work for him. "Yes, sir, I am."

"I want to see something that no other elephant can do, has ever done, or will ever do. Then maybe I won't hate you anymore . . . just dislike you. You wanted your chance, you got it. Let me down and I promise this—you will never see Modoc again. Do I make myself clear?"

"Yes, sir—very clear," Bram replied, tight-mouthed.

The smoke from the fire caused Mr. North to have a coughing spell. He got up gasping something about leaving as soon as Mo was able. Then he stumbled down the dark path toward the village.

Bram turned to Modoc, who was resting. He took a deep breath and slowly let it out, releasing his anger. He stroked Modoc's neck gently.

A belly rumble answered Bram, and together the two watched the embers in the fires dance into the night.

32

THE CARAVAN WAS WAITING. Modoc and the other elephants that were fit to travel, and carts carrying the food supply, fresh water, clothing, and trade products for the next village had been packed and were ready to go.

Mr. North had gone ahead in a far better arrangement to prepare for the trip overseas. He wanted all to be in readiness when the caravan arrived at the dock.

Bram had packed his belongings. Mr. North had given him an advance on his salary to buy a few things for his trip to the United States. There wasn't much to buy in the village, but with the help of some of the women a few shirts and pairs of pants had been made, along with a jacket for the cool nights on board ship. Even then, his possessions had easily fit into a knapsack.

There were a few things Bram had to do before leaving. First was to see his mahout friends. Some were still in bandages, others

limping, but all were grateful to be alive.

"We have shared so much together, we have become . . . family. Please tell the people of the village that I must go with Modoc to the United States. I have no choice. You all know that." He hesitated.

"Will you ever come home?" one asked.

"My life will now take a different direction. With Sian gone . . . and my work in another country . . . no, the chances are . . . slim. I don't think so." All was quiet for a while, then: "I spoke to Mr. North. He will see to it that all of you return safely."

Even Bram was surprised that Mr. North had agreed to help. "Tell everyone at the village that I will always treasure the memories we shared." Bram handed a small package of letters to one of the mahouts. "Will you give these to the people they are marked for: Mr. Singh was so kind to give me a chance; Kalli Gooma was my mentor . . . teacher of the great things of life; Sian's family, my family. They took me in as a son and allowed me to take their most precious gift, their daughter, into marriage. Tell them I love them and they will always be in my heart."

His letters to his mother, Gertie, and Curpo he carried with him so they could be mailed safely from the city.

Bram next visited the Valley of the Stones, which was what the locals now called it. The wind blew over a deserted graveyard. Those who had died were buried on the spot, those who survived were moved to another area so the bad spirits wouldn't keep them from healing. He remembered the terror that had occurred only weeks ago and was glad those who made it would return to the village and those who had died need suffer no more.

Early that morning Bram had taken the two-hour walk down the mountain to visit Sian's final resting place. He came to say goodbye. Kneeling, he laid the flowers he had gathered along the way on the grave. "Someday," he said quietly, "we will meet again, Sian, my love. Out there in the forest of Infinity. I will always love you, remember you, and every night in my dreams, I will meet you

under our tree. We will tell each other of what our day has been."

Bram looked up. The tree was strong and large and would protect the grave for many years. Puffs of crystal clouds floated in the ethereal blue sky. Two young birds sassed each other in the tree, both too young to know the solitude of the moment. Bram's voice was broken but he spoke aloud.

"Modoc wanted to come but, you see, we have a long way to go and I didn't want to overtax her. She wanted you to know she will miss you and . . . I love you, Sian. I always will. I miss you so much."

His tears fell upon her grave. One lingered at the edge of a flower petal. In that moment Bram saw in its reflection the clouds, the sky, and the tree. He realized then that all things of nature would be in Sian, and she would now be reflected in them. He knew that only the shell that had once been her was lying in the ground. The seed within, the life source, had been carried by the wind to nourish itself with the sun, air, and water. She was one with nature. Her beauty had been added to and now enhanced the universe.

Coming down the back side of the mountain was pure joy. Tree-laden valleys sloped up to meet them as the open spaces of the country spread out in a great panorama. From the moment he and Modoc left the village Bram found himself becoming anxious finally to arrive in the United States.

Once they reached the main road, a special truck had been constructed to haul Mo to the ship dock. It was a flatbed truck. No walls! Bram, with a smile, had Mo step onto the bed of the truck. The whole back of the truck crunched down, raising the front tires off the ground a few inches! Then, once she was on, Bram found center. He marked out four circles in which he instructed her to put her feet. Mo kept her feet in the circles pretty well. When she had an itch and raised her foot to scratch, the truck would swerve a bit until her itch was satisfied.

Bram rode in the back with her so she would feel secure. He

instructed the driver to go very slow, especially around corners. One of the mahouts rode up front to be sure he held the speed down. Then off they went down the twisted mountain road. Even though the truck was most unusual, riding in it reminded Bram of when he used to drive with his father. Things were different then.

The ship was smaller than *The Ghanjee*. She was a sailing vessel rather than a steam freighter, and her three masts towered into the sky. Under the circumstances this was the best Mr. North could do. The name of the ship was sprawled across the side of the bow but it was in some Arabic language Bram couldn't pronounce. Because there was no port crane to lift Modoc onto the deck, a huge ramp had been built and secured between the dock and the ship. Mo's eyes were as big as the portholes when she looked down between the slats of the ramp into the sea below.

Only Bram's gentle persuasion, urging one foot after another, gave her the security and trust to board the ship. Many had heard the story of her terrifying experience at sea, and a round of applause went up as her hind foot took its final step and cleared the ramp.

Seeing the ship and the ocean had brought back the horrors of the sea. Mo knew and felt the slightest movement. Being a sailing vessel, the ship didn't compare with the huge steam freighter they had traveled on previously. Rather than cut a wedge though the ocean, it rode with the waves, at the mercy of the sea.

Mo refused to enter the hold. All the begging and pleading from Bram was met with strong resistance. She remembered only too well the terrifying experience that had happened down there. With special arrangements from the captain and a bit of persuasion money from North, a makeshift "elephant's quarters" was erected aft on deck—a position high up and directly in front on the open deck. A huge brilliant orange and gold emergency flag was used as a roof to protect Modoc from the rays of the sun. It caused a glow to filter down across her body that seemed to light her from within like an ethereal spirit. She appeared as a golden statue.

"She would be the first to sight anything out of the ordinary,

had she a mind to," rasped the first mate. Being up top gave her the freedom to see the ocean, to know what was happening. The crew nicknamed her the Sea Nymph, a most unlikely name. When the sails were full, her stance was commanding, leaning into the wind, trunk raised, tusks forward as though going into battle.

As the days drifted by the warm ocean winds calmed Mo. Her personality seemed relaxed and her diet returned to normal. The head injury was healing nicely.

The ship headed west across the Bay of Bengal, around the southern tip of Africa, heading for the eastern coast of the United States.

Modoc seemed to ride the waves while standing still. The roll of the ship caused her to lean forward and backward, keeping her balance. The nights were warm, calm, the sea as still as glass.

The weeks turned to months. For exercise Bram learned to help hoist the sails, climbing to the top masts, taking turns in the "bird's nest."

Early morning found Bram on deck. He had heard that they would be in sight of New York harbor that very day. He strained his eyes searching the horizon. Nothing. Until a blast from Mo caused all to look, and there dead ahead—land!

She had spotted it long before anyone. One of the sailors had made a huge red and white sailor cap and neckerchief for her. The hat had a band around it to keep it from falling off. The scarf was tied in a bow and hung across her chest. She wore them proudly.

The great day had arrived! The ship had turned its bow and was heading directly into the New York harbor!

Everybody was running everywhere. It was still a little overcast but the sun would break through soon, and it promised to be a bright and sunny day. The huge foghorns blasted their arrival. Bram stood at the railing. He could see the tips of huge buildings high in the air. He had never even imagined a city so large. A fog bank left over from the night was lifting from a small island. As the ship approached, a large statue appeared. He heard someone call it

the Great Lady. Another spoke of it as the Statue of Liberty. She was magnificent! They passed close by, horns blaring. Modoc took up the note and together the horns and the trumpeting signaled their arrival. Bram noticed how even Modoc looked small in comparison to her, but there was one thing they both had in common. They were *both* great ladies!

Modoc leaned into the warm breeze coming from the city. She raised her trunk and smelled the strange odors, gathering up all the information she could before they arrived.

A caravan of trucks picked them up and brought them to a squeaky stop. Back doors were opened. Planks were dropped. Cargo was unloaded.

This was the circus grounds of the world-famous North Circus! Crowds of people had come to see the now-famous "Sea Elephant." There were more people than Mo and Bram had ever seen.

"Bram! Bram!"

The voice came from somewhere in the crowd. A man was trying to fight his way through. He broke from the multitude of people and rushed toward Bram.

"Kelly? *Kelly!* Oh my gosh. Mo, it's Kelly!"

The two men grabbed each other, hugged and danced around like kids. Bram was speechless. "How? Why? This is wonderful!"

"Did you forget? I work here!"

Bram had never even thought that Kelly would return to the circus. They were good friends, these two. There were tears on both sides but neither would admit it.

"Hey, Kelly, we've got a ship to unload," cried a voice from behind.

"I've got to go now, Bram. I'll see you later," and he was gone, lost in the crowd he had come from.

Bram unloaded Mo. They both were in rapture. A whole city in canvas. Why, the entire Wunderzircus could have fit in just one of the large tents! There were people everywhere. Clowns, circus hands, roustabouts, animals everywhere—camels, horses, giraffes,

and elephants! Modoc was ecstatic! She blasted her newly found foghorn trumpet, attracting the attention of some ten or fifteen of them. They, in their own style, blasted back. This started the lions roaring from the menagerie tents, the zebras and horses braying, and the hysterical hyenas laughing. All saw fit to welcome Mo to her new home.

≡ 33 ≡

SHE WAS THE BIGGEST FROM THE START. Even old Bertha, the lead elephant, couldn't match her size. Mo's tusks had grown, and although not long, they were thick and impressive. She was being groomed to be the center of attraction from the very beginning.

Beautiful ornate golden sheaths were made for her that slipped over the tips of her tusks and extended upward for almost a foot. They were etched with designs of the circus: acrobats, clowns, tiger and lion heads, and of course, elephants. Bram heard that a special blanket was also being made.

Mr. North saw that Bram and Modoc were treated quite well. They were going "First Cabin." A small but neat trailer was given to Bram. It featured a kitchen, a closet, and a compact but comfortable living room with chairs and a radio. The trailer was fully equipped with a stove, a heater, and an outdoor patio with a folding table, two chairs, and a portable green canvas roof.

It, like the trailers of the other performers, was designed to be loaded on the circus train as it moved from city to city. The toilets were separate units but always within walking distance. Bram knew that Mr. North never did anything out of the goodness of his heart. He figured Mr. North wanted to keep them happy so they would give a great performance. North couldn't risk anything going wrong for his opening day and surely didn't need any problems. What better way to keep them content?

To Bram, his salary was a lot of money but it was far less than what the other trainers received. Bram and Modoc were introduced to the other trainers and elephants. Kelly had mentioned it wouldn't be easy at first. Lots of jealousy, pride—egos ran rampant and one had to be "about themselves" so no harm would come to theirs.

Mo was kept in the lineup with the other elephants: a total of forty-two! Bram couldn't believe that many existed outside India. All were females except for four young bulls. They were all kept in position according to size, the smallest at one end, the largest, Modoc, at the other.

Bertha was the dominant matriarch cow elephant. The others had a great deal of respect for her and always backed down to her wishes. She carried a few scars from her years in the circus.

Within days Bram had made the rounds and gotten to know all the elephants in his special way. Kelly was amazed at how quickly Bram had captured the respect of the animals.

"It's one thing when a couple of elephants take a swing or ram each other but the worst injuries generally come from the bull hook in the hands of rough trainers." He traced his hands over the old wounds. "These, where the holes festered, had become infected. They were caused by the bull hook being used incorrectly. Foot, Bertha!" ordered Bram. Bertha raised her foot and placed it on a barrel used to trim the elephants' toenails.

"Most," Bram continued, pointing, "are in the region of the upper front leg muscle, behind the knee area on the hind foot, and the joint where the ear joins the head. Sometimes at the top of the back. All these areas are where a bull hook is used gently when han-

dling and controlling the elephant. But no good trainer needs to put holes in his elephant. The bull hook is used to teach, not abuse."

Bram put her foot down and leaned against her side. "You know, a young circus elephant's training may start with a gentle, competent trainer but as the years pass, trainers leave or are fired. Then the elephants are handed down from one trainer to another, each with his own style of training and handling. Bad habits become the way. Rough handling by the trainer puts the elephant in a survival mode—always nervous, jumpy, not knowing what to expect next. Many develop an 'I'll get even' attitude."

"Are there any bad ones here?" asked Kelly, looking down the long line of elephants.

"There're a few that are waiting for their chance. I've told the trainers, but they won't listen. They think I'm butting in on their jobs."

For the first season Mr. North used Modoc as a showpiece. The circus master, after a roll of the drum, would announce the performance:

"Ladies and gentlemen, children from around the world. The North Circus proudly presents the most FAMOUS, the most DARING, and the BRAVEST animal in the world! Ladies and gentlemen—we give you MODOC—the Golden Elephant!"

The spotlights would flood the entrance to the arena as Modoc, wearing a solid red velvet blanket with gold trim and tassels, would appear, led by Bram, her golden tusks throwing reflections that glittered in the light.

There was no mention of Bram throughout the performance. He would lead Mo to the center ring where he put her through the old routine she had performed at the Wunderzircus.

At first both Mo and Bram were shocked at the number of people! The roar of the crowd! And the applause was deafening! But Bram knew they were not applauding the performance. They loved Modoc for her act of heroism that Mr. North publicized in every newspaper in the country.

Many had seen the same act done by other elephants, but this was being done by *Modoc*, the *heroine*, the one they heard about on

the radio, the one who saved the people! This is what Mr. North wanted. His publicity was paying off.

Bram enjoyed the performance and loved seeing Modoc center ring. And, true, she had saved many lives. But he wanted to be able to show the world Modoc was capable of performing in a way no other elephant had ever done. He knew the time was coming when he would be able to show the world all that his father, the Elephantarium, and Kalli Gooma had taught him.

Bram never allowed the animal keepers to clean and feed Modoc, which upset the head trainer because the keepers were under his charge.

"We've been doing it the same way for many, many years. Why do you think your way is better?"

"It's not. It's just that I have an alternative, that's all."

The head trainer sat looking perplexed. He really was interested in what Bram was doing but didn't want to ask. As though reading his mind, Bram spoke. "Look, when the men clean and feed, they do it as a job. They have no interest in the animals. They don't try to know them, to understand. They don't look them over for health problems. We both know that many keepers drink, some are what you call winos and come to work reeking of alcohol. If an elephant is in the way, they jab it with a pitchfork to move it. They never check to see if the hay may be contaminated, or if the water container's clear of algae."

"But they're just animals. You make them out to be human," offered the head trainer.

Bram saw that he would never understand. It made him realize that if the head trainer felt that way about keeping them, he probably trained the elephants the same way.

"Yes, I know," he said and walked away, bewildering the head trainer even more.

Bram's happier times were when Kelly would stop by during his break and share a cup of coffee. They would talk of their past that seemed so long ago and of Bram's journey since leaving his country. They spoke of Hands.

"You were probably one of the last to see him," said Kelly.

"Ya, he was a good friend. I wanted to thank him for all he did. He saved my life, you know, and so doing, saved Mo."

The train seemed to stop at every small town on the East Coast. Bram was amazed at the precision with which the tents went up, the animals were unloaded, and the concession stands were erected. Before he knew it the calliope was playing and people were pouring through the entrance!

But the weather was changing and soon the circus would close down and move to a warmer climate farther down the coast to wait out the winter. This would be an excellent time for Bram to work with Modoc.

He had sent his letters home the minute he arrived in New York but had heard only from his mother and Curpo. Gertie had never answered. He decided to write again.

My dear Gertie,

The time has passed so quickly. I feel so much older than my years tell me. The terrifying ship experience that I spoke of in my last letter, my trip through India, the death of Sian, so much more, all have taken their toll. Sometimes I feel exhausted after having done just a small amount of work. I am told I still suffer from the shock of what happened. That's hard to believe seeing it was so long ago. I cried the other night . . . I can't believe I am writing this. But I feel that you, Mom, and Curpo are my only family. And I hurt you all. I guess it is my guilt that is writing.

I have been in America six months and have yet to hear from you. Curpo says he sees you, that you come to the house, bring my mother things of caring—cookies, jams, cakes. They say you refuse to talk about me . . . us. I understand . . . so very well. I cannot say that if I had to do it over things would be different. Someone I met while I was in India, Kalli Gooma, a very wise man, said, "All life is . . . and cannot be judged good or bad." I was in great pain loving two women. I went to the temple to ask

direction. I received no enlightenment. That in itself was an answer. I was forced to look within and do what I felt was right. To be with one I cared for a great deal, knowing that I would never see the other again, was confusing and terrifying for me. I know how I would feel if it was I who had to suffer you loving another man!

But now one is gone. My love for you has and always will be as strong a love as one can have for another. Kalli Gooma also said, "A love for one does not take away the love for another."

My job is good. Modoc says hello. Please forgive my rambling.

By early next year I will have saved enough to bring Mom, Curpo and . . . would you come? I guess not. Your pain must be very great. Gertie, I don't know how to handle this! I once told you that my love for you would never die. It's as true today as it was then. Why do I feel so uncomfortable writing to you? My mind is awhirl.

It is said that we can forgive but never forget. Please at least—forgive me.

Please come . . .

Love,

Bram

Dear Bram,

My love. You have always been my love. From the first day we met, when I peeked around Modoc's head to see you up there, so proud. Remember, I danced on her back, we swam at Cryer Lake. You were my prince on your way to be king! And I was to have been your queen!

Oh, Bram! I was so totally, so completely devastated when I heard about Sian. I know and understand why you did what you did. I can even forgive you. But my love, it still hurt!

Why, we were never to see each other again! But, as you say, just as bad comes from good, so must good come from bad. If it

wasn't for the horrible war and Mr. North finding you, we would never be writing these letters now. We had been so worried, me and the family. All that time! Not knowing! When you told me about Sian, I, in a strange way, was happy for you. Yes! If one truly loves another, then his happiness is the most important, even if it means being hurt yourself.

But to lose you! My love for you was great. So, so great! You were the man I would spend the rest of my life with! Now the question that keeps coming into my mind—who would you have chosen had I been there? Bram, Bram, do you hear me? Do you understand the pain, even though I can agree with your decision?

I had lost you! And now? I . . . find myself ecstatic one moment and confused the next. Could it . . . would it happen again?

Give me time. To see you, to have you hold me! Let's be patient, move slowly. Let's wait and see.

Love,

Gertie

Several weeks passed and another letter arrived from Gertie.

My dearest Bram,

I carry bad news. All agreed it should be me who tells you. Your mom has died. It was so sudden, my love. She was fine the night before. We had a wonderful dinner—Curpo and some of the old friends were there. After dinner she said she felt tired and went to bed. I stayed to help clean up everything in the morning. Bram, she went in her sleep. Peacefully. I didn't know how to tell you this any other way. She loved you so much! And was so proud of you! There wasn't a day that went by that she didn't read your letters and show the newspaper articles to someone or tell them how brave and good you are.

Your mother was a simple woman who lived a simple life. She was strong for others more than for herself. She was devoted

to your father, to you . . . to all of us.

She will be buried alongside Josef up on Grenchin Hill. Her gravesite will be the last. The iron gate will be closed, and only those who knew the deceased will be able to come and say their thoughts.

Oh! Bram, I wish I were there to hold you, to take away some of your pain. Her passing has awakened in me the realization of how short our time on the earth is. To be alone when there is someone whom you love more than anything else in this world there for you, wanting you, is all that life is about!

Mom would have wanted us to be together. Everybody does, and so do I! I'm coming, my love, together we can share the loves and problems that life will bring.

Yours forever,

Gertie

Bram slept with Mo that night. He needed the companionship of a family member. Someone who was there for him, who had proven time and time again her devotion to him. He didn't sleep head to head that night. He slept as a child curled up in her trunk. His tears were known only to her.

Bram shared with Kelly his sadness over the news of his mother's death. The broad spectrum of contrast was difficult to experience. The joy and delight of Gertie and Curpo's coming and the death of his mother. The yin and the yang at work once again. In the months to follow, his sorrow for his mother was replaced by remembrance; his longing for Gertie, by anticipation.

"Kelly! Gertie and Curpo are coming. Kelly! Kelly!"

Bram raced through the fairway chasing after Kelly, who was driving a loading tractor and couldn't hear him. He ran around in front forcing Kelly to see him and stop.

"They're coming! Gertie and Curpo! I just received a telegram!"

"Bram, that's wonderful! When?"

"Soon! It just said they're booking passage and will be here

within the month! That's all I know."

Kelly had been worried about Bram—his depression, his lack of interest in anything but the new act. Gertie would be the one to snap him out of it.

Bram on occasion still met Sian under their tree. But it was becoming more difficult. Sometimes the light in the dream seemed to fade. Now that Gertie was coming, he knew he must let the dream go.

"Sian, my love," he found himself saying out loud, "I must let you go. Our memories are everlasting. Sometime in the future perhaps we will meet again. I will never forget you!"

Bram felt she understood more than he did. She would have the knowledge to be content and know they both needed to move on. But it bothered him that he had promised they would always meet under the tree! And now he was breaking that promise! But, then why have the ability to promise? Are promises manmade? Maybe that's the problem . . .

Dear Curpo,

My good friend, what will I do when we all die and I meet both Sian and Gertie in heaven?

Dear Bram,

Who says you're going to heaven?

The train caravan rolled into New York City. Mr. North had decided to open the new season at world-famous Madison Square Garden!

For the last six months Bram had spent every waking moment working with Modoc. He had trained each evening in a special tent provided for him after the circus closed. An arena had been set up inside that had the same dimensions as the one in the main tent.

Everyone was curious about what the new act would be. Some of the roustabouts hung around. Circus people would come and go. A few trainers came in trying to learn the "secrets" of his training.

But there were no secrets. There wasn't one person capable of understanding, let alone learning what Mo and Bram's communication was all about.

He loved to baffle many by whispering in her ear, or folding his hands in prayer and sitting cross-legged between her front legs. Sometimes the back ones! Many thought him a loony, others just let him be.

Bram asked that the calliope be left in his tent so he could use it in his new act. While he worked for the Wunderzircus he had learned enough to operate the automatic so he could start, rewind, and stop it. When the calliope was in the tent, he closed the tent flaps and asked that no one enter so as not to disturb Mo's concentration. Then he would turn it low and work into the night.

Long ago Bram had conceived the performance. It was based on what his father had told him—about an elephant doing an act without a trainer. That would be something to make Modoc outstanding! He now had to create a performance that no other elephant had ever done. He wanted not only the audience to be impressed, but Mr. North and the circus people, too. It would be spectacular. It would be something that people would talk about for years. And he knew if he could just think of something, Modoc could do it! She was so smart. And then one night when he was thinking on his way back to his trailer, it came to him. It wasn't Modoc's size that impressed people, or even her personality—it was her heroics and her refusal to give up. It was the fact that they had survived a ferocious typhoon at sea, had many adventures in India, and had crossed on foot into the teak forest to pass a test in less than a month that it took many elephants years to do. It was the fact that together they had won the hearts of a people who allowed them into their village and led their own elephants to war, and their bravery that had saved many. That's what impressed them. But Bram knew all that was because Modoc was special—she could act on her own. It was her intelligence.

So he concentrated on Modoc's ability to think for herself. He

wanted the public to appreciate her intelligence, to learn that animals can think for themselves. He felt it was just as important *how* she did the performance as the performance itself.

He wanted to share with the world that animals weren't "dumb," that they could reason, that a power of choice wasn't just for the humans. And he thought of the perfect way to do it—he would have Modoc do an entire performance without him in the ring.

It would require her to think for herself and to remember each and every command. Now, that was something that had never been done before—with any animal! For her to be out there on her own with no commands, to remember—that would be spectacular. It was Bram's way of giving the world a new way to look at all animals. To bring them to a new dimension in the eyes of the people.

Mo was ready. Ready to learn. To please Bram and to use her ability to understand what he wanted.

First Bram established a series of behaviors that had not been performed before. Then he taught Mo each one. He played the calliope while she was doing the behaviors. Each time he had Mo do a behavior, he would play a corresponding note. The music became the trainer, not the man.

The months passed. Mr. North had given Bram a date to have the new act ready. The grand opening. The new season. Not just Bram, the whole circus had to be ready. All the performers had been working hard on their own acts all winter, and now the moment was at hand.

The morning of the big day. The newspapers and radio stations had been sending out commercials, free tickets had been offered, clowns were sent into many schools to entice the children to ask their parents to bring them. A parade of elephants, fancy horses, and clowns celebrated the coming of the circus down New York's main street—all to lure people to come!

The circus's public relations department had done a great job promoting Modoc, and now the time had come to produce.

New York was waiting for Modoc and Bram, Modoc and Bram were ready for New York, and the show was about to go on!

= **34** =

THE LINES AT THE TICKET BOOTH stretched down the block lead-
ing to the arena. This was opening day of the circus, the most
important day of the year. And a sunny day it was. The sky was
clear, the warm spring weather had brought an overflowing
crowd—lovers of the circus, of the big top . . . and of Modoc. In the
year that she had been at the circus, she had brought the attention of
many.

Mr. North, whether for the prestige, or because of a side of him
most didn't know, gave the proceeds of the day to a charity group.
In this case, the money was to go to the children's ward at a local
hospital.

This was also the time when all the new acts were to be pre-
sented. The press box would be full of reporters from every news-
paper and radio station across the country. In one day a performer
or trainer could be in the big top with a major act or out of a job.

Bram was as nervous as can be. He polished Mo's ivory and the golden tips over and over again. She had been scrubbed clean and oiled to give her skin a warm, soft texture. Her toenails had been trimmed and buffed. One thing Bram wouldn't them let do was put red polish on them! It just wasn't Mo!

Her red and gold blanket and headpiece were cleaned and brushed. Mo was ready, Bram wasn't. What if something happened? If Mo tripped or missed a cue, something . . . ? He could lose her! Mr. North had a matching outfit of red and gold made for Bram. For the first time, Bram felt he was somebody. He could be proud!

Bram peeked through the curtain. The crowd was enormous, and tension in the arena was at a high level. Many of Bram's friends came by to wish him good luck. Some told him to "break a leg," which he understood meant good luck, he just didn't know why.

"Ladies and gentlemen! Children from around the world! Welcome to Madison Square Garden! We proudly present the North Circus as it opens its spring season."

The drone of the ringmaster echoed through the big top. A hush fell over the crowd.

"I wanted to wish you and Modoc good luck," said a voice from behind.

Bram turned to find Mr. North standing there. He put out his hand for a handshake, the first he had ever offered to Bram!

"Thank you sir, I . . . we'll do our best."

Mr. North walked on, leaving Bram more nervous than ever.

For the next hour and a half the show went on, act after act, the acrobats, the High Flying Zifferonis, the clowns, the full herd of elephants stretching all the way across the arena. Some performers missed their cues, others performed beautifully.

Bram and Mo's act was due to open the second half of the show, just after intermission. The half-hour of people racing back and forth getting soft drinks, popcorn, candy, hot dogs, all anxious to see the second half, seemed like an eternity to Bram.

And then:

"Ladies and gentlemen, children from around the world," blasted the ringmaster. "The North Circus, under the personal guidance of Mr. North, brings you a *one of a kind, first of a kind* performance. One that has never been done before!"

You could hear a pin drop. No rattle of popcorn bags, no chairs scraping, no talking.

"You are about to witness a unique solo performance by an elephant—without a trainer! I repeat, no trainer! There has never been an animal known that has ever done it—except our one and only—our Golden Elephant—MODOC, and her friend and trainer, Bram Gunter!"

The applause from the audience was deafening! Bram and Modoc were waiting just behind the curtain. Bram was not surprised that North's racial attitude was reflected in the announcer's saying his name incorrectly.

This was the big moment he and Modoc had been waiting for! He leaned over and whispered in her ear, "This is for Papa, Mosie. And Mama."

The music started. They waited for just the briefest of seconds. The curtains parted. Modoc put up her trunk as Bram uttered, "Move up, Mo!"

Two spotlights, a blue and a white, followed as he ran Modoc to the center ring. She lowered her head; Bram held both ears and planted a kiss on her forehead. The blue spotlight followed him out of the ring into a waiting blue velvet-covered chair, and as he sat in it, the spotlight faded to dark. The bright white spot on Modoc was the only light on.

The calliope started. Modoc took her cue and for the second time in history, an animal performed without a trainer! She bowed low, then threw herself into a sweeping motion of twirls, spins, loops, high leg steps, lie downs, trunk fantasia—all interspersed by sounds of trumpets, squeaks, rumbles, clicks, and bellows. This wasn't an act—this was a blending of articulate movements gracefully performed with near-impossible positions and patterns woven

throughout. This was a song and dance performance! An overhead microphone allowed the audience to hear every sound she uttered.

Bram sat still in his chair, barely aware that he was breathing as his mind moved to the same beats as Modoc. He was so proud of her now. She was actually doing it! He had known all along that she was magnificent, special—and there she was, proving it to the world. He could almost feel his father and mother, Sian, Kalli Gooma, and even Jagrat's energy beside him, pulsing with the same pride. Everything the two had been through, everything they had taught each other and learned from each other—every exchange of love the two shared were coming together at this very moment in time. He could almost hear Modoc's laughter and enjoyment as she danced to the music to please the crowd. No terrifying ocean typhoons, no guns firing at her, no thieves trying to steal her from her beloved Bram, nothing but the happy energy from the people in the bleachers. This was magical, and everyone was caught in the luminous net of the moment. All came together smoothly on the beat, gracefully, as she ended in a sweeping bow. The light slowly faded to dark and at the last second a small but intimate "chirp" was heard—and the spotlight went out!

There was a long moment of silence, then the spotlights came on. The white on Modoc, the blue on Bram, and as he raced down from the platform, a thunderous applause went up! Bram gave Mo a big hug. Only he could hear her belly rumble.

She raised her front leg, Bram hopped up and slowly she raised him till he could jump to her back. A wave of his hand, a trumpet from Mo, as they exited the ring.

Bram headed her to the press box, a customary gesture to the dignitaries as well as the press. As Modoc bowed to them, he heard a familiar voice screaming above all the others. He looked up. There, standing cheering, applauding with the others, were Gertie and Curpo!

Bram wanted to jump off Modoc and run to them but instead waved and threw a big kiss.

Curpo almost fell off the seat he was standing on. Gertie was

jumping and clapping her hands, yelling, *"Bram! Bram!"* She
mouthed the words: *"I love you!"*

As Bram and Modoc passed the crowd on the way to the back-
stage curtain, the audience rose and gave them a standing ovation,
standing until the curtain closed. This was the highest form of com-
pliment they could give. Bram was off Modoc, leading her to the
exit door as they came through.

"Bram! Bram!" screamed Gertie as she jumped into his arms.
Bram caught her in midair, hugging, kissing his girl, his one and
only . . . his Gertie! They hugged and kissed, feeling the moment,
the pain of caring. Both had tears in their eyes. Bram felt someone
holding his leg.

"Curpo! Curpo!"

He fell to his knees, embracing his friend, kissing him on the
cheek.

"Blech! 'ave ya gone bloody wacky, now? I tell ya, is this a way
to greet a gentleman? Get off your knees, it's embarrassing!"

Modoc was dancing, trumpeting, and squeaking her "what
about me?" body action. Both Gertie and Curpo hugged and kissed
her. She wrapped her trunk around Gertie as she did to Bram and
belly-rumbled.

"We love you, Mo!" cried Gertie.

Mo picked up Curpo and opened her mouth as though to eat
him!

"I've missed ya too, ya big moosh!"

Gertie whispered in Mo's ear, "Thanks for bringing him back
home to me."

The three sat in the trailer and talked late into the night. A
knock came at the door. It was Mr. North.

"Bram, my boy, you did it," he said. "I'm proud of you. I'll
show my appreciation in the morning."

He tipped his hat to Gertie, ignoring Curpo completely, and
disappeared in the dark.

It was two in the morning before Curpo left. Gertie and Bram
talked for hours of the many things that had happened in the years

they were apart. Bram noticed that the girl he had once known had blossomed into a beautiful and intelligent woman. Their young love had matured.

Morning brought a new large trailer, a bonus check, a pay raise, and a box of candy for Gertie.

In the months to follow Gertie accepted a job offered by Mr. North to work with the equestrian act, a beautiful set of four matched palominos that did an exciting performance with four blond ladies. It wasn't long before she was asked to take charge of it all, scheduling, costumes, training programs, everything. The people loved her, and she, having been brought up on a farm, was knowledgeable about all aspects of caring for horses.

Curpo turned down an offer to work in the sideshow as the World's Smallest Man. "It was a put-down, it was. The man . . . what's 'is name? North . . . knew I'd say no before he asked! He feels all the people here are beneath him!" Curpo had to laugh at his own bad choice of words.

Bram intervened. He talked to Mr. North.

"I want him with me."

"To do what?"

"To help work Modoc."

"Ha! She'll smash him! Why, even I can't see him most of the time."

"Curpo may be small but he is excellent with elephants. He was my assistant in Germany. He's great with Mo and she cares for him very much."

"*Moooooo! Cares for him very much!!* How can she . . . ah! The answer is no!"

Mr. North was on his way out the door when Bram thought of a possible solution. He called after Mr. North, "What if I put him in the act! The public would love to see a giant elephant and the World's Smallest Man doing an act together."

Mr. North stopped. Bram knew anything that could make him more money was of interest to him.

"Hmm," said Mr. North.

Curpo was at work the next day, strutting around as if he were five feet tall.

It was no surprise when Bram and Gertie announced their marriage. Everybody at the circus was so excited for them, especially their friends at the sideshow. But their friends hadn't known until now that the ceremony was going to be held in the big top, center ring, during a performance! It would be this coming Sunday, during the matinee, at the beginning of the second half of the show, just after intermission.

The crowds flocked to see the wedding. As the audience took their seats, a hush fell over the big top. The ceremony began. The trumpets blared. The announcer intoned:

"Ladies and gentleman, children from around the world, the North Circus, under the personal auspices of Mr. North, is proud to have your presence at the marriage of Modoc's world-famous elephant trainer, Bram Gunter, to the lovely lady, Gertie Baron."

The calliope played a circus rendition of the wedding march. Colored spotlights searched the curtain. From the farthest end of the big top the curtain parted.

Six beautiful ladies, the acrobats who twirled on the ropes high in the air, entered, all dressed in shimmering silver gowns. Three on a side, they walked in timed steps, followed by the equestrian performers. The horses were slick and high-stepping, carrying the ladies they performed with.

Next came the aerial trapeze performers, each with a swirling, glittering purple cape. On and on they came. The clowns, jugglers, high-wire troupe, strutting their awesome elegance. The calliope changed tunes according to the performers' appearance.

So long was the procession that it wasn't until the girls in the silver gowns reached the other side of the tent that the elephants appeared. The smaller ones were first, gamboling, squeaking their little voices. Then the bigger elephants, two by two, gradually increasing in size. Forty-two in all, tons and tons of pachyderm, all

dressed in their fancy headpieces, lumbered into the arena. Each had a pretty girl up top, a trainer at the side. When the entire big top was completely full of performers and animals, all came to a stop.

Finally the moment everybody was waiting for. A roll of the drums, a series of horns heralding a special happening, a moment's hesitation at the curtain. In one sweeping gesture, the curtains parted. Standing there in all her magnificence was Modoc. Trunk raised, she stood as a statue made by the finest sculptor of all! Riding up top were Bram and Gertie. The calliope played a circus rendition of "Here Comes the Bride." Red, white, and blue spot-lights danced from one place to another.

Gertie was sitting in a beautiful sequined red and gold how-dah. She looked radiant, her golden hair flowing soft and fine. Sprinkles of stardust shimmered in her hair. She wore a pure white silk dress that accentuated her lovely form, its train overflowing down Modoc's back.

Bram stood behind her. He was dressed in a white velvet cos-tume, tight-fitting, elegant. The front of the shirt was laden with hun-dreds of tiny diamond studs cascading down the sides of his legs.

Modoc in her tux and bow tie, trunk up, nails painted, tusks golden, skin shining, trumpeted their arrival. The audience stood and applauded as they passed.

As they reached the center ring, Modoc positioned herself alongside a glass staircase. Silver and gold spirals of woven cotton cascaded down its sides. Bram helped Gertie step to the waiting staircase, and then together they descended to the waiting minister and their dear friends.

And so on a warm Sunday afternoon, amid thousands of admirers and friends, Bram married Gertie. Hundreds of white, pink, and blue pigeons were released, flying in swooping circles around the big top. Their kiss sealed a love born years before that now could take its first breath to live . . . and to flourish.

Bram and Gertie had known for some time where they would go on their honeymoon. Both felt a calling, a need to return to a time and

place where love had a different meaning, where life didn't sit so close to the edge. They yearned to be together in Germany, in the Black Forest, at Cryer Lake; to see the old farm, the barn where so much of their lives had been lived.

Bram knew how difficult it would be. His father and now mother were both gone. Probably many of his friends, also. Both Gertie's parents, although quite old, still lived in the same house. She felt the need to gently say goodbye, as she knew she would never return.

But their needs were of a more personal, deeper nature. The ends of the silver thread that bound them together needed to be tied in a square knot, never to come loose again. The thread was not meant to be tested for strength; it was too delicate for that. But rather the energy that ran through it needed to be circled, to be infinite, and only by going back could they feel content.

They had so little time. The trip would need to be short. They told no one of their arrival. It would have taken too much time searching for them, probably missing most, causing hurt feelings— no, they would go incognito. If they met someone, fine, if not, all right.

The plane ride was their first. Traveling across the world at such high speeds was something they had never thought of doing. Their arrival in Frankfurt, the hiring of a car, the ride to the farmhouse were done in silent anxiety.

The day was cool, a cloud cover blanketed the countryside. Bram had refused to sell the house after his mother's death. He could see the roof of the old house from miles away. Later they stood at the barn door. All around them were the memories they knew would be there. Inside, the old stove, a few moldy bales of hay, the tack room full of rusty nails, broken hammers, and a cracked light bulb.

He stood where Modoc had been born. The place felt musty, cold. The dampness made Gertie shiver. The house was empty save for a few pieces of furniture too old and worn to take.

They walked the land, occasionally picking up a piece of

something or other. The following day was spent at Gertie's parents' house, sitting on the porch, slowly talking, sipping tea, eating biscuits. They visited Gertie's room where he, in the cold of the night, had said his goodbye. "I'll never forget you, Gertie. I love you."

Gertie's goodbye to her parents was heartfelt by all. "I'll see you in heaven," she was really saying.

The third day was spent at the graveyard. Bram opened the rusty gate. Gertie saw him stagger a bit, not much, just a little, but it caused her concern. He put some flowers they had picked on the graves. Somewhere a calliope was playing.

Bram looked up to the hill where Modoc had carried him and Gertie to the funeral. His mind's eye could still see them there, looking down.

The last day was spent at Cryer Lake. Bram had picked field flowers for Gertie. They lay under their tree, the tree that grows from the top down. The river was still, quiet. A trout jumping was a major happening in the stillness.

The ravens dove low, looking, calling to the strangers as though they recognized them. From the small hill that led to the lake, one could hear the sobbing of a man, in grief. Each tear carried the memory of yesteryear, of happy and sad moments, of having to say goodbye.

The knot was tied.

= 35 =

Mo DIDN'T FEEL WELL. Her last performance had been a bit sluggish. Some of the other elephants were acting the same way. A veterinarian was called out, but after a quick once-over couldn't find anything wrong. The next morning, four elephants were down. Five or six others weren't eating and had bad cases of diarrhea. Again the vet was called. Bram found out he was a dog and cat vet and knew nothing about elephants.

Without asking Mr. North, Bram called the local zoo and arranged for its veterinarian to come. The doctor spent a couple of hours taking blood and urine samples, checking eyes, ears, trunks, reflexes, temperatures, and everything else. Finally he met with the head trainer at the far end of the menagerie tent. Bram, Gertie, and Curpo joined some of the elephant trainers to hear what the doctor had to say.

"I'm sorry, but it appears as though they've all been poisoned," he reported.

"What?" they said in unison.

"What's the prognosis?" asked the head trainer.

The doctor shook his head. "I won't lie to you. I think we'll be lucky to save half of them."

"No!"

"No way!"

"What are you talking about?"

Gertie gripped Bram's arm tightly. He hadn't said a word. She asked the vet, "Are you sure?"

"How could they have access to poison?" The head trainer couldn't believe his ears.

"It could've been bad food," suggested Curpo.

"No, this is too concentrated," the vet said. "The only way would have been by injection, or a strong dosage put in their food."

The head trainer said slowly, thinking while he spoke, "If they were injected, the person would have to know their weight, give or take a few hundred pounds, plus have access to poison."

"And have a way for it to be injected, like hypodermic needles. Who could do that?" someone asked.

The vet rolled down his sleeves and moved to the washbasin, where he scrubbed his hands. He began packing the vials of specimens into his case. "We'll know more when we isolate the poison at the lab, if we can, but my professional opinion is that since they all seem to be experiencing the problem equally, I suspect whoever did this put the poison in their food."

"Who in the world would poison elephants?" asked a trainer.

"Beats me. Who's capable?" said another.

"Could be a psychopath, someone who hates elephants," suggested the vet.

"Perhaps someone who wants to hurt the circus in some way, someone who recently lost his job," the head trainer said.

"What do you mean?" Bram finally spoke up. He inched his way toward the head trainer.

"Well, about two weeks ago, I fired a roustabout who was into the hooch . . . er . . . wine. Came in one night and began beating on the elephants."

"Why didn't you tell anyone?" Bram asked.

"I stopped him," the head trainer replied. "And had him fired. That's all I had to do."

"Two weeks ago?" Bram asked. "We were in Miami then. You think he could have followed us—just to do this?"

"Look, Bram, lots of men talk through their booze. I didn't see him around, so I thought he'd left."

"I'll have Mr. North call in the police to check him out." Bram turned to the vet, "Meanwhile, what can we do?"

"Depending how the poisoning has affected each elephant, the treatments will be different. I'll need all the help I can get. It'll be time-consuming, there are so many elephants. Once we figure out an antidote of some kind, and the dosage, they will need a round-the-clock vigil."

Bram and Gertie helped the vet load his car with his supplies.

Mr. North was in a state of panic. "Put a twenty-four-hour guard duty on the elephants, in fact, on the whole damn circus!" He ordered that a notice be put up at the main gate:

ELEPHANT ACT CLOSED DUE TO ILLNESS

The notice went out to the papers, radio, magazines, even billboards. All carried the message. Hundreds of concerned people called in asking if they could be of any help. An emergency tent was erected at the back lot, thick layers of sawdust were laid, and it was there the sick elephants were brought.

The vet had taken a leave from the zoo and was now staying on full-time.

"How come some aren't sick?" a circus employee asked the vet.

"Probably our killer never had the chance to feed the poison to them all—or perhaps he just ran out of it."

On the fifth day, the vet came running up to Bram.

"Bram, Mo's down!"

"Yes, well, I know she has been depressed but she's been eating a bit and—"

"No," the vet said, shaking his head, "I mean *down*, on the ground. She's taken a turn for the worse."

Mo was flat out, her breathing labored, and yellow slime dripped from her tongue. Bram knelt by her side and stroked her.

"We pumped her stomach, put her on saline, and are building up her system as best we can, but she's not responding," the vet informed him.

"She didn't seem this bad yesterday. What happened?"

"Bram, poison can take its time to permeate into the system. Remember what I said about the difference in elephants? Some just handle it better. Others, well, succumb."

"There must be something else that you can do!"

"There's not. I've given her every known counteracting drug I can think of. We've called in specialists from around the country. It's a waiting game right now." He put his hand on Bram's shoulder. "There's nothing more we can do. I'm so sorry."

Mo's insides were burning. The poison was taking its toll. She hadn't eaten in days. Her water intake was minuscule. Bram tried to reach her in a holistic way, using the methods taught him at the Elephantarium.

"How many are down now?" he asked the vet.

"Last count, eleven. This psycho was thorough."

"Yeah."

Additional tents were erected to handle all the elephants. Bram and Curpo, along with others, stayed the nights in the tent. Bram hadn't slept since the day it happened. Unshaven, eyes red, hair askew, he was visibly shaking from the thought of Modoc dying. He couldn't help thinking of the elephants that had died on the mountain and how all this reminded him of it. Within five days, sixteen elephants had died. Their carcasses were loaded into closed vans and hauled to a special dump area that the city had approved. There they were buried and covered with the dirt and garbage from the nearby dump.

The veterinarian was a dedicated man. He couldn't have done more. He made calls to research centers around the country, had spe-

cial equipment brought in to analyze the poison firsthand. He was given Bram's first trailer to catnap when the exhaustion was too much.

On the morning of the seventh day, as he took the cup of coffee Gertie gave him with a silent thank you, he told the trainers and the others, "The poison is strong, but since it's slow acting, it has given us the opportunity to try various drugs. It's obvious to everyone here that none has worked. Now the poison is reaching its full potential. Few of the elephants, if any, will be able to ward off the total impact."

He turned to Bram, who was standing near Modoc, watching her labored breathing with grave concern.

"Bram, body liquids are filling Mo's peritoneal cavity. We haven't been able to drain it off." He pulled him aside, and out of the earshot of Gertie and Curpo and the others, said quietly, "I think it's time that you begin to accept . . . she's dying, Bram."

But he wouldn't acknowledge it. "No! No! Look, maybe if we call . . . someone . . . anyone." He was becoming irrational.

"Bram, we've tried everything."

He lay with her all night, talking, holding, touching. Her eye watched his every move. If he got up and walked around, her eye followed him. When he lay close, her eye watched his. She was talking to him in her way. She showed little pain except when her stomach constricted, tearing and retching, burning, eating itself up!

A low light shone behind him and Bram turned to see the vet standing there, holding a lantern. There was a long moment of silence between the two. Finally he spoke up, the words coming slowly, "How long, Doc?"

The vet knelt down and patted Mo tenderly on the trunk. "She'll be gone by morning."

The night was the longest of Bram's life. What are the things that keep one from dying? Bram's mind raced through all he knew. There must be something they had overlooked. Drugs, rest, faith, belief, medicine, care, doctors, hospitals. He knew all had been tried. If the mind can allow sickness, then it can allow wellness.

In the very early hours of the morning Bram heard a commo-

tion at the far end of the tent. He hurried over as one of the circus workers was telling the others.

"They caught the guy! I just heard North on the phone. Boy, was he blowin' off steam at being disturbed so damn late, but you should've heard him telling the police what they should do with the guy! He's going down to police headquarters personally right now to press charges. The head trainer's going, too. Turns out this guy is an ex-professor of . . . wait, how'd they say it? Entomology."

"What's that?" asked someone.

The veterinarian explained, "It's the study of bugs. Insects."

Bram spoke up, "Insects? Maybe he used something like bug poison on them." He turned to the vet hopefully. "What do you think?"

"Could be, I don't know. We were sure it was a poison like curare, or nicotine, maybe botulism, but insect poison never crossed our minds."

Someone came in, out of breath. "Hey, Doc. there's a call for you in the office. It's the police doctor."

A minute later the vet was on the phone, Bram next to him, almost pressing too close for him to hear.

"Hello," the vet said. "Yes, this is he."

Silence as the man nodded. Bram was impatient and could hardly wait for him to finish. Gertie somehow appeared in the hallway, waiting for word. Finally the call was terminated and the vet turned to him.

"They've broken down the elements of the poison. The vaccine's been located at an Entomological Research Center about an hour by air from here. They're flying down the vaccine."

"When?" asked Gertie.

"Right now."

"That's great news! Isn't it?" asked Bram, taking Gertie's arm. She snuggled close to him.

The vet put his hand on Bram's shoulder, "Bram, these elephants have been down for a long time. Some won't make it, even with the vaccine. They're just too far gone."

Bram's expression immediately changed. "You mean like Modoc?" he asked somberly.

The vet put his head down. "Like Modoc."

The helicopter landed in the vacant lot next to the circus grounds. Three doctors, armed with hypodermic needles, spread out among the elephants, each giving huge dosages of the antidote. Ten cc's intravenous was slowly injected into the large vein on the inside of the back foot. But it was too late for two of them.

One by one their labored breathing suddenly stopped. Their huge bellows came to a halt. One was Bertha.

Modoc lay like a rock. Only the rhythmic swelling of her stomach and the blinking of her eyes was testimony to the life inside. The groans of pain seemed to be coming more steadily. She would seem to hold her breath, her body would rock, and then as the pain subsided she would relax till the next one. Bram stood by, feeling helpless at her discomfort. He had watched the doctors work on the other elephants and thought about Mo and finally came to a decision. He knelt by her as Gertie watched his pain from a small distance, holding herself strong for him. Curpo was astride Mo's back, gently stroking her skin, touching her for comfort, to let her know that they were all there for her. Bram spoke tenderly to Modoc, hoping she could hear, hoping she wasn't afraid.

"Mo," he said, "it's all right. I don't want you to suffer. You've been through so much in your life. Maybe it's time you got to rest. Maybe it's time you moved to the next phase, to do what's next for you. I can't bear to see you like this, Mo. I'd rather let you go than keep you in pain."

All of a sudden Bram heard a slight belly rumble. He put his ear to her stomach. Could it be? Yes, it was there, sure enough—a belly rumble. He stood up, excited.

"Curpo! Curpo! Come down! Now!"

"What's wrong, Bram?" he asked, sliding off.

"Kelly!" he cried, looking around like a wild man. "Kelly, get over here—and bring some help!"

Gertie rushed forward. "What's the matter, Bram, what is it?"

"I need Kelly—NOW!"

A minute later Kelly came rushing in with some other men.

"Bram, what's happened?"

"Kelly, you and the others get behind her, now! When I tell you—push!"

Seven or eight men got behind her.

The stomach started its laboring, the groaning came, and then the rocking.

"Now! Push!"

The rocking became stronger, more persistent. The veterinarian appeared and took a place among the men.

"Push harder!"

Her body began a rocking motion, raising her feet high in the air.

"AGAIN—NOW! PUSH!"

And on one big push, Modoc was up on her brisket, sphinx style. A roar of happy laughter, tears of joy, and applause followed.

The vet was flabbergasted. "I don't understand."

"Mo was trying to tell us to get her on her brisket. She knew from experience this was necessary for her recovery. We knew the peritoneal cavity functions normally in this position and her circulation would return. Modoc started the healing and the vaccine did the rest!"

The vet took a temperature reading and wiped his brow in astonishment. "It's returning to normal. But how is it possible that she would know what is good for her?"

"I wonder how . . ." said Bram, tongue in cheek.

Gertie leaped into Bram's arms, tears of happiness flowing down her cheeks, and then flew into Kelly's, giving him a hug, and finally gave Modoc a huge kiss. Curpo feigned disgust at her antics until he received the same big hug and he, in turn, grabbed her and gave her a big kiss. She burst out laughing for the first time in a very long time. Bram joined in while the others stood and watched, as confused and bewildered as ever. Bram, Gertie, Curpo—and Modoc knew.

Two months later the first elephant performances since the poisoning got under way.

A moment of silence was asked for those that had died.

36

"ALWAYS WALK IN THE VALLEY OF LIFE. The mountains on either side are rugged and steep. The chasm below treacherous!" Kalli Gooma's teaching was always with Bram. And he heeded it well. Bram walked in the valley. He had no desire to compete in a world of one-upmanship. There would be enough yang as it was, and he felt better prepared to handle it on familiar territory.

As the years passed, the trailer was exchanged for a larger one, much to Mr. North's chagrin, and a pickup truck was purchased to haul special food for Modoc, leather gear that needed repair, things for the house. Each winter and summer brought the same routine and reputation. The circus would quarter in Florida during the winter and play the performance dates all summer long.

Sometimes a letter would come from the Indian village. The mahouts would gather and write a letter together. They would speak of the elephants, the teak, and always mention Sian's family.

"They pray for you in the temple every Sunday and hope you are well."

Sometimes Sian's parents would write. Gertie could always tell the difference in the handwriting. Ja would usually do the writing for the family. He spoke often of the pain the village still carried. So many had died, the families had come together to help and support one another.

"We have put a monument at the lake where you and Sian first met. We think you would both like that." The letter went on:

> We thought many times to move her here with us, but I and my family, we think you have chosen a special place for her. She loved you with all her heart, and that love is with her forever. We miss you, Bram, chosen son of the maharajah. Come back to us someday. Our hearts and love are with you and your lady, Gertie.
>
> Your second family,
>
> Ja

"I think that's sweet of them, Bram. To build such a monument," Gertie said after he finished telling her.

"That was such a long time ago," he said sadly.

"Do you miss them very much?"

"Oh, from time to time, I think about them all and what happened, but it's in the past now and the past gives us our strength, so to be sad about gaining strength is not very wise, is it?" he asked, putting the letter aside.

"You make things sound so . . . I don't know . . . connected. It's a nice way to look at life."

"It is all connected, dear. Each moment connects to the next and it is through time we move in our lives. All is as it should be— to help us grow and become who and what we are."

"And Modoc . . . ?" she asked with a twinkle in her eye.

"Ah, Modoc . . . well, she is . . . Modoc."

* * *

The elephants had just finished their grand entry when it happened. A curl of smoke was seen rising from the entranceway.

At first nobody bothered about it, figuring someone nearby would take care of it. Nobody did. The smoke drifted through the tent, forming a thin line that could be seen high above the arena.

"Fire!" someone finally yelled. People in the stands rose and looked about, trying to see where it was coming from.

"Now don't panic, I'm sure it's nothing," said a spectator.

Suddenly a voice from the loudspeaker boomed, "Attention, please. Would everyone please move to far exit of the tent. Attention, please. Please move in a calm and orderly fashion. There is a small fire near the entranceway. For your safety, and the safety of the animals, please move to the far exit of the tent. Thank you."

"There's a fire!"

"Where?"

"Near the entrance!"

"No, he said the exit!"

The smoke, now having thickened, had become a dense gray fog throughout the tent. People became disoriented.

"Which way is the exit?"

"Over here!" someone yelled.

"No, you idiot, you're telling people the wrong way! It's this way!"

"I can't see!"

The panic began. Slowly at first, then building into a frenzy. People started screaming, coughing! The smoke by now was thick and dark.

Bram and Curpo had just finished buckling the blanket and headpiece on Mo when the fire started. They were on their way out the backstage exit when Bram heard the people screaming. He looked at Curpo.

"Ya go on ahead, I'll finish 'ere."

A nod of okay and he was gone. "Come on, Mo!"

Bram headed for the exit area. It was much worse than he had

imagined. People were crowding, pushing, fighting to get through. Many were falling down.

Bram yelled, "Follow the elephant! *Follow the elephant!* She knows the way! Hold on to the blanket, even her tail."

"Please take my children!" begged a woman, followed by others. He lifted them up to Mo's back. All huddled together.

"Hurry, hurry!"

A dozen more children scrambled up on Mo's back. As she started to the exit, the billowing smoke made breathing impossible.

"Hold your breath as long as you can!" Bram yelled for all to hear. "Move up, Mo. Move! Move!"

Going by instinct to where the open flaps were, she carefully moved forward. People hung on to her from all sides as she headed into the smoke. In the thick of it, some dropped at her side, unable to continue, and others quickly took their places. Like a locomotive coming out of a tunnel, she emerged from the smoke out into the fresh air. Mo staggered and fell in the open lot. She was burning!

The people fell to the ground coughing, choking, some vomiting, others lying still. Mo was wheezing and gagging, shaking her head trying to get rid of the smoke in her lungs. She blew air and smoke out of her trunk. Bram was on his knees coughing and choking as were the others. He staggered to his feet. People were running to help get the children off, carrying them away from the cloud of smoke coming from the tent.

Bram managed to find a hose and turned it on, spraying Mo first, then drenching himself with the water.

"Bram, Bram! Where are you?" He heard Gertie calling his name but his throat had been so ravaged by the smoke, he could barely whisper.

"Here! Here!"

When Gertie reached him she barely recognized him. He was covered in a blanket of thick black smoke. The water spray and soot had covered him and Mo with black ooze, dripping like mud.

"Where's Curpo?" Bram asked, thinking his friend had escaped into the safe night air.

"I don't know! I haven't seen him. Wasn't he with you back-stage?"

"He's still there! Oh my God!"

Bram ran to Modoc. He knew he could never fight the hysterical crowd pouring out of the tent. But Mo could. He had to get back in to find Curpo!

"Get up, Mo!"

Modoc slowly raised herself, her eyes tearing from the smoke. Bram was up on her in a flash.

"Gertie, hand me that tarp lying over there! When I put it over us, soak it down!"

Gertie handed it up to Bram, who spread it out over himself and Mo.

"Now! Gertie, NOW!"

She blasted the water stream over them till they were soaking wet. Bram headed Mo back into the tent. She never hesitated. Straight in they went. Once inside the big top, Bram could see the smoke had curled upward, giving a slight clearing in the smoke. Fire was racing up the canvas sides of the big tent, the bleachers were afire. He could feel the heat on his face. People ran by, coughing, gasping for air. Mo occasionally raised her foot to step over a body. When they arrived at the spot where they had left Curpo, Bram dismounted so he could see closer to the ground. He held Mo's ear, leading her through the smoke, trying to calm her as the searing heat and thick black smoke pressed heavy against them both. Visibility was becoming harder and harder. His eyes were tearing and he kept wiping them so he could scan the area.

"Curpo!" he cried, his voice so harsh it hurt. "Curpo, where are you?" He hoped to hear his friend's voice holler back, "Bram, over 'ere," helping the two find each other.

Nothing. He called again and again until his voice was just above a whisper. All around him he could hear people crying in fear, and in the distance he could hear the sounds of terrified animals—the big cats roaring, the horses whinnying, and trainers' voices trying to calm them and get them out of the fire line.

Bram's lungs were giving out. Mo was gasping for air. They made it to the backstage area when Bram went down. Modoc stood for a moment, then picked him up. He fell again, and again she picked him up. The movement brought him around long enough to see that Mo had found Curpo! She had him in her trunk, carrying him low to the ground where there was less smoke. She herself was staggering but got back to Bram. She gave him a leg up. He grabbed the blanket and by sheer willpower, inched his way to the top.

"Move, Mosie, Movvvve . . . "

Bram passed out on her back, clutching the blanket with a death grip.

Suddenly there was a loud explosion at the exit! The fire had found its oxygen when people raised the flaps trying to escape. The oxygen coming in from the outside fueled the smoke—and what had been a tunnel of smoke was now a wall of fire! Anyone who had been in there when it happened had met with instant death.

Modoc saw the wall of flame. She never faltered. She hit it with a vengeance. She screamed an agonizing, roaring trumpet . . . and raced full tilt into and through the raging inferno! The flames set the blanket on fire. Bram also was afire, as was Mo as she cleared the tent and fell twenty yards outside it.

People came from everywhere, grabbing Bram and Curpo out of the flames. Buckets of water were thrown on them, water hoses doused the flames, blankets were brought to snuff out the fire on Modoc's burning flesh!

Fire engines had arrived, police, ambulances all converged on the scene all racing, hoping to save as many as possible.

Gertie, who had been called to help with the horses, suddenly appeared. Her face was covered in soot and her dress was torn where she had ripped it to make blinders to cover the horses' eyes to guide them out of the danger areas. She raced to Bram, kneeling by his side.

"Bram! Bram, honey! Please. Please." She was holding him, rocking him like a child. He lay still. A fireman pulled her away. "Let me get him some air." He clamped an oxygen mask over

Bram's face and felt his pulse. "It's steady," he said as Gertie closed her eyes for a moment and took in a deep breath of relief. "He should be all right, ma'am. Just let him breathe easy."

"What about . . . ?" She couldn't finish as she eyed their little friend lying next to Bram.

Curpo hadn't moved. An oxygen mask covered his face as well. There was no sign of life. The fireman tried to find a pulse. Nothing.

Gertie turned her head away, unable to comprehend what was happening, and saw Mo lying as though dead. She had crashed headlong into the ground. Her head, tusks, and trunks were buried into the thick mud the water had created. The stench from her burning skin permeated the area. Gertie's knees almost gave way but she heard a familiar voice, calling.

"Gertie? Don't worry! I'll handle it!" The commanding voice was Kelly's. He turned to the watching crowd and pointed to several men. "You, pull her head up, and you, get that air hose from the oxygen unit over here!" he ordered.

Ten volunteers instantly helped to lift Mo's head so her breathing was unhampered. The air hose was run down her throat. Smoke was still coming from her mouth.

Kelly formed a line of men in unison to push on her belly to get the smoke out and some air in. He didn't know if it would help but he had to try! After what seemed like an eternity, Modoc started to cough. She tried to stand.

"Help her!" Kelly cried, and ordered the men about Modoc. "This way!" As he had seen Bram do on occasion, he now did to help Mo stand. In a few minutes she was on her legs. Shaken, but upright. She slowly moved to Bram and caressed him with her trunk. Gertie patted her neck and gave her a kiss.

"Oh, Modoc," she cried.

Curpo never regained consciousness. He had swallowed so much smoke that his little lungs collapsed. His small body was covered and put in the waiting ambulance. It didn't turn on the siren.

Bram opened his eyes. He saw Gertie's expression and the

tears streaming down her face. He removed the mask from his face and was almost afraid to voice the question.

"Curpo? Modoc?" he whispered, his throat still raw.

She knelt beside him and took his hand, her voice choking. "Bram, my love, Modoc's fine . . . but . . ." Her eyes drifted off to the departing ambulance. She shook her head in grief and loss.

Bram looked away from his wife. The tears filled his eyes.

Curpo was dead.

≡ 37 ≡

BRAM NEVER DID GET OVER CURPO'S DEATH. He blamed himself for not being there. He should have stayed or . . . something! Curpo had brought so much love and understanding into his life. He was his brother in life, a companion who was there to listen, to help, and above all, to share his pain and happiness. These thoughts made him realize how very little he knew about Curpo.

Yes, he knew where he was born, his parents' names, all that primary information, but what about his feelings about being small? They had never talked about it, or about his never marrying. Maybe because they talked only about Bram's problems.

No one ever filled Curpo's place alongside Bram. He did everything by himself. Sometimes when Gertie or Kelly wasn't busy, he would let them feed or clean, but no one else.

After the big top fire the circus closed down. For two years it battled the legal system. Dozens of people, including children, had

perished. The lawsuits nearly broke Mr. North but his bulldog attitude kept him fighting to reopen the circus. It was said that he hurt many families by fighting them in court. He had the wherewithal to hire big-shot attorneys, and many cases were won unfairly. Hospital bills that he should have paid were left to the poor people who patronized the circus on that fateful day. Some went bankrupt, others won a small amount but never enough to compensate their losses.

Mr. North held on to only those things he required to start up the circus again. Most acts were let go as they were replaceable when needed. Many animals were sold along with the equipment, such as cages, concessions, and any tent that wasn't fireproof.

Mr. North kept Bram on with Modoc because he figured when he opened the doors again, Modoc's act would still be the best thing going. Gertie lost her job, as did Kelly. They were promised, as were many others, that when the circus reopened, they would be hired back. Most of the employees didn't believe it would ever open again and went their separate ways.

Kelly found a job in the Midwest working horses on a ranch.

"He always did like to come around and watch the palominos work, or was it the girls?" Gertie would laugh.

Most of the elephants were kept. Bram was put in charge of them, and on any given day, he could be found out in the vacant lot putting them through their paces.

The head trainer was fired. He had been there ten years and was bitter about losing his job. Bram felt bad and told him so. He tried to explain that Mr. North had done it to save money, not because the trainer wasn't good at his job. But the head trainer blamed it on Bram.

"You and that damn elephant. If I would have known he wanted that kind of act I would have done so," he boasted. "You took away a ten-year career. Why didn't he let me work Modoc and fire you? Now you are working my elephants and I'm fired!" He got real close to Bram's face. "Just let's not meet up on a side street someday."

As always happens, the sideshow people were the hardest hit. Fingers wore five-fingered gloves and got a job parking cars, the Bearded Lady shaved her beard and became a bouncer in a strip club. Fat Lady went to a fat farm to lose some weight, but no one knew if she was successful. Snake Lady went to work as a hairstylist. Strong Man married a woman who was enamored of all those bulging muscles. Tall Man took a job as a doorman at a famous hotel in New York. Most said they would come back when the circus reopened.

The circus moved to its winter quarters in the South where the weather was constantly warm. Bram and Gertie lived on his new small salary and the memory of the past. They would sit by the hour and talk of what had been.

Modoc carried with her scars from the fire that would last a lifetime. Some of the skin on her back was permanently blistered with huge welts. Only those accustomed to elephants would notice, but Mr. North made Bram put her blanket on whenever anybody of importance came around.

After the court cases were over, Mr. North started to build the circus back. Slowly he found investors, and after a one-year period found the money, rebuilding the circus from top to bottom. He planned to use indoor stadiums whenever possible. The new equipment was fireproof. Animal acts were rehired. Some of the people, if they could be found, were asked back, but many had moved, died, or had "no forwarding address."

Opening day was successful but brought back the memories of friends like Curpo and Kelly. It was hard on Bram preparing Modoc. He found himself asking Curpo to hand him something, to get Mo's gold tips.

The circus was back in business. Receipts were good, the new acts were going well. Mr. North had made a special deal with a train company and now the circus traveled deluxe style.

Having their own train allowed them to go to towns they had never been to before, their schedule was more relaxed, and life in general was good. But it was one of these stopovers that was to change Modoc's life forever.

"Hi, elephants, whatcha doing, huh? Ya want a drink, huh! Burp, ahh, oops, I, ah, slipped, ha, in your poopie. Shusss, don't let them know I'm here, okay?"

A drunk had snuck into the elephant tent at night, unbeknownst to the security guard. He carried with him a bottle of scotch and a bull hook that a trainer had left on a hay bale. He sat on a hay bale in front of Modoc.

"I doon't feel soo good, ya know, soo I'll just sit down over here on this ole hay bale, oops, slipped, sorry. Now, you see this? Huh? Huh? Well, hist a bull hook. Ya know, soo don't mess with me!" Looking up, "They, burp, call you Moodoc, yoour the golden elephantee. You are good, that's for sure, hiccup, scuze me, you're in the center ring."

The drunk stood up on the hay bale, eye level with Mo. He sunk the hook into Modoc's chin and pulled. "Come here!" he shouted.

Mo swung her head to him so fast he lost his balance and fell off the hay bale.

"Hey now, that wasn't nice! You need to be taught some manners."

Modoc sensed the man wanted to cause her injury. He wanted something from her. What? He got to his feet, picked up the bull hook, and swung it at Mo. She backed away, avoiding the hit.

"You bitch, come here now, I say!"

This time he circled her like a cat does a mouse. She watched him carefully. He ran at her again and smacked the hook against her side, ripping the flesh. She let out a bellow. He swung again, cutting her a six-inch gash.

Modoc whipped her foot out against the leg chains but they kept her at bay. Again he lashed out, catching her square on the face above the eye. The man was now committed to his task. His drunken stupor was not as evident. His anger had overcome his drinking. Modoc felt threatened. She would never hurt anyone unless provoked—and this man was hurting her. He came at her again, bull hook raised. She held her head high so he couldn't reach her, then jerked her body to the side, breaking one of the hind leg chains.

"Well, now the battle is more even, isn't it?" he shouted.

Sweat poured down his face. His shirt was sopping wet. Mo's attitude was now aggressive. She balled her trunk, ears out, and waited for the onslaught. The man saw she now meant business. At first his face registered fear, as though he might back away, then the anger came again. He moved to the side of the barn and picked up a pitchfork.

"Now the score is a little more even, isn't it?" Like a matador he circled Mo, pitchfork in one hand, bull hook in the other, poised for attack. "I can't kill you, bitch, but I can hurt you."

With this he made his move. He jabbed the pitchfork into her leg so deep he had to tug to get it out. Mo roared her pain. Blood was spilling down her side from the first wound, but the flow from the pitchfork was more profuse.

It flooded the hay around her feet, turning it into a slippery pool. Mo picked up a large sheaf of hay and threw it at him. The whole barn became a shower of hay particles.

"Ha ha, you big boob!"

Mo jerked at the front leg chain. It was heavier than the back one and refused to break. The man, his bloody pitchfork poised, held out in front of him, the bull hook shorter but lethal, came again. Full out. Like a kamikaze, screaming like a banshee, he launched himself at her. Mo grabbed the pitchfork from him, breaking it against her own leg. Then she grabbed him, holding him high. Her eyes were deep red. She hesitated, wondering whether to stomp him or throw him. The hesitation was all it took for the monster to swing the bull hook with all his might, sinking it into her eye!

With the hook still sticking out, she, bellowing with pain, slammed him to the ground, put a foot on his head, and decapitated him.

Bram, having heard the screams of agony, raced in to find the horror—the headless man and the bull hook still imbedded in her eye hanging loosely, swinging back and forth.

* * *

Mo lay still, tranquilized from the operation.

"The eye is gone, Bram, she will never see out of it again. I've left it intact. It will stay a whitish color; it's the best I can do."

The man who had hurt Mo had been a top trainer many years past. The records showed he'd been working with elephants, lions, tigers, as well as horses and even Brahma bulls. He was very successful with the Lippizaners and had landed a top position in the circus. It was an easy step from there to learn the big cats from the arena trainer. He wasn't very good at it, but he was fascinated by the elephants. When a trainer was hurt by one of the big cow elephants, he asked for the position. That was the beginning of a new career that was to last ten years. He was a good trainer, gentle yet firm, and was praised by his peers.

He fell in love with the high-wire lady and they were inseparable. One day he was putting the elephants through their paces in ring three. The high-wire act was performing in the center ring. He heard a scream and looked in time to see her plummet forty feet to her death.

He turned to drinking hard liquor to help kill the pain of loss. It was when he started to take it out on the elephants that the management had issued a warning. But the beatings continued until one of the elephants, Rosie, picked him up and threw him about twenty feet. She would have killed him had she been off her leg chains. He never got another job after that. He hit skid row and stayed there for years, became an alcoholic, and the rest was history.

Anyone who knew him felt he wanted to die but didn't have the courage to do it himself.

For six months Bram nursed Mo back to health. The eyelids functioned normally, but the eye itself was a chalk white.

The newspapers were not favorable to Modoc:

KILLER ELEPHANT GOES CRAZY

Others dubbed her Ol' One Eye.

It wasn't that long ago they had loved her, called her the Golden Elephant. Now, with one terrible act, she was regarded as a monster.

= 38 =

"I'M SELLING MO."

Mr. North had called Bram into his office. "She's blind."

"No she's not!"

". . . in one eye. Her back is a mess!"

"From saving people!"

"And now she's killed a man!"

"Who was trying to kill her!"

"Look, Bram, although I'll never understand your . . . so-called love for this animal, I want to be fair. I will sell her to whoever gives me the most money."

"But you know I don't have much money saved on what little I earn."

"Well, maybe no one wants her and you can get her—*free!*" he yelled, grinding his teeth in a sarcastic way.

* * *

"Gertie, what are we going to do?"

For the last hour they had been in the kitchen trying to find a way to raise enough money to buy Modoc. "We don't have any-where near the amount of money that old miser will get for her."

Bram racked his brain for an answer. "We just have to raise enough to buy her."

"And maintain her," added Gertie. "Imagine the cost of just feeding her. Even if we do," continued Gertie, "where can we go? Where do we keep her?"

"*Gertie!*" yelled Bram.

"Well, I'm just being practical."

"You mean you would not want Mo?" Bram's voice showed great pain.

"Don't be silly, I'm just trying to think ahead. Women do that, you know."

"Hmm."

Bram called everybody he knew. Kelly, the sideshow people, everybody. Friends, bankers, shopkeepers, pet shops, asking to bor-row money to buy Mo. Many were sympathetic to his needs and responded fast and handsomely, others were more skeptical, afraid they wouldn't get their money back.

"How do you plan on paying it back?" he was asked time and time again. "You can't make much money with a killer elephant, let alone one that has only one good eye."

Bram tried in vain to convince them otherwise, but to no avail.

For two months Mr. North offered Modoc for sale to the high-est bidder. Bram was surprised that only a few offered to bid. Most were too scared to keep her.

"After all, she did kill a man. And who's to know when it might happen again?"

Many were afraid that she wouldn't work for them.

"She ain't gonna work for anybody 'cept him." piped up old Mr. Barnes from the Humane Association.

Others, knowing the details of what had occurred and Mo's love of Bram, refused to bid.

"They belong together, North," some said. "You shouldn't separate them."

Another, "Just go ahead and give her to him, you greedy old fart!"

"Bram, the old man wants to see you," a roustabout yelled into his trailer door.

Mr. North was exasperated. "The best offer I got was $5,000! I can't believe it! This world-famous elephant, the Golden Elephant, the one that can do an act without a trainer! $5,000. Huh! Amazing. Well, that's it. Can you come up with the money or do I call the dog food people!"

"They're the ones offering the money?" Bram asked. Then, without waiting for an answer, "That's sick! That's really sick!"

Mr. North loved to antagonize him. "We even had to weigh her on our truck scales to come up with the right amount. It was the only way. They were buying her at so much a pound!"

Bram had borrowed $6,000. He had never believed it would be enough to buy her. He was elated! But he didn't want to show Mr. North his feelings.

"Yes, we can match that."

"You mean beat it, don't you?"

"Okay. $5,500!"

"Sold!"

Mr. North was rotten through and through. Even to the end. The bill of sale and the payment exchange were to take place at the winter quarters. The season would be over. Bram had found a little house with a bit of property in the back where they could keep Mo. A few friends were going to help out on the payments.

Things were looking up.

They still had some fourteen hundred miles to go. They were in the Rhode Island area and winter quarters were in south Florida.

There were two trains. It was the procedure to allow the staff and equipment to take the first train to reach the facility earlier. This

way they could set up and prepare the quarters for the animals before they arrived.

Bram said his goodbye to Mo. "You just take it easy now. Trains are fun. You can look out the window, see the world go by. There are many cows in the pasture. You like cows don't you?" He planted a big kiss above her bad eye. "See ya," he said.

He didn't like being separated from Mo but it was for only a few days, and it did give him time to prepare everything at the new place before she arrived.

The trains separated in upper New York state. The staff boarded the faster train heading for winter quarters, leaving the keepers to stay and care for the animals on the much slower menagerie train.

At a small whistlestop somewhere in the Ozarks, the menagerie train came to a stop. It was two in the morning. A slight foggy mist had settled over the train depot. All was quiet except for the air brakes hissing their release. The only vehicle in the station was a large low-boy furniture van. The truck was parked in the shadows near the train track. A man smoking a cigar sat behind the wheel.

The sound of a boxcar's heavy steel sliding doors being opened was heard. A ramp was lowered, the lights from inside blasted the darkness, silhouetting a man leading an elephant down the plank. Only the stationmaster and a luggage boy saw the elephant being unloaded. The man in the furniture van flipped his cigar into the gutter and went to the back of his truck. Opening the huge doors, he winched down a ramp. The other man arrived and loaded the elephant. The two spoke for a minute, exchanged something, then returned to their respective jobs.

The truck drove away as the train pulled out of the station quietly, no slipping of the wheels, no sound, no whistle. Anyone sleeping on the train would never even have woken up.

"Where's Mo? North! Where's Mo?"

Bram and Gertie had met the train but Mo wasn't on it.

"Where is she?" Bram was breathing hard, trembling, talking to Mr. North, who sat calmly at his desk in the lead train. Two big bouncer-type guys stood at each side of his desk. Bram had never seen them before.

"I sold her," he said, quite matter-of-fact.

"What? *What?*"

"She was mine, I owned her, and I sold her."

He never looked up.

"You sold her to me! I have $5,500 for her right here. Where is she?" Bram's body was visibly shaking, his voice was reaching its breaking point, as was his control.

"I was offered $10,000 for her . . . and I took it."

Bram saw nothing but flashes of red. Not even the brawn of the two strong men was enough to keep him away from Mr. North.

"You dirty bastard!" He leaped over the desk, knocking him off his chair, and proceeded to beat his head against the wall. His fist connected with North's face, teeth flew, an arm was pointing the wrong way before the heavyweights could dislodge him, hauling him out of the room. "Where is she! Where is she!" he yelled as they dragged him down the hall.

Within minutes an ambulance and police car arrived simultaneously. Mr. North was put on a gurney and wheeled to the ambulance for a trip to the hospital. Bram was handcuffed, put into the backseat of the police car, and hustled off to the local jail.

The next morning the judge sat patiently while the lawyers battled out their complaints in favor of their clients. It wasn't a matter of why he did it. Everyone knew about Mr. North's meanness, and when the facts were told, even the prosecutor for Mr. North showed a bit of concern for Bram. He didn't voice it in court, but in the plea bargaining he was most lenient.

Assault and battery was the crime. A suspended thirty days in jail, one-year probation, and payment of all hospital bills, plus the replacement of one broken desk!

Bram later found out the judge was a friend of a friend and

never did like North since he heard what happened to the victims of the fire.

Bram spent all his money on the lawyer as well as paying for Mr. North's hospital bill and desk. Mr. North spent one month in the hospital recovering from his injuries.

Bram and Gertie continued their search for Modoc well into the future. But as the months, then years passed, the cold emptiness in Bram was cemented and he rarely lived a contented day. He was helpless to do anything more.

39

AN ANIMAL COMPANY called Gentle Jungle Exotic Animal Rental had acquired the contract to supply all the trained exotic animals for a television series. Gentle Jungle was owned and operated by a man named Ralph. Things were going along great until one morning when he received an early telephone call from the director.

"Ralph, this is J.B. Listen, I know we just wrapped the last show of the season, but I wanted to tell you what was coming up in a few months."

"Yeah."

"At the start of next season's series we'll need an elephant."

He said it as though an elephant was an item Ralph carried around in his back pocket. "You have one, haven't you?" he asked, following a slight hesitation on Ralph's part. "Haven't you?" J.B. asked again.

"Sure, of course," Ralph said, with his fingers crossed. "I was just writing it down. When do you need it?"

"About September. Three months should give you enough time to teach it its act."

"Act?" he asked.

"Yeah, you know—sitting up, bowing, hopping, all that kind of stuff."

"Uh . . . sure, no problem," Ralph said. "Just send me the script so we can get started practicing."

Ralph hung up, after assuring J.B. that he would have the best elephant act this side of the Ringling Brothers.

"Who was that?" asked Toni, Ralph's wife.

"Studio," he said.

"Oh. What did they want?"

"An elephant."

"Hmm. Where are you going to get one?"

"I don't know."

"Hmm. Did you tell them you had one?"

"Yeah."

"Why did you do that?"

"'Cause I was afraid of losing the contract."

"Well," she said facetiously, "you can always hang a rubber hose from the milk cow's head. That should do it."

"Funny, Toni! Very funny."

For the next five days, Ralph and his associates called everybody they knew to see if anyone had heard of an elephant for sale. A few turned up, priced at around $10,000 each—way over their budget. Plus, one of them was a "batter"—that is, an elephant that throws its trunk with the intent to do bodily harm. They even had a couple of offers from zoos, but none of their elephants was tame, let alone trained.

By the end of the week, things were looking pretty grim. Ralph knew his competition had an elephant, and that if they got wind of the job they could take over the series.

"Even if we did find one," said Toni, "for—how much did you say?"

"A thousand dollars," Ralph replied.

"A thousand dollars," she continued, "what would you haul it in?"

"I don't know. Maybe its owner would bring it."

They had exhausted just about every means of finding an elephant when a friend showed him a newspaper ad. It read: "For sale: Old female circus elephant with bad eye, to professional people only. Cheap." It gave a phone number for somewhere back East—they weren't sure where. Ralph called.

"Hello?" a rather burly-sounding voice bellowed in his ear.

Ralph could hear kids screaming in the background. "I read your ad in the Sunday paper about an elephant for sale. Is she still available?"

"Yeah, we got her. She ain't much to look at, and she needs some meat an' potatoes, if you know what I mean," he belched out.

"How much do you want for her?"

"A thousand dollars, mister—that's it. She's a steal. Not many around at that price."

"What's wrong with her? I mean, any defects, bad habits?" Ralph figured that for that price there had to be something wrong.

"Look—take her or leave her. If you want her, fine. If not, well, we'll just cook her up and feed her to the dogs. Ha!"

There had been a beat before his answer that told Ralph to believe nothing. He could just visualize this guy—baldheaded, overweight, shirtless, and unshaven.

"Look, I gotta go," he said.

"Okay," Ralph replied, "I'll take her."

"You will?" came his surprised answer.

"Yeah. But we're coming all the way from California. It'll take about a week to get there. Will you hold her for us?"

"If I don't get too tired, holding all that weight! Ha!"

What a jerk, Ralph thought.

"Send me a few bucks so I know you're for real, and you've got yourself an elephant," he said.

They exchanged telephone numbers and addresses. As Ralph was hanging up, he asked, "Oh, by the way, what's her name?"

"Modoc—at least that's the name she came with. But the locals here call her One-Eye Mo."

Ralph picked up a used van trailer for about $500. The sides were rusted and two of the tires were bald, but with some oil, a lube job, and new tires, she looked pretty roadworthy. As for the truck, an old Chevy Bobtail had been impounded for nonpayment and was being auctioned off at the police garage—and they hit it lucky.

Everybody they knew pitched in to fix up the trailer. They laid in a new, two-inch plywood floor to support Modoc's weight. Holes were drilled in the plywood, and heavy leg chains were run through. Lightweight panel boards were installed around the inside to prevent any "nosing" around with the electric cables running through the trailer to the sidelights and the back brakelights.

All the while, everyone was telling them they were crazy to embark on such a risky venture—after all, they were spending all the money, money that was badly needed for the ranch facilities for cage repairs, old bills, and the like. True, the deal *did* sound pretty scary. Ralph had never heard of an elephant selling for $1,000! Either she was on her last legs, or she was a killer rejected by the circus . . . or both. And if the elephant didn't work out, what use would they have for the truck and the trailer? But if they were lucky enough to be able to use her even a little bit, she would earn enough money to help the company.

Frank, the ranch foreman, and Ralph took off early one morning, heading for the small town in the Ozarks where Modoc was then residing. Neither one had ever driven a twenty-two-wheel truck and trailer before, but after a thousand miles or so each, they'd stopped grinding gears. Except for an occasional flat tire on the "new" retreads, the four-day trip went smoothly.

Seeing the country from high up in the cab was a new experience. The size and weight of the rig gave them a feeling of power and great energy as they sped across the deserts of Arizona and

lugged up the Rocky Mountains. Texas seemed to take forever, but the Plains states flew by—and from Chicago on, they were on the edge of their seats, anticipating their arrival.

Ralph had never owned an elephant before, but he was experienced in handling them for others. Always one of his favorites in the world of animals, elephants never failed to leave him in awe. He found them to be both extremely intelligent and very sensitive.

They had climbed high into the Ozark mountains. Pulling off the main highway, they entered a small community. After some searching, they finally managed to find the old, dilapidated, one-story house. A broken porch and a yard full of tin cans and old tires gave it a look of depression.

They knocked on the door. It seemed that nobody was home, but the door was cracked open a bit. Ralph could see the inside of the house was in about the same condition as the outside.

"Hello! Anybody here?"

No answer. Walking around the side of the house and across the yard, Frank and Ralph noticed a couple of boys pitching rocks at what appeared to be a large tree. They were heading toward the boys when the voice Ralph had heard on the telephone boomed out: "Hey, you! You're on private property!"

There was the man, almost identical to how Ralph had visualized him—fat, balding, and gruff.

"We're the people who called you from California—came to get Modoc," Ralph said.

"Well, you really *did* come, after all," he said, ambling over to them. "Thought you might forfeit the money." He wiped his dirty hands on his dirty trousers.

"I'm Ralph, and this is Frank."

"Bo Jenkins."

They shook hands all around. Ralph could smell that familiar circus odor drifting through the air, but couldn't figure out where it was coming from. Then he heard a squeal that sounded as though it had come from a hurt animal.

"I got 'er!" yelled one of the kids.

"You kids go on home now."

"I got 'er, Mr. Jenkins! Square in the leg! Here's your money." Ralph watched as the kids gave Jenkins a couple of coins. "I don't have to pay for the second one, right?"

"Yeah, sure, kid. Go on, now—beat it!" he said. An embarrassed smirk crossed his reddening face. He quickly changed the subject. "Come on, I'll show you Mo."

They walked over to a four-foot-high barbed-wire fence encircling a lot of roughly two acres. It was barren except for a few shrubs, dozens of beer cans, and soda-pop bottles, and an unusually large number of stones at the far end of the field. There a large dead oak tree straddled the fence. Tied to the base of the tree was a heavy tow chain. It stretched out about fifteen feet and was shackled to the foot of an enormous elephant.

This was Modoc. She was the tallest Indian elephant Ralph had ever seen. She looked to be around thirty to forty years old. A bent tin sign hung on a pole just out of her reach. It read: ONE-EYE MO—KILLER ELEPHANT. KEEP YOUR DISTANCE! The sign was full of rock holes and dents.

Ralph felt his face flush with anger. "What do you do? Have the local kids pay you so they can throw rocks at the elephant?"

"Naw! Well, just a few. It helps pay the food bill."

"By the looks of this elephant, she hadn't seen a proper meal or even eaten in a long, long time."

"Look here, mister," demanded Jenkins, "you either take her or forfeit your deposit. I just don't care one way or the other."

Frank was fuming. "Good Lord, Ralph, we can't show her on camera! The Humane Society people would hang us!"

"I know," Ralph said, "but we can't leave her here in this condition." He turned to Jenkins. "What does that sign mean, 'Killer'? Is she dangerous?"

"I don't know," he replied. "I was told she is, but I never gave her a chance to show me."

"You mean you never approach her? Clean or scrub or treat her for worms?"

"*Her?* No way! Hell, no! What do you think I am, crazy? You want to get me killed?"

Frank and Ralph were both ready to deck him. "How long have you had her?" Ralph asked.

"Couple of years."

"*Couple of years!* You mean she's been here like this for a couple of years?" He must have had a look of murder on his face, because Jenkins started to back away.

"Look, if you want her, fine, I'll be in the house. If not—see ya." He turned and headed toward the house at a rather fast pace.

Frank and Ralph took a deep breath and, holding the barbed wire for each other, climbed through the fence and headed for Mo. As they approached, they saw she was resting her head against the old tree. She had apparently being doing this for some time, since a large worn spot grazed the tree at the same height as her head. She slowly turned toward them, her great ragged ears slowly angling forward, capturing every sound they made.

As they got closer, they could see just how abused she was. She was about a thousand pounds underweight. Her huge backbone arched high in the air, and her skin was stretched taut across a skeletal rib cage, only to hang loosely in huge globs at the bottom of her stomach. She appeared to be blind in her left eye.

It was then that Ralph saw it—from afar, one would never notice, since it was on the far side of the tree—*the end of the heavy low chain disappeared into her ankle.* The chain had been there so long without being removed that the outer skin had actually grown over it. It left the leg looking as though it had an overlarge ankle.

"My God! Frank! That bastard! That dirty bastard!" He turned, heading back toward the house.

Frank stopped him. "Time for that later," he said.

They stood there, amazed at the total emaciation of the poor old girl. There were bruises and cuts by the dozens, obviously made by the stone throwing. Old, healed gouges showed where large rocks had taken their toll. The hair was missing from Mo's tail, and

Ralph recalled having seen an elephant-hair bracelet on Jenkins's wrist. He wondered to himself how he had managed that!

Ralph called to her, "Hi, Mo . . . Hi, old girl . . ." She raised her great head high in the air, and for a moment she was silent. Then she made a *whooshh* sound with her trunk and stepped forward toward them. They could hear a distinct grumbling deep down in her stomach. She seemed to beg for them to come to her. Ralph could see her bad eye. It wasn't so bad to look at, actually; there was just a white cast where the pupil should have been.

Modoc started to come to life. She was swaying and anxious.

"What do we do, Ralph?" Frank asked. "She hasn't been off those chains in years!"

"Let's take it easy and be careful. Keep your bull hook close."

They approached Mo straight on, talking gently. She was straining against her chain so hard that it was ripping out of her flesh. The open cracks oozed with blood and pus. Sometimes in their business, decisions must be made that could mean life or death, decisions based on an ability to read an animal—in this case, a nine-foot-tall, maybe four-ton elephant with the potential to kill in an instant. Ralph's natural instincts were at work. He felt these were not the actions of a dangerous animal, but rather of one who was affectionate and starved, an elephant that craved the touch of human hands.

With outstretched hands he walked toward Mo. She leaned forward, stretching out her trunk. He reached over and gently touched its tip. It seemed that to her this was like receiving an electric shock, or, more accurately, a jolt of pure energy. At what Ralph believed must have been her first human touch in many, many years, she started to trumpet. Tail held high, head up, ears forward, she pranced around. Both men were thrilled. What ecstasy!

Ralph moved in close. Mo gently laid her trunk over his shoulder, ran it down the full length of his body, and encircled the tip around his toe. Then she started to shake. Her belly rumbled. As a naturalist, he knew this was her way of greeting him. Yet, as an animal lover, he also knew this was the sobbing of joy, expressing years

of pent-up pain and hunger and the deprivation of solitary confine-
ment. Animals, like people, experience loneliness, boredom, and
despondency when the comfort of a friendly voice, a familiar smell,
or a gentle touch no longer brightens their day.

Frank went around by the tree and started to work on the
chain. It took many trips to the truck for equipment to finally cut it
away. They left a small extension of it leading to her ankle, as they
knew a veterinarian would need to be there when they took it off.
They cut a hole in the fence, and slowly, for the first time in many
years, Mo walked—quivering, and dragging her stiff, chained leg
across her prison yard—to freedom.

When she saw the truck, she bellowed, as though it should
answer back. Perhaps it reminded her of one of the circus vehicles
of years past. Many people had gathered when they heard the bel-
lowing. Adults hugged their children tightly as "Killer Mo" limped
by. She walked up the ramp and into the truck. Frank had laid a nice
carpet of straw for her to rest in and provided an ample pile of fresh
alfalfa for her to eat. They put the end of a garden hose in her mouth
and turned it on, and for five minutes she filled herself with gallons
of fresh water.

Frank went to the house, paid the balance, and got a bill of
sale. Ralph knew that if he had gone, he would probably have
punched Jenkins's lights out.

They didn't want Mo to back out the rear door while they were
on the road or do any structural damage inside the trailer, so they
tied one of her legs, for safety reasons. Patting the old girl's derriere,
they closed the ten-foot door, revved up the engine, and slowly
drove down the driveway. They had themselves an elephant!

The states passed quickly, as did the days and nights. They
stopped every few hours to check and see that Mo was riding com-
fortably and that her leg chain was secure. They kept the floor cov-
ered with fresh straw, and fed Mo about a fourth of an elephant's
normal daily intake (concerned that a normal-sized diet might be
too rich), placing twenty to thirty pounds of alfalfa well within
reach of her trunk. Four times a day, she was given her five gallons

of a special mix of grains. Powdered penicillin from the first aid kit was sprinkled in the leg wound morning, afternoon, and night, and the wound was kept as clean and sterile as possible to prevent infection.

The gas stations along the way were very helpful when they asked for a drink of water for the elephant. Modoc would pick up the hose with her trunk and place it in her mouth. When Ralph saw her control the flow of water by stepping on the hose, he began to suspect that this lady had a history. On hot days she would suck water up in her trunk and spray her back to stay cool.

Other times, they would take her out for walks to keep her from getting stiff from standing in one place for too long, and to get good circulation going in her injured leg. During one of these walks, they caused a major jam-up on the highway—everybody wanted to see the elephant. Some cars even pulled off to the side so the children could see Mo up close.

In Texas, the temperature was approaching 101 degrees. When they asked a gas station owner who had some property behind his station if they could use it to bathe the elephant, he happily agreed. They bought some laundry soap and a scrub brush from a local grocery store and set to work. They scrubbed and scrubbed, pouring the soap and water over Mo until she looked like one giant bubble. She seemed to thoroughly enjoy the scrubbing and occasionally she'd raise a foot and let out a squeaky sound when they found a ticklish spot on her ribs, just behind her left front leg. It must have been her first bath in years.

It took a while to get through the crust and the scabs, but finally they laid her down and washed one side of her thoroughly. Her skin appeared a sleek, gray color. Her cheekbones and the bottoms of her ears had a pinkish cast, confirming Ralph's previous estimate of her age. He carefully flushed out her eyes, paying particular attention to the left one.

The sun dried her quickly, and her spirits seemed to lift. Tipping the gasoline attendant a ten, they walked Mo back to the truck. For all her previous wear and tear, she looked immaculate.

Two days later they reached New Mexico. They stopped at a telephone booth to call the ranch to let everyone know they were on their way.

By now, they had learned how to drive a truck and trailer with an elephant on board. Elephants tend to rock considerably to maintain good blood circulation. However, when there are four tons up off the ground, rocking back and forth, the handling of the trailer becomes difficult. There is a danger of turning over, especially if the elephant is rocking to the right as a right-hand turn is made. But by the time they hit Arizona, all was going quite well. Every time they crossed a state border, the state police had them unload Mo, as her constant rocking prevented an accurate reading at the weigh station.

A day and a half later, they rolled into the ranch early in the morning. All the smells of the other animals must have brought back some memories that excited Modoc, for she let out trumpet after trumpet, blasting the air all the way up the half-mile entrance. Ralph and Frank followed suit by blasting their diesel horn. Modoc was home!

The horses and zebras bolted and raced around their pens, and the macaws and peacocks shrieked. The camels looked on, munching, while the ostriches ran in zigzag patterns, looking like ballerinas in tutus. Everyone came out to greet Mo. Ralph and Frank jumped out of the cab into the arms of their loved ones and amid the accolades of the group. Then they went around to the back door, put down the ramp, and walked in. They undid Mo's leg chain and slowly backed her out of the trailer. For the next few hours, she was lavished with care, and with goodies: popcorn (to make her feel at home), candy, soda pop, cookies, bread. She even ate a bouquet of flowers that had been brought for her arrival!

A reconstructed garage became her new house. A thin, lightweight, fifty-foot chain was attached to her good hind leg, giving her complete access to the outdoors as well as to the interior of the garage. She could have broken the chain at any time, but she never

even tried. A large bathtub filled with water was at her constant disposal.

The vet arrived early the next morning. He took one look at Modoc's condition and told them that they'd gotten her out just in the nick of time. She would never have survived another winter back there.

They went to work on her nails, which were overgrown, gnarled, and broken. They worked for hours clipping, filing, and rasping, but Ralph figured it would be months before they would be back to normal.

The vet then wormed her, treated her minor cuts and injuries, and put her on some fast-acting vitamins and mineral supplements. Checking her teeth, he found he had to "float" the back ones. Sometimes, due to a poor diet, an animal's back molars will grow sharp points that prevent the teeth from grinding food properly. "Floating" is done by rasping the points off with a large steel file, making the molars flat and more efficient.

Then they all concentrated on the big problem . . . her ankle. The vet felt that major surgery was needed, but in Mo's weakened condition, it was too risky to put her under an anesthetic. So he decided to use a local painkiller and depend on her good nature and mild attitude to allow him to work.

They brought Mo to a small, clean pad of cement, which was normally used for washing down the camels and hoofed stock. Giving her a command to "come down" and another to "come over," they laid her down and prepared her for surgery. Once the drugs had taken effect, the vet began to cut the hide along the top of the heavy chain with a large surgical knife, with the aim of cutting a complete circle. The cutting was so difficult that they had to take turns holding and separating the thick hide. The skin was exceptionally tough, and penetrating it was very hard work.

Once the vet had cut completely through, he gently used a small scalpel to part the flesh all the way to the embedded chain. Even though he had given Mo a blood coagulant, she was still

bleeding profusely. Toni assisted by dabbing gauze and cotton swabs after each cut. Frank kept Mo lying quietly with gentle persuasion and touching.

That she hadn't died of infection or tetanus was amazing, the vet said. Her body had built up a tough wall of gristlelike flesh surrounding the chain. The rust from the chain had penetrated the area and turned it a dark brown. They cut the main bolt holding the chain around the leg. Ralph took one end and the vet took the other, and together they slowly lifted it away from the raw flesh, uprooting its many-yeared implant. In places it was held fast by the skin growth, but a quick cut with the scalpel set it free. Once it was out, they went to work washing and disinfecting the trench, which was about two inches deep. The bleeding continued, so Mo was given more coagulants.

Suturing was impossible. The excessive, or "proud," flesh was trimmed off to promote growth, shots were given, bandages were applied, and a specially constructed shield cast was strapped into place over the wound. It was shaped like a cone and served to protect against dirt and Modoc's probing trunk. Her good eye was searching back and forth, trying to see what was going on. On Frank's command of "Up," Modoc threw her legs out and up. Then, bringing them down hard, she pulled herself into a sitting position, and finally she stood up.

Mo was kept dry and warm, and her bandages were changed daily. Painkillers were injected as often as needed. For the next few weeks she favored the other foot, keeping the pressure off the injured one.

The weeks passed, and Mo's overall condition continually improved. Although she had a long way to go, the wrinkles in her skin had began to disappear, as she had gained a couple hundred pounds. The new television season's shooting was coming near, and after consultation with the vet, they decided that a few short and easy training sessions would be acceptable.

They had built some sturdy pedestals and set them up inside a

circular area the size of a circus arena. Around it they placed cut oak logs, to serve as the perimeter. Quite a few of the staff had gathered to watch Modoc go through her paces. They moved one of the oak logs so that she could enter the arena. As Ralph stooped down replacing it, he heard a gasp from the onlookers. He stood up and turned around to one of the most phenomenal sights he had ever witnessed.

Modoc had walked to the center of the ring while he was putting the log back in place. Someone had found some old circus music and had turned it on, and the music of the calliope sounded across the arena. Suddenly she had started to dance. When Ralph turned, there she was, performing on her own in the dusty old arena. Her massive frame shook and quivered.

He couldn't believe it. What she was doing was impossible. No animal performs without a trainer—at least, he'd never seen it done. Plus, whatever the reason, she hadn't performed in years! How was this possible? Here she was, dancing like a seasoned performer, pirouetting and swirling, doing hops and skips, waltzes, leg-ups, and pedestal work. She was circling the arena—one, two, three, waltz; one, two, three, waltz. Her muscles were weak from years of inactivity, and her sore foot must have made it difficult, but she was doing it! Trunk up, head held high, Modoc wasn't in this old arena—she was in a circus tent, on a sawdust floor, swirling to the music beneath a spotlight. She was a star of the big top, with thousands of people applauding. There were clowns and children and cotton candy—"Step right up! See the big show!" It was all there. The memories, the smells, the laughter, the applause. Modoc ended her act with a bow, and the music stopped. The huge audience dwindled to those few who were standing on the fence or seated on the top rail.

They were all speechless, teary-eyed at what they had just seen. Modoc stood, waiting quietly. It was then that Ralph looked down and saw the blood oozing from her ankle. She had opened the wound.

Then came the applause, the whistles, the congratulations. They all rushed to her with hugs and kisses and many "well done" pats, and then gently headed her back to the barn for treatment. True, her performance had been somewhat shaky and uneven, and some of it she hadn't been able to do at all. But she had *tried!*

Ralph knew then that this lady must have been a star—a great star—to be able to perform in the ring without a trainer. She must have been world-renowned.

= 40 =

"THEY HAVE ANIMAL RENTAL COMPANIES HERE," said Gertie.

"What's that—who would rent an animal?"

"The movies would. How do you think they get all those animals to perform?"

"Let's go. There are only a few of them. We can ask about Modoc and work!"

The animal establishments were scattered around the northern end of Los Angeles. Each was nestled in the countryside as exotic animals were not allowed in the city. Bram and Gertie visited them one by one, asking if there was any work available. But the answer was always the same. Sorry, and no, we don't know of any . . . Modoc!

The final place was in a remote area called Aqua Dulce. The countryside changed from green to semi-arid. The weather turned hot, the country bleak, almost barren.

They turned onto a ranch road with an overhead sign that read: GENTLE JUNGLE EXOTIC ANIMAL RENTAL.

"Sounds strange."

"Sounds nice."

As they pulled in they noticed the vegetation had changed. Sycamores, oaks, palm trees, semitropical plants abounded. Unique rock formations added to the dramatic change.

Animals were everywhere! Many Bram had never seen before. Orangutan, leopards, camels, chimps, tigers, lions. There was an ambience of the past here. The name implied love and animals, the two things most dear to his heart.

The truck rolled to a stop near a large arena. Bram sniffed the air. "Gertie, they have elephants!"

An animal keeper came out to greet them. "Howdy, what can I do for you?"

"We came to see if you had any work available and . . . ?"

"Gee, I'm sorry, but the owner is away and won't be back until later. Best if you came back then."

"But I . . . "

The man had walked on, not rude, just going on with his duties.

"Well, what do you think?" asked Gertie.

Bram had walked off a bit, his head held high, eyes searching, listening . . . "Gertie, Mosie's here!"

"What!"

"She is, I know it! Oh! My God, Gertie . . . !"

Bram started to walk into the animal compound.

"Bram, we're trespassing."

He never heard her. He walked attentively, listening, alert. "Mosie, where are you girl, Mosie, MODOC!!" he yelled. He started to run. To cry heartfelt sobs. Tears flowed down his cheeks. "WHERE ARE YOU?"

The earth seemed to explode! A blast of pure vocal energy in a volume not heard before came from somewhere, everywhere.

"Gertie, it's Mo! It's MO!" Bram ran faster, following the trumpeting!

A ripping, tearing noise was heard. It was coming from around the side of a building! Bram was now racing. As he came around the corner he saw her! There was Modoc coming on, dragging her injured foot, trumpeting, heading for a fence. Lowering her head she plowed through it—throwing stakes, wire in all directions. Bellowing, shaking her head, ears out, the leg chain she had just uprooted dangling behind her, she held her head sideways to see him with her good eye, crashing through the fence. Limping from her injury, she headed toward Bram.

Bram was running full out, Gertie close behind. The dust hadn't settled when she came to a sudden stop before him! Bram leaped up, grabbing her trunk, hugging, holding! She swung him high in the air, dancing, squeaking, shrieking, kicking her feet.

"Mosie, Mosie, how I missed you!" he cried.

Her good eye opened wide to take in the man she loved, the man who all her life had been her friend, her father figure, her mentor. They had, at last, found each other.

Gertie, too, was held tight by her trunk. Mo's belly rumbling said it all. They were together again!

The keeper stood awestruck, his mouth open. To ease the keeper's confusion, Bram turned and said happily, "Don't worry, we're family!"

Bram noticed the foot. The blood was pouring from the opening because of the activity.

That evening Ralph arrived from working a lion at the studio.

Bram and Gertie, along with the keeper, were up in the barn changing the bandages on Modoc's foot when he arrived. At first Ralph was upset that these "strangers" were there treating Mo. For the next hour and on into an evening dinner, they talked. Bram and Gertie told Ralph the story starting way back in Germany.

Ralph was overwhelmed. "In all my years in the animal business, never have I heard such a story! Incredible! I don't know how you made it! What an extreme series of emotional ups and downs,"

he said. Then, thinking about it, "You know, in many ways we're quite similar. We both share the metaphysical approach to life. Our method of handling animals is as one. We feel the same about nature and particularly about the animals. My idea of affection training is kin to your training beliefs. Look, I'd love to have you on board here at the ranch. But you have to be aware that sometimes your salaries may be a bit late. Jobs in the movie industry are few and far between. Money to run the ranch is hard to come by, sometimes nonexistent. It depends on how much studio work comes in. A big job can bring a handsome profit, but it's short-lived. The animals keep eating, bills have to be paid. Companies bigger than mine take most of the business . . . but someday with the knowledge of affection training spreading throughout the studios we hope to get our fair share. But it's up to you."

Bram and Gertie started work the next day.

In the years that followed a whole new experience opened up for Hollywood. With Ralph's affection training methods, actors could work directly with animals that in the past had been too dangerous to be with. With the advent of this new gentle way, the company soared to the top. The name was changed to Africa, U.S.A. because of the large number of African animals that were being filmed. In a short time Africa, U.S.A. became the largest animal rental company in the world. Modoc, along with Zamba the lion, C.J. the orangutan, Judy the chimp, Clarence the Cross-eyed Lion, and many, many more were to become famous animal movie stars. They and others were awarded over twenty-four PATSY awards, the highest honor given to an animal that performs in the movie business.

Hollywood and its movie stars fell in love with Mo and her friends. She had made her comeback—and had risen to stardom again. Bram also built a name for himself. His fame in Hollywood as a great trainer was matched by his reputation as a warm and gentle man.

41

"MO IS LOSING HER SIGHT IN THE OTHER EYE, Bram. I don't think it's related to the injury in the left one. I think it's just old age. She's getting up there, you know. Her life has not been an easy one, and it's just taken its toll."

She had never really recovered from her years away. That had been a terrible ordeal!

Bram knew that the veterinarian was right. Lately he had to smooth out the ground in and around the barn because Mo, not being able to see where she was going, had been tripping a lot and he was afraid she might hurt herself.

"Modoc needs to retire, Bram."

"Ah! To retire is to die."

"No, I just mean not to do any big jobs, jobs that take her energy."

She could work around the ranch, maybe do a few things for

the schoolchildren on the weekends but . . . "It's time."

Bram knew it as well, but to face it, to tell Mo . . . He, too, was feeling physically tired in ways that he had not experienced before. He felt a calling alerting him that time was running out. A Cross-Over was in the making,

They were growing old together. They were given a job appearing at a beautiful affair held on the lawn of a Beverly Hills mansion. A job that the veterinarian approved of.

The proprietor had asked that Modoc be put on top of a small grass hill so everybody could see her. Nothing more, no performance. She was there as a "movie star."

Bram scrubbed her till she sparkled. Her eyesight by now had gotten worse, but as long as she could hear Bram's voice she was content. She accepted her blindness as a matter of fact. As long as she was fed, watered, and knew he was there, and knew she could wrap her trunk around him and belly-rumble on occasion, she was happy.

The crowd gathered in a huge circle around her. Oohs and ahhs were heard. They asked questions about her studio career. Some of the dignitaries had their pictures taken with her.

Late in the afternoon Bram settled down under a nearby shade tree, as most of the crowd had left, when a solitary figure walked out of the shadows. He was an older man, large, dressed in a wool turtleneck sweater, heavy pea coat, oversized baggy pants, a wrinkled brimmed hat, and old heavy-duty shoes.

The man, limping a bit, headed straight up the hill to Modoc.

"Excuse me, sir!" said Bram

He never stopped.

As he approached Modoc, he stood for a moment, then dropped to his knees and put his arms around her leg. As Bram came up the hill he heard him quietly sobbing.

Mo was tender with him. She touched his head gently and then, as a sign of recognition, belly-rumbled. Bram knelt down beside the man, his hand on his shoulder. The man turned, looking straight into

Bram's face. Bram's mind exploded into a sea of memory, of one lost in the annals of time. Eyes that once saw death, that . . .

"Hands! Oh my God . . . Hands!" He threw his arms around the big fellow, practically knocking him over.

"Bram, my friend, my dear friend!"

They sobbed together, hugging, laughing, choking back the tears of joy. The hands that had held Bram up, that gave him the hope to stay afloat, now wrapped around him, holding as before.

"What are you doing here?" asked Bram through the sniffles.

"I was invited to the party by some old friends. It was so boring I was leaving when I saw . . . Modoc. I wasn't sure it was her," he said, wiping his eyes. "But when I came closer, I knew. I didn't even see you under the tree!"

"But where have you been? I tried to find you, looked everywhere."

"I left for England after I got out of the hospital. I was told all the people who were in the water had perished due to exposure. I checked the local hospitals—nothing."

"And Modoc?"

"I called the zoo, they knew nothing. Only that an elephant had been used to save some people out at sea. So I went to England. Spent a good many years there as a longshoreman working the docks out of Southampton. Sometimes I signed on one of the ships heading for points unknown, you know, just traveling around to different ports. It's great fun and the money's good. Then, quite a while back, I came here to better myself but the work I do, the life I lead, is back there at the docks."

"And now?" asked Bram.

"I'll return to England. A freighter is leaving for India and I want to be on board her. Ever since the sinking I feel that I must go back." Hands's attitude changed. "All these years. Do you imagine? I don't know why, but there is something I have to do or see. I don't know. Maybe it's just to relive the experience emotionally. I don't think I ever gave what happened a chance to settle itself. It's still

with me, you know what I mean?"

Bram nodded. He knew very well what he meant.

Mo's eyesight had gotten worse. She couldn't leave the elephant barn without Bram being there to help.

"Well, Mosie, how ya doing today, huh?"

Mo had developed a new way to compensate for her blindness.

She constantly kept her trunk busy, like a man with a cane, touching all things, whether standing still, walking, meeting people, she had to touch them; it was the only way she could "talk" with them. But she was getting into everything. Chairs, tables, cars, glasses, nothing escaped. If it was loose, it fell victim to her ever-swinging trunk.

When Bram took her out, she moved carefully, touching as she walked, but still anything in her way was fair game. Bram, seeing the problem, decided to resolve it.

"Today I will teach you something new."

He put the tip of her trunk into his back belt loop. "Now you just hang on to that and I'll be your 'seeing-eye' person."

And so it was. Wherever they went Mo would tuck her trunk into Bram's belt and off they would go. She would slide her feet as she walked, to assure herself that the ground was smooth. After a while even that stopped, her trust in Bram was so complete.

Bram taught her how to go up and down the steps to the circus ring he had set up, where he worked her three times a week.

"You must have a purpose in life, girl," he would say. "Work is important."

Her act was not the same. Slower, but passable. Sometimes she staggered, her moves weren't as graceful. But she performed!

Gertie saw the deterioration. She worried what would happen to Bram were Mo to die. "She's getting old, Bram. You know, the time will come when . . . "

"I know, Gertie, I know," he would say and then walk away, usually in the direction of the barn.

Bram walked up and down the aisle in front of Mo, sometimes

his hands locked behind his back, other times they were expressing a point. Mo listened, swinging her head to and fro, not missing a word.

"You know, Mo, I've been thinking of the Elephantarium lately. You remember Atoul, the white elephant? Well, he taught me that all things need to change form to live. When we die we change into ashes, gases, things like that. Then they carry on until they change. The ashes may help a tree grow, the gases could mingle with others and become . . . something else! That means someday you and I are going to change and . . . ah . . . well . . ." His voice stuck in his throat. He stopped, cleared his throat, turned and walked to Mo. He rubbed the soft leathery skin on the underside of her ear. "And you . . . you will become something greater and more wonderful than you can imagine! You will soar in the cosmos, become part of all things, you will sit at HIS side and help rule all of nature."

Bram's whole being felt the impact . . . the thought of not being with her.

"I will be waiting for you, okay? I'll meet you there." His voice broke, tears were streaming down his cheeks. "I just don't want you to go first. Okay? I don't want you to be there . . . alone." He rested his head on hers and cried aloud.

"So don't be afraid. You have many friends here to take care of you." He whispered in her ear, "Don't cross over before me, Mo, okay?"

He rubbed his hand gently over her white eye, smoothing the soft skin around it. She stood stock-still, quiet, her trunk hung loose. Head held low. A little chirping was heard, a small belly rumble.

"I'm so, so, sorry . . . "

"Bram, you in there?"

It was Gertie, calling him for dinner.

"I'm coming." He wiped his eyes, hers, too. "I'm coming."

Ralph had decided to retire Mo. He was afraid that she might get hurt, trip . . . maybe even fall. Yet he knew how Bram felt about retiring. "To retire is to die," he would say.

He had a private meeting with the ranch trainers.

"I want to retire Mo without her . . . I mean . . . Bram . . . well, both of them knowing about it. We can't ever use that word."

"How old is she?"

"The best we can figure is around seventy."

"Wow! That's got to be some kind of record."

"That's it! We'll throw her a birthday party. Bram, too. You know they share the same birthday."

"In reality, you mean like a farewell to Mo."

"God, it's like she's got cancer and is going to die!"

"No, silly, many people have a farewell party for those who served their company or country well," spoke up one of the female trainers.

Ralph broke in, "She has spent her entire life helping, pleasing people. It's a way of saying thanks to her."

"Will she know it, I mean is it for her . . . or for us?"

"Both."

Ralph contributed into the pool allowing them to rent a large tent and have it erected at the ranch over the circus ring. It was big enough to house the ring and bleachers for a large group of people. They even had a calliope brought in to simulate the feeling of the circus.

Invitations were sent out near and far, to all her friends.

"There is to be a birthday celebration."

The response was more than they could have imagined. Letters, telegrams, telephone calls, all poured in from around the world; some sent their love, others said, "Hope I can be there." Many others said they would come.

"Well, this is an important day for you, big girl. All your friends are coming."

Bram washed her early in the morning in preparation for the celebration. He sprayed her with some perfume.

Mo's trunk was fussing with everything, wouldn't stand still, playing with Bram's nose, his face, messing his hair. Her backbone

had become more prominent as she aged, the burn scars from the fire more noticeable as well.

Bram covered her with the red and gold blanket he had been given by the sideshow people from the circus.

"It's yours, Mo, nobody else can ever do or be what you are!"

Sometimes Bram would look up at her white eye and bony back, and tears would come into his eyes as he remembered the past when she had been young and strong. "Remember, Mosie, pushing that cart up the ramp when the wheel broke?"

These thoughts brought back vivid pictures of Sian smiling, her black silky hair blowing in the breeze. It was as though she were looking at him. The tears rushed to his eyes; he turned his head away, breaking the thought into a thousand bubbles.

"Sorry, Mo, it's just that lately it's all been coming back to me. Maybe to you, too, huh?"

Mo was too busy swaying, feeling the tassels bounce against her side.

Bram donned his old costume, saw that the pants didn't fit as they used to.

"The jacket will do," he said.

A package arrived addressed to Modoc Gunterstein. Bram gave it to Mo to check out. She tried to eat it. A letter accompanied the package:

Dear Mo,

I received a letter of your commemoration. Congratulations. Through a most unusual pattern of communication I had the opportunity to purchase these from the circus. They had no use for them and anyhow, no one else should wear them. Wish I could be there. In many respects, I am.

> *Best to Bram,*
> *Regards,*
>
> *Kalli Gooma*

In the package were the two golden tips. Bram slipped them on as he had in the old days. He fought back the memories. They were too painful.

"I'll remember them later," he said. He stood back a bit, looking at Mo. "Let me see how you look, girl!"

She was so proud! Trunk curled, head held high.

The blanket hung a bit loose, the headpiece had been taken up, the golden tips were a little lopsided, but she was PROUD! She stood tall, her spirits high! She was young again!

Bram, taking his choon, rubbed his hand over his father's initials. Then he tucked Mo's trunk into the back of his waistband. With a proud note in his voice, he said, "Move up, Mo! Move up, old girl."

The circus music could be heard coming from the tent. Mo followed him across the yard, her trunk playing with his belt, sashaying to the music, down the steps, into a darkened arena. A voice rang out.

"Ladies and gentleman, children of the world, we give you Bram Gunterstein, and the world's greatest elephant, the one, the only, Golden Elephant, MODOC!!"

A single spotlight flashed on the center ring. Bram slowly brought Mo into the center ring and as the calliope started, he backed away, not too far, but where she could hear his voice.

"Okay. Mosie, you're on!"

Mo stood for a moment, ears out as though . . . listening. The calliope started to play. She stood there . . . missed her cue. Or did she?

She was somewhere else, hearing different music coming from a different place. Then she started to sway, to dance . . . her dance, in her own time, more beautiful than ever before. The calliope played on, and somehow it matched her movement, or maybe it just seemed to. The slight stumble, a waver off balance were dissolved in the beauty of the moment . . .

The circus tent seemed to spin, flashes of performers, the girls

on the flying trapeze, the Great Zifferoni and his fall of death, Gertie dancing on her back, uprooting the flower fields, the scorching fire, her trunk around Bram . . .

She bowed at the end of the performance, not quite as low, and the spot went out.

When the tent lights came on, she heard the thunderous applause. The stands were full.

Hundreds had come to say their goodbyes, to thank her for all that she had done to better the lives of so many. The audience rose as one. They stood in respect, in honor of a great lady.

Gertie was there, as were Kelly, Fat Lady, Thin Man, Fingers, even Hands, and if one looked closely one might have thought there was a little fellow standing on the seat, waving, nearly falling off. They had all had come to say their farewells.

☰ Epilogue ☰

Bram died soon after Mo's birthday celebration.

Mo was to follow shortly.

Who is to say that their Cross-Over wasn't arranged, so she wouldn't be . . . alone.

Move Up, Mo!

Move UP, Mo!
The ragged flapping ears slapped alert.
The massive trunk swayed, spraying dust
Huge mammoth pondering feet stirred
Keeping in step.
As though waiting for the inner beat.
Then, gathering it all together
All parts lurching in unison
. . . it MOVED!
Nine thousand one hundred eighty pounds
Eight foot two
. . . moved.
Move UP, Mo!
Her tail swayed as if to keep the balance,
Her trunk touching out in front of her to check the ground.
And if you fall, don't FRET, Mo.
The chains, the cranes, our LOVE will get you up.
Trunk UP, Mo!
Lift me up (I need it now).
Pack your trunk, smell the flowers,
Fall asleep against the old oak.

Talk to the birds, talk to the children,
Lift them to your mighty back
Spray them with water till they giggle
Your trunk was so long
A trunk was born
And God added an elephant.
Lean way down, I'll put my eye to yours.
Or is it yours? For it seems another is looking out at me from inside.
How you loved it when we patted your tongue and pulled your
 teats. The bellowing rumble emitting from your cavernous
 tune seemed to say, "I was great, wasn't I?"
And you were! So great! So kind! So gentle!

A good life you had, Mo. Seventy-eight years. You were the oldest!
 World traveled . . . India, Germany, England, the U.S.A. The
 great days of the circus, the calliope, the midway: "Step right
 up and see the great Modoc!" Center ring, you had, Mo.
 Remember the lights, the popcorn, the clowns. "Ladies and
 gentlemen . . . children of all ages." The great tent would
 darken, voices would still, the music would begin. A spotlight
 blasted the darkness on you, Mo!
Bedazzled with sequins, the sop would follow you, swaying and
 bowing. Trunk up! Head down! No trainer, Mo. You did it
 . . . alone, alone! Lights on! An avalanche of applause and
 then back to the menagerie tent. Pushing, pulling, helping
 . . . always helping, no complaining.
Remember the fire, Mo! The screaming people! The frantic ani-
 mals? How many you saved? Pulling circus wagons free,
 pushing, lifting fiery beams. And the poisoning? So many
 died, but you survived. Remember, Mo?
And then that horrible day the mad, drunk keeper blinded you in
 one eye. One-eye Mo, they called you. Couldn't use you
 then. No green pastures, no thanks. For ten years you stayed
 in that zoo, Mo. So thin, so depressed. I didn't even have

enough money to buy you. Had to borrow. Not even a truck
to haul you. Took a loan. We suffered hard time together,
Mo, good old, Mo. I owe most all to you. It was you who
gave to me! You trained me! You taught me how to "affec-
tion train."
Move, up, Mo!
Move up through those great gates!
Make way for the best of them all!
Crank open those pearly gates just a little wider
Strengthen that bridge a little stronger
. . . for Mo's comin'!
Move UP, Mo!
Give her a railing to guide her.
She only has one good eye.
Call out to her loudly but with love
Her hearing's not too good.
I know her great legs are weak.
But she can make it.
You won't have to worry about her
complaining.
Or giving you any cause for trouble.
Mo's a good girl
 It's time to go, Mo.
 May you live in a gentle jungle
 And when my time comes,
 Let down your trunk, Mo
 And lift me up
 to YOU, Mo.
 to you.
 (Written two days after Mo's death)

RALPH D. HELFER